D0734266

Word
Image
Psyche

Word
Image
Psyche

BETTINA L. KNAPP

THE UNIVERSITY OF ALABAMA PRESS

Library of Congress Cataloging in Publication Data

Knapp, Bettina Liebowitz, 1926–
Word/image/psyche.

Bibliography: p.
Includes index.
1. Art criticism. 2. Psychoanalysis and art.
I. Title.
N7476.K62 1985 701'.1'8 83-17856
ISBN 0-8173-0206-9

ACKNOWLEDGMENTS

Grateful acknowledgment is made as follows:

"Archaic Torso of Apollo" by Rainer Maria Rilke, *Selected Works Volume II: Poetry*. Translated by J. B. Leishman. Copyright © 1960 by Hogarth Press, Ltd. Reprinted by permission of New Directions Publishing Corporation.

Passages from Baudelaire, *The Mirror of Art: Critical Studies by Baudelaire*. Translated by Jonathan Mayne. Copyright © 1956 by Anchor Books and Phaidon Press, Ltd.

Passages from Gerd Muehsom, *French Painters and Paintings*. Copyright © 1970 by Ungar Publishers.

Quotations from translations of "The Panther" and "Flamingos" by Rainer Maria Rilke reprinted by permission of Siegfried Mandel. From *Rainer Maria Rilke: The Poet Instinct*. Copyright © 1965 by Southern Illinois University Press.

Contents

Illustrations

Word
Image
Psyche

Introduction

Any artist who takes in hand brush or pen, and uses it for creative purposes—to objectify and portray some private vision—thereby transforms what previously lay embedded in the subliminal sphere into a deliberate act. The painter or writer thus concretizes the amorphous and endows with an independent life and order that which was heretofore inchoate, and, in so doing, the artist brings into existence a mirror image of his or her inward climate. It is generally true that by exposing one's unconscious fantasies to the light of consciousness one may confront and react to them in a way always in keeping with one's own personality. As C. G. Jung declared in *The Spirit in Man, Art and Literature:* "A series of images whether in drawn or written form, begins as a rule with a symbol of the Nekya—the journey to Hades, the descent into the unconscious, and the leave-taking from the upper world. What happens afterwards, though it may still be expressed in the forms and figures of the day-world, gives intimations of a hidden meaning and is therefore symbolic in character."[1]

Although the nineteenth- and twentieth-century writers, whose art criticism and fiction are scrutinized in this book, were arbitrarily selected, they disclose their personal and collective reactions to the paintings and sculptures discussed. A reader may therefore approach these essays either individually, as a study of the ideas and subjective reactions of a single writer, or read the entire volume as a whole, as a composite of segments implicit in an evolving aesthetic and psychological process, an aspect of a cultural canon.

The nine writers represented in *Word/Image/Psyche* are not primarily critics, but rather poets, men of letters, and novelists for whom art was a meeting ground and a means of confronting another artist's reality, which, having observed and encountered, they either assimilated or rejected. For them, art was a way of discovering a link between their own inner lives and

the outside world. Writers—like the Goncourt brothers, for example—when describing the paintings of Watteau and Chardin, or the work of Utamaro and Hokusai, incarnated their reactions in word images replete with their own personal sensations and emotions. For the Goncourts, the contemplation of a painting was an outlet; it fulfilled a private need. Their criticism enabled them to express feelings that otherwise might well have remained stifled and repressed. The act of criticism also revealed to them the wider, larger movements taking place at the time in France: a renewed interest in the long-neglected and nearly forgotten art of the eighteenth century, and the new international cult of *Japonisme* that reflected a collective need to look for renewal beyond the borders of one's own time and place. Similarly, Henry James's attitude toward the feminine principle—the anima—was eternally caught in his gallery of portraits in *The Ambassadors*. These verbal images allowed him to face what he unconsciously felt to be a terrifying element in the empirical world—the flesh-and-blood woman; the images also reflect the puritanical and Victorian views then existing in the collective psyche in Britain and the United States. Again, the *puer-senex* interchange can be seen at work in the most volatile of ways in Rilke's reactions to Rodin's sculptures—reflected in the poet's writings as both a present and an eternal psychological condition, that of the father-son dynamic.

Whether expressed through the medium of painting, sculpture, or literature, the whole creative process in general is comparable to an ultrasensitive "seismograph," wrote René Huygue.[2] It measures the inner rhythm and energy at work in the limitless and mysterious world of the unconscious breeding ground of archetypal images that burst into being in a creative impulse. As an aspect and function of human life, art serves a further purpose as well: once the hidden elements have been endowed with form and consistency in the work of art, they may impose a fresh, innovative outlook on the empirical world. As such, they may help to fashion a new, less-outworn reality. To facilitate a better understanding of the ideations and configurations flooding exterior reality, academic critics have attempted to circumscribe and define them by labeling unconscious ontologic patterns and modes of sensing in terms appropriate to cultural art history such as primitive, classic, medieval, Gothic, neoclassical, romantic, naturalistic, impressionist, cubist, fauvist, futurist, and so forth. Each new wave in art and art criticism has brought a different understanding to the cultural canon. Sometimes the emerging contents are expressed in archetypal images, perhaps lending the work of art a feeling of eternality; sometimes they are simply fleeting

manifestations, and inconsequential figurations. Erich Neumann, in *Art and the Creative Unconscious*, has defined archetypes of the collective unconscious in the following way: "as intrinsically formless psychic structures which become visible in art. The archetypes are varied by the media through which they pass—that is, their form changes according to the time, place, and the psychological constellation of the individual in whom they are manifested."[3]

Those writers whose works are discussed in *Word/Image/Psyche* have sounded their own inner depths, and in so doing, have come into contact with the collective unconscious—that primordial past, that realm devoid of the rational space-time continuum. In this world, Baudelaire, Kokoschka, and Malraux, for example, *knew* "the obscure feeling of the solemn and the grandiose"—the world beyond appearances—which Rudolf Otto looked upon as the *mysterium tremendum*.[4] Others, like Théophile Gautier, nourished their writings with fantasy figures, rich sensory tonalities as well as meaningful thought processes.

It is in the penumbra of the collective unconscious that the individual first perceives the archetypal images that then emerge into consciousness to develop ad infinitum, and in so doing, they create a kind of "magnetic field," or "energy center," comparable to that of an active volcano.[5] If the energy inherent in the archetypal image remains repressed in the psyche, it may well erupt and then be transformed and concretized in such a way as to influence and even warp its contents in the process. It is the descent into the subliminal sphere that enabled an artist like Virginia Woolf to confront her own creative impulses, and to perceive cataclysms and abysses which she then verbally expressed by transposing to her own work what she had learned from the art of the impressionists and Cézanne. Unwittingly she endowed the archetypal image with magical powers and divine force, comparable to that of the Greek *daemon*. Similarly, Oskar Kokoschka was subject to those powerful urges inhabiting his psyche when writing his play, *Murderer Hope of Womankind*. This outpouring of rage reveals the need to dismember the status quo and exposes great chunks of self-hatred and an inability to resolve personal problems. Huysmans, too, responded to the impact of the mangled and bloodied forms and empty skies he perceived in Grünewald's excoriating *Crucifixion*.

To the sensitive critic, a work of visual art speaks its own language: it is the tangible visible symbol of a transcendental invisible reality. In Baudelaire's reactions to Delacroix's paintings he made explicit the excitement engendered by the visualization of what he perceived; to him the paintings were

virtual hierograms, sacred representations, in the same way that dolmens and menhirs were for Neolithic man. They aroused in him the profound emotions of awe, fear, and terror. In his case, it is not too much to say that spirit inhabited matter. In Malraux's *Saturn*, unconscious contents broke through from the irrational to the rational sphere, allowing an inexplicable and vast mystery to reach the light of consciousness and then become part of the visible world.

Images and symbols produced spontaneously by the collective unconscious have for centuries been defined and refined by writers and painters; it is the artists' responses to symbols and images—and to the messages and arcana contained therein—that are examined in *Word/Image/Psyche*. Gautier's delineations of Ribera's gnomes and Zurbarán's monks disclose a dissatisfaction and an incompatibility between his subjective inner being and his external life: a desire on Gautier's part to return to what he considered to be the pagan classical world of Greek beauty and order.

To analyze any work of art too explicitly is to deprive it of its mystery, to divest it of the very element that initially caused it to be created. For both the painter and the writer the symbol acts as a psychic transformer; it makes viable what would otherwise have lain dormant in the depths of the unconscious. As long as this catalyst does not become impoverished by the light of reason, it will not dry up, but will continue to activate the energy that is used to form the archetypal image and which compels it to surface into consciousness. But when the mystery becomes over explicated, or the symbols overly exposed and rationalized—and this is the case in religious symbolism, also—the conception becomes sterile and disintegrates. The parts, which are then more dynamic than their over-rationalized sum, are reabsorbed into the collective unconscious. Sometime in the future they may be revivified and emerge into consciousness in an altered form—and so participate in the cyclical process of life: birth, death, and the rebirth that is transformation.

The autonomous complexes, hidden drives, insights, and perceptions of the writers whose art criticism is discussed in *Word/Image/Psyche* are expressed in a network of archetypal images and analogies. In leaving this criticism relatively free of detailed explication, my hope is that just as the writers whose work I have discussed in this book were inspired by painters and sculptors, so, too, the reader's own psyche and artistic sense will be stimulated by examples of the graphic and plastic arts.

Because anyone's reaction to a work of art is multivalent and virtually

unlimited in scope, no objective or subjective interpretation can be said to be right or wrong in terms of the artist's original vision: "One meaning does not exclude another when the signification probes several levels," wrote René Huygue.[6] In searching out the symbols—the images and words used repeatedly by these artists and writers—as I have attempted to do in *Word/Image/Psyche*, my hope is that the reader will perhaps glimpse unknown patterns, receive soundings and tenors that will help him or her to experience the work of art both as an individual contribution and as a manifestation of the culture and society from which it emerged.

The intuitions of artists and writers, which filter from the unconscious to the conscious, alter in form and consistency with each new generation. The drive to discover unknown factors, to seek new forms of expression is eternal. The inner fire and energy that dwell in the creative individual's subliminal sphere is forever operational, shedding its Heraclitean sparks and fire, forcing the artist to struggle to express what sears, pains, corrodes, dazzles, and sensitizes the inner being. Whether fighting to impose one's own personal vision through the pictorial arts or music, or attempting to delineate such a perception in words—or simply projecting one's own inner anguish in tangible form—whether through painting, writing, or any other medium, art like life itself "is a battleground," Jung wrote. "It always has been, and always will be; and if it were not so, existence would come to an end."[7]

1

Gautier:

Aestheticism versus Asceticism in the Paintings of Ribera and Zurbarán

Théophile Gautier (1811–1872), worshiper of the Greek ideal of polished form and physical beauty, of azurite blues and sunlit yellows, of joy and harmony, was stunned when he confronted the paintings of Jusepe de Ribera (1588–1652) and Francisco de Zurbarán (1598–1664). It was during his five-month tour of Spain, in 1840, that he was exposed to a plethora of works by Spanish artists. He shared his ideas and responses to the creative geniuses living to the south of the Pyrenees in *Travels in Spain* and in his volume of poetry, *Spain*. I have singled out for analyses some of Gautier's reactions to the works of Ribera and Zurbarán as these appear in the above-mentioned books. The vision depicted by Ribera and Zurbarán, perhaps more strikingly than the canvases of other Spanish painters, represents the antithesis of the French poet's aesthetic, religious, and psychological aspirations. They are, therefore, of great interest not only to admirers and students of Gautier, but also they are of use in the study of certain aesthetic trends such as the Parnassian movement of the nineteenth century.

The sin-obsessed flagellants peopling the world of Ribera and Zurbarán were alien to Gautier. He yearned for brilliant sunlight and beauty, and not for the darkness and livid tones that shone on the distorted features of figures portrayed by these Spanish artists. Their structured paintings had nothing to do with glowing health nor dreams of gentle bucolic beings so close to Gautier's heart; he took pleasure in this life and did not trouble about the life to come. The French poet and art critic understood the significance of the canvases of Ribera and Zurbarán; he understood the rapid and elongated brushwork, the muted browns and blacks and stark whites, the skeletal figures staring deeply into what he considered sinister realms. He was, however, repelled and terrified by these painters' values and moral implications, their obsession with the Crucifixion and self-immolation—an *imitatio Christi*—and

the drama and realism of the bloodied, distended limbs with their protruding blue and purple veins, with which these emotional states were pictured. Such visions were foreign to his intellectual and emotional makeup.

Gautier was an extrovert, a man for whom the exterior world existed. By nature, he looked outside of himself at the large expanse of life to find the joys and pleasures he sought. As both man and writer, he wished to live as fully as possible. When viewing the Parthenon, in all its exquisite proportion and harmony, or the Greek sculptures of Praxiteles or those attributed to Phidias, his whole frame responded with delight and jubilation. He considered the human body to be one of God's most magnificent creations, not something to be tortured, mutilated, and degraded. Pastel color, networks of muscles and arteries elegantly intertwined in graceful lines, instilled in him a sense of serenity and optimism. There was no conflict between the flesh and the spirit for Gautier; no feelings of guilt, no sense of sin, no desire for masochism corroded his psyche; he had no need to expiate those elements that the Christian ascetics featured in the canvases of Ribera and Zurbarán spent their lives trying to extirpate.

Gautier believed that art should be devoid of all moral connotations and all utilitarian requirements. He took a wholly unpragmatic view of artistic creativity. Art, he believed, was not a means but an end unto itself; the rallying cry "Art for Art's Sake" was originally coined by Gautier. "Art exists by itself, outside of philosophy, poetry, and history. That is why a Greek torso, without head, arms, legs, anonymous fragments of a destroyed statue— by its plastic beauty alone—can arouse a sensitive soul to a state of pure beauty."[1] For him ideal beauty was the concern of art. It opened a door into the transpersonal, infinite, and absolute sphere into which Gautier could escape—a world that titillated his senses, filled his heart and lungs with pure clean air, and encompassed him with warmth and serenity.

Gautier was not alone in his distaste for what seemed to him to be guilt-ridden Christianity. In the nineteenth century there emerged among the intelligentsia a movement that spoke of a yearning for a return to paganism and evinced a profound and generalized distaste for modern Western religion, culture, and civilization. In his poems, "Myrtho" and "Delfica," Gérard de Nerval, for example, delineated the realm of beauty and harmony known to the ancient Greeks. The "mystical pagan," Louis Ménard, who reinterpreted Greek legends in the light of contemporary society, believed polytheism to be the force behind the republican form of government and Catholicism to be the force behind absolute monarchy. In *Ancient*

Poems and *Orphic Hymns*, Leconte de Lisle sought to re-create the perfection
of proportion the Greeks had achieved in their architecture and sculptures.
Insofar as religious ideations were concerned, he contrasted polytheism as
incarnate in Hypatia, the beautiful philosopher, with Christianity repre-
sented by the superstitious and ugly crowd which stoned her to death.
Théophile Gautier also longed for a return to the Greek way: to a society
whose goal was purely aesthetic; to a religion based on beauty and guiltless-
ness rather than on ugliness and repression; to a world of serenity and love.

Gautier had been fascinated by art and literature from early childhood.
When he was eighteen, he enrolled at the Lycée Charlemagne, where he
became a student of the painter Louis-Edouard Rioult. There he learned to
paint, to use such colors as Veronese green, to brush on pigment and apply
rub-on overtones, thus heightening the emotional value of certain areas of
the canvas. At this time, too, Gautier inadvertently voiced his own artistic
credo. A beautiful model came to pose in Rioult's studio. After painting her,
Gautier expressed his disappointment: "Art adds something to even the most
perfect natural form." *Art* for him was henceforth *artifice;* it was designed to
improve on nature, no matter how sublime the human form which it sought
to reproduce. Years later, Gautier confessed: "I always preferred the statue to
the woman and marble to flesh."[2]

As a youth, Gautier enjoyed being part of the flamboyant French roman-
tics, participating in such poetic and artistic groups as the petit Cénacle,
which was formed around the young sculptor Jean Duseigneur. Like his
friends, he dressed elegantly, if a bit outlandishly, and parted his hair on the
side in the then stylish Merovingian cut. He also dreamed of having his
studio and of spending his life painting and writing. His devoted father paid
for the publication of Gautier's first book of poetry, *Premières Poésies,* in 1830.
In keeping with his friends' romantic views, Gautier held the bourgeois in
contempt. Unlike them, however, he was unsentimental; he did not believe
that the artist was intended to be either a magus or a messiah nor that the
poet's aim was to alleviate poverty stemming from the injustice of society; nor
did he contend in his work with the practical world and political ideas of
progress. The artist, he believed, should not be engaged in trying to create an
earthly paradise or seeing to the redemption of the human race, as Lamartine,
Vigny, and Hugo preached. Such a view in no way means that Gautier's own
writing—his poetry, fiction, and art criticisms—lacked intellectual content.
On the contrary, he wrote, "Place the idea in the very depths of the sculpted

form"; from there let it radiate outward, concretized in the form or flights of verbal fantasy.³

The creative process must concentrate on the concepts of beauty, harmony, and happiness—the creation of the ideal. "There is no truly beautiful thing except that which cannot serve," Gautier wrote in his preface to *Mademoiselle de Maupin*. "Everything that is useful is ugly."⁴ Beauty for Gautier was modeled along classical lines, measured, proportioned, and sequenced. It was as durable as stone and as fragile as filigree; beauty existed in capturing and eternalizing an exquisite, fleeting smile, a raised arm, an elegant pose, an evanescent life experience. It was in no way, however, relegated solely to classical sculpture or architecture. Modern society might also construct towns and cities shaped by aesthetic concerns. "That world of azure and white marble, called the world of antiquity, may be balanced on the sphere of time by a new world brilliant with steel and gas, as beautiful in its activity as the other was in its serene reverie."⁵ Beauty comprised both the world of contingencies, inspired by the culture in which it was rooted, and the eternal metaphysical sphere conditioned by archetypal images, with laws of its own and divested of all time-space limitations. For Gautier, this ideal realm was infused with Platonic overtones. Unlike the Greek philosopher's views, however, no moral connotations of either good or evil were to be included. "Oh beauty, we were created to love and adore you on bended knees once we have found you; to search for you eternally throughout the world if this happiness has not been awarded us. . . . Besides, I do not circumscribe this beauty in such and such a sinuosity of lines. The air, gesture, walk, breath, color, sound, perfume, everything that spells life for me participates in my composition of beauty."⁶

Gautier's aesthetic interest lay in the creation of fanciful realms like *The Thousand and One Nights*, where imagination is given free rein to create regions of the spirit untouched by time. Reincarnation, transmission of thought, déjà vu, signs, omens, magic, and a universe tingling with life, as Pythagoras thought of it, are implicit elements in Gautier's creative outlook. His short stories, *Arria Marcella* or *Spirite*, return the reader to ancient times, to Pompeii and Byzantium, there to wander about narrow unpaved streets, and peer into houses, temples, and mosques.

Gautier rejected the romantics' impassioned attitude toward the creative process. He did not rule out inspiration, which he considered a divine force that touches the artist and penetrates his imagination with an inexplicable

energetic charge that infiltrates soul and psyche; by contrast the emotional upheavals described by Lamartine, Hugo, and Vigny were merely beginnings, and catalysts. But this is only a start. The work of art must be worked upon thereafter with lucidity, objectivity, and infinite willpower in the refining process. Discipline and craftsmanship must be applied during the long hours of work required to reach eternal dimensions. It is also often a requisite of greatness that the artist experience emotional discomfort, a period of aliena-tion, extreme egocentricity of a narcissistic kind, that the creative person must endure in order to bring his or her inner vision to the light of consciousness. In fact, Gautier considered the artist's lot a "malediction," an ordeal that few could appreciate or understand.[7] Like Goethe, Gautier shared an elitist point of view: no matter how perfect a painting, sculpture, or poem might be, the masses would be left largely untouched by these noble creative endeavors of mankind.

Gautier's ideas were neither doctrinaire nor ordered in concept. They were derived largely from the subjective reactions of his psychological makeup: that of the extroverted eternal adolescent who sought happiness, joy, and beauty in the life experience. Like John Locke, who rehabilitated the senses and imagination, and like Denis Diderot, who had high regard for passion and feeling, Gautier was frequently emotionally moved by a specific work of art, even waxing lyrical when describing it. He enjoyed the beauty of form and line embodied in Greek sculpture; he shared Johann Winckelmann's belief that beauty exists outside of time; and agreed with Friedrich Schelling, that art is an expression of both the conscious and unconscious, a fusion of finite and the infinite; and with Hegel, that art is not meant to be merely an imitation of nature. On the contrary, Gautier and Hegel felt that nature was fortuitous and even superfluous. An artist must express his vision by descend-ing into the self, by discovering the subjective psychical realm, the imper-sonal, collective domain; and by concretizing it in the art form of his choice. Art for Gautier was a conscious force; it was a willed act—a feat of magic, a birth of the unformed into the formed.

Unadorned nature was not beautiful to Gautier; it had to be refined and perfected to bring out an inner glow, a fresh vision, and another dimension of activity. Watteau, whose canvases Gautier so enjoyed, did not delineate the solid, objective, actual world; rather, he dismembered the mimetic principle and transposed his rehabilitated universe onto the picture space. So, too, did Ingres, whose rounded forms, smooth surfaces, and delicate colors were also highly pleasurable to Gautier. In his view, the artist must superimpose his

personal vision upon the world of reality; his imagination must be called upon to make its contribution; he must engender tension between past and present rather than a rigid conformity with the past as adhered to by the neoclassicists. He saw the artist's perceptions and intuitions as buried beneath layers of dross which must be excised, buffed, shined, and burnished, allowing the spectacular diamond, resting within the blackened carbon, to leap out in all its purity and beauty. Nature, Gautier suggested, is "the painter's invention."[8]

Like Baudelaire, Gautier believed in universal analogies, correspondences, the cosmic implications of metaphors and analogies. The artist sees beyond the visible world; he senses the network of inner activities taking place, understands the feelings aroused, the coordinates of impressions that he then intuitively fuses into a new unity. In so doing, he seizes upon and embodies what would otherwise be left adrift and unassimilated, and amplifies it. What he creates exists in amorphous form both inside and outside himself; his task is to embrace his findings, blending and enlivening them with new insights and touches as he urges a personal-impersonal existence into form-being.

Gautier, the mystic, adhered to the theory of the microcosm which he described in his *Salon of 1839:* "Goethe said somewhere that all artists carry within themselves a microcosm, that is, a complete little world, from which they draw the thought and form of their works—it is in this microcosm that the blond heroines and dark-haired madonnas dwell."[9] A work of art is not created from a vacuum. Like all else, whether in the visible or invisible world, it is linked to something else and to the cosmos. The artist, therefore, not only experiences himself as an independent entity but also sometimes feels that astral forces inhabit his inner being and guide his hand and mind. These psychic powers work on the creative individual's soma and psyche at all times. It is by becoming aware of the power of this microcosm and expressing it in his work that the painter or poet becomes a creator and not a mere copier of the natural world.

In view of Gautier's theory of aesthetics, one can readily understand why his tour of Spain was so important to him. A broadening experience, if not always a pleasant one, it enabled him to study masterpieces he had previously only read about or viewed in reproduction. In his *Travels in Spain*, he described his sojourn in the fascinating cities of Cordova, Seville, Burgos, Madrid, and Toledo, with their museums, cathedrals, and castles, which transported him into a past dimension of time, from antiquity to Moorish and Christian Spain. Two years after his return to Paris, in 1845, Gautier

collected the forty-three poems inspired by his stay south of the Pyrenees, and published them under the title *Spain*. Two of these poems, "Ribera" and "Zurbarán," have been singled out for discussion below.

Baudelaire wrote in his *Salon of 1846*, "the best critique of a painting will be a sonnet or an elegy."[10] It is from this point of view that Gautier created his "Ribera" and "Zurbarán," his transpositions of art as they are sometimes called. The transposition of pictorial art into verbal art is to the poet what chamber music is to the musician; it is a concision of orchestral overtones, a reduction of feelings and ideas, an intensification of sensation, a distillation of spiritual notions. The suggestive power of Gautier's verse, in alexandrines and terza rima, is such that it brings into existence an intellectual and emotional climate that shifts and alters the reader's inner world. Gautier succeeds in accomplishing this feat by verbalizing the artist's palette; his language transmutes the artist's rapid or prolonged brushstrokes; his rhythmic devices at times impinge upon and even blur the visual image he seeks to delineate, while also, paradoxically, clarifying it expressionistically. Poetry and painting were virtually synonymous for Gautier. Each revealed an inner drama, compositionally and verbally, which the observer or reader could penetrate if properly attuned and sensitized to this art medium. As Gautier wrote in *Mademoiselle de Maupin:* "no one more than we love painting: we have always abandoned, and this is obvious, literature for canvases, and libraries for museums. . . . After having seen, our greatest pleasure is to transport monuments, frescoes, paintings, statues, bas-reliefs into our art, even if it means forcing our language somewhat and changing the dictionary into a palette."[11]

In view of Gautier's extroverted and highly aesthetic and sensitive approach to art, it is not surprising that the shadow world of Ribera and Zurbarán affected him deeply and adversely. Gautier was shocked and traumatized by what he felt to be the excessive and obsessive focus on the Crucifixion, the agony of the event, and its perpetuation in a constant reliving of the *imitatio Christi* upon which these baroque painters focused. Martyrdom, flagellation, bodily mutilation—the gruesomeness of existence endured by the figures inhabiting Ribera's and Zurbarán's world sickened Gautier. All that was represented by these sin-drenched, damned beings filled with a need for punishment was anathema to him. It was ugliness, not beauty, that emerged; malediction, not beatitude. Did these artists seek to bathe in their own warmed, free-flowing blood? Could these same human beings who had fostered the Inquisition, routing out, villifying, and burning

countless victims at the stake, really believe they would earn redemption by flaying themselves? Gautier questioned not only the depicted religious attitudes of these penitents, but the paintings delineated by them, the horrific emotions inspired by them, and values promulgated. The accompanying psychological outline sets Gautier clearly apart from Ribera and Zurbarán.

Psychological Outline

Gautier	Ribera and Zurbarán
Extroverted thinking	Introverted thinking
Existential preoccupations	Celestial preoccupations
Pastel and light tones	Black and tenebrous colors
Joy in life	Sorrow
Ecstasy in sensuality	Penitence, martyrdom, flagellation
Aphrodite/Apollo	Christ/Crucifixion
Beauty/Body	Ugliness/Spirit
Sexuality	Repression
Pleasure	Asceticism
Idealism	Reality
Life	Death
Warmth	Coldness
Good	Evil
Flamboyance and exuberance	Humility and morosity

When observing the canvases of Diego de Leyva in Burgos, a monk himself who spent his time first performing—then painting—agonizing disciplines, Gautier could not but question the unhealthy condition of Leyva's psyche. He singled out Leyva's painting of Saint Casilda's martyrdom for scrutiny; she had had her breasts cut off by the executioner. "Blood spouts in great streams from the two red spots left on the chest by the amputated flesh; the two breasts lie by the saint's side; she gazes with an expression of feverish convulsive ecstasy at a tall angel with dreamy and melancholy face, who bears a palm to her."[12] Gautier could not understand why Leyva emphasized the blood and gore. Why did the artist take pleasure in delineating such agony. Not a single drop of blood was spared the viewer, Gautier confessed, as he described the quivering body, the purple, blue, and dark red lines streaking across the canvas, "the bluish whiteness of the skin" marked by the

horrendous "whips and rods of the tormentors," leaving "gaping wounds which vomit blood and water through their livid lips—all rendered with frightful accuracy."[13] Gautier neither psychologically nor aesthetically understood the obligation certain monks, nuns, and martyrs felt to relive the agonies of Christ sixteen centuries after his death. To inflict corporal punishment on the human form in no way elevates the spirit or enobles the soul, he stated. Why torture, whip, punish the body? Greek and Roman values were of greater import to him than Christian views—at least as they were interpreted in Leyva's painting. The beauty of the natural world, joy in bodily perfection, were drowned out by this emphasis on pain, disgrace, scorn, and rejection. He understood the depth of meaning that the Cross symbolized, particularly for Western civilization. It was the Christian's equivalent of the Greek Ixion—condemned eternally to be bound upon the fiery wheel—but not to include the joyous elements in the religion, the Nativity, for example, was to single out and inflate a dark, depressing, and destructive view of life.[14]

Jusepe de Ribera: "Ferocious Fierceness"

What Gautier found offensive to his sensibilities and an outrage to his aesthetic views was Ribera's proclivity for the ugly, the sordid, and the cruel. Crucifixions, punishments, torture, suffering, dismemberment, deformity, amputations, monstrous and somber powers of all sorts were at work, Gautier felt, in Ribera's painting.

> Ribera has painted in this way things that would make *el Verdugo* himself shudder with horror; and it really takes all the dread beauty and the diabolical energy characteristic of that great master to enable one to bear with those ferocious slaughter-house paintings, which seem to have been done for cannibals by an executioner's assistant. It is enough to disgust one with being a martyr, and the angel with his palm strikes one as but a slight compensation for such atrocious torments. Ribera very often refuses even this consolation to his tortured victims, whom he leaves lying, like the pieces of a serpent, in a dun, threatening shade which no divine ray illuminates.[15]

With morbid reiteration, Ribera sounded what Gautier looked upon as sterile themes, which disclosed in painting after painting the blackened abyss in which soma and psyche are imprisoned.

Ribera showed his psychological makeup, indelibly intertwined with his

religious beliefs, in such canvases as the *Martyrdom of Saint Bartholomew*, leaving Gautier to conclude that the "genius of the Spanish people is devoid of aesthetic feeling."[16] Ribera's monks and martyrs bleed continuously; they encourage and excite horror and terror. Even so, Gautier conceded that Ribera's paintings emanated from the deepest areas within himself, in a microcosmic-macrocosmic *temenos* which is the hallmark of a master. Despite the fact that Ribera's delineations were attuned to and in perfect accord with universal harmonies, they disclosed a macabre vision that bruised Gautier's sensibilities, for they cut him off from the pictorial realm of soft brocades, satins and silks, pastel colors, golden flesh tones, lapis-lazuli blues, verdant greens, and tawny yellows which he so relished. Even Ribera's *Le Pied Bot (Boy with the Club Foot)* discloses his mutilated, suffering psyche. The grin on the lad's face, rather than expressing the joyous ebullience of youth, seems an emblem of suffering and growing distress.

That Ribera should originally have concentrated on religious painting is understandable, because he studied with Francisco Ribalta, whose favorite subjects were drawn from scripture. Furthermore, the culture of medieval Spain encouraged this propensity; the pain involved in martyrdom was a way, the deeply religious Spanish felt, of elevating and purifying the spirit, making it worthy to enter the paradisiacal state. Later, however, after Ribera moved to Italy, and immersed himself in the works of Michelangelo, Raphael, and Caravaggio, his sanguinary inclination did not diminish. Of all the painters of the Italian Renaissance, perhaps Caravaggio affected him most profoundly. Caravaggio was the founder of the naturalistic school in Rome, one of the early masters of chiaroscuro, and he was far from idealizing the human form. Nevertheless, he depicted it fully and completely, emphasizing an individual's character by a dramatic interplay of light and dark, thereby increasing the violence of the figures he pictured. Unlike Ribera, however, he was not obsessed with the depiction of cruelty and anguish.

Ribera settled in Naples, a Spanish possession at the time, and was given the name of Lo Spagnoletto (the little Spaniard). His works became immensely popular, and he was awarded many honors. Velásquez came to visit him and bought some of his paintings to take back to Philip IV of Spain. No matter the praise heaped upon him or the success of his canvases, Ribera's approach to his paintings remained the same; his many Magdalenes, Immaculate Conceptions, martyrs, beggars, cripples, lascivious *lazzaronis* dressed in rags and tatters, were always built upon agony, pain, and willed privation.

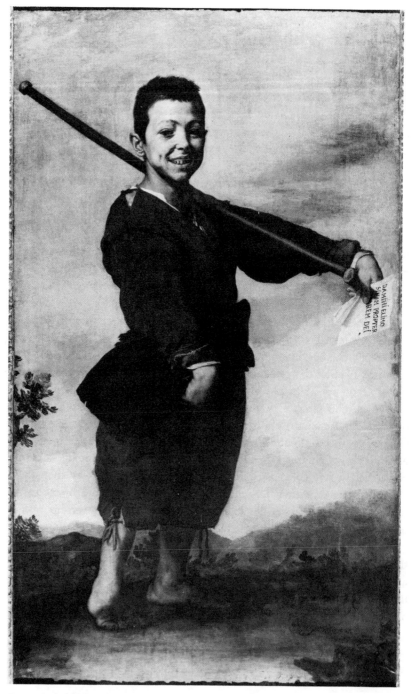

Boy with the Club Foot by Ribera (Louvre, Paris)

Rather than singling out one canvas in particular, Gautier in his poem "Ribera" (from *Spain*) comments upon the Spanish master's works in general, embracing the impact of his visualization as a whole: his fixation on the ugly, the cruel, the violent.

Rien ne put amollir ton âpreté féroce,
Et le splendide azur du ciel italien
N'a laissé nul reflet dans ta peinture atroce.

Nothing could soften your ferocious fierceness
And the splendid azure toned Italian sky
Left no reflection in your atrocious painting.

The mendicants, dismembered beings, and gruesome emanations of all kinds that Ribera renders by lurid or subdued colorations and jagged, disturbing lines emerge from the canvas like phantoms spreading fear and horror throughout the pictorial space. None of Italy's sun-drenched skies fill this visualized world; the human form is withered, degraded, and mutilated. Torso, arms, and legs are not elevated to the highest possible degree of perfection as they were with the Greeks; rather, these unsightly, offensive, disagreeable pictures underscore a most ominous note—the underlying schism between Christianity and paganism that Gautier discusses at length in his essay "Civilization and the Plastic Arts."

> The substitution of Christian for pagan ideas appears to me to be the primary cause of this degradation of form. . . . In the Christian doctrine the body not only ceases to be the ideal, it becomes an enemy. Far from exalting and glorifying it, it is abased, reviled, tortured, and killed. It was a palace; it is now turned into a prison. The soul that manifested itself gently under the fair form, now is restless within it and seeks to throw it off as though it were the poisoned tunic of Dejanira.[17]

That Ribera was a meticulous and exacting draftsman increased the horror for Gautier of the anomalies and atrocities he depicts. Exactitude, which was one of Ribera's goals, did not permit blurring or smudging; every line, form, and color, although suggestive of both temporal and atemporal realms, is clear and concise, bound within dull and flat tones, or enclosed by open spaces. Whatever the face or feature, martyr or hangsman, gypsy or tramp, each highlighted area of the canvas stands out sharply, incisively, starkly against a dark background. Ribera's thick or sometimes overly refined and thin brushstrokes give the impression of staccato and quixotic climates, of

restraint and constraint, overwhelming and subduing whatever the emotions
emerging from these tortured beings.

> Comme un autre le beau, tu cherches ce qui choque:
> Les martyrs, les bourreaux, les gitanos, les gueux,
> Etalant un ulcère à côté d'une loque;

> As another the beautiful, you search for the shocking;
> Martyrs, executioners, gitanos, scoundrels,
> Displaying an ulcer next to a wreck;

Streaming blood, muscles strained to the breaking point, bruised, sore, and
distended flesh are depicted by Ribera in both *Saint Sebastian* and the *Dead
Christ*. Each figure emerges from the picture space in static, yet highly
charged, tonalities. Reality, as Ribera conceived it, is brought into the harsh
light of consciousness, there to be eviscerated, to undergo the terrifying
mysterium tremendum. Ribera magnifies the grisly side of life, vividly portray-
ing men and women, young and old, in the last stages of decomposition and
they are totally loathsome. His preoccupation with the Crucifixion, which
began with the mockery and scourging of Christ and ended with his six hours
of suspension on the Cross, was the focal point of his vision. To Gautier the
tortured agony that lived and relived did not bring inner harmony nor instill
feelings of grace. Rather, it inspired hatred instead of love, cruelty rather
than compassion, stringency instead of freedom. The plunge into such
realms, under the guise of religion, indicated a penchant for masochism and
sadism.

> Pour toi, pas d'Apollon, pas de Vénus pudique;
> Tu n'admets pas un seul de ces beaux rêves blancs
> Taillés dans le paros ou dans le pentélique.

> For you, no Apollo or discreet Venus;
> You admit not a single one of these white dreams
> Carved into paros or pentelic marble.

Ribera's paintings preserved forever the gray beards, rough faces; the days
and years spent in prayer, penance, and the study of the Bible and patristic
and saintly texts. It was a world peopled with demons and satanic figures
forever threatening to gnaw at men's and women's vitals, to overwhelm and
smother whatever élan vital remained. Yet, as Gautier suggested, even these
monstrous figures possess a strange and terrifying kind of beauty as they lure

and allure others into their abject world, so antithetical to the graceful contours of Hellenic creations.

Ribera's personifications seem to breathe pain and misery. Dreams of purity and beauty of soul, of ethereality and health, Gautier suggested in *Travels in Spain*, are unknown to Ribera who seems to have carved his world out of black granite. Even in *The Repentant Magdalene*, which might well have evoked a soft, gentle interpretation, black shadows bite into the skin and facial contours, emphasizing Mary Magdalene's state of torment, and the expression in her eyes reveals the agonizing pull and tug of her divided inner world. Angels, those messengers of God and bearers of tidings, are indeed painted by Ribera as fervent, ardent, and zealous beings, but their faces are always sorrowful, their gaze filled with pensive supplication and melancholy. Torturer and tortured, victim and executioner, each in his own way suffers as he or she seemingly enjoys the spiritual and physical task of endurance—luxuriating, as they seemingly do, in anguish and agony.

Avec quelle furie et quelle volupté
Tu tournes la peau du martyr qu'on écorche,
Pour nous en faire voir l'envers ensanglanté!

With what fury and voluptuousness
You turn over the skin of the flayed martyr,
To show us the bloodied inner side!

Ribera's attraction for bloodied and gangrenous flesh is but one way of depicting pain. In the *Martyrdom of Saint Bartholomew*, the contrast between the diagonal and vertical lines is sharp and incisive, thus emphasizing the agony of the figure who is in the process of being hoisted onto a pole—body and skin stretched, muscles and sinews flexed, veins and arteries witnesses to the heaving agony his skeletal figure experiences. Again Gautier questioned the value of this kind of anguish. Did Ribera enjoy this calcination and abrading of the flesh? Did he derive sensual or sexual fulfillment from dwelling upon these horrific emanations?

D'ou te vient, Ribera, cet instinct meurtrier?
Quelle dent t'a mordu, qui te donne la rage,
Pour tordre ainsi l'espèce humaine et la broyer?

Where does this murderous instinct, Ribera, come from?
What has bitten into you that you should feel so rabid,
Twisting and grinding the human species as you do?

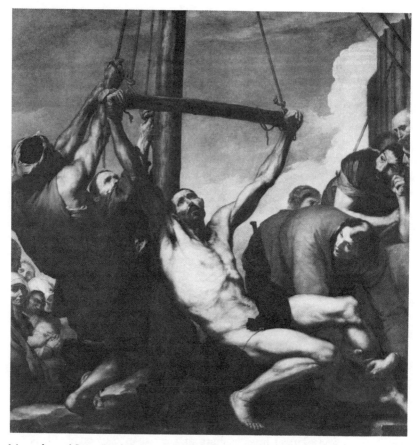

Martyrdom of Saint Bartholomew by Ribera (Prado Museum, Madrid)

Gautier accused the Spanish painter of seeking out carnage, of dwelling upon bloodshed in order to assuage some latent murderous instinct in himself. Guilt must be the focal point of Ribera's inner being; sin and torment must comprise his entire existence.

> Que t'a donc fait le monde, et, dans tout ce carnage,
> Quel ennemi secret de tes coups poursuis-tu?
> Pour tant de sang versé quel était donc l'outrage?

> What then did the world do to you and, in all of this carnage
> What secret enemy do you pursue with your blows?
> What was the offense that forced such spilling of blood?

Even in his description of the *Adoration of the Shepherds*, in which beauty and contentment might have shone forth in effulgent purity, Ribera chose to portray a scene of frozen blackness, devoid of warmth and rapture. The faces of these figures are not filled with incandescent light and tenderness. Instead, there are blood-red tonalities, harsh and abrasive colors, underscoring a secret turbulence and sense of solitude. There is no rest from terror, no repose from anxiety, no release from sin, in Ribera's hallucinatory world. Joie de vivre has yielded to decrepitude, a world haunted by darkness, disquieting tension, and sinister distress. The primal darkness of Gnosticism reigns over Ribera's canvas, a *massa confusa* of negative contents that erupt in artfully contrived fashion. Even Ribera's portrait of Archimedes, the Greek mathematician, physicist, and inventor, although the subject is shown wearing a smile, he is endowed with an intensely derisive and ironic expression; the deeply furrowed forehead bears no trace of nascent and evolving ideas, no vision of future grandeur; there is only the fury and vigor of a sin-filled martyr fighting off an overpowering fear of damnation.

Gautier castigated Ribera time and time again for what he considered to be the Spanish painter's murderous rage, his penchant for the demoniacal, his crushing and grinding of flesh and body—the life spirit. Christian morality as viewed in Ribera's canvases is an affliction, a morbid condition requiring contrition and bodily punishment, which each individual must exact from himself. Those viewing such depictions—the bleeding wounds and severed limbs—are as involved as the painter who re-created them, as drawn to immolation and mutilation as Ribera was. Gautier was repulsed by them.

Gautier was opposed to a life replete with negative figures. Refusing to leave his magical state of perfection, which he felt existed in the classical view of physical form and beauty—in balance, harmony, proportion—he banished suffering and pain from his phylogenetic paradise. It is understandable that Gautier, whose archetypal visions were blends of harmonious color and exquisite polished form, could not tolerate Ribera's darkened realm, a mournful, sinful, gloomy world steeped in deep monochromatic overtones.

Francisco de Zurbarán: "The Stone Slabs of the Dead"

The weight and impact of Zurbarán's canvases were nearly as jarring to Gautier's sensibilities as Ribera's had been. Although less violent and blood obsessed, Zurbarán's paintings are similar in focus, stressing the so-called

spiritual values to the detriment of the body and everything associated with it. Asceticism was emphasized by Zurbarán, and so was the greatness and grandeur of suffering and sacrifice.

Zurbarán, who was born in Estramadura, worked in Seville and Madrid where he received many of his commissions from ecclesiastical orders. His greatest works were created in the space of twelve years (1628–1640), when he was in full control of his art and psyche and enjoyed the balance and equilibrium that allowed his talents to flower.

Although his figures are for the most part emotionally chaotic and complex, they do, at times, express a kind of contentment, peace, and beatitude, as for example, in his *Life of Saint Bonaventura*, *Miracle of Saint Hugo*, and *Apotheosis of Saint Thomas Aquinas*. Like Ribera, however, he was a master of the *tenebroso* technique, contrasting brilliantly lighted areas with an implacably dark background, thus endowing his painting with frightening otherworldly qualities. Mystery intrudes, as does ecstasy, each coupled with its own intensity, each pounding out its abstract, impersonalized emotion in greens, yellows, purples, and blacks.

Zurbarán does not underscore physical agony and cruelty to the same extent as Ribera; he does, however, focus more intently on human isolation and loneliness—an inner dimension that was augmented perhaps by his own inability to experience the pleasures of the flesh or the joys of the senses. Psychic energy (libido) flowed inward in Zurbarán's case, activating unconscious contents, extending the dimensions of his conscious sensate world. Though the ascetic creatures who figured in his paintings inhabited a domain of their own, some objective force—some transpersonal charge of energy seems to have brought them into existence. Prodded perhaps by inner churnings, Zurbarán's beings are rarely outwardly bound, but nourished and enlivened by a hidden and secret realm, mystical emanations revealed in glimmers and glances—in eye tones and contours. Seldom does Zurbarán portray his figures in movement or motion. Their immobile quality is reminiscent of medieval wooden sculptures, each figure turned inward, lost in their sad, bleak, and austere asceticism. Everything in Zurbarán's vision is divested of superfluous outside objects; they would have detracted from the poignant mood he sought to create.

Moines de Zurbarán, blancs chartreux, qui, dans l'ombre,
Glissez silencieux sur les dalles des morts,
Murmurant des *Pater* et des *Ave* sans nombre.

Zurbarán's monks, white Carthusians, who, in the shadow
Silently slip on the stone slabs of the dead,
Murmuring *Paters* and *Aves* without number.

In his poem "Zurbarán" (from *Spain*), Gautier expresses his distaste for Zurbarán's mendicants and monks through his use of sibilants and alliterations: as though he were castigating them, reviling them for having exiled themselves from the sunny world of joy and pleasure. Preoccupied with hammerings, nailings, and whippings, they are world-weary beings; uncertain as to their place in this existence and in the next, they sit or move about in slowly paced steps, intoning their prayers or praying with outstretched arms. In Zurbarán's *Crucified Christ with Saint Luke*, one observes not the customary three-nailed Crucifixion, but a four-nailed figure on the Cross, in keeping with the early medieval depictions of the crucified Christ. There he hangs, suspended—*nuditas naturalis*—in midair, prior to the thrusting of the lance. Saint Luke stands beside him, apparently listening first, then speaking to him in a highly charged, emotional way. Devoid of worldly sensations, each figure is encompassed in light, steeped in the transpersonal sphere.

Zurbarán, like Ribera, was obsessed with death and sacrifice—all the pain and pathos man or woman could bear; all the physical discomfort these pilgrims could endure for Christ—bringing salvation to some and further torment to others. All of Zurbarán's old men are ascetics, contemplatives, singled out as lonely units, isolated in the picture-space as they are in the temporal world. To underscore their psychological condition, Zurbarán generally lights only a quarter or half of the face, the rest being hidden behind a cowl or extended shadow; thus he increases the mystery, power, and depth of these frail beings. Their monastic garb also helps in this regard: the long, smooth folds enhance the inner drama, through active rhythms, so antithetical to their external static state.

In much the same way that Gautier felt a distaste for Ribera's religious martyrs, he was disturbed by Zurbarán's penitents: pitiful God-fearing beings living under the aegis of sin and damnation.

Quel crime expiez-vous par de si grands remords?
Fantômes tonsurés, bourreaux à la face blême,
Pour le traiter ainsi qu'à donc fait votre corps?

What crime are you expiating that you experience such great remorse?
Tonsured phantoms, executioners with livid faces,
What did your body do to treat it in such manner?

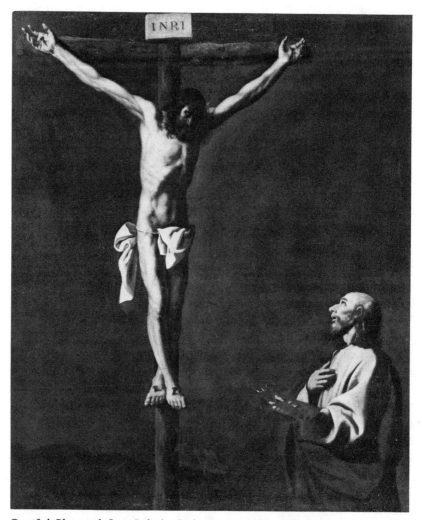

Crucified Christ with Saint Luke by Zurbarán (Prado Museum, Madrid)

This desire to revile the body, this need to attempt to destroy it—daily, weekly, yearly—which was their goal, encouraged Gautier to question again and again the reasons for such destructive acts. Why suffer? Why agonize? flay? dismember?

Zurbarán's world was cold and bleak—chthonian; death, torment, and hopelessness imprisoned his individuals in blackened vaults and underground

galleries of their own manufacture. Although the dark coloration is inter-laced with white, these opposing or polarized tonalities never fuse, never cancel each other out. Zurbarán's figures absorb but do not possess or reflect light. They are schriveled and calcinated but never warm; they take in but do not exude heat. These transpersonal emanations were arid for Gautier; abasing themselves in order to gain sanctity.

> Pourquoi donc chaque nuit, pour vous seule inhumains,
> Déchirez votre épaule à coup de discipline
> Jusqu'à ce que le sang ruisselle sur vos reins?

> Why each night, for you alone inhuman beings,
> Do you flagellate yourself, tearing your shoulder with metal whips
> Until blood streams down your back?

Holiness is their goal; endurance and sacrifice their way. To emphasize an inner urgency, Zurbarán builds up his paintings through a series of relation-ships between the human figures and rays of brilliant light, contrasting them with dark shadowed areas and open spaces. Each phantom being seems to project its own blackness. These burdened forms, considered by Gautier to be manifestations from extratemporal realms, may also be viewed as sixteenth-century extensions of ancient pagan funeral cults, like those carried out at Serapis and on Delos, about which Pausanias wrote: men dressed in black followed the corpse or corpses while intoning their prayers, thus expunging their grief.[18]

Over and over Gautier questions the need for expiation, for sin, remorse, and guilt—particularly when carried to the pitch depicted in Zurbarán's canvases. Hangman and tortured, killer and killed, innocent and Inquisitor, all seek redemption, yet some of these very beings had forced others to adhere to their religious credo or be burned alive. These dual beings mirror humankind's antithetical visions and needs in a single religious credo: a complexio oppositorum, a world in which good and evil are forever battling with one another. No peace exists for such emotionally torn and atomized beings; all distinction between life and death has also been erased.

Gautier who loved the physical body and revered its representation in a work of art—for its beauty of form and movement, its lines and contours—could not acquiesce to the mutilation and mortification of this God-given gift. Why be ashamed of the flesh? Why mortify it? Zurbarán's figures degraded and uglified form. Whippings, scaldings, torture—deep or superfi-cial—and drawing and quartering of human beings cannot, Gautier believed,

redeem or ennoble humankind; it hurled him into Thanatos. When in the Roman period martyrs were fed to the lions, a heroic religious stance had to be endured; struggle was valid as was the overcoming of tortuous experiences. But today, Gautier suggests, such practices reveal suicidal desires and masochistic inclinations. "Imagine men who have been flayed walking about, all bloody, through the streets, with their black arteries and their blue veins, their red flesh, their network of nerves and their quivering muscles! Could anything be more horrible?"[19] Such visions cut into Gautier's sense of well-being, and blocked off his feeling of health and vitality. To wear a crown of thorns and lacerate one's flesh with a hair shirt and metal whips, to pursue the pain principle was a negation of life. Was this really God's intention? Gautier queried.

> Croyez-vous donc que Dieu s'amuse à voir souffrir,
> Et que ce meurtre lent, cette froide agonie,
> Fasse pour vous le ciel plus facile à s'ouvrir?

> Do you believe that God amuses himself by watching you suffer,
> And that this slow murder, this cold agony,
> Makes heaven easier for you to penetrate?

Gautier described the "leaden eyes" depicted in Zurbarán's skeletal penitents, their need for ecstasy, their feverish heads, yearning to experience grace. That the spirit is immortal, Gautier conceded; but to consider the flesh "infamous," is to reject God's work of art—the act of creation—and to calumniate his purpose: his essence in man. Gautier further remarks that to withdraw from life, friends, family, and feminine companionship into a "pale shroud," and to stare into a tormented domain indicates singleness of vision, but it also reveals a being bereft of all warmth and compassion.

Everything within the shadowed planes of Zurbarán's canvases seemed baleful and malignant to Gautier. The angular geometrical faces of the monks seen in The Refectory of the Carthusians, The Miracle of Saint Hugo, or San Luis Beltran, are depicted as hard and unbending, their cowls drawn closely about their blood-drained faces. These fleshless disembodied beings with their haunted expressions imposed an inhuman world of fear and terror upon their viewers. Zurbarán's forms, which seem to rise out of nowhere and exist in some neuter clime, were for Gautier "dead and buried" alive. They must inhabit some catacomb—or were they automata?

Death, not life, dwells in Zurbarán's canvases; various stages of mortuary

disguise are depicted: bloody hands and feet, blue and ashen skin, leaden colors and fiery hues spurt, flow, and cake.

> Qu'il vous peigne en extase au fond du sanctuaire,
> Du cadavre divin baisant les pieds sanglants,
> Fouettant votre dos bleu comme un fléau bat l'aire,

> Whether he paints you in ecstasy in the depth of the sanctuary,
> Kissing the bloodied feet of the divine cadaver,
> Whipping your blued back like a flail beating wheat,

the visions are always the same: cloisters, shadowy and pain-ridden dreams, "white cloisters," monks muttering their prayers, fingering their rosaries, eating barely enough to keep body and soul alive. Yet mystery dwells within their breasts; awe shows in their rigid faces—similar in tone and texture to medieval sculpture, as each appears to lose himself in the realm of the spirit—as if facing an empty sky.

Ribera and Zurbarán found the appropriate language to express their temperament and beliefs: austere forms, flat and cold colorations that allowed the flow of energy to penetrate the inner depths of their being. Gautier, on the other hand, who inhabited the world of light and joy, stood aloof from what he considered to be their black indwelling on night, gloom, and doom. He understood and appreciated the uniqueness of their art, but he found repugnant the concentration on the crucified Christ, on mortification, and self-flagellation. Gautier lived in the existential sphere; divinity was but one element in his exciting and rich sense of being. It was not that "terrible Eminence" which inspired an *effroi mystique*; nor was it *daemon* become God; but a beautiful harmonious spiritual force that filled his world with happiness, lightness of spirit, and visions of harmony and beauty.

Art for Gautier opened up a sphere beyond the consciousness; it revealed beatific images existing outside himself in the transpersonal sphere. These allowed him to experience the *numinosum*, not in shadowy and gloomy tones, but in exotic and exciting ones; heightened most frequently by sensual pleasures and increased perceptiveness. Rather than the severe, austere, patriarchal figures depicted by Ribera and Zurbarán, Gautier's world was dominated by tender and understanding matriarchal forces—avatars of the Virgin Mary as they appeared in the Eleusinian and Ephesian mysteries in the form of Diana or Isis. Neither pathos nor suffering was emphasized nor were

isolation and violence; rather, it was a world yet to be realized in its fullness and pleasure.

"Deep Night," Gautier wrote, had "settled on humanity" in the canvases of Ribera and Zurbarán, the antithesis of the "pagan Catholicism of the Renaissance," when artists depicted both flesh and spirit with fervor and passion. These painters, Gautier continued, listened

> to the nightingale's song and breathed the scent of the rose without dreading to see the devil's eyes glaring between the leaves, and his tail whipping round the trunk of the tree. God the Father became as majestic as Jupiter Tonans; Christ borrowed the form of the Pythian Apollo, and the Virgin Mary, standing upon her azure globe, with the crescent of the moon under her feet, became lovelier and more attractive than Venus. Never were the body and the soul associated in happier proportions. [21]

What could be more glorious than "the beauty of a human smile," Gautier questioned, or the form of a physically perfect human body? For Gautier, the aesthete and bon vivant, to portray the human body as ignoble was to be unworthy of art and genius. Art as artifice should be a feast for the eyes and the heart; it should nourish the senses in truly Hellenic fashion—through its representation of spiritual order and physical beauty.

2

Baudelaire and Delacroix:

The Celebration of
a Mystery

For Charles Baudelaire (1821–1867) to look deeply into one of the canvases by Eugène Delacroix (1798–1863) was the celebration of a mystery; it was to witness a dramatic unfolding lived in the space-time continuum. What Baudelaire absorbed as his eye encompassed the picture's surface and depth, wandered about in its form, color, and melody, was the mirror image of his own pure yet tainted soul.

Baudelaire's critical appraisals of Delacroix's paintings, which appeared in his *Salon of 1845*, *Salon of 1846*, *Universal Exposition of 1855*, *Salon of 1859*, and *Work and Life of Delacroix*, are not mere evaluations, although they fulfill this goal. They are in themselves creative acts, distillations of a spiritual adventure—Baudelaire's adventure. Delacroix's paintings stimulated Baudelaire's vision, prolonged, enriched, and expanded it. Form became a means of unifying the abrading conflicts which otherwise tore at him; color activated an emotional climate veering from ecstasy to horror, shearing into his quietude or impressing harmony upon his soul; the tones, vibrations, spreading from the figures, rhythms, and hues, seemed to send mellifluous or strident sounds into the atmosphere, comforting or flaying his psyche.

Delacroix's paintings with their dramatis personae and scenarios sparked electric currents in Baudelaire, bringing viewer and canvas, subject and object, into closer proximity.[1] The resultant isomorphic relationship that was ignited between animate and inanimate worlds activated an entire mnemonic sphere in Baudelaire, fusing "drama and reverie" as well as space and time (p. 970). That Baudelaire should have used the word "drama" so frequently in connection with Delacroix's paintings is not surprising. As a boy he had dreamed of the stage and of being an actor; as a young man he had even written two plays, *Idéolus* and *The Drunkard*. In time, however, he yielded wholly to the power of the directly written word with its clusters of images,

colorations, tonalities, complexes of vibrations, and hieratic gestures that worked more powerfully upon his soma and psyche than did the more remote world of the theatre. Still, the drama and its conventions were never entirely abandoned; they remained at the heart of his work and particularly of his art criticism. Dialogue, therefore, was a potent force between poet and painter: Delacroix's canvases spoke to Baudelaire, for he identified with their protagonists—Dante and Vergil, Mary Magdalene, Ovid, Sardanapalus, and the Crusaders. When his poet's eye immersed itself in a painting, it rested within the visible and invisible spheres, bringing the painting's mysterious forces to work upon his creative ventures.

Baudelaire's art criticism sprang from subjective experiences: forays into a private world, articulations of affinities that existed inchoate within him. When Baudelaire approached a Delacroix painting, it was as a *mystai* of old, with reverence and awe, and with the hope of transcending the dualities consuming his flesh. Well-versed in the writings of Heraclitus, Pythagoras, Meister Eckhart, Jacob Boehme, Swedenborg, and the alchemists, Baudelaire searched for harmony and balance—that primordial oneness that existed prior to the Creation, when division and conflict were unknown. This longed-for condition may be psychologically viewed as a *regressus ad uterum*; a desire to step back into a paradisiacal, childlike period when there were no polarities (man-woman, good-evil, solid-liquid, hot-cold) to destroy an all-embracing sense of belonging, when self-consciousness had not yet been born nor the limitations of individual life been realized.

Considered from a visionary point of view, Delacroix's canvases afforded Baudelaire an ideal condition, because they absolved him of the sordid world of contingencies which he detested, and enabled him to soar into celestial spheres. Rising to heavenly heights in this world, however, always entails earthly descent; and with each return to the telluric domain, Baudelaire's pain and torment were also renewed. What might otherwise be described as a highly negative condition also held its fascination for Baudelaire, who was to write of the excitement involved in flagellation, whipping, expiation. Contraries inflamed him; their friction caused heat and passion. For him the opposites—departure and return, death and transfiguration—became part of a mystical adventure that enriched his visionary world as poet and critic. Delacroix's thick pigments, his broad, quick, and sometimes frenetic brushstrokes, as well as his more subdued and tender ones, enhanced Baudelaire's sensate world, endowing it with rapture and pathos—paving the way for the *surnaturel* which he defined in *Fusées* as "the general color and accent, that is,

intensity, sonority, limpidity, vibrativity, depth and resonance in time and space" (p. 1256). The *surnaturel* for Baudelaire did not imply hyperemotionalism or undisciplined inspiration, conditions so prevalent among the romantics. Rather, it meant a blending of fire and water, a fusion of passion with detachment, flamboyance mitigated by order and symmetry. Both vision and technical excellence were needed to create the work of art; one without the other spelled failure.

The *surnaturel* and all it implied for Baudelaire were operational in Delacroix's canvases, giving rise to a synesthetic reaction. Synesthesia is a literary technique, but it is also a device that aids the mystic to experience higher spheres of consciousness. It implies a correspondence among the senses: the visual may be heard, smelled, touched, and tasted, or the tasted may be heard, seen, smelled, and felt, and so on. Baudelaire experienced synesthesia as a great awakening, a psychic happening within his unconscious that affected his nervous system, either soothing or shattering it. It also enabled him to experience simultaneity of sense impressions in a timeless dimension: he could, therefore, perceive the work of art at its inception, as it came into being, and in so doing, relive a preformal experience, contacting and palping a panoply of signs, species, or forgotten languages. Interestingly enough, it was in his *Salon of 1846* that Baudelaire first mentioned his theory of correspondences, an amplification of the synesthetic experience, in a quotation from E. T. A. Hoffmann's *Kreisleriana:*[2]

> It is not only in dreams, or in that mild delirium which precedes sleep, but it is even awakened when I hear music—that perception of an analogy and an intimate connection between colours, sounds, and perfumes. It seems to me that all these things were created by one and the same ray of light, and that their combination must result in a wonderful concert of harmony. The smell of red and brown marigolds above all produce a magical effect on my being. It makes me fall into a deep reverie, in which I seem to hear the solemn, deep tones of the oboes in the distance. (P. 884)

Form, color, and music inhabit Baudelaire's world of correspondences and infinite analogies. Form, reproduced in the picture plane, is visible as an image—or images—and perceived as an idea. The intellect, a part of both soma and psyche, works on the emotions, awakening still another dimension of being. Color may also be said to take the same route: when incorporated in form, it, too, inhabits a spatial zone. Its emotional level, however, is frequently more highly charged than such a compositional structure as that of lines, cubes, circles; however, the vibrations being ejected from the colors in

unequal rhythmic patterns electrify the viewer's psyche. Whether defined by
Newton or Goethe, colors have their emotional equivalents, and this was
particularly important to Baudelaire. Reds, blues, greens, violets, blacks,
yellows, ushered in specific emotional responses: serenity, passion, melan-
cholia, morbidity, and the like. Music for the mystic inhabits the world of
contingencies and the fourth dimension. Invisible to our naked sight, its
harmonious or discordant tones exist in waves, subatomic particles, as
mathematical sequences informing both an outer and inner space-time
dimension. Sonorities may be apprehended by an individual as a prolonga-
tion of a psychic state, or as detached and cerebral modulations. Baudelaire
frequently wrote of the musicality that Delacroix's paintings inspired in him
and of their effect on his "ultra-sensitive nerves" (p. 974). The musicality of
color and form helped him to experience the sculptured three-dimensional
structures he observed in Delacroix's canvases and to intuit the historical
scenes depicted.

Visual form, archetypal images, signs and symbols of every kind, had
impressed themselves upon Baudelaire's mind's eye since his earliest child-
hood. Perhaps this aspect of his personality had developed so powerfully
because both his father and his mother had painted and sketched, and he had
become accustomed as he grew older to spending long hours haunting
museums and painters' studios—intoxicated, he wrote, by the effect that the
rendition of three-dimensional form and color had upon him: "The entire
universe is nothing but a storehouse of images and signs to which imagination
will give a relative place and value" (p. 1122). Interestingly enough,
Baudelaire's art criticisms were among his earliest publications (the *Salon of
1845* and his poem "To a Creole") and were more extensive than his literary
evaluations.

Archetypal images are endowed with powerful energy charges. As primor-
dial visualizations, which exist in an amorphous state in the collective
unconscious, they frequently surface with such violence that their impact
disorients the individual, affording him "luxury, calm, and sensuous plea-
sure" as well as excoriating experiences. Baudelaire's inner eye seized the
archetypal images depicted in Delacroix's canvases, apprehended them by
piercing through form, color, and tonality, and in so doing, created his own
vision, his own dream.

Baudelaire's sense of sight functioned with an intense power. As an organ
of perception, the retina of his eye was a prey to external stimuli, sending its

messages to the brain, which then experienced them as idea, light, spiritual-
ity, or abstraction. (Let us recall that the Greek root for image and idea,
eidos, is one and the same, and is defined as view or vision of form.) His
eyesight was the faculty that allowed Baudelaire to grasp an entire exterior
world and to interiorize it, to translate it into his own polymorphic language
and entwined sensations. As the body consumes what it requires, so the eye
of the seer or visionary takes from the cosmos at large what it needs to nurture
an interior dimension. As an instrument of the intellect, it possesses its own
soul and in this respect is comparable to what mystics allude to as Siva's Third
or Cosmic Eye. It can view solar and lunar expanses, encompass earth and
sea, penetrate color and form. Similarly, Baudelaire's vision could work
continuously in shifting patterns and zones, transmuting a nonverbal world
into word—a feat of magic, to be sure, which led Baudelaire to continue his
courageous and harrowing exploration into sacred and infernal domains.

Delacroix might be termed Baudelaire's "mystical brother." At the outset
of his career he had wanted to be a poet and dramatist and had even written
some tragedies. In time, however, the beckoning of the other world of art
grew too imperative to be ignored. Orphaned while still young, he first
enrolled at Pierre Guérin's studio, then for financial reasons transferred to the
less costly École des Beaux-Arts. Like Baudelaire, Delacroix refused to rely
solely on the fire of inspiration; although at times he painted frenziedly, in
bursts of "fury," still, method, order, and discipline were always his. He spent
long hours studying and copying the old masters (Rubens, Michelangelo,
Veronese, the Venetian school, and many others) and in doing research in
relative color values, their historical use, and chemical components.[3] Before
he started to paint, he always saw to it that his brushes were clean and his
colors laid out beforehand; studies prior to the actual inception of a canvas
were always made. But passion and fire were also in him. When, for example,
his friend Théodore Géricault invited him to see the still-unfinished but
already powerful *Raft of the Medusa* (exhibited in 1819), Delacroix's reaction
was explosive: "So violent was the impression that it made upon me on
leaving his studio I began running like a madman and ran through the streets
the whole way."[4]

Like Baudelaire, Delacroix had an extraordinary visual sense. In 1825
when he went to England, he was captivated by the canvases of Constable.
Upon Delacroix's return to Paris he seemingly repainted large portions of his
Massacre at Chios and *The Death of Sardanapalus*, adding touches of flamboy-

ant and violent color that enraptured him but enraged the conventional
French art critics. A trip to Morocco in 1832 further enriched his already
powerful imagination, endowing his future paintings with lustrous semitropi-
cal and tropical colors as well as with the veiled forms of women—as we see
in *Women of Algiers* and *The Jewish Wedding*—whose concealment only
seemed to increase their sensuality and desirability. Four years later, a visit to
Belgium and Holland impressed Rubens's fleshly and massive forms upon his
consciousness and provided him with even more strikingly outrageous—so
the critics suggested—colorations.

Delacroix was vilified for his innovations by those jealous of his artistic
ability or simply oblivious to his genius. Any kind of excuse was used to
destroy him. Étienne Jean Delécluze, critic for *Débats*, called his *Dante and
Vergil* (1822) "not a picture but a regular hash!" (*tartouillade*).[5] Some even
stated that he could not draw. Such charges, however, were the cumulation
of a longtime quarrel between the colorists and the draughtsmen, the
Poussinists and Rubenists. Delacroix wrote: "The forms of a model, be they a
tree or a man, are only a dictionary to which the artist goes in order to
reinforce his fugitive impressions, or rather to find a sort of confirmation of
them. Before nature itself, it is our imagination which makes the picture."[6]
Color, form, and texture nourished Delacroix's imagination and sense of
wonder, filled his tempestuous yet serious temperament with new approaches
to painting, which he noted in his *Journal* (1848): "I am at my window and I
see the most beautiful landscape: the idea of a line doesn't occur to me. The
lark sings, the river shimmers like a thousand diamonds, the leaves murmur;
where are the lines that produce these charming sensations?"[7] Delacroix also
had his supporters: Théophile Gautier, writing for *La Presse* and *La Revue de
Paris*; Gustave Planche of *La Revue des Deux Mondes*; and Jules Janin of *Le
Constitutionnel*, who, as quoted by Baudelaire in his *Salon of 1846*, had
predicted as far back as 1822 that judging from the canvas *Dante and Vergil in
Hell*, Delacroix's future would be a great one.

Delacroix's "concision," "intensity," and "concentration," Baudelaire
wrote, enabled him to reach bedrock. In addition to the *temenos*, or sacred
center, out of which he constructed his pictorial composition, there also
existed for Delacroix a storehouse of color combinations and harmonic
overtones (p. 1126). In describing Delacroix's inner artistic balance, Baude-
laire cited Ralph Waldo Emerson: "The hero is he who is immovably
centered" (p. 1116).[8] The balance that Delacroix possessed allowed him to
reach out into space without a loss of equilibrium; his imagination working in

consort with his rational sphere encouraged him to seize those forces that served him best, to structure and shape them and finally to bring them into existence in identifiable form.

Perhaps it was Delacroix's extraordinary imagination that earned Baudelaire's greatest admiration, all else being subordinate to this one effulgent force. For this reason, he believed that Delacroix belonged to the elect: "Heaven belongs to him as does hell, as does war, as does Olympus, as does voluptuousness" (p. 1122). During the seventeenth and eighteenth centuries, imagination had been deprecated by such philosophers and metaphysicians as Pascal, Spinoza, and Malebranche, and this had caused a concomitant shift in the outlook of art critics and practitioners. Art had evolved into a copy of the past, an ornament, a diversion, and was no longer an evocative, suggestive feat of magic that transported the beholder into primeval or sacred domains. For Baudelaire, the work of Delacroix, the *peintre-poète,* coexisted with mystery, was suffused by an acausal world of probabilities and potentialities.

Imagination, "the Queen of Faculties" for Baudelaire, did not imply the replication of natural, realistically viewed images, a technique used with felicity by such neoclassicists and idealistic painters as David, Ingres, Vernet, Chasseriau, and Ary Scheffer (p. 1036). Imagination was a way of perceiving the outer world in terms of inner subjective experience, thereby freeing the painter from the constraints imposed upon him by the world's conventional codes and concepts. Imagination for Baudelaire was an aggressive faculty. It harmonized with movement in time and space; it could depict physical action, and it could summon before the mind's eye the past, present, and future. Imagination thus might be compared in some ways to the centuries-old meditation techniques used by Hindus and Buddhists. The *yantra* image, for example, the center of visual focus, activates the unconscious, arousing archetypal images in the process, those "unknown motivating dynamisms of the psyche,"[9] which alter mood and temper, temporal and atemporal conditions bringing on the *numinosum.* As Baudelaire stated:

> It [imagination] is both analysis and synthesis. . . . It is that, and it is not entirely that. It is sensitivity, and yet there are people who are very sensitive, too sensitive perhaps, who have none of it. It is imagination that first taught man the moral meaning of color, of contour, of sound and of scent. In the beginning of the world it created analogy and metaphor. It decomposes all creation, and with the raw materials accumulated and disposed in accordance with rules whose origins one cannot find save in the furthest depths of the soul,

it creates a new world, it produces the sensation of newness. As it has created the world (so much can be said, I think, even in a religious sense), it is proper that it should govern it. (P. 234)

Imagination implies philosophical and spiritual factors: aspiration—the awareness of ethereal or nonformal spheres, invisible sound and light vibrations, and rhythmic patterns. Imagination presupposes intuition—the experience of a transpersonal dimension that encourages leaps into a pleromatic realm, there to face the void—that terrible chasm, the mystic's nothingness. Once the image is implanted in the creator's mind, it evolves, grows, expands, takes on momentum, and becomes crystallized in the finished work. Imagination involves a kind of mutation between the "real" landscape envisaged by the neoclassical academic painters (who sought to replicate objects by fixing their structure and determining their number and color) and the "unreal" sphere of the imaginative artist who feeds on both inner and outer space, vibrant with musical discords and harmonies.[10]

Mary Magdalene in the Desert: The Desert Experience

A head of a woman thrust back, in a very narrow frame. High up to the right, a little scrap of sky or rock—a touch of blue. The Magdalene's eyes are closed, her mouth soft and languid, hair dishevelled. Short of seeing it, no one could imagine that amount of mysterious and romantic poetry that the artist has put into this simple head. It is painted almost entirely by hatchet strokes as are so many of M. Delacroix's pictures. Far from being dazzling or intense, it is very gentle and restrained in tone; its general effect is almost gray, but of a perfect harmony. (P. 4)

Baudelaire found Delacroix's *Mary Magdalene in the Desert* filled with mystery, imbued with a secret inner glow. Symbolically it seems to represent the charred remains of one way of life and the gestation of another. The turmoil and agony endured by this reformed prostitute who was cured by Jesus are visible in the figure's pose. She can almost be heard voicing her lamentation, disclosing her penitence and grief. The lyrical head is thrust back in agony, not held erect which would have implied authority, a sense of control over her person, and the direct working of a governing principle. Her mouth is referred to as *molle* by Baudelaire, which can be translated as soft but also as flabby, indolent, languishing, a vestige of her sinful existence prior to her conversion. Lust, which had formerly inhabited the Magdalene's body, fascinated and haunted Baudelaire; it evoked a whole network of shameful

and forbidden erotic pleasures. The hair, disheveled as if torn apart, seems to display her emotional lacerations even more strikingly than her facial expression, the disorientation that has overtaken her in what might be called her "exile" or "desert experience."

The Magdalene's eyes are shut, indicating a rejection of the world of appearances and the powerful desire to live a deeply inward life in order to reaffirm the hidden realm within her. Like the blind seers of old, she seems to peer into the future and feel something stirring within her; a remote and secret part of her being knows joy—the witnessing of an epiphany, the risen Jesus. Her face, suggested only, hatched into relief and not delineated by definitive brushstrokes, evokes a whole hidden dimension. The figure seems isolated in space as if replicating the Magdalene's solitude now that she has left the world of people. The sense of isolation is numbing; it is, however, also productive because it compels her to inhale and exhale her own disturbing shadow world. The thought of the grace for which she yearns and has yet to experience adds a note of tension, even of cruelty and acerbity, to the canvas, underlining the struggle entailed by her sacrifice.

The blue tones in the upper corner, which represent celestial and spiritual values, imply a nonmaterial existence, a transparent and airy sphere, and a far cry from the hard-crusted earthly domain that Mary Magdalene is in the process of excising. Let us recall that Mary, the mother of Jesus, who is identified with perfection, is generally portrayed wearing a blue mantle, representing the ideal, and, therefore, the formless, the unstructured, the unrealized. It is in this remote sphere—cold and icy in its purity, a kind of neutral zone—that the Magdalene's spiritual existence comes into being. Earth begins to commune with Heaven as the eye scans heights and depths, the blue patch and the arid land; sensations of verticality underscore the penitent's alternating moods: the need to exercise volition so that the intermediate state she now endures will vanish when her emotions are rechanneled toward higher domains.

Enforced isolation brings on a condition of *metanoia*—the birth of new values, or at least a shift in old ones; the forty years, for example, that the Hebrews spent wandering in the wilderness after their flight from Egypt, the forty days and nights that Jesus spent in the desert after his baptism by John the Baptist. In the desert experience, or exile, the struggle waged against insurmountable odds can be viewed as a testing of strength and faith. It forces a person to face the self and to grapple with unconscious forces projected onto the outer world as either grotesque or loving emanations.

Why are desolation and isolation required to pave the way for a new frame of reference? When a person (ego) can no longer tend to his or her desires in a psychological manner or function in a satisfactory way, he or she must withdraw from ordinary life in order to allow the libido (psychic energy), which would otherwise have been absorbed by daily activities, to be rechanneled inward, to energize the unconscious contents, and, in so doing, nourish the whole inner world. When the Hebrews were exiled in the wilderness, hoping to reach the Promised Land, they nearly died of starvation, but "miraculously" at the last moment, they were fed by manna from heaven; Elijah, the prophet, was fed by ravens; so was Saint Paul. The food or manna sent by God, which fed the Israelites and the prophet and the apostles, may psychologically be looked upon as aspects of the self (the total psyche), helping to rescue the weak ego, to strengthen and to water what has grown wan and sterile.

It was in the desert in Delacroix's portrayal that Mary Magdalene discovers the source of living water—in her new life as a follower of Christ. The dry and barren landscape in the painting takes on a catalytic dimension and paves the way for increased awareness. Inner richness as energy is progressing inward, discovering hidden treasures, the secret source of nourishment. The desert is also an area where supernatural happenings may occur: loneliness may give rise to hallucinations, visions, mirages—archetypal fantasies and the *numinosum*. The influx of life at these junctures may be so sudden and forceful as to bring on vertigo, even madness. Once turmoil and turbulence subside, however, the tide turns, and balance is frequently restored with a life bathed in renewed clarity.[11]

Baudelaire underwent his own desert experience in 1845, after attempting suicide. The causes for his action were complex and almost surely will never really be fully understood. What is certain, however, was the indignation and the sense of shame caused by his mother's decision—enforced by a court order—to stop him from "squandering" the capital inherited from his father. Deprived of many of life's luxuries—fine furniture, paintings, clothes—Baudelaire was enraged. Any intrusion upon his freedom, material or psychological, was anathema to him. Feelings of guilt also accompanied his anger at what society labeled his immoral conduct. That he frequented prostitutes, and admitted a penchant for depravity and perversion represented sharp and conflicting emotions antagonistic to his deep Roman Catholic faith. Important also in his self-destructive deed was his own feeling that he was a failure as a writer; until 1844 he had published only a few anonymous works.

When Baudelaire's mother was informed of her son's near-fatal act, she had him brought to her home where he could have lived in comfort with her and with his stepfather, General Aupick, for the rest of his life. He chose instead to leave home the second time after having stayed there for nearly six months. His distaste for his stepfather was certainly instrumental in his decision, but there were other reasons also. Had he yielded to this kind of bourgeois existence, where all his wants would be met with little or no effort on his part, his life and his talents would have wasted away. Struggle—the desert experience—and not passivity; solitude and contemplation, and not continual social encounters, were the sine qua non of a literary career for Baudelaire. He needed the stress of the workaday world, which he looked upon as an enemy because his talents were as yet unappreciated and misunderstood. Struggle, however, fosters growth; a *regressus ad uterum* and the indulgent ways of a loving mother had therefore to be sacrificed.

The gray tonalities Baudelaire noted in Delacroix's painting of Mary Magdalene mirrored his own inward state of mind. Such hues in Christian symbolism represent penitence, analogous to the gray ash daubed on the foreheads of the devout on Ash Wednesday, the beginning of Lent. The lusterless tonalities of the painting, which usher in foggy and nebulous regions, parallel the emotional trauma, the obscurity and sadness, residing in Mary Magdalene's soul—and in Baudelaire's as well. In the depth of the Magdalene's solitude, however, in her "bizarre and mysterious" smile, which Baudelaire was years later to describe in his *Salon of 1855* as "so supernaturally beautiful that you cannot tell whether she has been crowned with a halo in death or beautified by the spasm of divine love" (p. 970), resides the mystery of sacrifice. The loneliness of solitude and of the exile-in-the-desert experience has shown the Magdalene the way; it also enabled Baudelaire to discover his own manna—the dream state from which he would extract the living waters of creative impulse.

The Last Words of Marcus Aurelius: Patriarchal Consciousness

Marcus Aurelius commits his son to the Stoics. A half-draped figure, on his death-bed, he is presenting the young Commodus—a young, pink, soft voluptuary, seemingly a little bored—to his austere friends grouped around him in attitudes of dejection. A splendid, magnificent, sublime and misunderstood picture. (P. 4)

The death of Marcus Aurelius (A.D. 121–180) signaled the beginning of
the end of a civilization—the decline leading to the fall of the Roman
Empire. Stoic and emperor, Marcus Aurelius struggled valiantly during the
greater part of his reign against encroaching tribes of Germans, Parthians,
and Britons. The humanitarian views expressed in his *Meditations* are re-
flected in his efforts to decrease the sufferings of the poor by lowering their
taxes and to diminish the brutality perpetrated in the gladiatorial shows. His
son, Commodus, reversed his father's foreign policy by making peace with
former enemies, and instead of tending to the needy, he spent his time in

The Last Words of Marcus Aurelius by Delacroix (Musée des Beaux Arts, Lyon)

illicit pleasures and flaunting his prowess in gladiatorial combat. Finally, after
demanding to be worshiped as an incarnation of Hercules, he was strangled at
the age of thirty-one by a wrestler, seemingly upon orders from his own
advisers.

What were the tenets of Stoicism that Baudelaire, in his appraisal of
Delacroix's painting, should have described Marcus Aurelius and his friends

as "austere" and boring, and characterized Commodus, the hedonist, as a "young, pink, soft voluptuary"? Stoicism advocated and taught control over human passions and desires, renunciation of both pleasure and pain, detachment from the external world. Stoics believed that personal emotion was evil and should be overcome by cognitive means; that ethical progress was a matter of reason and knowledge; morality, a personal question; and virtue, a matter of will, and the only source of true happiness. Stoicism gained impetus to a large extent as a counterforce at a time when Rome was in a state of decay, when licentiousness bloomed, and when moral and religious structures were crumbling.

The psychological implications of such a philosophical movement were significant. An ego-centered way, Stoicism was a philosophy based on pride and self-virtue; it was an abstract system that runs contrary to nature in that it disregards human frailty. The cognitive view of life advocated by the Stoics takes no account of the instinctual world which plays an important part in the human psyche. It essays rather to suppress this aspect—the entire affective side—which it considers weak (including love, affection, and relatedness). The suppression of this part of a human being is tantamount to starvation. As a result, the animal within hungers, rages, and loses control, destroying all balance within the personality. The Stoics tried to do away with what they considered humanity's inferior characteristics—the instincts. What they did not consider was that the instincts when properly recognized, understood, and accepted act in harmony with the other aspects of the personality. As such, they are positive forces. When unattended, it is true, they crave what is rightfully theirs and become virulent and destructive. Not to take into account the earthly half (*physis*), and to cultivate merely the godly or spiritual side (*logos*), is to cut the human off from life, to create a top-heavy being whose illusions and delusions will cause part of him or her to wallow and grovel in the most turbid of mires.

For Baudelaire, Commodus's way of life was the result of Stoic education. Father and son represented two conflicting ways of life: patriarchal consciousness with its severe, stern, and repressive ways; and the hedonist approach, soft, flabby, sensual, depending upon gratification of the senses for its pleasure principle. Age and youth, rational and irrational, past and present, dreams lived and lost and yet unborn, are all implicit in Delacroix's canvas. What Marcus Aurelius stood for is about to be abandoned, broken up, rejected in favor of dissolute ways in the behavioral sphere and passivity in

the political one. Like those flower gods of antiquity, Narcissus and Hya-
cinth, so too would Commodus live a *provisional life*, to use C. G. Jung's
words, never delving into anything deeply, yielding to an undisciplined and
charming nature in a continuous quest for sensual pleasure and excitement.
Incapable of growth and the creation of his own personality, Commodus was
struck down at an early age, ravaged, asphyxiated by his own licentiousness.

Baudelaire identified to a great extent with the handsome youthful Com-
modus, and, in so doing, he fused irony with rapture. Neither was inclined to
focus upon renunciation or repentance; rather, they savored the splendidly
passionate moments that offer sensual delight and are accompanied by
equally splendid and luxurious tactile sensations. It is noteworthy that
Baudelaire used the adjective *mou* to describe Commodus, the same word
that he used in its feminine form of *molle* when referring to Mary Magdalene.
Translated "soft" or "flabby" and "indolent," it establishes an association
between fleshiness and flabbiness in both religious and sensual experience—
not an uncommon tendency on the part of Baudelaire when referring to the
admixture of human and divine love and the mystery therein involved. The
color rose, which Baudelaire used to describe Commodus's skin tones, arouses
a whole complex of imagined pleasures; the flower rose also held a special
meaning for Baudelaire, whose olfactory senses were acutely developed. So
carnal pleasure on an earthly level can be transformed into a cosmic
experience. As for *rosa*, the root of the word rose, it can be identified with
ros, or dew, that substance so necessary to the revitalization of plant life,
nourishing it in both the morning and the evening, and one that was equally
important in the nurturing of Baudelaire's spiritual *renovatio*, which enabled
him to write his poetry.

Baudelaire's auditory nerves seem also to have been sparked by *The Last
Words of Marcus Aurelius*. Sounds resound; they speak to him, lacerate, and
create the division implicit in the divergent paths taken by father and son.
Discord is also suggested in the reds and greens used by Delacroix in his
canvas. The tension engendered by the interplay of color and its philosophi-
cal and emotional equivalents—good and evil, passion and control—seems
to have dilated Baudelaire's emotional reactions.

> In modeling with a single tone—that is with a stump—the difficulty is simple;
> modeling with colour, however, means first discovering a logic of light and
> shade, and then truth and harmony of tone, all in one sudden, spontaneous and
> complex working. Put in another way, if the light is red and the shadow green,
> it means discovering at the first attempt a harmony of red and green, one

luminous, the other dark, which together produce the effect of a monochromatic and *turning* object. (P. 5)

Although green is usually equated with positive factors such as nature's growing power, with its fertility instilling feelings of hope and optimism, the color possesses more uncertain recalcitrant attributes that usher in a panoply of so-called negative vibrations. Lucifer's emerald, which he wore on his forehead prior to his fall, shone in eerie green tones when he appeared as Light-Bringer, spreading chaos, doubt, and upheaval. Satan's green skin and green eyes depicted in one of the stained-glass windows in Chartres Cathedral is evocative of terror and fantasy. Devils in medieval iconographic representations are frequently portrayed as green blooded. In Delacroix's canvas, the dichotomy is intermingled: danger and serenity, fertility and aridity, rapture and terror, harmony and cacophony, good and evil.

The color red, symbolic of Marcus Aurelius's battles against the enemies of Rome as well as of Commodus's future sanguinary deeds and his own murder, represents fire, psychic energy, libido—that secret element which generates frenzy and ardor as well as death. Infernal fire purifies heart and soul, but it may also consume the very person seeking redemption. Red, which was used so frequently by Delacroix to indicate pain, torture, suffering, and bloodshed, also stands for the internecine warfare taking place in the ongoing drama between patriarchal consciousness and the youthful pleasure principle—and of a world smoldering as it sinks into oblivion.

That Baudelaire should have used the word "turning" in his analysis of Delacroix's canvas implies an acutely developed motor sense. At this moment color, form, and concepts circle about, points of light swirl in smoky tonalities, and what had formerly been chaotic is unified and moves toward a new birth. Logic, Baudelaire stated, exists in opposition. The Greeks personified this notion as Nemesis, the goddess of retribution and moderation, whose function it was to rectify what was not moving on a steady course. The pull and tug of Stoic and hedonistic philosophies were to be harmonized for Baudelaire in a sphere of being which he viewed as beautiful and where he could live unhampered, unattached, and irresponsible. Baudelaire's aesthetic views were intertwined with his mystical and philosophical ideas: the unforeseen, the unexpected, the bizarre, the irregular, and the factor of surprise, represented in some ways by Commodus, as opposed to Marcus Aurelius's steady, patriarchal, and predictable attitude, were implicit in Baudelaire's definition of *"le beau."*

Harmony existed in dichotomy for Baudelaire; and as Delacroix's canvas turned in frenzied and dynamic rhythms, it disrupted, pulverized, and finally hurled him into the painting's "splendid, magnificent, sublime, misunderstood" depths—there to dream (p. 816).

Dante and Vergil in Hell: Nekyia or the Night Sea Journey

A picture by Delacroix, *Dante and Vergil*, for example, always leaves a deep impression whose intensity increases with distance. Ceaselessly sacrificing detail to the whole, and hesitating to impair the vitality of his thought by the drudgery of a neater and more calligraphic execution, he rejoices in the full use of an inalienable originality, which is his searching intimacy with the subject. (P. 58)

When Baudelaire viewed Delacroix's *Dante and Vergil in Hell,* he felt that he was witnessing "the celebration of some painful mystery"; and a "desolation," a "singular melancholia," and "human pain" enveloped him (p. 898).

Dante and Vergil in Hell by Delacroix (Louvre, Paris)

The tumult aroused in him by what he beheld opened to him a whole *surnaturel* dimension.

Delacroix, too, must have been seized with frenzy when he brought this canvas to fruition; he worked on it for twelve to thirteen hours a day for two and a half months. The painter had always admired Vergil and had committed to memory many of his verses which he translated and recited for his friends. Dante's *Divine Comedy* was also one of his favorite works, as attested to by his many references to it in his *Journal* and other writings. In *Dante and Vergil in Hell*, the pagan poet's head is wreathed with laurel; his eyes, although calm and sad, show an expression of serenity. As psychopomp, that is as guide, he stands steady on the bark that is making its way through the tenebrous waters of the river Styx, holding Dante's hand as if to comfort the Florentine and dispel his overwhelming terror. Dante's features, in sharp contrast, are distorted by fear. With all his might he tries to pull back from this journey—from what he considers sinister, from the subterranean waters, from night, death, and oblivion. In the foreground at the bottom of the painting are the damned thrashing about in the waters in their agony, each attempting to grab hold of the bark so as to be towed to the safety of the other side. Dramatic conflict is implicit in the canvas; as the lost souls try to grasp the solid boat, they endanger the lives of the two poets who, should the bark capsize, will be caught in these poison-infested waters.

What did Vergil and Dante's encounter of this "mysterious" underworld mean to Baudelaire that he should have mentioned this canvas so many times in his *Salon of 1845*, *Salon of 1846*, *Universal Exposition of 1855*, and *Salon of 1859*? From an artistic point of view, he was well aware of Delacroix's debt to Michelangelo (the monumental style in which he delineated his figures) and to Géricault (for the slashing waters distilled into pure color and glistening with wetness). He understood, too, that the savage atmosphere created by Delacroix's powerful use of diagonal lines stimulated sensations, reinforced the struggle, and underscored the agitation of the pitiful souls floundering in the dark of the polluted waters. Baudelaire's powerful inner eye spanned contours and cut through the livid countenances and the sweeping masses of matter to partake in the "human drama" being enacted before him—his own.

When Baudelaire wrote of "sacrificing" detail for compositional reasons, when he stated that "intensity" increases with distance, he spoke as an art critic, but he was also voicing metaphysical concepts with psychological ramifications. *Dante and Vergil in Hell* was, indeed, a living mystery, that of *nekyia*, or in the words of Frobenius, the "night sea journey." Such a

trajectory entails a numinous experience in keeping with Baudelaire's comments that "Delacroix alone knows how to experience a religious dimension" (p. 894).

Experienced by the ancient Egyptians and Greeks and implicit in myth and art, the nekyia implies a descent ad inferos; into the dark world of Hades, that is, into the collective unconscious. It entails a perilous journey that brings the individual face-to-face with extinction. If the traveler is sufficiently strong, he is restored to life—resurrected. Psychologically, the nekyia may be explained as follows: when the ego or conscious personality delves into the collective unconscious, it puts itself in a dangerous position. It may be extinguished by powerfully active subliminal forces and consumed by seemingly terrifying entities—the unconscious contents that it meets along the way. Diminution or extinction of consciousness, or as the ancients put it, the "peril of the soul," is the most fearful of all experiences. Yet such testing has always been an important factor in religious rituals because it sharpens vision and strengthens the disciple's mettle. In certain initiation mysteries, for example, such heroes as Theseus and Pirithous, held captive in the Underworld for long periods of time, were forced in this way to deal with all kinds of terrors. According to an image depicted on the base of a fifth-century Attic vase, Hercules volunteered to die in order that he might achieve a rebirth. During his struggle, unconscious forces rescued him, nourished and strengthened him, so that he came through victorious—as did Jonah from the whale, Joseph from the pit, and Christ from the tomb. The alchemical document, Aurora Consurgens, attributed to Saint Thomas Aquinas, describes the "night sea journey" as "Horridas nostrae mentis purga tenenbras, ascende lumen sensibus!"[12] (Purge our mind of horrible shadows, let the light ascend from the senses.)

To descend into Hades, or into the depths of the psychic substratum, is not only a means of plumbing one's depths and earning redemption, or psychological healing; but also these dark realms hold a certain fascination for the sojourner, and as such they represent a great threat. One may be mesmerized by those forces and in time become locked into them, an outcome that leads to schizophrenia and to the disintegration of the personality—to the complete withdrawal of the ego into the subliminal world.

Baudelaire submerged himself in his underworld in part because of his distaste for the phenomenological realm, but he also did so because it became a stepping-stone for forays into the unknown and archaic spheres of his psyche, offering him the opportunity of self-discovery. Let us recall that the

goddess Night (daughter of Chaos and mother of Uranus, the sky god) gave birth to Death and Sleep—conditions longed for by Baudelaire. They nourished his dream world—a fertile field where his poems gestated, fed by beatific and monstrous images, and where forces that impressed themselves on his inner eye inflated his imagination and orchestrated his senses. He discovered manna, spiritual nourishment, during his inner journeys that strengthened him in his struggle with matter, form, and music; he then transformed these amorphous entities into the written word. So deeply did Baudelaire penetrate his own being that he experienced periods of alienation followed by momentary eclipses of consciousness that Kierkegaard, alluding to his own experience, termed "despair."[13]

Alienation, which in Baudelaire's case gave way to an egoless world, brought with this an *abaissement du niveau mental,* an entrance to the *numinosum* or religious experience. This is the level of understanding that he reached when assessing *Dante and Vergil in Hell:* Vergil's serenity and sense of earthly well-being contrast with the trembling and horrific atmosphere in which Dante's soul seems to be suffused, conjoining Christian and pagan outlooks in a single mystery. Both replicate Baudelaire's own suffering inner being, as do the sinful who grab hold of the boat, seeking to reach that other side where there is safety, pardon, redemption, and grace. The lurid counte-nances of the doomed inspired a horror in Baudelaire that paralleled his own abrading anguish, his obsessive preoccupation with sin. Grace, Saint Paul wrote, is offered by God through the sacrifice of the God-man by Jesus Christ: "But where sin was thus multiplied, grace immeasurably exceeded it in order that, as sin established its reign in righteousness, and issue in eternal life through Jesus Christ our Lord" (Rom. 5:20–21). For Baudelaire, grace and sin were irrevocably interlocked; repentance and contrition alone could, therefore, earn the redemption and the restoration of balance that he so needed. As Baudelaire projected his inner experience on the figures in Delacroix's painting, he was overwhelmed by feelings of morbidity, pain, and sadness. Menacing sounds seemed to strike as they flowed forward; screams, shrieks, cries of agony, emerged from every corner of this shadowed realm. Colors also flayed the poet: greens, browns, blacks, auburns, dark reds; living tonalities that the residue of smoke and flame depicted in the painting rendered even more lurid, endowing the environment with patches of burnished yellow and doleful grays, which, Baudelaire suggested, were not only in keeping with the mood of the canvas but also most suited to Roman Catholicism: "the serious sadness of his [Delacroix's] talent is perfectly suited

to our religion which is itself profoundly sad—a religion of universal anguish, and one which, because of its very catholicity, grants full liberty to the individual and asks no better than to be celebrated in each person's own language—so long as he knows anguish and is a painter" (p. 61).

So periods of ascent and descent marked Baudelaire's entire life; regression into morbid melancholia, leading to torpor and turmoil as well as to horrific experiences, followed by momentary release into an ideal condition, offering expanded vision and an immersion into an ecstasy crowned with grace. The creative individual, he came to realize, armed with "a great passion" must "accept the fatality of talent and not bargain with genius" (p. 892).

The Taking of Constantinople by the Crusaders: A Blood Sacrifice

What a sky, and what a sea; All is tumult and tranquility, as in the aftermath of a great event. The city ranged behind the Crusaders who have just passed through it, stretches back into the distance with a miraculous truth. And everywhere the fluttering and waving flags, unfurling and snapping their bright folds in the transparent atmosphere! Everywhere the restless, stirring crowd, the tumult of arms, the ceremonial splendour of the clothes, and a rhetorical truth of gesture amid the great occasions of life! . . . For after Shakespeare, no one has excelled like Delacroix in fusing a mysterious unity of drama and reverie. (P. 213)

The Taking of Constantinople by the Crusaders, commissioned by the French government for the Palace of Versailles, encompasses an unending sequence of shifting forms and alternating masses of stress that whirl the viewer from a foreground of large figures to a background of smaller, more obscure, and less visible ones. The city, helpless in the background, lies torn, wounded; persistently pillaged by crimson-robed Christian soldiers, it has become a prey to murder, lust, and spoliation. Brutality is magnified by the Crusaders on horseback who seem, once they enter a house, to set it aflame, hacking away at its living inhabitants. They appear to rise quite out of the canvas, shedding splendidly muted colorations—shadows drowned in blood-red; gray tones, turquoises and aquamarines, smothered in browns and blacks—creating an atmosphere hounded by destruction and death, vanquishers atomizing the most radiant and golden of cultures.

The Fourth Crusade (1202–1204), a war of extermination, was led by Count Baldwin of Flanders, among others. Under the guise of wiping out the pagan Muslims, the Crusaders with their *Veni Creator Spiritus* reached

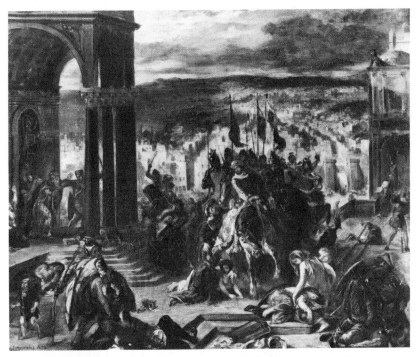

The Taking of Constantinople by the Crusaders by Delacroix (Louvre, Paris)

Constantinople, that Byzantine capital renowned both for the richness of its culture and the beauty of its art and learning, and put the city to the torch, transforming what had once been a glittering golden city into burning coals and blackened ash. Ravaging countless treasures—during Easter week, ironically enough—the Crusaders pillaged homes, palaces, shops, mosques, and churches helping themselves to all the gold, silver, jewels, and sacred relics they could gather. They even took the precious stones encrusted in the great altar of Sancta Sophia, destroying the altar in the process.[15]

Delacroix's canvas, exploding with sonorous vibrations of color and rhythm, profoundly affected Baudelaire. He sensed the rapturous thrill of the Crusaders as they thundered to victory, as well as the more sinister sentiment portrayed on the faces of the conquerors. Energetic charges seem to flood the atmosphere as the army moves about, as flags crackle sharply, fluttering in the wind, and gray-black smoke rises in gusts, encircling alike the living and the dead. The smell of smoke and flame seems to fill the nostrils and pain the eyes of the beholder, reflecting and reverberating from every area of the richly

textured canvas, expelling deadly fumes everywhere. In contrast to the vigor, vitality, and mobility of the men on horseback, who strangle and stab those about them, is the relative calm and depersonalized atmosphere depicted in the far distance: the mountains blackened with ever-widening bursts of smoke, the clouds moving slowly, sluggishly, in a desolate sky. East and West are at odds; the interplay of luminosities accentuates the antitheses involved: the superimposition of one layer of feeling upon another dulls the atmosphere of the hallucinatory canvas. A double drama is depicted in Delacroix's painting: power and weakness, conqueror and conquered.

Catachresis is implicit in Baudelaire's excited reactions—a figure of speech he used to depict an ambience overflowing with matter, generating undulations and harsh beats, reflecting the mournful echoing groans and shrieks of the expiring. It was as if Baudelaire's pathological personality fed on the disaster; it invigorated and inebriated his senses to the point of distraction: hashish and wine were no more effective in taking him out of himself. The isomorphic relationship born from this vision of pomp, tumult, and ruin paved the way for a panoply of images, each encouraging the poet to pierce ever more deeply into the harrowing events depicted, a drama of light plowed into darkness, a visitation into an inner scene—*agònia*.

That Baudelaire should have been so attracted to bloodshed and carnage is not surprising. He was a great admirer of Joseph de Maistre: "De Maistre and Edgar Poe taught me how to reason."[16] Author of *On the Pope* and *The Saint Petersburg Evenings*, de Maistre believed that the world should be ruled by a single spiritual leader—the pope—and that no temporal ruler should possess any independent political authority; blood purges were a way of cleansing impure elements in both society and the individual. Bloodshed and carnage were therefore not viewed as negative factors either by de Maistre or Baudelaire. Both implied that the shedding of blood was a sacred necessity: a ritual act of reverence offered by earth to heaven.

Blood rites are as old as mankind. In ancient times animals were slain and burnt offerings made in an act of awe and obeissance to the gods, thus assuring seasonal fertility. The spilling of blood supposedly dazzled and dazed the Great Earth Mother who sucked it up in deep draughts. As it traveled through her recesses, nourishing her every step of the way, a new growth and a new sensibility came into being. The greatest of all blood sacrifices, of course, was Christ's Crucifixion. Afterward, Joseph of Arimathea gathered up Christ's blood in the Holy Grail, which he then carried to England. From

Christ's blood was born a new vision and new understanding of life upon which the Western world is based.

Blood to Baudelaire represented cruelty and carnage, but it also meant purification, energy, an influx of strength, the expansion of consciousness. *The Taking of Constantinople by the Crusaders* therefore stimulated him. What had been depersonalized—the outer world—was personalized and exploded with fresh vitality. Blood, a living and functioning symbol for Baudelaire, was an appropriate offering to God, a necessary sacrifice for a broadening of the life experience—and for the birth of new spiritual and creative understanding. Just as the Mass or Eucharist allows the Catholic to experience a transpersonal element (the Godhead) rejoining man with the Creator, so, too, the individual, absorbing forces from the collective (blood) in war or periods of intense creativity, also finds immortality. For these reasons Baudelaire immersed himself in Delacroix's canvas and the essence of life contained within it—blood; it empowered him to pursue his own mysterious quest as creator.

Ovid Exiled Among the Scythians: The Androgyne

> There he is, the famous poet who taught *the art of* love; lying on the wild grass, indolently, sadly like a woman. (P. 1051)
>
> The mind sinks into it [the canvas] in slow and greedy voluptuousness, as it would into the heavens, or into the sea's horizon, into eyes brimming with thought, or a rich and fertil drift of reverie. (P. 252)

Its gentle serenity seems to have drawn Baudelaire to *Ovid Exiled Among the Scythians*. Ovid (43 B.C.–A.D. 17) was the author of *The Art of Love* and *Metamorphoses*, which won him great acclaim but also brought about his exile to what he must have considered to be a desolate and bleak fishing village near the Black Sea. There, in solitude, he wrote *Songs of Sadness* and *Letters from the Black Sea*, begging the emperor Augustus to allow him to return to Rome.

Delacroix's background of sky, lake, and sloping mountains seems to envelop the Roman poet in its embrace, fostering an atmosphere of contentment and receptivity. Unlike the actual Scythians, who were a nomadic, violent, warring people, those depicted by Delacroix are charming and gentle, bringing gifts to the poet who is at the center of their attention. In this Edenesque ambience, the Roman poet seems to be reliving the myth of

the noble savage—which the romantics used so often as the theme of their poems, novels, and dramas. Living close to nature, Ovid experiences its purity and beauty, its strength and melancholy, all of which, Baudelaire suggested, streams from the canvas: "I shall certainly not try to translate with my pen, the sad voluptuousness which is exhaled by the verdant exile" (p. 1052).

Feelings of well-being and gracious sensuality prevail, in sharp contrast to the dark tempestuous waters portrayed in *Vergil and Dante in Hell*, the divisionism in *The Last Words of Marcus Aurelius*, and the flaming torches of the Christian conquerors in *The Taking of Constantinople by the Crusaders*. In this canvas nature's own colors abound: pale blues and greens, turquoises and aquamarines, blending with emerald hues in a climate filled with longing for an absent idealized world, but also one luxuriating in its own charm and enchantment. The pleasure principle is operational here: Ovid lies as if embedded in the greenest of grasses; lethargy has overcome his features; drowsiness has benumbed his senses; the dream proliferates, expands, dilates. The Roman poet basks in the stilled surroundings, withdrawn into a world that offers him comfort and protects him from brutalities, but which by the same token lulls his sensibilities. Conflict has been banished from the scene; tension is nonexistent; oneness prevails.

That Baudelaire refers to Ovid as tender and gentle—feminine characteristics insofar as he is concerned—is not surprising. Ovid is portrayed as being both masculine and feminine in the Delacroix painting. Yet, in fact, Ovid here is neither—he is androgynous. In the Roman poet's *Metamorphoses*, a recollection of tales in verse describing the many fluctuations and changes the gods and goddesses of antiquity underwent—among them, women turning into men, and men into women—a kind of borderless world is brought into being where sexual boundaries have either diminished or disappeared.

Androgeny is a mystical concept that always fascinated Baudelaire, as it did Swedenborg, Balzac, Nerval, Hugo, and many others. The androgyne or Original Man was a paradigm of primordial unity: the *vir unus*—the one prior to the two—Adam before Eve's creation from the rib.[17] In Vedic tradition, such a being produced his own feminine half and united with her. Plato described the androgyne as dwelling in a self-sufficient and integrated sphere in his *Banquet*. When a woman asked Christ when she would receive the things for which she was waiting, he answered: "When ye have trampled on the garment of shame, and when the two become one and the male with the female is neither male nor female." In Christian allegory, woman sprang from

Christ's side, signifying that the Church is the Bride of the Lamb.[18] John Scotus Erigena, the medieval scholastic philosopher, considered Adam's sexual differentiation a replica of the cosmogenic process. The dividing of the Original Man into husband and wife—psychologically speaking the division between the conscious and unconscious—gave birth to a pair of opposites, that is, to the undifferentiated and the manifest world. For the mystic, the androgyne represents both the primitive state of unified wholeness—the undifferentiated oneness of preconsciousness—and the integration of disparate forces at the end of life's struggle; therefore, the ideal condition represents order instead of chaos, richness rather than paucity.

That Delacroix placed Ovid in an Edenlike atmosphere indicates that the poet is living through and by collective forces, that he has been virtually mesmerized in these idyllic surroundings; he has not yet either assumed or rejected consciousness and, with it, the sense of individuality. Such a condition is also attested to by his smallness and the largeness of the background—a baby in a cradle, a fetus in the womb. It should be noted that at this juncture the ego lives in a state of *participation mystique* with the self (or with the world, parents, and society). Psychoanalysts have referred to this condition as existing during the prenatal period and early infancy; the Gnostic image of the serpent eating its own tail has been used to depict this original state of wholeness and self-containment prior to the birth of consciousness. In such an undifferentiated state, all one's wants and needs are met; should such passivity persist, however, erosion and deterioration of the personality would surely ensue.

Rituals and imitative rites are implicit in the androgynous experience insofar as the mystic is concerned. It offers liberation from dichotomy between the disparities of the exterior world and harmony of being. Such a sphere, if experienced spiritually, is considered an ideal state that few can reach—an intrapsychic condition—when both outer and inner aspects of the personality are well developed, each identifying with his or her own sex as viewed not according to the stereotypes of masculine and feminine, but in keeping with the individual's particular frame of reference. (Any nonsymbolic androgyne, however, born in the world of reality—as a hermaphrodite—was frequently killed at birth, the ancient Greeks considering such a form a physical aberration and, therefore, unworthy of life.)

Delacroix's *Ovid* may have been a "ritual" androgyne to Baudelaire. Its atmosphere glistening with soft tones, light blue-greens, beiges, ochers, blues, mat reds, may have reduced the French poet's frenzy, enticed drowsi-

ness, lulled his sense into a state of euphoria. Immersed in such an ideal androgynous condition, Baudelaire felt at ease with his being and his environment, warmed and locked in its embrace. Mellifluous tonalities and fresh harmonies came to life in this state of wholeness, not the brazen hues of a conquering army or the lamentations of the wounded, but the music of the spheres which beckoned him on to pursue his *invitation au voyage*. Still, Baudelaire knew—and perhaps this perception was instrumental in heightening his pleasure when viewing Delacroix's canvas—that he would be thrust back moments later into the melee, the harsh reality of life with its metallic overtones, its sexual divisionism, which cruelly lacerated him in the past and would soon do so again.

Baudelaire's experience of the androgynous condition was realized on an aesthetic and literary plane. It cannot be considered liberation in the psychological sense; that is a reconciliation of opposites, a symbol for the self-containment that is achieved after prolonged psychological struggle for the integration of polarities. The sense of wholeness that he experienced when the myth of the androgyne stirred his inward being, as it did in *Ovid Exiled Among the Scythians*, offered him moments of respite that enabled him to dream, and in so dreaming, to partake of the food of poets.

The Death of Sardanapalus: Flaming Flesh Consumed

Many times have my dreams been filled with the magnificent and agitated forms in this vast painting; itself, marvelous like a dream. *Sardanapalus*, seen again, is youth recaptured. The contemplation of this canvas thrust us so far back! Has a painted figure ever given us a vaster idea of the Oriental despot, with his black and plaited beard, than this Sardanapalus, dying as he does on his pyre, draped in muslin, his attitude like that of a woman? And everything is fire, freshness, poetic enthusiasm. All this *sardanapalesque* luxury which scintillates in the furnishings, clothings, trappings, dishes, jewels, who? who? (*Oeuvres complètes*, p. 112)

Delacroix's painting, inspired by Byron's tragedy *Sardanapalus*, tells the story of the mythical king of Assyria (erroneously identified with Assurbanipal) who lived in great splendor, and who after two years of war against the Medes, who were besieging his kingdom, realized that his struggle was doomed. He then set fire to his palace, causing himself along with his entire court to be consumed.

So powerful for Baudelaire were the emotions clustered about *The Death of*

Sardanapalus that a supernatural or mythical element seems to have been called into experience. In this work, color again is used by Delacroix for the realization of form, and emotion veers from darkened, pallid, and lurid tones to the joys endured in the consummation of the flesh. Lavish greens, ochers, oranges, blacks, yellows, grays, and reds, glow, sparkle, crackle, and sizzle as they collide, suggesting all the brash and eerie tones implicit in the rule of the pleasure-pain principle. Delacroix was perhaps never more intoxicated by form, color, texture, and rhythm, than in this sumptuous canvas: the fire raging in the background; the flames soon to scorch and scald the trove of accumulated treasures depicted—as well as the fleshy, flabby beings revealed in various stages of nudity. Feelings of ecstasy are portrayed: the rapturous excitement of these bejeweled men and women, the luxurious material enhancing their bodies. Sublimation for the depraved seems to reach its height when soldiers enter this garden of delight, stabbing, maiming, flagellating the physical bodies they encounter. Shrieks and lamentations emanate from the writhing figures in the foreground, some of whom seem to be beseeching their conquerors for death as a release from their lives while

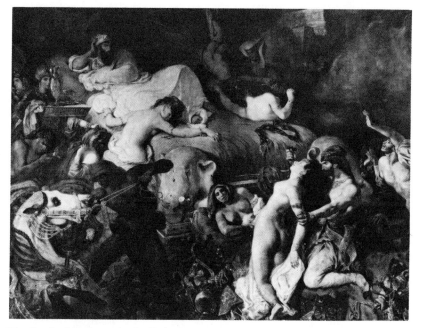

The Death of Sardanapalus by Delacroix (Louvre, Paris)

others simply submit to their torturers. Violence, passion, and agitation rock the canvas. *The Death of Sardanapalus* is a painting overwhelming in its diffused energy and its rapid eddies of pain and joy. In a sense, it is a visual replica of the passage in Revelations (10:4): "And death and hell were cast into the lake of fire."

That the bed occupies a nearly central position in Delacroix's work indicates both a conjugal and funerary intent: a *temenos*, a sacred area within which the death-life mystery was, is, and will be enacted. In the Christian tradition the bed is not necessarily only a place upon which one rests or makes love. The bed represents the physical body—the paralytic cured by Christ, for example, was ordered to take up his bed—that is, his body—and to use it in a virtuous way, so that disavowal of the sin, which was now cast out, might bring grace and purification. So here, too, the fire of purgation will transform the bed into ash, diffused matter, subatomic particles, to be plowed back into the earth and at some future period be returned to life.

The room within the palace, housing the lust-loving beings in *The Death of Sardanapalus*, is comparable to both the womb and the city, in that it contains and protects as well as imprisons. Let us recall that a number of cities mentioned in the Bible—Nineveh, Babylon, Tyre—were frequently personified and sometimes alluded to as harlots or unfaithful women (Jer. 50:12, Isa. 23:16, etc.). They were symbols of the Terrible Mother that lures her sons and daughters into temptation, whoredom, lechery, and perdition. In Delacroix's painting we learn that the capital of Sardanapalus's empire that had once stood for growth, during his youthful years, has now outlived its usefulness; it presently represents decadence and, like an infection, it must be *cauterized*, so that a new higher city or way of life can come into being. Rather than moving outward, which might have brought fresh emerging ways, Sardanapalus locked himself within his city, his realm, his palace, his room—a condition that not only precludes growth, but leads to a psychologically incestuous relationship with the Mother image, which symbolically may be defined as city, palace, room. From the Babylonian creation texts, we learn that when Marduk brought forth the world from the Great Earth Mother, Tiamat, she had to be destroyed (sacrificed), so that the energy expended by her could be used to activate the earth. Such was not the case in Sardanapalus's domain; there was regression into the room, the tomb, the womb.

The glowing center of Sardanapalus's palace—his room where passion flames—is the scene of destruction. The spectacle of fire born from sin, which

awakened in Baudelaire concomitant feelings of anguish, guilt, and fear, nourished him in some strange way, instilling joy and ecstasy of a most powerful kind into his very being. *Concupiscentia,* and not the flame of consciousness, activated his pen; his religious canon which outlawed Satanic ways made what they stood for even more thrilling and provocative. The "terrible hymn to pain," which sang so deeply in Delacroix's painting and which Baudelaire likened to the very essence of Christianity, did not muffle his emotions but whipped them up, saturating his being with visions of erotic poses, burning flesh, dazzling odors—taking him back to his youth when life was burgeoning, when freedom of choice and the hope of a brilliant future loomed before him. With *The Death of Sardanapalus,* a segment of the past intruded into the present, allowing Baudelaire once again to find deep nourishment on the "magnificent forms" and richly textured colorations of Delacroix's genius, "marvelous like a dream," set before him (p. 1112).

In 1867, five years after having written his impressions of *The Death of Sardanapalus,* Baudelaire died in his mother's arms. The agony of his life was over, and with it, the tug of opposites, of forces instrumental to his spiritual and visceral understanding of Delacroix's paintings and of his own creative process, which he voiced in varied and recurring threnodies as poet and critic.

> Je suis la plaie et le couteau! I am the wound and the knife!
> Je suis le soufflet et la joue! I am the slap and the cheek!
> Je suis les membres et la roue! I am the limbs and the wheel!
> Et la victime et le boureau! And the victim and the executioner![19]

3

The Goncourt Brothers:

Écriture-Sensation

The Goncourt brothers, Edmond (1822–1896) and Jules (1830–1870), wrote novels, plays, and history and art criticism; but interested though they were in the other genres, it was the appraisal of art that ultimately became for them a way of life. They lived through their appreciation of a particular painting, sculpture, a piece of porcelain or lacquer-ware. Each time the Goncourts reflected upon what they considered to be a great work of art, they embraced its contours with all their senses, and responded to it with profound pleasure. They cultivated these periods of heightened aesthetic excitement that enabled them to transpose the sensory impressions they experienced into verbal images which they were then able to integrate into their writings.

We might call this literary technique *écriture-sensation*; it was the hallmark of the Goncourts' works of criticism—of their monographs on Watteau, Chardin, Utamaro, and Hokusai among others—and it formed the basis for certain descriptive passages devoted to art in such novels as *Manette Salomon*. Rather than using their own term, *"écriture artiste,"* I have used the phrase *écriture-sensation* to describe the Goncourts' almost obsessive focus on the tactile aspect of the graphic and the plastic arts. The expression *écriture-artiste* points up the historical and literary aspects of their creative efforts which stemmed, in part, from their quasi-scientific training as naturalists. Their approach to criticism reflects, too, something of their sensibilities; they had a need to re-create for themselves a whole world of privileged moments in their *écriture-sensation* when form becomes touchable and the visual is transmuted into the sensual. It is also true that *écriture-sensation* may be considered psychologically, for it may well have been a means of sublimating their erotic impulses.

The Goncourts refused to expend their energies on what seemed to them to be an increasingly alien world; rather they husbanded these energies by

first interiorizing them, then letting them germinate in the realm of their imaginations. Finally they articulated the fruit of this process in their criticism.

Edmond and Jules de Goncourt were men whose outlook was shaped by aristocratic dreams of past grandeur. They looked with contempt upon the bourgeois entrepreneurs of their day, upon the rapid growth of industrialization which, they felt, was creating a breed of crass beings who valued money more than all else; they also viewed with hostility those they considered to be the ignorant masses agitating for a leveling down of society. Introverts, the Goncourts centered their interests upon what was closest to them; their writings, their well-being, and, above all, objets d'art that titillated their senses and flooded their beings with pleasure. The outer force—the work of art—acted as catalyst; it prepared them for the day or evening ahead, arousing in them those pleasurable emotions that made their existence worthwhile.

The Goncourt brothers lived in a world of appearances and dealt only superficially with intellectual concepts, aesthetic systems, and theories; but they were always fascinated by the evocative power of an artistic work and its impact upon their senses. Their own observed reaction was for them the barometer for measuring the greatness or inferiority of a given painting or piece of sculpture. Never did they delve deeply into the work of art, grapple with its ideas or forms, nor did they analyze its meaning, unless it related to their own needs and responses. What pleased them most, for example, in Watteau's canvases, were the "idealized landscapes"; these provoked reverie and evoked a kind of "surnaturalized" life.[1] It allowed them to escape from the humdrum present and savor the beauty and refinement of their favorite period in French history—the prerevolutionary eighteenth century. Their senses also fed on the work of the landscape painters of the Barbizon school in general, and of Théodore Rousseau in particular. His landscapes encouraged them to imagine that they were experiencing the fresh breezes, the cool aromatic odors of forested areas, and the fragrant scent of flowers. Rarely, if ever, did they directly wrestle with ideas, with aesthetic theory. Actually, the misogynist Goncourts were more art transmitters than critics. Their responses to form, color, composition, and texture were transmitted in glistening verbal contours, palpable images, and rhythms that might be either harsh or gentle. Their monographs provide a feast for the senses and are intoxicating for the emotions; they are less noteworthy, however, in their critical acuity.

Edmond and Jules de Goncourt's father, who had served as an officer in the

Napoleonic wars, died in 1830, the year of Jules's birth. Fortunately there was sufficient money to allow the brothers to have a good education. Upon graduation from the lycée, Edmond took up the study of law, then abandoned it in 1847 to accept a post with the Treasury. A year later, during the Revolution of 1848, Mme de Goncourt died. Edmond, eight years older than his brother, then became the head of the household; and as they were relatively well-to-do, Edmond and Jules were able to live a life of leisure, spending their time doing what they loved best—painting and writing. They had been introduced to the world of art by their aunt Nephtalie de Cour-mont, when they were still young boys. She used to invite them to her home and show them her many paintings and bibelots, which in time they came to love and admire, and the taste she fostered in their childhood now became a great part of their lives.

As the Goncourt brothers were well aware, the world was rapidly chang-ing. The Revolution of 1848 had ushered in the political possibilities of democracy, socialism, and theoretical, if not actual, communism. The Goncourts realized that the elegant and privileged society which they had known and loved was in the process of being destroyed. What would remain? Art alone, they reasoned, the creative element in man would withstand the drastic change. In keeping with the doctrine of their friend Théophile Gautier, they believed firmly in "Art for Art's Sake." Art, they were convinced, was to be cultivated by an élite, and regarded with veneration as if it were the object of a sacred rite.

Before settling down to their careers as men of letters, the brothers took a trip to Marseilles and then to Algiers. It was at this time (1849) that they first began noting down their thoughts, feelings, and reactions, and sketching certain scenes which they wanted to remember. In 1851 they started keeping what was to become their *Journal*, which they continued for the rest of their lives, combining in it history, biography, drama, and art criticism. In so doing, they captured for posterity an entire cultural period.

As time passed, the Goncourts, neither of whom ever married, withdrew more and more into their own refined world, developing habits of extreme order and refinement. Some scholars have labeled their psychological condi-tion neuro-pathological; in any case, their nervous systems were so delicately tuned that they became prey to all sorts of compulsive anxieties and obsessions. It is small wonder that such hypersensitive beings could describe minutiae in such an objective way, studying an art object with mathematical precision, flooding a page with verbal color effects, describing light phenom-

ena in a series of fitting epithets. The literary style they developed resulted from both a certain attitude toward life and a cerebral conditioning. Their strange linkage of adjectives and nouns, their use of neologisms and metonymies, allowed them to transform humdrum everyday experiences into a hauntingly alluring world. Using the technique of synesthesia, which Baudelaire and Gautier had practiced before them with great felicity, the Goncourts perfected their own stratagems; they followed the realists and naturalists of the period, whose success required close and accurate observation of both the organic and inorganic. Like the sensationalists—John Locke, Étienne de Condillac, and others—they believed that knowledge can be derived only from the senses and that it is the result of experience. In other words, knowledge is transformed sensation, and ideas are the result of the mental association of related sensations that are contiguous in time and space. Their *écriture-sensation* fused subjectivity with objectivity, remoteness with familiarity, detail with generalization, and rigorously accurate documentation with lingering afterimages. Their critiques of the art of eighteenth-century France and of Japan are a memorable and unique contribution to the art criticism of their time.

Eighteenth-Century Art: Effete Wistfulness

The Goncourts' volume, *Eighteenth-Century Art* (1875), is composed of their monographs on *Watteau* (1860), *Boucher* (1862), *Greuze* (1863), *Chardin* (1864), *Fragonard* (1865), and *La Tour* (1867). Calling themselves "historians of the past," their goal in this work was to foster interest in a period which they felt had been not only neglected but also denigrated. The Goncourt brothers were distressed when they learned that one of Watteau's great canvases, *The Embarkation for Cythera*, was being ridiculed by the all-powerful neoclassical school of painting. The French, they believed, should take pride in their national heritage and feel a sense of identification with so fruitful and glorious a past. Still earlier critics had "rehabilitated" the art of the eighteenth century, but it was the Goncourts who consolidated this effort and fostered an even greater interest in the period.[2]

No other work of the Goncourts conveys the sense of wistfulness and nostalgic regret that is found in *Eighteenth-Century Art;* it is as though the brothers had an emotional attachment to the past grandeur of the time. They might almost have belonged to the period dominated by idle aristocracy who reveled in the pleasures of the moment. In describing the work of Watteau,

Boucher, and Greuze, for example, they convey their reactions in taut, elliptical phrases, as if their nerves were continuously being stretched by their reactions to the ultra-refined tonal colors and the compositions of the canvases they were studying. Moreover, because they had studied painting—and had even made their reputations as watercolorists—they had a familiarity with technical details that enhanced their criticism. They were able to transliterate meaning from one medium to another and to measure in terms of language the subdued or brilliant lighting effects, smooth or jagged brush-strokes, and the delicate or heavy decorations which sometimes added to their critiques a three-dimensional or sculptured quality. Such verbal pyro-technics endowed their critiques with specific moods—languorous, provoca-tive, angry, or melancholy, for they were well able to adapt the written word to the specific tonal values under consideration. Hues and forms were solidified in their verbal abstractions, and under their pens language ex-panded, altered course, and embraced emotions and sensations which might otherwise have been explicated away in arid analyses. Moreover, their verbal skills invigorated and objectified their appreciations and injected them with the very breath of life.

JEAN-ANTOINE WATTEAU (1684–1721): THE WORLD OF DREAM

The Goncourts called Watteau "the great poet of the eighteenth-century," the finest of lyrical colorists.[3] His canvases, which feature fêtes champêtres, imaginary parks, graceful gatherings, and delicately meandering streams, evoked for the brothers a dreamlike atmosphere which drew them into an entrancing world of elegance and beauty. "A world, an entire universe of poetry and fantasy sprang up from his mind and filled his art with the subtlety of a supernatural life. A magic spell, a thousand magic spells, took wing from his imagination, from the humor of his art, from the absolute originality of his genius."[4]

Reacting as they did to "the smile of a contour, the soul of a form, the spiritual physiognomy of matter,"[5] the brothers felt themselves attuned to Watteau's idealized and receptive universe. Their personifications and me-tonymies capture the painter's moods and themes, which usually concern the subject of love, depicting it in a manner at once refined, capricious, and wistful.

When writing appreciations of The Embarkation for Cythera, Enchanted Island, Outdoor Reunion, Gilles, and The Indifferent One, the Goncourts gave

primacy to their sensory reactions and to the world of appearances. Watteau's enchanted garden parties held in the dusk, during those dimly lit hours when clouds hide the vibrancy of the real world, stirred the Goncourts' imaginations. Their literary talents enabled them to replicate in words the visual scene that moved them, and to suggest its physical and emotional ambience. By blending languorously sensual figures into undulating contours, painted with delicate colors and subtle overtones, they drew their readers into a realm where gentility and tenderness were vibrantly real. But the Goncourts also sensed Watteau's changeable moods, his restless nature, his frequently caustic ways, and his melancholia, due in part to his concern over his own ill health caused by the tuberculosis of which he was to die. They rendered these undercurrents in warm but also strong visualizations.

The Goncourts called Watteau's *The Embarkation for Cythera* a "marvel of marvels," and wrote:

> Look at this terrain, barely covered over with transparent and bronzed oil; this terrain tempered with rapid splashings, rubbed over with light brushings. Look at the green of the trees cut through with reddish tones, penetrated and ventilated by an airy aqueous autumnal light. Look at the furry material, the hood, set in relief against this delicate transparent mass of fatty oil, spread over

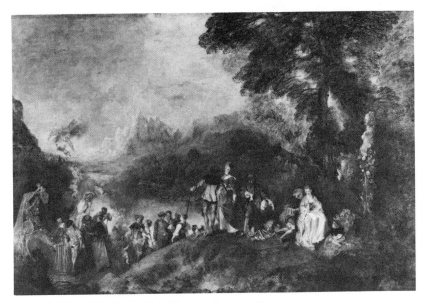

The Embarkation for Cythera by Watteau (Louvre, Paris)

a generally smooth canvas. Look at the thick paste used to delineate the small faces, their expressions buried in the recesses of an eye, their smiles buried in the recesses of a mouth. The brush's beautiful and flowing fluidity as it cuts out a neckline; and those areas where naked flesh exposes its rosy voluptuousness in the shade of the woods! The pretty intertwinings of the brush used to round out the nape of a neck! The beautifully undulating pleats with their soft breaking lines, reminiscent of those sculptor's tools used to cut into clay! And the wit and gallant touches Watteau's brush adds to everything it attacks: the frills, the chignons, the tips of the fingers! And the harmony of those sunny horizons, those mountains with their rosy snows, those greenery-reflecting waters; and also those rays of sun running along the rose dresses, the yellow dresses, the red-violet skirts, the blue capes, the dappled-gray vests, and the little white dogs with spots of flame! No painter was ever able to render, as Watteau has, such beautifully colored transfigurations bathed in the sun's rays—their soft palings shedding these diffused illuminations, these brilliant touches into full light. Focus your attention on this group of pilgrims crowding together under a setting sun, as they stand near the ship of love, ready to cast off: gaiety is infused with the most adorable earthly colorations as if a ray of sunlight had taken them unaware; and all the thick and tender silky hues in shining fluid tones make you think, involuntarily, of those brilliant insects that one finds dead, their color still alive, in the golden light of a piece of amber.[6]

In the above description, the brothers Goncourt were obviously impressed by the touch of wistful sadness that pervades Watteau's paintings: *The Embarkation for Cythera*—a setting sun marking the conclusion of a carefree day. It is nearly time to embark for the Island of Cythera to honor Venus, whose statue, garlanded with fresh roses, is seen in the picture. The terrain is outlined in fluid colorations, the Goncourts noted; the underbrush and trees are tinged with red and green; the air is cool and pure. The Goncourts' descriptions suggest an atmosphere of delicate abandon, of happiness blended with sadness—all amiable and civilized feelings, in keeping with the eighteenth-century's code of refinement. A lover kneels at the side of his lady, whispering to her, begging her to respond to his feelings; she seemingly feigns indifference, apparently fascinated by the design on her fan. Other couples are similarly depicted. A lady viewed from the back gives her hand to her beloved; the nape of her neck is bathed in those blond tonalities that Watteau knew so well how to achieve. As with the evanescent colors of the evening, time is fleeting; the day is drawing swiftly to a close. Colors seem to merge in the twilight; the heavy impasto with which Watteau has covered certain areas of the canvas enhances its secretive quality; the love relationship is presented as covert and mysteriously exciting.

The Goncourts' ability to articulate both the smooth and rugged textures in the painting, to replicate the various densities of Watteau's pigments, lends a strange flavor both to the figures themselves and to nature in general. The trees and shrubbery, the light and dark areas, each in its own way harmonizing with the entire vision, cut the viewer off from the workaday world, offering him a world which has a pensive, elusive quality. The uneven colorations used by Watteau, the Goncourts suggest, reveal the claylike nature of the soil; its dark, mossy sections form a fitting background for the gentle scenes and sensual spirit of the eighteenth-century beings involved. A kind of voluptuousness is caught in the hazy veil-like atmosphere that encircles some of the lovers, bathing them in a faltering light that suggests their own uncertainty about the promise of rapturous moments of delicious delight.

The Goncourts highlight in turn each section of *The Embarkation for Cythera*; they focus on the fluid brushstrokes that draw attention to ladies' dresses and the décolletage which glorifies the tones of their skin, and endow the entire scene with a quality of controlled passion. The Goncourts, always fascinated by texture, describe it in great detail: "undulating pleats" which lend a fluid as well as a statuesque quality to the figures; the ladies' hair, coiffed in a complex fashion, glistens in the light of the sunset. It is a scene with enigmatic nuances. The brothers marvel at Watteau's delineation of the ladies' dainty fans, shawls, and jewels, painted with remarkable authenticity of detail. Watteau himself kept costumes of all kinds in his home, and when he could, he persuaded friends to pose for him in them, so that he might paint not only with fidelity to style and period, but also in a natural manner. So, too, did the Goncourts introduce rich and opulent hues into their verbal canvases when describing the ladies frolicking about, drawing to themselves their gallant cavaliers. As some of the pilgrims make their way to the little boat adorned with flowers and red silk pennants, the Goncourts even describe the slow breezes waiting to waft the company on its way.

Watteau's canvases with their grace and lightness of touch, their accuracy of expression, and sustained mood of wistfulness, imposed themselves on the inner vision of the Goncourts. They suggested that specific segments of certain paintings seemed to participate in life. Watteau's mastery of shimmering light and his use of evanescent tones of rose and gold frequently give the impression that certain figures are divested of corporeality as fragile and almost translucent they, nevertheless, stand out against the landscape. Through their study of Watteau, the Goncourts experienced the sensation of

entering a land where even the ill and lonely can find solace, where fancy and playfulness rule the day, where musicians and actors entertain all participants in joyful communion.

Whether he paints actors in the Italian commedia dell'arte: Harlequin, the Doctor, Columbine, and Pierrot—or a figure in a Shakespearian mythical kingdom, Watteau veils his world in a nostalgic poetry of ambiguity that the Goncourts re-created with utmost sensitivity and understanding. Their appreciation of Watteau's canvases may well be defined as encounters among painter, author, and reader—each being nourished by the others.

JEAN-BAPTISTE CHARDIN (1699–1779): LIVING STILL LIFES

For the Goncourts, contemplating a Watteau canvas became a rite échappatoire that ushered them into a realm of grace and beauty. The very different tonalities of Chardin's paintings have nothing to do with fantasy and fairylike scenes; rather, they focus on domestic interiors and on still-life studies (French nature morte, literally "dead nature") considered, at the time, a secondary genre. Yet, these, too, possess a magic to which the Goncourts responded. "Never, perhaps, has the material fascination of painting been developed so far as by Chardin, who transfigured objects of no intrinsic interest by the sheer magic of their representation. . . . Who has expressed as he did the life of inanimate things? Like a ray of sunshine Chardin seems to enter the beautiful but somber little kitchen of Wilhelm Kalf. Beside Chardin's magic everything pales: Van Huysum with his herbals and dried flowers, de Heem with his airless fruit, Abraham Mignon with his poor, meager, cut-out, and metallic bouquets."[7]

Chardin went against the dictates of the French Academy when he refused to paint heroic historical scenes à la Poussin or like Boucher and Fragonard, to eternalize on vast canvases courtiers and nymphs at play. The son of a carpenter, a member of the lower bourgeoisie, Chardin commemorated in his paintings the life of his own people and that of the working class, the peasant, the domestic servant, and the poor. "Nothing is too humble for his brush," the Goncourts wrote. A domestic scene, such as The Blessing, which depicts a mother seeing to it that her two children recite their prayers with proper awe and respect; a still life delineating a bunch of grapes set on a table beside a Chinese porcelain vase; or a basket of fruit with two biscuits, a jar of olives next to them; or simply some leeks and carrots placed beside a few gleaming onions—all were fit subject matter for the painter.

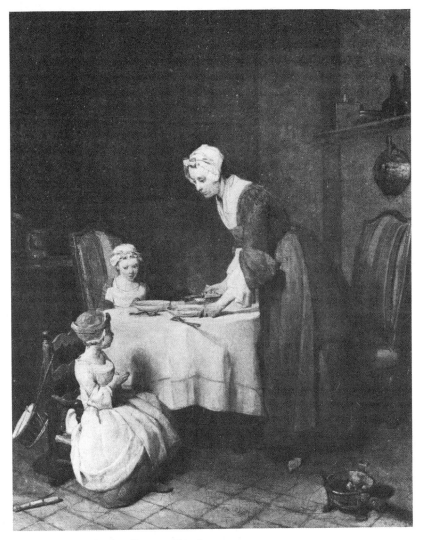

The Blessing by Chardin (Louvre, Paris)

Strangely enough, the effete Goncourts felt the reality with which Chardin infused his subjects and responded viscerally to his world. *The Morning Toilet,* for example, which portrays a mother putting the finishing touches on her little daughter's dress is simple in theme, but forceful in composition because the objects are individualized through color, form, and texture. *A Girl Peeling*

Vegetables has its own kind of beauty. In no way comparable to Watteau's figures basking in luxurious settings and idyllic countrysides, it still contains its own subjective excitement; a whole scene of active domesticity is presented within which, one senses, the girl's mind is filled with dreams and fantasies, always realistic, yet lending a certain enchantment to her otherwise drab existence. Chardin's inventive brushwork, his thinly daubed pigment, his subtle richness of color, his sure three-dimensional sense of form, all lend feelings of intimacy to his humble domestic scenes and still-life paintings as if the very objects he painted were vibrant with life. Even his portrayals of what the French in the eighteenth century termed *"les retours de chasse"* paintings of dead wild game—hares, pheasants, and other fowl—underscore his "solidity" and "truth" of vision, and display his abilities as an artist.[8]

As Chardin brought to life a whole new world of beings and objects, so, too, did the Goncourts invest their appreciation of his work with a similar vitality. Even when depicting Chardin's domestic utensils—whether they are made of fine silver or of base metal—they evoke a whole realm of associations ranging from the smooth and glistening objects found in wealthy bourgeois homes to the rugged and frequently primitive forks and spoons appropriate to the difficult and poverty-stricken life of the peasant. The broken tonalities and the complex and alternating light patterns, used by Chardin to paint distant objects, reverberate in the Goncourts' verbal discussions of the canvas, as if one artistic entity were reflecting the other, and in so doing, unifying form and feeling. The Goncourts poured life into their observations. One can almost see the kitchen they describe, experience its warmth, the aroma of vegetables cooking on the hearth, and the bread baking in the oven next to it. This is also true of a dining-room scene, with fruit set on the table, for the soft mat colors used in the latter give an aura of contained excitement. Awakening the appetite and giving a sense of zest for life, they write of the "transparency of the amber-white grapes, the frosted sugar of the plum, the humid crimson of the strawberries, the thick seed of muscat wine and its bluish mist, the wrinkles and verrucosenesses of the orange skin."[9] A shaft of light infiltrates the Goncourts' description, just as it does in Chardin's paintings, drawing the reader into the very essence of the objects described, activating each of his senses and flooding the atmosphere not with Watteau's sensuality or love but rather with a homey and secure serenity.

In describing the way light falls in *The Provider*, the Goncourts present a veritable symphony of whites in various chromatic overtones, and the world

of domesticity is evoked by the singularly moving unity of the figure taking front stage.

> Let us recall this bonnet, this white overblouse, this towel, this blue apron which reaches up to the neck, this scarf flecked with flowerlets, these rose-violet stockings, this woman who radiates, from shoes to bonnet, in a so-to-speak "creamy" white clarity; everything emerges from his [Chardin's] canvas victorious and harmonious, from the richly oiled contours to the wrinkled edges left by the brush's uneven markings, to the lumps of color due to a kind of pale crystallization. Light, tender, and laughing tones, as if cast all over, return continuously to the white overblouse, rose as if daylight were being interwoven into the vision, a hazy dapple-grey, a dusty heat, floating vapor enveloping this woman, her whole costume, the buffet, the crumbs on the buffet, the wall, the room behind in the back.[10]

The delicacy of the Goncourts' verbal transcription, as it draws each object together in controlled sequence, serves to delineate both figure and function. The adjectival phrases and epithets—the creamy white of the woman's apron and bonnet—set the mood of the canvas and place its subject in perspective as well. *The Provider* stands for the nurturing principle in life, a force without which neither human nor animal would exist. Everything about the feminine figure is radiant, bathed with unblemished light and purity. The textures of her apparel, as the Goncourts noted, are a composite of roughness and softness, and it is as if the very words themselves had been brushed onto paper in thin or thick impasto, in granulated scrapings, implying the economic and emotional stringencies with which the housewife must contend. The drawn and wrinkled edges setting off the bonnet and apron contrast with the rose-violet of the stockings, which assume an almost three-dimensional quality; they serve to enhance the strong and robust nature of the woman. The Goncourts animate the figures, giving the impression that she is ready to step out of the painting and speak to the viewer. The subtly variegated colors which are predominantly light and aerated, add to the warmth of the canvas, shedding a loving warmth all around—not passionate love but love imbued with understanding and the quiet acceptance of life. The positive feminine principle, which is featured in *The Provider*, nourishes and fructifies those with whom it comes in contact by diffusing feelings of relatedness and continuity. Even the background seems to envelop the woman in its embrace, pulling together form and color in a coherent whole.

In this picture, Chardin's tonal hues have, the Goncourts noted, a special

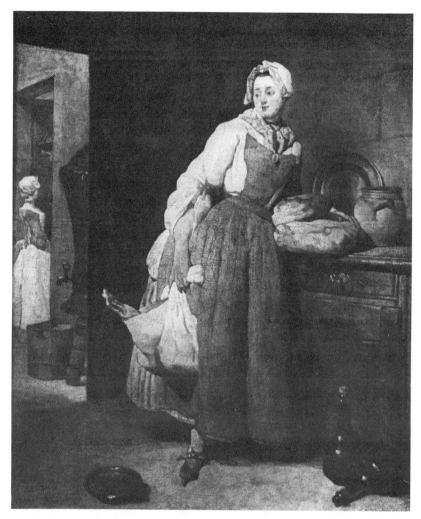

The Provider by Chardin (Louvre, Paris)

luster, as if the ray of light that shines directly on a pot or pan, on butter or
bread, on leek or carrot, absorbs the object endowing it with the very stuff of
life. The naturalistic subject matter, considered banal by other painters, takes
on a function of its own and operates as an external stimulus, energizing the
Goncourts' criticism and marking it with tones geared to arouse perceptual
and conceptual operations in the reader's mind.

The undramatic unfoldings that Chardin chose to paint represent light struggling against the invasion of darkness, joy and contentment overwhelming pain. "The secret and strength of Chardin, his grace, his rare and intimate poetry, rest in the stillness of things, their unity, harmony and serene light."[11]

Whether taking immediate notes on their reactions or relying on their memories, the Goncourts always grouped their responses, objectifying each item coming under their scrutiny, then fitting their sensory impressions into symmetrical patterns—as if piecing a puzzle together. Their verbal manipulations are dense and concentrated; and there is nothing unfinished about their appreciation of Chardin's work. Their method of *écriture-sensation* presents the reader with the literary equivalent of a banquet, a visual feast to be tasted, savored, and fully experienced.

Japanese Art: Exotic and Remote

Although the Goncourts claimed to have been the first to introduce *Japonisme* into France (see their novel *In 18 . . .* and their *Journal* entry, June 8, 1861), others also did much to foster an appreciation of things oriental. Félix Bracquemond, for example, the French engraver and friend of Degas, was so impressed with Hokusai's *Manga* (*Sketches*) when he first saw them in 1856 that he hastened to introduce them to his fellow artists.[12] In 1862, Mme Desoye, who had lived for many years in Japan, returned to Paris and opened *la Porte Chinoise*, a shop on the rue de Rivoli which featured fans, netsukes, prints, porcelains, figurines, silks, kimonos, and bronze lacquer-ware. Degas, Manet, Whistler, Baudelaire, Monet, and the Goncourts used to congregate at this exciting storehouse of Far Eastern treasure. With the opening of the Paris Universal Exhibition and the Japanese Pavilion in 1867, additional impetus was given to the new artistic trend. In fact, in Manet's *Emile Zola* (1868), there is a Japanese print hanging on the background wall alongside a sketch of Manet's *Olympia*.[13]

Japanese art, the Goncourts wrote, is fascinating and comparable "to a magic mirror"[14] which reflects and highlights subtle tonalities in multiple images. The oriental perspective, colorations, and general technique were vastly different from those used in the Western painting which the Goncourts knew so well.[15] The mountains, the huge waves, the landscape blending into the foggy horizon, the rounded and straight lines contouring certain objects, and the immobile, remote, and exotic figures inculcated in the brothers a

fresh set of values—a "new decorative system," and an innovative "poetic fantasy in the creation of the art object."[16] Their fascination for *Japonisme* also had its impact on the Goncourts' home in Auteuil which had already been filled with Western art objects and was now to become the repository for woodcuts, kakemonos, fousoukas, Satsuma bowls, jade, celadon, and lacquer-ware.

Japanese artists, the Goncourts remarked, were master observers; they drew precisely the essence of what they saw, be it a mushroom, a jellyfish, a leaf, or the sparkling plumes worn by a beautiful woman. "Their art copies nature, as Gothic art does," the Goncourts were to write in their *Journal.* After Jules's death, Edmond's fascination with Japanese art became even more compelling. He set out to write a complete study entitled *Japanese Art of the Eighteenth Century,* but he lived only long enough to complete his monographs on *Utamaro* (1891) and *Hokusai* (1896).

KITAGAWA UTAMARO (1753–1806): THE BEWITCHING WORLD OF THE COURTESAN

Utamaro's wood-block prints impressed Edmond de Goncourt deeply. The studied, stylized forms, the dignity and flowing delicacy with which the Japanese artist invested his figures, created a system of linear composition that Goncourt's eye followed with rapturous ease. An embroidered flower on a robe or obi, a leaf or petal, became a center of energy upon which he focused and which evoked for him certain mysterious, perhaps forbidden realms, arousing in him verbal images and a hierarchy of restrained emotions.

Utamaro became one of the great masters of wood-block printing in the 1790s. Concentrating on the upper part of the body and most specifically on the face, he idealized his feminine models, depicting them in the fewest possible lines, thus underscoring their facial delicacy. In Japan, where women were considered objects made for men's enjoyment, Utamaro was one of the few to focus on the feminine inner world. He saw beneath their masks of placidity, penetrating in the most subtle way their hearts' yearning for affection, and sounded feelings deeply buried in their unconscious by centuries of repression.

Utamaro, one of the masters of the Ukiyo-e school, depicted feminine entertainers: geishas, actresses, and prostitutes. He was not, however, the school's originator. That honor belongs to Torri Kiyonaga (1752–1815), who made woodblocks and prints of well-known courtesans in the most erotic of poses. One can understand the appeal that Ukiyo-e prints had for Goncourt:

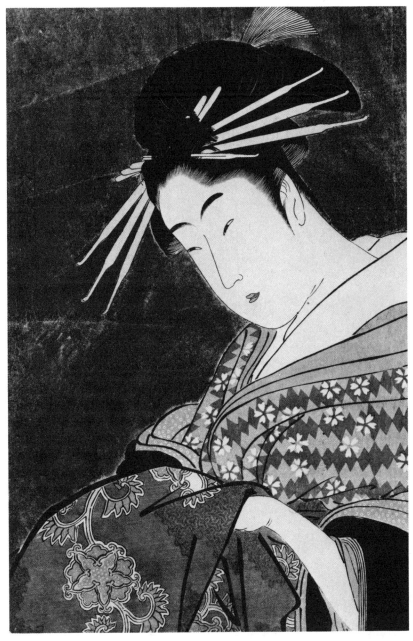

Courtesan by Utamaro (The Metropolitan Museum of Art, New York, The H. O. Havemeyer Collection, Bequest of Mrs. H. O. Havemeyer, 1929)

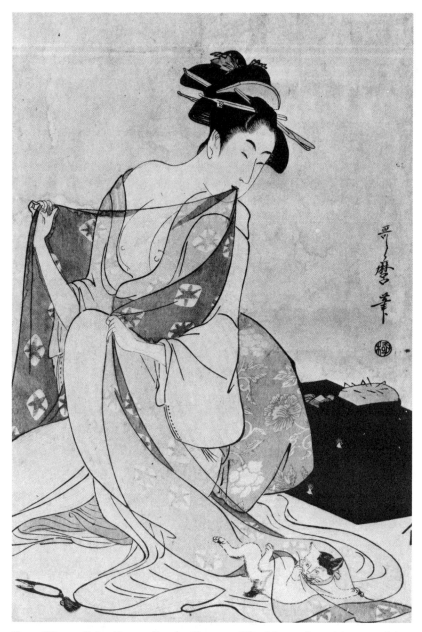

Young Woman Doing Dressmaking by Utamaro (The Metropolitan Museum of Art, New York, The H. O. Havemeyer Collection, Bequest of Mrs. H. O. Havemeyer, 1929)

their elegant lines and the contours of the women depicted, ensconced as they are either on cushions or affecting other, more delicate poses. He thrilled to Utamaro's palette, a symphony of vibrant and pastel hues: eggplant white shedding greenish overtones throughout the drawing, rose taking on the freshness of new-fallen snow, smooth and lustrous blue and peach tints, deep red-yellows, flaming primary-color tonalities.

Utamaro's *Morning Cleaning of a House of Prostitution at Year's End* draws the reader into the bewitching world of the courtesan in terms of color: "three different states of coloration: a first state, when the most delicate linear contours are grouped in faded tints, almost all variants of greenish and yellowish tones; a second state, when a kind of introduction, a soupçon of blues and violets is perceived; a third state comprised of natural colors, always harmonious, but in less distinguished polychromatic nuances."[17]

Edmond de Goncourt was particularly intrigued by Utamaro's genius for being able to transform the small, rounded, short, Japanese woman into a svelte, elegant being. Her face became long and oval, subtly alluring. No longer were her eyes reproduced in a conventional manner, "as slits with a dot in the center," nor was her mouth made to resemble a "shriveled flower petal." Utamaro created an exquisitely sensual, touchable woman; he humanized her by the magic of his brushstrokes. He was one of the first, Goncourt maintained, to endow the Japanese woman with "roguish grace, naive astonishment, spiritual understanding."[18] Less remote, less detached, some of his figures were delineated at times as shadows or silhouettes, but always rendered in subtle and dramatic fluctuations. The imbalance and asymmetrical quality evident in Utamaro's woodblocks—a characteristic of Japanese art in general—stirred Goncourt's sensory perceptions and intensified his vision. They provided a charge of energy that was channeled into his writings, increasing their evocative power by incorporating into them the thrill that comes with the discovery of a tantalizing new world.

The form and tonality of Utamaro's prints, Edmond de Goncourt suggested, are somehow associated with the "insect-like characters of the Japanese alphabet."[19] Each element joins with the other, bringing into existence a world of infinite analogies: behind the robe or mask—an illusion-studded covering—exists the collective, nonindividualized courtesan or geisha, the eternal feminine performing her obligations. Moreover, Goncourt rejoiced in the fact that the Japanese woman's trousseau consisted of twelve dresses for state or formal occasions, each one representing a specific month, each featuring a flower or tree—jasmine or bamboo, grape or weeping willow,

set in shimmering reds, "sky-blues," "honey-yellows," "tea-greens," and "peach-blossom pinks." Each area of the garments, whether embroidered or simply delineated in patterned sequences, is explored in Goncourt's verbal transcription in which he replicates a whole delicate network of flowing textures and designs, equally captivating to the sight and touch. Brooks, trees, mountains, seem to glow and vibrate in their diverse colors that herald fresh and new auditory equivalents—as if nature itself had become diffused in a shimmering force. Utamaro's vision divested Goncourt of a world embalmed in conventional drabness, and transported him into an enchanted sphere to which he willingly surrendered.

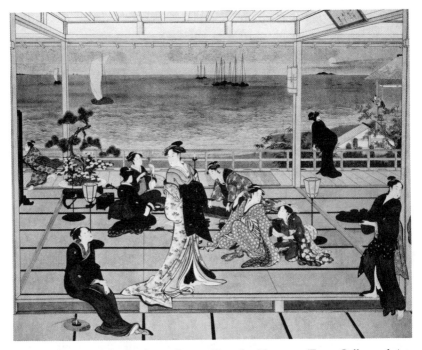

Detail from *Moonlight Revelry at Sagami Dozo* by Utamaro (Freer Gallery of Art, Washington, D.C.)

KATSUSHIKA HOKUSAI (1760–1849): THE GREAT WAVE

In the art of Katsushika Hokusai, Japanese wood-block printing with its gradations of color, its green treetops and pink peach and yellow flower petals, also found a great master. Goncourt was captivated by Hokusai's

Manga—sketches of weasels seated in a clump of bamboo or of a cat catching a mouse—and by his landscapes and Ukiyo-e paintings. Goncourt eternalized them also in his prose but in less florid language, in a more compact, matter-of-fact way than in his essay on Utamaro.

Hokusai, who adopted this name in 1791, had used as many as fifty different pseudonyms during the course of his career. He practiced many genres of painting: landscapes, interiors, greeting cards, and Ukiyo-e. His prodigious output numbered thirty thousand drawings. In writing about Hokusai's *Thirty-six Views of Mount Fuji: Southerly Wind and Fine Weather*, Goncourt takes us outside the home into the breezy, fresh atmosphere to experience the Japanese master's parallel picture plane, pulsating with visual gradations of rhythmic line. One of the first to liberate Japanese art from Chinese and Persian influences,[20] Hokusai felt relatively free to develop his own personal style, as well as to further his nation's original contribution to the arts. "Brick-colored Mt. Fuji, with its fissures of snow at the extremities of its peak, etched against an intensely blue sky lined with stratified white clouds, gives the impression of a beach—from which the sea has withdrawn. An impression of extreme originality emerges: the artist has the courage to depict what he saw in all of its implausible truth."[21]

The sequences of subtle patches of light and gray are re-created in Goncourt's description in which he reproduced in words Hokusai's economy of lines. His sumi brushstrokes are at times swift and delicate; in other instances, they are slow paced and deliberate. They captivated Goncourt, inspiring him to mirror in his verbal renditions the exotic quality and the controlled passion conveyed by the canvas.

More detached in his appreciation of Hokusai's prints than he had been with Utamaro's work, Goncourt listed the objects he saw in the drawings before him. Still impressions of grandeur and sacrality emerge, particularly when focusing on Hokusai's famous series *One Hundred Views of Mount Fuji*. He endows Mount Fuji with a transpersonal force which for the Japanese is as significant as Mount Kaf is for Muslims, Mount Sinai for Jews, or the Mount of Olives for Christians. Its sides portrayed in black ink and rich shades of gray and its peak buried in misty snows add to its mystery. Buddhist monasteries were built on the side of Mount Fuji, and monks ascending to them purified themselves on the way so as to be worthy of the rarefied atmosphere of the monasteries. A kind of numinosity, far removed from anything in his other writings, pervades Goncourt's description—as if nature itself had awakened something within him, powerful and all-consuming.

In Hokusai's *The Great Wave on Tokaido Road,* Goncourt identified with the gigantic forces of nature uncontrolled by man: "a slightly divinized sketch by a painter under the dominion of religious terror—of a frightening sea encircling his entire country; a sketch which leaves you with the impact of its irascible climb to heaven, the deep azure color of its transparent inner curvature, the shearing of its crest which dissipates itself into droplets of rain in the form of animal claws."[22]

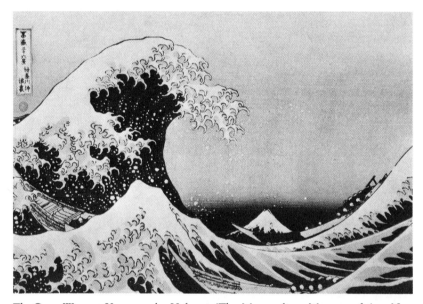

The Great Wave at Kanagawa by Hokusai (The Metropolitan Museum of Art, New York, The Howard Mansfield Collection, Rogers Fund, 1936)

Goncourt's verbal images cascade in rhythmic pattern with the energy of the huge wave that is about to break and dissipate into curls of foam. Fear and terror are implicit in this awesome vision, heightening its activity as well as the sense of imbalance it imparts. Hokusai's tidal wave is no ordinary wave, Goncourt points out. The artist's ability to penetrate and accentuate nature's own line through such an image is startling, almost frightening. The elder Goncourt was well aware of the symbolic meaning that water had for the Japanese and accordingly understood that it connoted the domain of the dragon. A yin force, it could purify as well as destroy. Delineated in magnificent curves, this cosmic power is coiled so that when it explodes,

depleting and drowning embankment and humankind, it becomes an exteriorization of cosmic rage. Something certainly seems to have been tearing at Goncourt when he depicted Hokusai's *Great Wave;* for him, too, a whole unfathomable dimension was unleashed in all its terrifying power.

Manette Salomon: The Writer's Palette

The setting of the Goncourts' novel *Manette Salomon* (1867) is the Paris of the painter, the sculptor, the creative artistic spirit, in the years between 1840 and 1855. What is important for us about this novel are the descriptive passages in which the authors' verbal colors shine forth in bold and in muted tones. Although the characters are of interest and the discussions concerning neoclassical, romantic, realistic, and naturalistic art highly informative, they are not our present concern. Singled out alone for scrutiny is the Goncourts' description of a panoramic view of Paris, of Middle Eastern coloration, of their delineation of the ideal model, and their conception of the Barbizon landscape.

PARIS

The opening scene of *Manette Salomon* features Anatole Bazoche, who might have been a successful painter but who, because he yielded to an undisciplined Bohemian life, never achieved his goal. We see him showing some tourists around Paris. It must be made clear that the Goncourts—Parisian through and through—knew the city incredibly well; every street, monument, cathedral, and neighborhood have been delineated with accuracy as well as with a painter's palette.

It is November, the beginning of winter. Dusk is enclosing the city in darkness. The many colors in the descriptions, the greens, rust browns, and a range of whites and grays invite the reader to gaze upon a seemingly unending view. Every segment of Paris may be contemplated at leisure; but the reader is also drawn behind the massive facades of the buildings to see what lies hidden beyond them. Vitality is generated, too, by the city's twinkling lights, which reflect their illumination through windows which, from a distance, seem like so many slits, each spelling out its drama in multichromatic overtones.

Between the tips of green, the curtain of green pines opened up areas of the great city which extended as far as the eye could see. In front of these stood closely knit roofs, their brown tiles creating a mass of tannish tones, the color

of grape rinds; detaching themselves were the rose-colored clay chimneys. These extensive tones, burnished hues, darkened and sank into blacks and reds as they made their way toward the quay. Blocks of white houses stood on the quay, with their little black slits of thousands of windows, taking on the forms and contours of barracks with their faded whiteness and yellowish cast; from the distance, really far away, embedded in the rustiness of the stone itself, an older construction became visible. Beyond this tidy and clear line, a kind of chaotic area seemed to lose itself in a night of slate, a jumble of roofs, thousands of roofs, with black pipes rising with the finesse of a needle, blending with the tips of the trees and tops of the houses—all enveloped in the obscurity of distance, blurred in the depth of the declining day.[23]

The Goncourts concentrate their vision on a misty and dismal land mass—on a city built in circular rows in unending stone construction. The green trees—active, fertile elements—introduce a sense of growth into an environment otherwise dominated by the gray stone of the granite facades. The roofs looming high above, with their brownish tiles like so many tannish grape skins, lend a headiness to the verbal canvas. Grapes, used for wine, are a gustatory delight, and like the trees introduce a living quality into the massive conglomeration of inorganic material. Rose-colored pottery chimneys lighten up the burnished browns, deep reds, and blacks, a somber and lugubrious tonal cast presaging the dismal and icy winter ahead, so that the physical climate replicates the bitter emotional drama about to ensue.

The whiteness of the houses, however, stands in sharp contrast to the sadness evoked by the drab tonalities of the panorama of the city. The white—as white as any Paris building can be—lends excitement, a sense of beauty to the scene; but in the setting sun, all takes on a yellowish tinge, like barracks, underscoring the regimented and aggressive nature of society. Some of the houses wear a patina of age, their rust colors reminiscent of an earlier Paris.

What is particularly arresting in this panorama of slate roofs, yellowed and white houses, and sculptured monuments, is the Goncourts' constant reference to stone: hard, unyielding, indicative perhaps of the unfeeling attitudes of the inhabitants of this metropolis toward their counterparts. So likewise are the stone facades of the buildings, screening people from each other, allowing distance and remoteness—qualities so dear to the Goncourts—to dominate. Nowhere in this dispassionate description of Paris is a vibrant note subsumed, a heartbeat reached or probed. No identification is experienced, no rapprochement with a cathedral's spire or dome, or with any of Paris's domiciles. An evanescent mood does emerge, however, in the fluidity

paradigmed in the masses of clouds brushed onto the Goncourts' verbal canvas; these are cotton configurations vanishing and reemerging, infinitely small, yet enormously large. Even the twinkling lights take on a transpersonal power as they pour forth their shafts of light like so many distant constellations—or like humankind, all struggling, fighting, then burning themselves out. Shadows crowd in at dusk to dominate the scene; vapors arise from every corner of the metropolis, a mushrooming mist that seems to envelop the city in its embrace.

MIDDLE EASTERN TONAL COLOR

In sharp contrast to the somber blue-gray tones that the Goncourts used in describing the oncoming Paris night is their portrayal of the world of Naz de Coriolis, the protagonist. A talented young artist, he is seen in his studio on the rue Vaugirard. He yearns to create a painting filled with chalky-colored plains, opalescent sea, indigo and coral mountains in order to capture the exact flavor of the Middle East, which he experienced during his travels in Turkey and Asia Minor. The colors would not, as the Goncourts wrote, be either "brutal" or "fauve"; to use such brash hues would be vulgar and banal. His colors would be soaked in sunlight, in "nuanced, vaporous, volatilized, subtle" hues, in "tender blond"[24] colorations, each sparkling like finely cut crystals, yet layered, giving an impression of weight, of substance, underscoring their three-dimensional quality. The nude, the center of focus, would be painted in the most exquisite of flesh tones, thereby enhancing her beauty and feline sensuality.

The Goncourts' verbal replication of Coriolis's vision not only brings to life a world of enchantment but also accustoms the reader's eye to the most flamboyant tonalities: the whiteness of iridescent pearls, the gleaming multicolored precious stones which seem to diffuse their light like so many sparks of fire until their flamelike tonalities "eat everything up," and the jaspers and carnelians glistening like mosaics. The Middle East described by the Goncourts is warm in tone, sparking not only the canvas Coriolis has in mind but the events to come.

He started painting the nude in a setting where he could endow the greatness of the human body with power. The set featured a Turkish Bath. A woman as if bent in half was seated on the sweaty stone of the steam bath, on the gleaming granite; she seemed to be emerging from a cloud of spray, soapsuds cast at her by a seminude negress; her hips tightly draped in a brilliantly colored *foutah*. The

seated bather faced front. She was gracefully put together and round like a disc; she took on the contours of a C—crescent moon. Her two hands were raised, crossed in her hair; the tips of her elevated arms looked like an arch, a crown. Her head, bent, lowered softly, a little bit of shadow shone on her raised neck. [25]

The Goncourts piled high their epithets, adjectives, personifications, and symbols in describing the flawless canvas conceived by Naz de Coriolis. The figure of the woman in the painting, *The Turkish Bath*, emerges in all her sensuality and beauty, exuding vagueness and mystery, but there is a deadness to her features and an emptiness in her gaze. Although the woman in the picture seems to be enjoying her languorous state, the clouds of steam billowing forth in vaporous transparencies, and the warmth and heat enveloping her body, Coriolis destroyed the picture after its completion because he felt he had failed to bring it to life.

That the Goncourts should have used the image of the crescent moon in portraying this woman is not surprising. From as far back as there are records, divinities such as Isis, Artemis, and the Virgin Mary have been associated with that celestial body. Birth, death, and renewal, the biological rhythms of waxing and waning, are all part of our image of the eternal feminine. Ancient peoples thought that the moon's strange behavior, evident in its appearances and disappearances in the heavens above, its entire cyclical system—the seasonal fertility that alternately leads to growth and aridity—was the feminine province. The moon also has its dark, chthonian side, representing woman's sinister and death-dealing power. As a cold satellite, lighted only by the rays of the vanished sun, the moon is often equated with indirect knowledge and sensation. Its light reverberating as a reflection symbolizes a shadowy and irrational sphere. As opposed to yang, the moon is yin, the dark passive feminine principle; beautiful from a distance, calm in attitude, but also emerging at times as a deadly, devouring force.

The exquisite jewel-like body on Coriolis's canvas radiated flamboyant colorations that intensified the reader's optical sensations and triggered excitement. The figure was a woman's, to be sure, intellectually created, and had no bearing on the reality of life nor the blood of passion. The clarity and exactitude with which the Goncourts described this exquisite form, her enamel-like flesh, so pure in color and cast, so classical in line, give the impression of an immaculately elegant figure. The zones of light that set off the dark areas in the canvas are delineated not brashly or abrasively, but in subtle nuances; nevertheless, they deadened the work. The transluscent colors juxtaposed with flat and opaque shades, interspersed with relatively

swarthy tones, seemed saturated by the Middle Eastern sun, yellow sand, and general golden brilliance. They stimulate the viewer's sight, but the woman in question remained merely a gesture, a fixed entity—a phantasmagoria.

MANETTE SALOMON: THE IDEAL MODEL

Coriolis spent six months haunting the streets, ateliers, and cafés in search of a perfect model before he found her in Manette Salomon. Like a fine figurine, soft and smooth, real yet unreal, touchable but remote, each aspect of her physical self was resplendent in its beauty and youth. She evoked for him that rare sensation for which he had been searching to produce in his new canvas, *The Turkish Bath*.

As depicted by the Goncourt brothers, Manette's beauty radiates from her skin tone; her beauty is measured by its elegance and elasticity; "Nature is a great and unequal artist; it creates arms, legs, torsos, and heads but sometimes puts them together hastily and thoughtlessly," even banally, as if blending *prima materia* for no reason at all, "without purpose, design, genius." There are times, however, when genius does come to the fore; then nature apparently molds its beings in exquisite proportions, endowing them with "polished," smooth, pastel flesh tones—finishing its work "with love, with pride." As the Goncourts remarked, Manette emerges from "the artistic hands of Nature" in all perfection.[26]

In describing Manette disrobing before the painter, the Goncourts reproduce not only her every gesture but also her expressions as they change while she reveals her body. Beginning rapidly, continuing haltingly, she proceeds with masterly pride in her role as artist's model; suddenly shame is reflected in her gestures and facial contours; embarrassment grips her but soon disappears when she takes note of her exquisite body—looking at herself with a kind of "love," her eyes caressing her every fold, sinew, crevice. Regal in manner, Manette is now ready to be re-created by the artist.

Organizing space as the Goncourts did when presenting a scene, they methodically and logically draw Manette standing still in her pose, her very immobility encouraging Coriolis to observe her well, authentically, impersonally, never in a prurient way but always with the goal of transferring his vision onto canvas. And the days passed in this manner until Coriolis's painting begins to take on "the radiance of a masterpiece" (p. 128). What is most impressive in the Goncourts' transcription of the scene described above is that of Coriolis's reaction to Manette's body.

Coriolis had not yet seen such young and full form; and slim and serpentine elegance, such a finely delicate breed—still very much of a woman; yet the fragility and thinness of her wrists and ankles were like those of a child. For a moment he forgot himself and was dazzled by this woman; her flesh, darkish, dull as it absorbed the clarity, the whiteness, that warm southern whiteness which effaces the mother-of-pearl whiteness of western lands; those sun-drenched flesh colorations when light seems to die as it disappears in the halftones of tea rose and amber shadings.

His eyes were lost on such fine colorations: areas so tenderly cast, so varied, so nuanced, that many painters express and believe they can idealize with their banal and flat rose colors. He embraced these fugitive transparencies, these tendernesses, these lukewarm colors—hardly colors at all—these imperceptible impressions of blue and nearly insensible greens, these delicious areas of the woman's epidermis, that one could say were made from the part beneath a dove's wing, the interior of white roses, the dull blue-green transparencies of water flowing over a body. Slowly the artist studied the rounded arms, the reddening elbows as they rose forth. (P. 185)

As the Goncourts reproduce in words the figure of Manette, we visualize the volume and mass of her body and her flesh alive with excitement and resiliency. As the light "splashed" up and down her body, shimmering like a "divine flame" as it enveloped her in its play, encircling her completely, the Goncourts suggest that even Correggio's extraordinary painting *Antiope* "pales" by comparison. Manette's soft and silky-textured skin seems to undulate in "milky diaphanous" tones, awakening a whole world of illusions, enticing the sense of touch as well as that of sight. The shaded areas appeal by their mystery, drawing the viewer or reader into darker, tawny beige regions. The Goncourts' verbal brushstrokes blend and atomize color, dispensing rose amber, petal white, peach yellow, flamboyant glowing tones, throughout the description, at first in shafts of dim light and then taking on strange hypnotic luminosities.

Never before, the Goncourts suggest, has an artist injected such lifelike characteristics into form with the sweep of his brush. Rarely, we may add, have such evanescent tones been captured in writing. Coarse and fine, ribbed and smooth, skin textures are allotted their tonal impress as the Goncourts, artists themselves, seem to move their fingers verbally over Manette's flesh, pressuring the surface, transmitting the physical sensation by their linguistic skill. Unlike the nudes of Greek and Roman sculptors for whom the Goncourts felt so little affinity, considering them cold and remote, they re-create Manette's physical form with feeling, thus triggering tactile, olfactory, and auditory impressions.

That the Goncourts identified Manette with the element of water endows her with a sort of extra femininity. The source of life, a purifying and regenerative force, is the *fons et origo* of existence itself, because without it life cannot come into being nor pursue its course. Manette, in time, becomes for Coriolis the source of life. She is his water element, that nonformal essence that takes on consistency and fixity in his mind's eye. When he first met her, she represented the virtual, the germ, the as yet unfinished entity, then she became a living part of his imagination, an emblem, a symbol, a collective force. Later, however, this anima figure will no longer be based on objectivity, kept at a distance, and studied solely on an aesthetic level. Nor will she nourish, feed, and immerse him in the transpersonal sphere where the great creative artist belongs. As their relationship grew closer, particularly after the birth of their child, this fluid water principle stagnated, brought psychological disease, and their life together became mephitic and destructive. As Coriolis slowly became aware of her growing dominion over him, his inherently weak moral fiber yielded to her and he became her victim. For the misogynist Goncourts, this opaline beauty circumscribes the artist; she dulls, and befouls the air he breathes, and so ends his career.

THE BARBIZON SCHOOL: DIPPING INTO NATURE

Barbizon, a village in the forest of Fontainebleau, became the residence of a group of landscape painters who rejected the rigid and restrictive atmosphere of the academic art world and sought to paint directly and simply from nature. An artist's colony grew around Théodore Rousseau, Jean François Millet, Diaz de la Peña, Charles Daubigny, to mention but a handful of the sixty artists who lived there from 1830 to 1870. The Goncourts admired the Barbizon artists; Millet's canvas *The Gleaners;* Rousseau's *Oaks,* Diaz's *Edge of a Forest.* When they visited Barbizon, prior to their writing of *Manette Salomon,* they went to see Millet, watched him plant, rake, dig on his patch of land, immerse his hands in the dark rich soil. Fastidious in their ways, the Goncourts would never themselves touch earth, to do so would mean they would be dealing directly with life—with the substance of reality. It was not their way. Life was approached through the domain of art.

When depicting Coriolis's trip to Fontainebleau, the Goncourts, inspired by the natural surroundings, jotted down everything they oberved; nature's extreme diversity, its eruptive qualities, and its munificence. The picture they draw of Coriolis in this forest environment acts not only as a backdrop for his altering feelings, but also as a disturbing element for the reader. As the

Goncourts filled their description with rapid yet delicate strokes, intensifying a line here, relaxing it there, and, in so doing, underscored feeling, they achieved a powerful dramatic effect.

> Coriolis spent days in the forest, without painting, without drawing, allowing sketches to form unconsciously, the kind of floating sketches which the painter's memory and palette fix later on the canvas.
>
> A feeling—an almost religious feeling seized him each time he reached the bas-Bréau Avenue after a fifteen-minute walk; he felt as if he were standing in front of one of Nature's great majesties. And he always remained there for several minutes—experiencing a kind of rapturous respect—a moving silence of the soul—as he faced this entrance, this alley, this triumphant door, with its trees arched high in rows of superb columns, their immense greenery redolent with the joy of daylight. At the end of the winding alley, he looked at the magnificent stately oak trees, as old as the gods themselves, the solemnity of these monuments, beautiful, bearing that sacred beauty of centuries, emerging as if from some stunted grass, a forest of crushed ferns robbed of their height.
>
> The radiant spectacle, the happiness of the light on the leaves, this summery nimbus encapsulating the trees, this brisk air flowing over the temple, the cordial aromas, the odor of health and the fresh breath of woods, the gravity and tenderness of solitude's caressing ways, enveloped Coriolis. (P. 239)

As Coriolis enters the thickly forested area just beyond the small hamlet of Barbizon and stares at the trees, the shrubs, and earth, feelings of awe overcome him. He sees himself as entering a sacred grove, an area where nature's power reverberates, making itself known to man and beast. Coriolis looks at the grasses around him, at the flowers, the pearly white, the pink, the yellow, and the dark violet. The stream that runs through the forest can be heard in every area. Suddenly all quiets into silence. Moments later, Coriolis hears the forest noises, the leaves crackling and rustling underfoot as if "smothering" and "strangling" life itself, or flailing it into form. Such violence, the Goncourts impress upon the reader, is indicative of the protagonist's subliminal feelings of rage at his own weakness.

The dexterity of the Goncourts' compositional architecture allows the reader to follow Coriolis every step of the way in his wandering in the forest, in search perhaps of some very special unknown adventure. Like an awakening giant, the forest seems imbued with the breath of life, and the Goncourts, using their verbal dexterity, evoke an ambience of freshness and coolness, as if air were filling the lungs, breezes cleansing the cheeks and softly caressing them. Coriolis's entire being seems filled with youthful vigor as he savors deeply this day. Suddenly he comes upon overgrown fields where

nature grows wild and where chaos takes over, mirroring perhaps his own unchanneled impulses, disordered feelings, and confused emotional state. One is led to believe that Coriolis has lost his way, not so much in the forest as in his own being. A sorting of his inner feelings is imperative if he is to pursue his course as an artist.

Coriolis leaves the forest but only momentarily; when he does so, the sun begins to beat down upon him; the darkened groves and trembling shadows recede. As if isolated in space, Coriolis stands there, then pursues his walk as transparencies "zigzag" about him, leaving their zebra-striped lines fluctuating in fiery array. Soon flaming "emerald" tonalities explode. A panoply of visual modulations appears: greens and yellows blend in analogies and personifications. The verbal virtuosity of the Goncourts endows the atmosphere with throbbing vibrations, echoing Coriolis's own impulses. A flock of birds flies overhead, their gentle song soothes his own inflamed emotions.

The Goncourts approach the natural world with a certain innocence and faith, but they never really penetrate their subject. They cultivate certain lines and contours as musicians cultivate a specific melody: a grove of trees as it cuts the horizon spatially, filling the bottom half with a dark mass and gleaming opaque areas, while the sky above is empty. The Goncourts fuse the outer and the inner landscape; their colorations and verbal line drawings are reminiscent of the seventeenth-century Dutch masters—Ruisdael, Cuyp, Hobbema—who were, in actuality, also influences on the Barbizon painters. The sky flames again as the sun beats down on Coriolis; it glows and intensifies. Nature's every aspect becomes visible, indicating symbolically the necessity for consciousness to prevail, so that Coriolis can sort out his darkened emotions which had been brought to the fore by the tenebrous world of the forest.

Two domains are at stake, two ways in life: the clearing and the forest, the light and the dark, fertility and aridity—two visions that the Goncourts delineate through one sweeping device—the walk. The Fontainebleau episode is decisive for Coriolis; it represents a turning point in his career as artist and in his life as man. When he returns to Paris, much to the surprise of his friends, he does not embark on painting a great new canvas. The period in which his work as an artist won him recognition is now drawing to a close. The forest acted upon him as a kind of rite of passage; but he failed to pass it successfully. Discipline, heroism, courage, sacrifice—the mainstays of the real artist—will henceforth for Coriolis yield to the safeties and comforts of bourgeois life.

Art for the Goncourts was both a way of life and a refuge from life, a means of stilling their frequent feelings of "despondency, the blackest, deepest, most intense despondency." These periods, they acknowledged, also brought them a sense of "bitter, raging satisfaction,"[27] which they cultivated, perhaps unconsciously, pouring their emotions into their critical and creative literary works. In this they experienced the full impact of their proclivity for the erotic. They also made plain that being swiftly sated they were forever on the prowl for the new, for what would stimulate that rare and exquisite response which they could then transmute into their own *écriture-sensation.* It was there that real life resided for them—in the erotic, ever-fluctuating, pulsating word.

4

Huysmans:

The Catalytic Eye

Vates, voyant, voyeur—Joris-Karl Huysmans (1848–1907) was all of these. He absorbed and made his own the life he drew from the texture, color, and form of the canvases he chose to explicate. From his youth Huysmans immersed himself in the world of art, for it offered him some semblance of contentment and a sense of relatedness. These qualities were especially important because his childhood had been far from happy. His father's long illness and early death, his mother's remarriage to a Protestant, which the boy considered a betrayal to his father's memory, and then the birth of his half sisters—all these increased his sense of neglect and the rancor he felt against his mother. After passing his baccalaureate, Huysmans accepted a position at the Ministry of Interior. This time, which might have been one of contentment, was marred when he took a mistress who later gave birth to another man's child. It was during this period of bleak desolation that, under the mentorship of Zola, Huysmans found a great creative outlet in writing.

His novels, for the most part, are morose. For example, in *Setting Up House*, his view of humanity is bitter, and life itself he sees as absurd. This novel is more of a psychological analysis than—as one would expect from a naturalist—a study of the effect of environment upon his characters. Huysmans, however, eventually broke with the naturalists because he believed that in placing great emphasis on the importance of environment, they were neglecting the psychological aspect of life. In *Down There* he developed his own method of expression which he called "spiritual naturalism."

As time passed, Huysmans became increasingly introverted. He was always a difficult person, and as the years increased so too did his shortness of temper, his nervousness, and his disgust with things of the flesh, all of which served to alienate him more and more from society. At odds with his own time, Huysmans believed both that mankind had made no progress since

ancient times and that humanity had lost contact with nature, and now, being incapable of true spiritual belief, was totally devoid of depth and understanding. Huysmans, himself, had become exceedingly devout, and even spent a short time with the Trappist monks. This is reflected in his last works, On Route, The Cathedral, and The Oblate all of which deal with his search for holiness and his need for penitence. Even in this period of his extreme spirituality, however, he experienced depression and a continuous sense of a demonic force within him—a force which questioned, doubted, and disturbed.

Huysmans's sight—the most powerful of his senses—was the means by which he was enabled to transform signs, glyphs, kanji, and perspectives into verbal pictures. His visual memory appears to have been such that an afterimage could stir his senses and emotions until that image was transformed into a structured work of art. This power and sensitivity was what made Huysmans's art criticism unique; it was at the same time a study of the work of art and a reflection of his own inner drama that was being enacted on the deep and shadowy psychic level.

The eye, a hollow sphere, is, symbolically, not only a mirror in which the outer world is reflected, but also a repository of the events and feelings of a person's life. This is so because sensations and memories lie dormant in this archaic sphere that can pick up portents within the space-time continuum. It is also an observing consciousness in that it illuminates what lies in darkness, renders finite what exists in the infinite, and evaluates by distinguishing what is sharply immediate from the cloudy depths of the psyche.

Like the eye of the archetypal Father who sees his creatures wherever they may be, Huysmans's eye measured, estimated, evaluated, and probed whatever canvas was before him for information. Clairvoyant though it was, Huysmans's eye was also Promethean and solar. It perceived all in one detailed yet all-encompassing visualization. Art criticism answered a need in Huysmans. It enabled him to fill with an intensity and passion the void left by his loveless childhood.

Huysmans may well be called an expressionist before his time. His art criticism is subjective to the point that his feelings and his egocentric reactions determine, for the most part, his value of a painting. Unlike the impressionists who sought to create a world of beauty and harmony, the expressionists—and this is true of Huysmans—distorted what they saw to correspond to the fears and terrors that they experienced so powerfully in the secret places of their psyches. In keeping with this expressionistic credo,

Huysmans's reactions to paintings were not passive; on the contrary, they were active, aggressive, and hostile experiences. As he was provoked by what he saw, so he sought to provoke the readers of his criticism. In so doing, he experienced a new world opening for him and for them. This world which he brought into being spoke to him, but perhaps this was not always so for his readers.

Huysmans's photopic (his ability to see in bright light) and scotopic (his ability to see in the dark) sight aroused inner vibrations that dilated the forms he saw and troubled and disoriented his psyche. Whatever the signs or symbols, his vision was forever evoking clusters of ambivalent feelings and sense impressions in which monstrous and beatific configurations coalesced. Paintings, like nightmares, were torturing experiences for Huysmans, for they brought him terror as well as ecstasy.

Like the alchemist who transmuted metal in crucibles and alembics, Huysmans, with the aid of his catalytic vision, projected his yearnings, fantasies, and hatreds onto the canvas before him, and, in so doing, altered both form and reality and interjected his terrors. In Huysmans's art criticism, his approach brought him to the transpersonal realm where an emerging psychic power grew in force and strength. To be meaningful for Huysmans a painting had to bring into his frame of vision something that was hitherto unknown. Often enough this meant an encounter with a subject that amplified and distorted his own inner vision, and consequently caused him lacerating pain. Only then would his repressed instinctual world acquire concrete form and dimension.

In Huysmans's *Salons*, collected and published under the title *Modern Art* (1883), *Certains* (1889), and *Three Churches and Three Primitives* (1905), as well as in his novels such as *Against the Grain* (1884) and *Down There* (1891), he attacked academic painters in violent terms. As far as Huysmans was concerned, a painting could not be considered art unless it spoke of and to a psychic reality. A true work of art, he contended, must reach into those profound depths of being, must lay bare these spheres so that an inner radiance may be apprehended. Huysmans did not just describe a painting anymore than did Baudelaire, the Goncourts, or Gautier. What he discovered was the vision that lay behind the figurative representation: a world of audible silences, secretive and darkened forms where one treads with fear and caution. When he assimilated a painting with his mind's eye, Huysmans discovered its meaning, and experienced its sensate quality. Details were de rigueur in his art and so was the depiction of color tones and their emotional

equivalents, rhythms, and harmonies. Huysmans's catalytic eye allowed him
to leap beyond the surface reality and to penetrate directly into the inner
levels of being. His eye apprehended, then, a new sphere, where everything
flowed, oscillated, and vibrated—impelling the reader to follow Huysmans's
own circular trajectory through the canvas he was describing.

His criticism created new concepts, fresh ways of experiencing works of
art, for it articulated a subjective inner climate. A painting became a
projection of Huysmans's own emotions: the turbulent masses structured in
sharp contours within the formalized image set off chaotic responses within
him, angering, distressing, even alienating him at times, or paving the way
for his experience of the *numinosum*. To Huysmans, a great painting was a
presence speaking out its message in spellbinding terms: a black orb, dispens-
ing evil or beauty, love or hatred; it was a sphere of influence that mesmerized
the viewer.

Although he was fascinated by the works of such artists as Goya, Manet,
Renoir, Forain, Rops, Pissarro, and Degas, as well as many others, I have
singled out for discussion the *Isenheim Altarpiece* by Mathias Grünewald
(1480–1530) because it expresses most powerfully certain unconscious com-
ponents within Huysmans's psyche, and it also reveals to the reader the
archetypal reality it held for painter and critic alike.

Huysmans was aware of what might be considered Grünewald's limitations
as an artist. He stated categorically that the German artist did not possess the
variety of a Bosch or of a Brueghel.[1] Yet, it was Grünewald's *Crucifixion* that
arrested his attention. He expressed his feelings about this canvas in a
conversation with his friend Gustave Coquiot.

> Well! it is eloquent enough? It surpasses by far all of Leonardo's paintings. It
> lives and is new in another way! We're tired of the Jesuses painted to look like
> little old men, and of those sebaceous Virgins, flabbier than pigs' bladders. I'll
> certainly have to say these things in detail one day; because it's annoying and
> exhausting in the end, to always hear the same platitudes and imbecilic
> opinions about art—rehashed over and over again. Ah! if only the art clic as a
> whole knew Grünewald! But no! those people are such cretins![2]

Grünewald's *Isenheim Altarpiece*, a polyptych composed of nine panels
portraying Christ at various stages of his life, was commissioned by Guido
Guersi, the Sicilian director of the Isenheim monastery in Alsace, which, in
the thirteenth and fourteenth centuries, had been a Dominican convent
consecrated to Saint John the Baptist. It was "the most extraordinary place

Christ ever inhabited," wrote Huysmans. It was here that the nuns were all saints, and Jesus lived in the soul of all communicants; mysticism, the visionary and supernatural, ecstasy, and miracles were a way of life.[3]

That a hospital, specializing in such diseases as the plague, leprosy, and syphilis, adjoined the monastery is important to our story, for the Grünewald altarpiece was created to answer a definite need in the postulant. "When a sufferer was brought in, he was first led to the altar and prayers for his miraculous healing were said."[4]

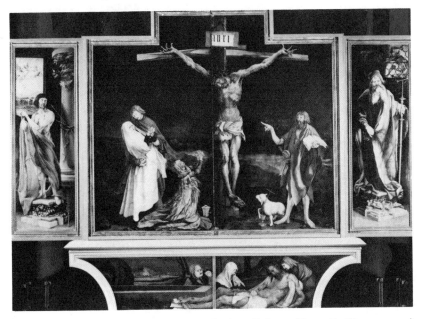

Crucifixion by Grünewald (Musée d'Unterlinden, Colmar, Photo O. Zimmermann)

Both in *Three Churches and Three Primitives* and in *Down There*, Huysmans has described in detail his first encounter with Grünewald's polyptych and with the *Crucifixion*, one of the panels he singled out for particular scrutiny. Huysmans's style was lapidary: carved, cut, hammered, sculpted, with smooth or rough surfaces as the feelings and image warranted. It was as if Huysmans's words were themselves expanding and erupting as he wrote them down. As he depicted the flesh of the dismembered Christ, bloodied, bruised, Huysmans's eye brushed the torso, the face of the God-man before him. Something strange happened to Huysmans as he entered the ancient

cloister which had been abandoned for centuries. When he walked toward the altar of this quiet and remote religious edifice, his eyes were riveted to a "ferocious" depiction of the crucified Christ. This "giant" form, so shockingly out of proportion to the other figures portrayed on the panel (to the left, John the Evangelist, the Virgin Mary, and Mary Magdalene; to the right, John the Baptist), may be considered both a paradigm of the disfigurement and imbalance that existed between the spirit and flesh, the divine and the earthly, in sixteenth-century Europe and within Huysmans's own psyche.

Huysmans's gaze rested on the crown of thorns encircling Christ's head; the sharp nails had punctured the flesh; a darkened spot of coagulated blood resonated in a variety of hues. As Huysmans's eyes absorbed the image, a tidal wave of emotion was unleashed within him. He needed several minutes, he noted, before he could regain his composure. He then commented on the "brutality" of the traits with which Grünewald had endowed his subject, on the "quivering flabbiness of the mouth." No longer was Christ presented with the beautiful form seen in a painting by Raphael, Fra Angelico, or Piero della Francesca. Grünewald's vision of Christ pulsated with humanity and inhumanity: he was depicted as "a sad thief placed on the gibbet";[5] a man with whom the sick and suffering could identify—a diseased, deformed, misshapen, blemished body—a mirror image of themselves.

This lacerated corpse upon which Huysmans commented is comparable, writes the English art critic, Herbert Read, to Otto Dix's canvas War (1929–1932) which depicts the dead and decaying soldiers caught in a tangle of barbed wire. Like Dix, Huysmans saw the truth—his truth—which transcended the world of reality and bit into the emotion—the raw nerve—itself.[6]

Huysmans, fastening his eyes on this mutilated Christ, forced himself to study form and pigmentation, to spiritualize line and color, and, in so doing, to fix the fluid, concretize the amorphous, and thus enable himself to create in words a new state of being. His unconscious and conscious reactions to the materialization sparked clusters of harrowing sensations within him. Grünewald's incredibly realistic "exactitude," Huysmans suggested, was extreme, even delineating "the halo of inflamed flesh which develops around the small wounds,"[7] and which the Renaissance painter had observed in the sick and dying who came to the hospital.

Huysmans's inclusions of contemporary medical opinion concerning the visual experience are interesting. Dr. Richet, while examining Grünewald's

Crucifixion as a scientist, noted that the care taken in setting down details, including the redness surrounding the small punctures, is monomaniacal and characteristic of syphilitics. Dr. Charcot, the director of the Salpêtrière Hospital in Paris and a man who is noted for his work with hysterics, also remarked on Grünewald's obsession with line, fold, and coloration. Not only may it have been a sign of syphilis, he suggested, but also leprosy. Dr. Charcot also contended that over-sensitivity to color was characteristic of hysterics and the result of an atrophy of certain nervous fibers in the eye.[8] Even the textures of the fabrics in the painting (the loincloth covering Christ, the other garments in colors ranging from red to ocher) are depicted in virtually microscopic detail: the threads, fibers, folds, and opacities showing the physical form of the clothed people. The inanimate thereby acquires a life of its own, becoming an active force that plays a vital role in the harrowing drama.

For Grünewald, this ghastly, livid crucified Christ represents the collective agony of suffering humanity; for Huysmans, it reflected his own indescribable emotional torment. In fact, after viewing the canvas, Huysmans went out for a breath of air, to look at the surroundings, but perhaps also to calm himself. He walked around the small cloister with its gothic arcades, chiseled forms, and red earth, a region "saturated with iron oxide," he wrote. Certainly this earth must have inspired some of Grünewald's multiple hues: the lusterless oranges, the flat and thin ochers, the faded, washed-out tones "similar to the sludge of slaughterhouses"; the flamboyant reds were like "pools of blood." That Huysmans should have used the word "slaughterhouse" in such a context, fusing the animal and human, instinct and spirit, indicated an attempt on his part to unify the disparate, profane the sacred, humanize the divine, mortalize the immortal. The division he felt so acutely between flesh and spirit—as did many Christians—tore at him and accounts to a great extent for the viscosity of his depictions, the excitement injected in his verbal color tones, that emerges as if from a gaping wound—his own.[9]

Grünewald was not "a painter of mangers, but of tombs," Huysmans wrote.[10] It was the agonizing Christ upon which he focused, the Christ of the early Church Fathers: Tertullian, for example, and saints such as Cyprian, Cyril, and Justin. Martyrdom was rendered that much more powerful by Grünewald's use of a technique Rembrandt was to favor; as Huysmans notes, "the light which focuses on his face mirrors the inner struggle." This light is not fixed; it moves, accelerates or slackens, depending upon how one looks at

the face, the angle, the illumination; even at times "softening and enobling the traits by vaporizing them in a cloud of gold,"[11] as in Grünewald's painting of *The Nativity.*

For Huysmans, Grünewald's *Crucifixion* replicated an indescribable emotional torment which he amplifies in *Down There.*

> Christ rose before him, formidable, on a rude cross of barky wood, the arm an untrimmed branch bending like a bow under the weight of the body.
>
> This branch seemed about to spring back and mercifully hurl afar from our cruel, sinful world the suffering flesh held to earth by the enormous spike piercing the feet. Dislocated, almost ripped out of their sockets, the arms of the Christ seemed trammelled by the knotty cords of the straining muscles. The laboured tendons of the armpits seemed ready to snap. The fingers, wide apart, were contorted in an arrested gesture in which were supplication and reproach but also benediction. The trembling thighs were greasy with sweat. The ribs were like staves, or like the bars of a cage, the flesh, swollen, blue, mottled with flea-bites, specked as with pin-pricks by spines broken off from the rods of the scourging and now festering beneath the skin where they had penetrated.
>
> Purulence was at hand. The fluvial wound in the side dripped thickly, inundating the thigh with blood that was congealed mulberry juice. Milky pus, which yet was somewhat reddish, something like the colour of grey Moselle, oozed from the chest and ran down over the abdomen and the loin cloth. The knees had been forced together and the torulae touched, but the lower legs were held wide apart, though the feet were placed one on top of the other. These, beginning to putrefy, were turning green beneath a river of blood. Spongy and blistered, they were horrible, the flesh tumefied, swollen over the head of the spike, and the gripping toes, with the horny blue nails, contradicted the imploring gesture of the hands, turning that benediction into a curse; and as the hands pointed heavenward, so the feet seemed to cling to the earth, to that ocher ground, ferruginous like the purple soil of Thuringia.
>
> Above this eruptive cadaver, the head, tumultuous, enormous, encircled by a disordered crown of thorns, hung down lifeless. One lackluster eye half opened as a shudder of terror or of sorrow traversed the expiring figure. The face was furrowed, the brow seamed, the cheeks blanched; all the drooping features wept, while the mouth, unnerved, its underjaw racked by tetanic contractions, laughed atrociously.[12]

Huysmans stared unflinchingly into the panel. There, he discovered "a river of sadness"—death permeating the blackness that lay beyond the enormous crucified form. The figure, hanging in its agony in the foreground, underscored man's capacity for cruelty. The backdrop of night, which, to Huysmans's catalytic eye, became the *prima materia,* a chaotic mass of as yet

unlived, untried feelings and forms, engulfed and then illuminated the figure of Christ as he hung in protracted anguish.

When Huysmans compared the "tragic cries," the heightened colorations, and the violence of Grünewald's *Crucifixion* with the canvases of some of his contemporaries, theirs seemed pallid and uninteresting. Unique among artists, Grünewald had nothing in common with Cranach, Dürer, Altdorfer or any of the German primitives. Huysmans resorts to contrast in order to explicate and clarify Grünewald's artistry. He mentions, for example, the "anemic" paintings of Saint-Severin, the creator of *Life of Saint Ursula*, whose reputation was solid, but whose work did not speak to him. Perhaps Hans Baldung-Grien's name may be mentioned in the same breath as Grünewald's: although a visionary in his own right and known for the architecture of his compositions and the manner in which he powders his landscapes and skies, his paintings lack the spellbinding and "delirious fire" of Grünewald's. They are masterful, yet they do not possess "the grimness of his [Grünewald's] mystical naturalism, nor his grandeur." Yet, they are important.[13]

Huysmans's critique of Grünewald's *Crucifixion* is so subjective that it may be likened to a laceration. It is corrosive because it mirrors his own abrasive, surly temperament. For Huysmans, as for Grünewald, and all those who looked at this giant, mutilated body, there was solace "at the thought that this God, whom they supplicated, had also undergone their tortures and had also been incarnated in as repulsive a form as they; and so they felt less disinherited and less vile." Huysmans, too, projected upon the canvas and was troubled, moved, and catalyzed by it. Unlike the Crucifixions of Holbein, Dürer, and Cranach, who depicted a sublime Christ, Grünewald's related "to the deformed, despairing, and the monks through the suffering members of the Christ."[14]

Why did Huysmans react so powerfully to this particular panel when there were eight others? As the sick in Grünewald's time responded to the scourged Christ on canvas, so Huysmans, as we have already pointed out, also identified with this alienated divinity who had been mutilated and flagellated by the collective power of his day. This encounter triggered energy centers within Huysmans, which at first overwhelmed him, making it impossible for him to note down a lucid first appraisal. What were these mysterious factors within Huysmans's subliminal realm that accounted for his reaction? What he saw was not the past classical ideals of heroism, strength, power, fortitude,

and victory, but rather those of another archetype, elevated in Christianity: the endurance of anguish, pain, and suffering. The greater the agony, the more likely the Christian believer was to find salvation through an *imitatio Christi*. Huysmans was deeply touched.

The contorted and lacerated body with its bruised and discolored flesh was depicted as a hideously suffering mass: near death and riddled with gaping holes, pustules where the redness of the skin revealed infection, the green-gray of the physical body near decay, the swollen feet and rigid toes and fingers—the entire image expressing *agònia*. Such a dismemberment (a superimposition of the Osiris and Orphic mysteries in earlier civilizations), indicates that a concomitant process was going on within Huysmans's own unconscious: his former conscious outlook was being broken up so that a new understanding of his own temporal condition might emerge and he could achieve a different sort of adaptation to the outside world.

Still, Huysmans adhered to certain aspects of the naturalistic credo with which he had felt so at home when under Zola's influence. His assessment of Grünewald's painting, for example, is documented and factual. He is, in fact, delineating a "slice of life" when he includes so many details; his nonidealized description is the fruit of his keen observations. Unlike the naturalists, who prided themselves on their detachment, Huysmans's views are subjective, pessimistic, and revolve around his deepening disillusionment toward life.

Huysmans's visions of Grünewald's canvas took on a hallucinatory power of their own. We are reminded of des Esseintes's brilliant and tormented chimeras when he had typhoid fever, his nights filled with burning and searing terror. So, too, was the effect of Christ's crucified form on Huysmans. As the writer's eye penetrated the layers of paint, the nuances of color tone, the abnormal body before him grew increasingly menacing. He saw what the expressionists were to see in the following century: art that answered a need for the supernatural and an appetite for phantasms, for the sinister, the freakish, the grotesque. Having broken with the naturalists, whose works Huysmans considered to be limited because of their dogged adherence not only to Taine's principle of race, milieu, and moment, but also to Zola's so-called scientific and experimental method, Huysmans skirted the domain of the ancient *mystai*—the acolyte prepared for the onset of the living mystery. A contemplative at heart, Huysmans, like Durtal in *Down There* and des Esseintes in *Against the Grain*, went beyond the exterior world, and transcended social situations and institutions in his art criticisms. Unlike the naturalists who stressed hypotheses and observation, Huysmans underscored

both the "why" of phenomena as well as the "how." Observation searched out procedures; it is, to be sure, the basis of all experimental sciences, but Huysmans knew that there was something beyond a body of laws and principles, a body of verities and realities. It was just this unattainable sphere that he revealed concretely and viscerally to his reader. It was his own unique contribution to art criticism.

It is no wonder that Huysmans noted with some surprise that while he was observing Grünewald's painting that he felt something unleashed within him, engulfing him in a whirlwind force. He used the word "typhoon" to describe it, as if an immense wind had come his way and dismantled, disoriented, and disturbed him. Wind, we may recall, refers in metaphysical terminology to *pneuma* and *ruach:* that spiritualized condition when God breathed a living soul into Adam (Gen. 2:7). A *mysterium tremendum* had virtually overcome Huysmans: the mortal sphere was annihilated; that is, his conscious or rational frame of reference as experienced in a world of contingencies had been obliterated. In its stead, the mystical domain opened to him; a virtual epiphany had come into being and the nature of God was shown to him. C. G. Jung has suggested that psychologically Christ is, for the Christian, a vision of the self: and when such images take over, the observer loses his sense of individuality; his relationship with the known and conscious world vanishes; his ego is drowned in the swirling waters of the collective unconscious and is replaced by a sense of the ineffable, the omnipotent, and the eternal. Viewed in this way, it is not surprising that Huysmans should have been gripped by a sense of overwhelming awe. Not only did the *Crucifixion* with its nailed and wounded body represent a harrowing archetype of pain and scourging, reflecting Huysmans's own inner geography, but also it caused a momentary eclipse of his rational powers—an overcoming of the ego by the self.

Huysmans viewed the polarities expressed in Grünewald's *Crucifixion* in Gnostic terms: as a battle between good and evil. Evil, he felt, was very much on the march in time—a time which he considered ugly, sordid, mediocre, and materialistic. He had lost faith in the credo of naturalism and positivism with their objective of a scientific attitude toward life. Isolated from the security of prevailing values, unable to find an answer to his own inner chaos, Huysmans felt set adrift, dissociated from his own time and his contemporaries. What had once seemed right was no longer so. What had previously been looked upon as good now seemed evil. Lonely and pessimistic, Huysmans experienced life as an almost constant torture.

Grünewald's painting of a God hung "suspended" on the Cross portrayed
to Huysmans the savagery implicit in humanity, its capacity to violate and
victimize. It seemed to speak to a man alienated from himself and his culture,
a man in conflict with himself and his times. This same Christ, interestingly
enough, had been rejected when it was later offered for sale to emperors and
kings throughout Europe. They were unwilling to face "the ugliness of the
crucified Messiah," symbolizing "all the sins in the universe."[15]

Huysmans was among the first to appreciate Grünewald's polyptych. While
such a critic as Jacob Burckhardt looked down upon this sixteenth-century
masterpiece, considering it far inferior to the works of Dürer, Cranach, and
Holbein, Huysmans's catalytic eye was held spellbound by it. The directors of
both the Kaiser Friederich Museum in Berlin and the Germanic Museum in
Nüremberg remained unimpressed with Grünewald's great work and refused
to buy it when it came up for sale; but the young expressionists, Max
Beckmann and Oskar Kokoschka, among others, understood the implications
involved in the Isenheim Altarpiece.[16] Ugliness, torture, pain, and flagellation
replicated the zeitgeist that was to give birth to two world wars. It concretized
a spiritual condition in which the infection of horror and pain spread
throughout the world. An expressionist ahead of his time, Huysmans's
catalytic eye recognized, gripped, and captured these invisible and inchoate
forces. It impounded mystery and sacralized the profane, giving material form
to the shadowy, shifting, terrifying world of the unknown that the vates alone
can grasp.

5

Henry James:

Portraiture and
Anima in *The Ambassadors*

"There is no greater work of art than a great portrait," wrote Henry James (1843–1916), and his novel *The Ambassadors* attests to the truth of his statement.[1] Portraiture as a literary device enabled James to express not only his own aesthetic taste but also his own psychological needs and predilections. James's extraordinary visual memory, his literary ability, and his verbal skill allowed him to transmute inner experiences into outward forms, and thus to create vivid portraits of his characters. The eye for James was an instrument of the brain. With his characteristic verbal intellectualizations, he constructed images so vivid that they brought to life for his readers identifiable persons, places, and things.

That Henry James was deeply involved in the world of visual art is not surprising. American born, he had spent much of his youth traveling in Europe where he, with his parents, brothers, and sister, visited museums and art galleries in England, France, and Italy. Art for James represented a cultural canon. It permitted him to relate to a variety of periods; it stood for continuity and permanence, a way of fixing memories, recording sensations, and revealing a chain of past and present experiences.

Having as a young man briefly studied painting with William Morris Hunt, James had acquired a knowledge of the painter's vocabulary and some technical skill. From his friend John La Farge, he also absorbed an appreciation of the structure and discipline inherent in painting. Prior to this, James had seen the works of the Pre-Raphaelite painters and also been impressed by Millais's *Blind Girl* and Holman Hunt's *Scapegoat;* he later developed an attachment for the landscapes of the Barbizon school, singling out particularly the works of Daubigny, Rousseau, and the now nearly forgotten Lambinet, one of whose paintings is described in *The Ambassadors*. James was also very much drawn to the art of the Italian Renaissance: Fra Angelico,

Leonardo da Vinci, Titian, Veronese. One of his favorites was Tintoretto, whose canvases held a lifelong fascination for him. He admired them for their harmony of elements, their use of light, color, form, and composition.[2]

James's critiques on art, some of which were published during his lifetime (*Picture and Text* and *The Painter's Eye*), do not purport to be profound philosophical or aesthetic assessments, nor are they works of art in and of themselves, as was true, for example, of *The Salons* of Baudelaire. Nevertheless, what gives his criticism its importance is that he discusses in detail pictures by such important contemporary painters as John Singer Sargent, Daumier, Burne-Jones, Delacroix, and Whistler; and in so doing, he captures certain qualities and inner rhythms, a whole interlocking chain of intricate relationships and emotional overtones. He also coordinates what might otherwise seem disparate elements in a painting. Delineating background and foreground in one vision, he evaluates images in depth and movement, outside of the space-time continuum, setting each, so to speak, on its own easel and distanced from its surroundings.

James's views on the art of portraiture as they appear in *The Ambassadors* are useful to determine his handling of the painter's techniques to delineate character and to heighten atmosphere. Furthermore, the portraits of women singled out by James for scrutiny may be considered anima images: projections of his unconscious attitude toward the feminine principle. These, too, will be explored for the light they shed on James's protagonists.

The verbal portraits that James created in *The Ambassadors* are in a sense encounters and detached materializations that both emanated from and fed his intellectual and introverted nature. James thus used portraiture as a literary device that enabled him to concentrate on the creatures of his imagination and to express their secret worlds. This approach also allowed James to relate his characters one to the other and encouraged him to discover a whole new dimension as artist and creator.

Portraiture in the visual arts dates back to ancient Egypt (4000 B.C.), when a likeness of the deceased was placed in the mummy case so as to fix the semblance of the person for eternity. In ancient Greece, where there was a less confirmed belief in immortality, relatively few portraits are extant. In Rome, on the other hand, likenesses were used in family rituals and funerary ceremonies, and there was a flourishing development in pictorial arts. Early medieval Christianity, noted for its denigration of the material world, looked down upon portraiture so that the practice of painting virtually ceased to exist. Not until the Renaissance, when a sense of the importance of the

individual personality revived, did portraiture again thrive. Life-size like-
nesses of emperors, popes, and kings decorated the walls of public and private
buildings. The countenances of well-known people appear in Veronese's
Marriage Feast at Cana, in Botticelli's *Mars and Venus*, and in a number of
works by Titian, Tintoretto, and Holbein. The seventeenth, eighteenth, and
nineteenth centuries saw a continued fostering of the art of portraiture in the
works of Goya, Ingres, Gainsborough, Raeburn, Romney, David, Boucher,
Winterhalter, Gérard, Degas, Renoir, and Cézanne, among many others.
The universality of portraits, which discloses a need for permanence, a desire
to retain the memory of a living physical presence and thus to prolong the
person's earthly life, encourages observation and direct vision. Like a mirror,
the portrait reveals, to those who know how to read it, the character of its
subject. When identified with the Latin word for mirror, *speculum*, such an
image reflects and encourages speculation.

The portraits of two characters preoccupy us in *The Ambassadors;* Mme de
Vionnet and her daughter. Both are anima figures, and both are instrumental
in the psychological evolution of James's central character, Lambert Strether.
As defined by C. G. Jung, the anima is a man's "inner woman," the
repository of unconscious attitudes toward the feminine principle. Anima
figures, which have been depicted in art and literature since time immemo-
rial, range from the virgin to the harlot. Always, however, they stand for
eros, for love, and for relatedness. As an eros image, the anima figure
establishes the feeling relationships among the characters in James's novel—
which are often described in terms of taste (bitter or sweet) or of color (white,
red, black, golden). As was the case for James, a man who has difficulty
relating to a woman in the conscious sphere may project his anima on the
imaginary beings of his own devising. In so doing, he may succeed in
connecting or discovering links between his own abstract verbal portraits and
the real woman in his life.

Anima portraiture in *The Ambassadors* is a magical instrument that not
only guided James in his intellectual reflections but also permitted him to
reveal, in subtle and symbolic form, his own repressed instincts and feelings.
Mme de Vionnet, for example, is many-sided. She impresses her personality
upon those surrounding her in a variety of ways: she is the *femme du monde,*
femme inspiratrice, a shadowy, dangerous, mysterious woman, and prototypal
mother. In the process of personifying the various aspects of the feminine
principle, she serves as a filter for Strether's feelings; she measures and
clarifies ambiguous relationships, veils motivations and sensations. She

creates magic through her eyes, her smile, her gestures, her stance, and the color tones James used in describing her. Her daughter, Jeanne, plays the role of the virgin, the as yet unformed untouchable feminine being. Both mother and daughter are each in her own way expressions of James's personal vision, and of his aesthetic, social, and psychological values with all their moral qualifications and diversities.

The Ambassadors focuses on fifty-five-year-old Strether, a widower from Woollett, Massachusetts; a man with a New England—and for James, this meant narrow—outlook on life. Mrs. Newsome, also from the same town, is a wealthy widow. She and Strether are considering marriage, but before marrying him, she asks Strether to go to Paris and persuade her twenty-eight-year-old son, Chad, who has lingered there far too long, to return home, so that he may take over the family business and marry the young lady of whom his mother approves. Strether lands in England and then proceeds to Paris where Chad introduces him to the exquisite and deeply understanding Mme de Vionnet. Strether finds the situation to be quite the reverse of what he initially supposes—Chad is in love with her and not with Jeanne, her seventeen-year-old daughter, the conventionally innocent jeune fille. Mystery surrounds these two feminine principles and as the story progresses, the reader realizes that Strether finds considerable ambiguity not only in Chad's situation, but in his own.

Irritated by Strether's delay in concluding his mission, Mrs. Newsome dispatches to Paris her daughter, her son-in-law, and her son-in-law's sister, who is the girl whom she hopes that Chad will one day marry. Their attempts to persuade Chad to leave are to no avail and they depart for home frustrated. When Strether finally discovers that it is Mme de Vionnet who is the object of Chad's passion and understands the depth of the young man's relationship with her, and richness of their life together, in contrast to his own limited experience, he encourages Chad to remain with Mme de Vionnet in Paris, while he himself returns to Woollett.

All the portraits of the characters in The Ambassadors are seen only through Strether's eyes; his is the central consciousness, the suprapersonal authority. It is his eye that sees, his retina that transmits external stimuli, thus arousing sensation and memory which are then translated into the word. In so doing, Strether singles out characters, depicts situations, conveys impressions, records the sequences of events, while at the same time seeking out clues that will reveal the mystery surrounding the situations—the mother-daughter complex. It is through his understanding, his impressions of

people and places that the reader formulates his (or her) own vision. These portraits, then, as filtered through Strether and projected into the narrative at appropriate moments, determine the relationships between the characters. Interestingly enough, James's portraits of Mme de Vionnet and her daughter are rarely complete; they shed an oblique light on the situations singled out for scrutiny in such a way that the reader can better understand Strether's progressive alteration in his point of view. Because the anima figures are not clearly delineated and exist only through a detail, a glimpse, a tonal modulation, a nuance in a given scene, James succeeded in increasing the ambiguity and interest surrounding them.

A kind of fixity, nevertheless, remains in most of James's verbal portraits. Perhaps he felt that in halting motion and change, time also could be stilled and immobilized. At heart, James was a traditionalist, a classicist who conceived of art and life in terms of abiding permanence. Opposed to stream of consciousness or impressionism, which endorses the Heraclitean dicta of flux and transience, James clung to the idea of a cultivated moral world, attempting in this way to retain what he considered the best in Western civilization. For the most part—and until the very end of *The Ambassadors*—he banished the fugitive world of altering phenomena by framing and fixing form through word, image, and idea.[3]

Such a set attitude toward portraiture represents, psychologically, a quasi unproductive inner condition, an inability to adapt to the changes inherent in life itself. James's dislike of change may perhaps have been a reaction to his peregrinations as a child and adolescent. On the other hand, European civilization, during his travels in his youth and later on in his life, seems to have been a refuge for him, providing him with a much-needed security. In fact, in 1875, James decided to live in Europe permanently; first in Paris, and then a year later in England, where he eventually became a British citizen.

Mme de Vionnet: The Eternal Feminine

The character of Mme de Vionnet is defined in a series of successive portraits. Each is a part of Strether's educational European experience. Her avatars are depicted in what might be called chain reactions; that is, through association and clarification via form, color, and line. Like Ariadne's thread, each of these verbal portraits takes the reader more deeply into the dark, hidden area of the psyche, where he can examine the various currents and

tensions, sound out the affective climate, and be drawn to probe still further the mystery and complexity of the characters. Strether, the central consciousness, who sees and reports is, in Jungian terms, the ego. His are the elements on which to concentrate, for it is his delineations that hold the key to a better understanding of the personalities involved.

As an anima figure, Mme de Vionnet is a psychic factor, a generative force; she is the raison d'être for Strether's own stand. As a fantasy figure, she personifies the unconscious contents within Strether's—or James's—collective unconscious, an aspect of the male's emotional and instinctive inner being. She is an abstract principle in that she comes alive through the word; a kind of psychic presence that hovers over all the scenes, a light-bringer who causes Strether's growth and development. For Chad, however, Mme de Vionnet is very much made of flesh and blood; she is a loving, caring woman, in the true sense of the word—neither cold nor detached, and certainly not puritanical—as Mrs. Newsome, his mother, has always been.

Mme de Vionnet in her role as anima figure is part of the nonpersonal, archetypal, dimension; nevertheless, she is imprisoned in Strether's consciousness as his subtle, selective, discriminatory frame of reference. Strether conceives of her originally as a "dreadful woman"; so James writes in his *Notebooks.*[4] Paradoxically, he portrays her as a nearly angelic figure, an exquisite, romantic ideal, a woman whose world is wholly centered upon the good. Both views coalesce in Strether's first sight of her.

THE GARDEN

When Strether first sees her, Mme de Vionnet is standing on the steps leading to the garden. Moments later, he notices that she bears an "air of youth"; and when he first talks to her, he remarks that she is charming in speech, though her choice of words, accent, and intonation seem a bit odd. "She was dressed in black, but in black that struck him as light and transparent; she was exceedingly fair, and, though she was as markedly slim, her face had a roundness, with eyes far apart and a little strange. Her smile was natural and dim; her hat not extravagant; he had only perhaps a sense of the clink, beneath her fine black sleeves, of more gold bracelets and bangles than he had ever seen a lady wear."[5]

Strether's reactions to Mme de Vionnet are expressed in the disciplined lines of a classical painter or sculptor. Whether standing alone or set against a background—a garden in this case—Mme de Vionnet is endowed with

certain qualities reminiscent of the portraits of the neoclassical Jacques Louis David. A painter who searched for beauty of form and style, David infused a kind of stationary fixed quality into his figures, a stiffening and severity of form. In his depictions of Mme Seriziat and Mme Récamier (despite the latter's languorous pose), the immobility of face and body endows these women with a haunting quality reminiscent of the great statuaries of classical antiquity. They also have the aloofness of those ideal creatures so admired by sculptors of all ages because of their perfection of form, their almost inhumanly detached beauty. Unlike the romantic painters—Delacroix, for example, who allowed energy, emotion, and movement to flow forth unimpeded—David channeled such feelings. James's portrait of Mme de Vionnet is in some ways analogous with John Singer Sargent's portrait of Miss Burckhardt (1882), which so impressed James that he wrote: "The face is young, candid and peculiar. Out of these few elements the artist has constructed a picture which it is impossible to forget, of which the most striking characteristic is its simplicity and yet which overflows with perfection." Sargent's figure, dressed in black satin, "glows with life," James remarked, with "the beauty and finesse of a personality superbly rendered, of noble countenance, but also inhabiting a darkened realm, questionable as to motivations, mysterious in its infinite dimension."[6]

Strether's description of Mme de Vionnet may be likened to a draining off of James's own emotions into identifiable and traditional paths, and a discharging of his energy in appealing images. In the picture language of the psyche, form, line, depth, and rhythm are important to be sure; but so is color, for it is color that carries emotional overtones. Therefore, it is interesting to note that color plays little part in this first description of Mme de Vionnet.

The transparent blackness of Mme de Vionnet's dress does, however, reveal her shape; it also contributes to creating the psychological atmosphere. Black, representing both negative and positive qualities, weighs heavily in the specific image. Let us recall that prior to Strether's meeting Mme de Vionnet he had harbored preconceived notions concerning that "dreadful woman." He thought of her as sensual, evil, witchlike; she was, he imagined, a *shadow* being, an ominous force which, if not checked, could lead to Chad's utter ruination.

The shadow for C. G. Jung represents those characteristics that the ego considers negative and unacceptable. So, Mme de Vionnet, in her shadow capacity, is to be feared as an inauspicious force that has infiltrated and can

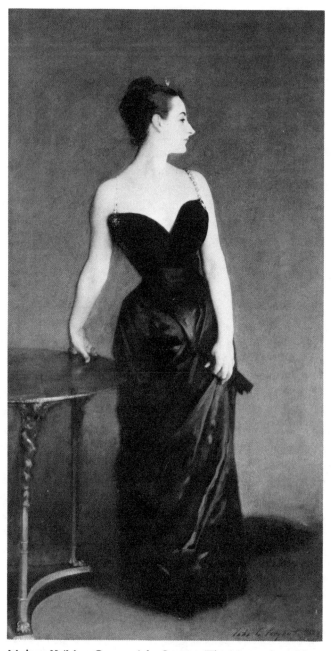

Madame X (Mme Gautreau) by Sargent (The Metropolitan Museum of Art, New York, Arthur H. Hearn Fund, 1916

still further permeate the lives of innocent people. She is instinct, a femme fatale, an adventuress, a modern counterpart of those ancient sirens so destructive in their ways—a Calypso, perhaps, or a Laurelei—who lure men into their domain with sweet songs and hypnotic rhythms, finally incapacitating them.

Black, like white, can be considered as the sum or absence of all colors, as negation or synthesis, as evil or good, depending upon one's associations. Mme de Vionnet's appearance in this first portrait is ambiguous, for she may represent either primordial darkness or the fertile domain that matures in obscurity before a vital content is forced to emerge into the light of consciousness. To use Van Gogh's statement, the black of Mme de Vionnet's dress could represent *per tenebras ad lucem*—a light-bringer.[7]

Mme de Vionnet's black dress absorbs light but does not reflect it. It evokes a nocturnal and unfathomable world. Although he does not realize it, it is she who has caused Strether to come from Woollett to Paris and who will force him to become conscious of what he has thus far ignored: the knowledge that happiness can exist on earth, that fulfillment is possible. This realization, so far as Strether is concerned, lies buried somewhere in an inner dimension—somnolent, almost dead. The fact that Mme de Vionnet's black dress strikes Strether "as light and transparent" indicates her positive characteristics and spiritual powers.

Light and transparency usher in forces considered in the Judeo-Christian world as the brightest and best in humankind. Light implies wisdom, beatitude, spirituality, the highest sort of integrity. It is the first step taken in the ascensional process from the formed to the unformed, from consciousness to the unconsciousness. The light and transparency of Mme de Vionnet's dress also suggest a kind of epiphany: a visible symbol, a sacred sign. Such a vision, psychologically speaking, brings to mind an otherworldly numinous aspect—perfection incarnate—a characteristic that slowly comes to the fore as the novel progresses. In this first portrait, Mme de Vionnet encompasses both light and darkness which are blended symbolically in her dress—a *complexio oppositorum*. As such, she is the bearer of a mystery; she is the blackened woman Strether, or James, might have surreptitiously been attracted to. She also is the one who is later portrayed in prismatic and iridescent hues, who becomes an object for worship.

In this first portrait Mme de Vionnet is described as slim and as having a rounded face and eyes set far apart "and a little strange" (p. 137). Her figure is agreeable, to be sure, but relatively unimportant to Strether, whose rational

being and discerning eyes are his guiding principles. That to Strether her eyes
are unusual indicates the depth of the perceptive qualities; she is different and
her way of dealing with the sensate world is perhaps "strange," but it is,
nevertheless, fascinating to him. She has something alien about her; an
enigma that may be glimpsed in her eyes, leading him into another dimen-
sion.

Mme de Vionnet's smile is described as "natural" and "dim," implying an
insufficiency of light at this juncture. There is apparently nothing clear-cut or
vigorous about her facial expression. The details that Strether supplies are
scanty; his apparent uncertainty evokes a sense of mystery. The dimness of
her smile is in keeping with the blackness of her dress; each in its own way
seems to clothe, cloak, and conceal her relationship with Chad—thereby
alerting Strether's questioning mind and tensing his interest.

Mme de Vionnet's gold bracelets and bangles which Strether instinctively
feels most ladies would not wear—at least no lady from Woollett—enhance
her regal tone. Gold, the purest of all metals, is considered by mystics and
alchemists to be the earthly counterpart of the sun. It is therefore God's
mouthpiece. Not to be confused with the common gold of existential man,
this is the incorporeal and invisible metal. In Strether's mind, gold stands for
material values; only later will it come to represent spiritual forces.

That Strether's first meeting with Mme de Vionnet takes place in the
garden, an intimate area concealed by a wall from the street, gives privacy to
their interchange. James loved both French and English gardens for their
grace and charm; they were like oases, representing structured natural order
in the hustle and bustle of artificially manufactured life. Both in *The
Ambassadors* and in a number of his other works, a garden is a favorite place
for James's characters to meet. This garden is like Eden: it represents a
planned and cultivated approach to life as opposed to the forest, for example,
where untrammeled growth, unmanicured fertility flourish.[8]

THE DRAWING ROOM

In the next portrait of Mme de Vionnet, she is seen in her drawing room.
Instrumental in bringing about Chad's development and his initiation into
the world of mature adulthood, Mme de Vionnet also is to be a factor leading
to Strether's inner growth. She forces an "intense ethical drama" to take
place in both males and, in so doing, increases their consciousness and
understanding. Mme de Vionnet knows how to manipulate checks and

balances, retain poise and dignity, and yet charm and ingratiate. She has all the social skills and is master of all the feminine wiles associated with European civilization. Strether is a perfect foil for her because he had been inculcated in puritanical ways, and much of his life has been limited by repression.

The reader is not only given a full view of Mme de Vionnet in her drawing room, but she is also seen as a figure inhabiting a larger picture space. James's vision of her is a truly three-dimensional composition, each section of the verbal canvas being interwoven into the next. Memories and images are also evoked in the description of her surroundings, thereby providing the reader with a perspective on Strether's view of her personality. As the novel's conscious observer, Strether brings to his impressions of Mme de Vionnet varied textures and analytical touches. In so doing, he creates his own reality, generates his own personal responses to the beauty and elegance with which this woman is surrounded—reflections, as Strether understands it, of her psychological makeup. Although her facial features are still unclear, both background and foreground are clearly reproduced and interconnected.

Like the fine draftsman that he was, Ingres revealed the perfection and grace of classical line with masterful strokes and minutely delineated contours. So, too, James's tonalities, his refined choice of ornaments, the finesse of his placement of certain details serve not only to describe this anima figure but also to endow her with haunting and alluring qualities. Even the empty spaces implicit in the description of Mme de Vionnet in her drawing room imbue the entire construct with a sense of plenitude and universality.

Before entering Mme de Vionnet's drawing room, the reader sees Strether viewing her home which is on the first floor of an old house on the rue de Bellechasse. Its "large and open" courtyard indicates a sense of privacy as well as a certain element of inner freedom. Old houses were always very dear to James; they represented, he felt, a "quality of life," a fitting background for many of his characters. Mme de Vionnet's home represents the elegance of the ancien régime and the continuity of purpose of a bygone era, which, nevertheless, is still very much alive. She is therefore not only a living memento of the Old World, but also of modernity, actuality—her own time.

Strether describes the hall and the staircase leading to Mme de Vionnet's apartment, which is tastefully decorated with medallions, moldings, mirrors, and "great clear spaces." Thus James provides the reader with visual impressions, as well as with thoughts and feelings of many kinds—a treasure trove of insights into her character. The objets d'art and furnishings in her home are

not those of the nouveau riche of the Second Empire. They are in a sense metaphors, extensions of Mme de Vionnet's own personality, that realize and reveal her as a private person as well as a collective image. The objets d'art described, the reader realizes, reveal the link she maintains with the past and with tradition, neither passively nor aggressively, but with concerned vigilance.

Mme de Vionnet obviously belongs to a world of wealth and gentility. Her objets d'art come from the Napoleonic and romantic periods, when Chateaubriand and Lamartine dominated the literary world and Mme de Staël was calling for the emancipation of women. Mme de Vionnet's bound books, pictures, and leather-works of all textures and colors—even her magazines—have not been acquired, but "received, accepted," suggesting that she herself is a storehouse—the recipient of "supreme respectability" and "private honour" (p. 160)—of ancient and modern elegance and values. When Strether first met Mme de Vionnet, he projected, as we have seen, a certain uncertainty upon her. Now, however, this feeling is dispelled. The elegance and taste of her surroundings endow her with a sense of uniqueness, a "rare unlikeness to the women he had known" (p. 160).

However, a fixed quality still pervades James's delineations of Mme de Vionnet. She retains almost the same position throughout the scene; her expression alone alters, taking on a more serene look. As for her gestures, they sometimes vary but only slightly with a "turn of the hand" (p. 162).

> She was seated, near the fire, on a small stuffed and fringed chair, one of the few modern articles in the room; and she leaned back in it with her hands clasped in her lap and no movement, in all of her person, but the fine prompt play of her deep young face. The fire, under the low white marble, undraped and academic, had burnt down to the silver ashes of light wood; one of the windows, at a distance, stood open to the mildness and stillness. . . . Mme de Vionnet, while Strether was there, was not to shift her posture by an inch. (P. 161)

Strether grasps from her pose that "her trouble was deep," her strength great, her feelings contained; deducing these traits from "the unbroken clasp of her hands in her lap and the look her expression had of being most natural when her eyes were most fixed" (p. 162). Through the observations, perceptions, and rationalizations which are blended into James's verbal picture, Mme de Vionnet is also portrayed as laughing and as possessing a "deep and beautiful" smile and a voice that "flattered" at times. As Strether begins to understand her better, she becomes for him one of those "rare

women he had so often heard of, read of, thought of, but never met, whose very presence, look, voice and mere contemporaneous fact of whom, from the moment it was at all presented, made a relation from mere recognition" (p. 164).

James's incredible sense of form, his elliptical, polished style and metaphoric use of the surrounding furnishings in the above description, reveal still further qualities in Mme de Vionnet's makeup. The chair upon which she sits and the fact that she sits upon it firmly, squarely, indicate a sense of security and repose. She knows her worth; she knows how to comport herself, to make an impression if need be. The chair is modern in style, as opposed to the traditional nature of the other objects in the room, implying that she is up-to-date and that her ideas, though they may have waned in grandeur, have waxed with the time.

The fact that her hands are clasped points to a certain rigidity and also strength of character. Hands symbolically represent activity as well as power, because they reach out and gather in objects from the outside impersonal world, thereby indicating involvement. Mme de Vionnet's folded hands also reveal her concentrated energy, her need to muster all the strength she has at her disposal. In so doing, she gains time to discover the best way to ingratiate herself with Strether. By the same token, she encourages him as a person in his own right. Clasped hands in the Buddhist canon suggest a secret being kept. Thus when "truth" is broached during the course of their conversation, it is understandable that Strether should ask "And what do you call the truth?" (p. 165).

The fire that glowed in the "white marble" fireplace is by this time no longer blazing but has "burnt down to the silver ashes of light wood" (p. 161). The height of youthful passion, the raging intensity of physical love have burned themselves out. What remains are the "silver ashes," considered by the alchemist to be the desired residue, that is, love in its purest form and in its ideal state. Mme de Vionnet is a spiritual force and also an earthly woman; the one who had perhaps seduced Chad; but also that sublimated mother figure, that harbinger of wisdom and wholeness who aids man to realize a blissful destiny—and mistress as well.

CHAD'S HOME AND DINNER PARTY

Strether next sees Mme de Vionnet at a dinner party in Chad's home on the boulevard Malesherbes. A *femme du monde* endowed with both heavenly

traits and pagan beauty, she now becomes for Strether an ideal in both the Greek and Christian sense of the term. As a "goddess still partly engaged in a morning cloud" and as "a sea nymph waist-high in the summer surge" (p. 178), she responds to the inner masculine needs of those gathered together on this night.

Strether compares Mme de Vionnet with Shakespeare's Cleopatra, thus underlining her sensuality by stressing the erotic powers possessed by the Egyptian queen as described in Shakespeare's play:

Age cannot wither her, nor custom stale
Her infinite variety; other women cloy
The appetites they feed, but she makes hungry
Where most she satisfies.

 (II, ii)

Through associating her with Cleopatra, James highlights Mme de Vionnet's feminine subtlety, her charm, and ingenuous ways. Beauty and luxury are implicit in the satins and silks of her gown of exquisite manufacture. She acts according to a "mysterious law of her own," and for Strether, she is "a woman of genius," an individual who knows how to obscure her intent, whose inner life glows yet remains hidden. Reason guides her ways, enabling her to alter her persona, thus increasing the interest she generates in those about her. A "muffled person one day; and a showy person, an uncovered person the next," Strether thinks (p. 178); she is a woman who holds the key to her own personality and definition.

Her bare shoulders and arms were white and beautiful; the materials of her dress, a mixture, as he supposed of silk and crape, were of a silvery grey so artfully composed as to give an impression of warm splendour; and round her neck she wore a collar of large old emeralds, the green note of which was more dimly repeated, at other points of her apparel, in embroidery, in enamel, in satin, in substances and textures vaguely rich. Her head, extremely fair and exquisitely festal, was like a happy fancy, a notion of the antique, on an old precious medal, some silver coin of the Renaissance; while her slim lightness and brightness, her gayety, her expression, her decision, contributed to an effect that might have been felt by a poet as half mythological and half conventional. (P. 178)

The bareness of Mme de Vionnet's shoulders not only accentuates the statuesque quality of her figure, but also heightens her resemblance to a goddess of antiquity, or to some pagan queen known for her beauty and sensuality. For Strether, accustomed only to New England trappings, the

luxurious note cast by Mme de Vionnet's gown of silk and crepe-embroidered satin mirrors the richness of her inner world, resplendent and dazzling.

One's dress, psychologically, is a manifestation of the subliminal realm; it also reflects one's social condition, as well as individual personality traits. The silver-gray cast of Mme de Vionnet's gown emphasizes her lunar aspects. For the alchemist, silver was a noble metal representative of shining and glimmering characteristics. When associated with the moon, silver expresses the occult side of nature, a word already used by Strether when referring to Mme de Vionnet's objets d'art. Moon silver or moon dew, when identified with the dress of Mme de Vionnet, endows her with a very special power—that of shining, reflected light. To play the part of universal receptacle, one who receives and then pours forth mysterious contents, gives woman dominion over life and death, hate and love, aggression and passivity. Like the moon, which gleams cold and distant, Mme de Vionnet also stands apart in her unique splendor—inaccessible, enigmatic, as she travels on her course in orbit. Her antique emerald necklace with its greenish color symbolizes life and fertility, earthly contents as opposed to the iridescent tones of her dress's silvery gray. She is the moon, a heavenly figure; she is also emerald, an earth stone—thus she represents both ideal and real, eternal and temporal.

The emerald connotes regenerative powers, according to the alchemists and visionaries of the Middle Ages, and also bewitching and malevolent forces. When properly applied, an emerald, it was believed, could cure disease; conversely, when inappropriately used, it could destroy. Lucifer, who had an emerald set in his forehead, was the bringer of light—*fiat lux*—who illuminated shadowed elements, but he also created doubt and sowed tension. So, too, Mme de Vionnet—the instrument that brings light and increases consciousness in Strether—is also the disseminator of fear and trembling. It is she who is yet to determine Chad's and Strether's life course.

Strether, observing Mme de Vionnet's head—"extremely fair and exquisitely festival"—likens her to "some silver coin of the Renaissance." The allusion to precious metal again brings to mind the intrinsic spiritual values of gold and silver—or their use for false and evil purposes. It must be remembered that portraits, as well as abstract designs, were imprinted on coins—sun, moon, wildlife, queens, kings, and great men. Coins were and are culture objects. To describe Mme de Vionnet in such a way emphasizes the collective and eternal nature of this anima figure. That she is compared to a Renaissance coin is also significant, for that was a period during which coins were stamped with portraits of the nobility. The Renaissance renewed faith

in the existential experience, underscored humanity's desire for life and beauty in both body and soul, as opposed to the Middle Ages which rejected the physical being for the spiritual. In this connection, it is understandable that Strether alludes to Mme de Vionnet as "half mythological and half conventional" (p. 178). She stems from both heaven and earth and is mistress of both fantasy and reality.

Just as Ingres was enraptured by beauty of line, so too, James cultivated it in his own art form, modulating his verbal configurations with dark, firm background tones and luminous overtones of every kind. Form and shape dominate this scene, enveloping Mme de Vionnet in verbal curves and arabesques, which detail and perfect Strether's vision of a refined yet pagan being. Prototype of the eternal feminine, Mme de Vionnet is neither Greek nor Roman, French nor Italian, corporeal nor ethereal. As an anima figure, she is all of these—a replica of James's unconscious fantasies blended into one—plenitude and emptiness, flesh and spirit, physical and nonmaterial.

NOTRE DAME CATHEDRAL

The reader is next taken to Notre Dame Cathedral in Paris. Although "the great church had no altar for his worship, no direct voice for his soul," (p. 191) it soothes Strether, instilling in him a sense of repose and vastness. After describing "the long dim nave" of the cathedral, its "splendid choir," he chances to see a lady in "supreme stillness, in the shade of one of the chapels" (p. 192), whom later he recognizes as Mme de Vionnet. She is sitting immobile, "strangely fixed," gazing straight ahead of her "within the focus of the shrine" (p. 192). In deep meditation, she is lost to the world around her, but connected with her own sphere, related to herself—to her own thoughts and feelings. Strether looks upon her as "a friend," as "some fine firm concentrated heroine of an old story"; he experiences her "inner clarity and courage" and her "splendidly protected meditation" (p. 139). Although he sees only her back, he knows she has not come to pray, but to consult her inner voice.

James's placing Mme de Vionnet in a cathedral may have been partially accounted for by the emphasis the Pre-Raphaelite painters placed on religion and morality; more specifically, by Ruskin's influence which James had undergone early in his career. For the Pre-Raphaelites in general, and Dante Gabriel Rossetti in particular, canvases imbued with deeply religious feelings and medieval flavor, and reflecting for some the purest kind of Christianity,

would eventually lead to salvation. Other painters, contemporaries of James, also depicted churches and cathedrals—Monet and Pissarro to mention but two—but they lacked the religious fervor of the Pre-Raphaelites and regarded these places of worship mainly as art objects.[9]

The cathedral setting, which James used as background for this scene, generates in itself impressions and vague sensations of sanctity. A vestige of the past, representing a period of unquestioning spiritual faith, the cathedral also represents human feeling; it is a sanctuary enclosing a strange mysterious essence. Although Strether feels detached, aloof from metaphysical meanderings, cut off from his own emotional base, the cathedral allows him to project his anima figure into a spiritual context—a religious domain. The Latin word *religio* indicates a relinking not only with past periods in history but also with the psyche, and endows Strether's feelings that now surface with a sense of continuity. Unlike medieval man, Strether does not turn away from the earth; nor does he encapsulate the Renaissance credo, "My kingdom is of this world." Unlike Tintoretto, for example, who reveled in physical beauty in the global sphere, Strether lived in a kind of no-man's-land; an abyss of his own, determined by his puritanical upbringing and limited view of life that anchored him to bourgeois views and repressive social concepts.

Mme de Vionnet presently emerges from the shadows of the side chapel into the nave of the cathedral, where Strether views her full face. Comparing her to a being arising from the primal waters, he sees her as she steps into the light, which suggests the birth and growth of another aspect of this anima figure. Observing her just as he had the sculptures and the bas-reliefs in the cathedral, she arouses in him a "sense of beautiful things" (p. 194).

Strether notes that Mme de Vionnet's dress is "subdued and discreet," suited to the occasion; "the way her slightly thicker veil was drawn—a mere touch, but everything; the composed gravity of her dress, in which, here and there, a dull wine-colour seemed to gleam faintly through black; the charming discretion of her small compact head; the quiet note, as she sat, of her folded, grey-gloved hands" (p. 194). She seems to fit into the "vastness and mystery of the domain," in both the spiritual and earthly sense, as understood in medieval and Renaissance thought. She exists beyond space and time; she has escaped from present reality to capture the remembrance and grandeur of past glories. The Church, sometimes referred to as "the bride of Christ," is also identified as the Virgin, symbolizing a womb, a warm protected area under the mother's benign aura. Strether understands that Chad undoubtedly

sees her in this light as virgin and mother and—as Strether realizes—so does he.

Mme de Vionnet's serene beauty shines through her veil. Although veils dissimulate, they also reveal, but only to those ready to be initiated into womanly mysteries. Like Isis, Mme de Vionnet will presently remove her veil—reveal her radiance at the appropriate moment. Then the light within her will be understood and allowed to flow harmoniously about her, and reach out to those whom she wishes to illuminate. To remove her veil—her persona or mask—at this point would be to disclose inner knowledge, the heart of a sacred mystery, which rather than serve her purpose, might endanger, or even destroy, her power. Perceptions must be concealed; matter protected, and what cannot yet be assimilated must be screened in the same way that the Hindu Pakriti spreads the veil of illusion before those who are as yet unable to comprehend.

As Strether gazes at Mme de Vionnet, he sees her "dull wine-colour" dress which seems to "gleam faintly through the black." Exalted notes are sounded; the wine of transubstantiation, the elixir of life, the blood of being. Wine, the beverage of energy, life, and immortality also indicates Dionysian fervor, the joy of sacrifice to a force that is responsible for life's perpetual rejuvenation. The fact that black is also visible in this context indicates, as it did in the first portrayal of Mme de Vionnet, unresolved happenings, the great void, the summation or negation of untapped areas. Yet the serenity that marks her features, her hands folded in gray gloves, endows her with an aura of sadness and melancholy, with an intangible, ethereal quality. In medieval iconography Christ is shown wearing a gray coat when presiding over the Last Judgment; it was a time of decision and action—and finality for him. So, too, for Mme de Vionnet. Shortly after the cathedral encounter, she realizes that her course had been firmly traced and that she must now take overt action.

THE FRENCH COUNTRYSIDE

Strether's walk in the French countryside at the conclusion of *The Ambassadors* takes him into a new dimension within himself. No longer the limited, repressed, overly rational man he was when he first arrived on French soil, Strether now experiences the outer world in all its variegated color; the trees with their multihued green foliage, and the slowly flowing river. Instead of the classical, fixed, even rigid terms that Strether has heretofore used to describe Mme de Vionnet and her surroundings, the reader

is presented with a landscape of suggestive wonder and mood-creating images of myriad shades and nuances. Vague sensations come into being; presentiments of feelings and emotions unconnected with outside realities. As Strether strolls in this fertile landscape, where nature grows untrammeled—as opposed to the structured, ordered garden where he first encountered Mme de Vionnet—he sees "a boat advancing round the bend and containing a man who held the paddles and a lady, at the stern, with a pink parasol" (p. 361).

From the distance, landscape and color blend in one idyllic glowing vision. James had Lambinet in mind in describing the scene, as he suggests in *The Ambassadors*. This less well-known Barbizon painter, rather than Corot, Rousseau, Daubigny, or Millet, allows him to underscore the elusive nature of the scene, to avoid stereotypes. Meandering water is delineated, as are the suggestive and misty slopes of gently forested areas, and the blue sky glimpsed through the foliage—all in gentle muted tones that encourage sensations and thoughts to multiply. Exquisite tonalities indelibly engraved in the mind's eye permeate the verbal canvas. The light vibrates, capturing the glistening forms in its embrace, revealing nature in one of its languorous, delightful moods. James descants in indefinite verbal lines and brushstrokes that suggest contours composed of small particles of pigment in a variety of delicate shadings; in so doing he discloses a world of tender gradations of configurations and texture. The scene also evokes the poetry of water, bringing to mind such pictures as Manet's *En Bateau*, Renoir's *Canotiers à Chatou*, and Monet's *La Grenouillère*.[10]

The boat comes close enough for Strether "to dream the lady in the stern," thereby framing his vision.

> He too had, within the minute, taken in something, taken in that he knew the lady whose parasol, shifting as if to hide her face, made so fine a pink point in the shining scene. It was too prodigious, a chance in a million; but, if he knew the lady, the gentleman, who still presented his back and kept off, the gentleman, the coatless hero of the idyll, who had responded to her star, was, to match the marvel, none other than Chad. (P. 361)

The deep colors of the previous scene in the cathedral have now given way to a variety of pastel tones and a hierarchy of light nuances—from sharp or metallic green to grayish hues—each multifaceted. Idyllic pink spots are also peppered onto James's verbal canvas arousing haptic sensations and, paradoxically, calling excitation and calm into play. Conflict, which had at first

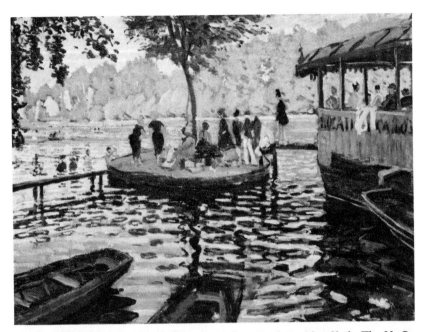

La Grenouillère by Monet (The Metropolitan Museum of Art, New York, The H. O.
Havemeyer Collection, Bequest of Mrs. H. O. Havemeyer, 1929)

weighed so heavily on Strether's mind, is now transformed into harmony,
fragmentation into wholeness, the two into one.

Mme de Vionnet and Chad are now linked in Strether's mind; together, he
realizes they represent a *summum bonum*. In this latest portrayal Mme de
Vionnet, set off by a country landscape, is viewed as perfection incarnate;
accomplishing simultaneously the role of mother and wife, of Isis and the
Virgin Mary, experiencing through her love for Chad her own reality, her
own center of being. Pink, the color of her parasol, the color of regeneration
for the ancients, similar to the medieval rose, signifying to the mystic the
beginning or center, now represents the heart in all its glorious feeling—life
must be lived openly to function as it should, and bring fulfillment to two
human beings. The rose color—that dominates this picture of Mme de
Vionnet and Chad in the boat—symbolizes the emotional strength inherent
in the characters who are strong enough to brave the rigid views of the
Woollett group and to express their own love experience. For the first time
Strether sees and feels and no longer merely intellectualizes; he is involved in
the mysteries inherent in their love relationship.

At the conclusion of *The Ambassadors*, Mme de Vionnet emerges as the Great Mother archetype par excellence; she is the psychopomp who not only entices youth and middle-aged men into her fold but educates and initiates them into mature adulthood. In every sense of the word she is the *femme inspiratrice* whom poets have written about and painters have portrayed. Resplendent in her feminine wisdom and inner and outer beauty, Mme de Vionnet is also very human: when Strether indicates to her the possibility of losing Chad, tears appear in her eyes. She has descended from the pedestal as transcendent Mother figure and entered, in all her luster and elegance, the temporal sphere. She was woman.

Jeanne de Vionnet: Virgin and Sacrificial Victim

Love may be sublime for one individual and death dealing to another. When Demeter's daughter, Persephone, was ravished by Pluto, her mother wept, and during the six-month period of her daughter's captivity within the Underworld, the earth remained barren. The opposite situation takes place between Mme de Vionnet and her daughter: so that the mother's love could flourish, the daughter had to be sacrificed. Many reasons, both conscious and unconscious, may have entered into the proceedings: perhaps even Mme de Vionnet's jealousy toward her daughter as a future rival.

WHITE DRESS AND WHITE HAT

Jeanne, a seventeen-year-old convent-bred girl, is fragile like Dresden porcelain; she is discreet, innocent, exquisitely brought up. She is frequently compared to a delicate flower, an image used from earliest times to express beauty, the evanescence of youth. Reminiscent also of Greuze miniatures, Jeanne's gentle features are usually veiled in transparent pastel tones, in shimmering overtones.

> A young girl in white dress and a softly plumed white hat had suddenly come into view . . . bright gentle shy happy wonderful. . . . She stood there quite pink, a little frightened prettier and prettier and not a bit like her mother. There was in this last particular no resemblance but that of youth to youth . . . so slim and fresh and fair. (P. 145)

Strether describes Jeanne in all her whiteness and pinkness, thus setting her apart from the other characters; yet he also underscores her relationship with her mother. Both delineations are vague, each appearing to dissolve,

blur, vanish into some intangible realm, implying an atmosphere of irreality and dream. Reminiscent of the tinctures to Winterhalter's painting, *The Duchess of Morney,* Jeanne's rosy cheeks, her fragile and charming countenance, her innocent ways reveal an exceedingly vulnerable personality. Although her happiness is mentioned in the description, a kind of vacant expression implicit in the canvas of Burne-Jones, is here implied. She emerges as a premonitory vision of the role she is to play.[11] As an anima figure, Jeanne is the young maiden par excellence: pure, virginal, her unlived and untried characteristics come to the fore. A reincarnation of the Greek Persephone (or Kore), she, too, will be violated, not by the god Pluto, but in an even crueler way because such an act is accomplished with her mother's complicity.

Jeanne's colors are white and pink as the quotation implies: representing purity, the dawn of life, the onset of a new day in all its pristine purity and possibilities. The luminous pastel tonalities surrounding and encapsulating her accent James's idealization of this sort of diaphanous and ethereal being. She emerges exquisitely into existence and, in so doing, intensifies the beauty of youthful girlhood, its pristine perfection, and dazzling illuminations. She is the bud ready to blossom, to open, the unripened fruit ready to be picked—the romantic idealization of the maiden, the object of man's desire. An abstraction and not a flesh-and-blood being, she stands in opposition to her mother; as Strether remarks, she is "not a bit like her mother."

Strether's portrait of Jeanne is resplendent in its own light and optical system: it sets up sequences of vibrations, perhaps replicating in certain ways Carravaggio's canvases where light infiltrates, cuts, and divides his paintings into zones, spatial areas, and spheres of sensateness. The white and pink colorations also bring to mind the ancient glyptic art of the cameo, which dates back to Greece and which was so exquisitely practiced in Persia and Italy, glorifying queens and princesses of the court in the most flattering ways. So, too, James immortalizes Jeanne as he fashions the contours of her face and gives her cheeks the glowing pinkness of life.

James's description is reminiscent also of Renoir's painting *Girl in a Hat* (the hat is white) because of its softness and tenderness, or one of his canvases depicting Lise and about which Fritz Bürger, the art critic, wrote: "the dress of white gauze, enriched at the waist by a black ribbon whose ends reach the ground, is in full light. . . . The head and neck are held in delicate half-shadow under the shade of a parasol. The effect is so natural and so true that one might very well find it false, because one is accustomed to nature

represented in conventional colors."[12] Monet, Manet, Bazile, and many other impressionist and postimpressionist painters portrayed young girls clad in white, underlining their purity and projecting in this way their own feelings of longing for the "untouched" being.

JEANNE AT CHAD'S HOME

Mme de Vionnet, her husband, and Chad were all instrumental in finding a suitable spouse for Jeanne: one whose family was of the highest and wealthiest society. A cruel custom to be sure, such an arrangement was entered into for social reasons, but also, perhaps unconsciously, from a personal standpoint, because of Mme de Vionnet's and Chad's desire to be together unencumbered by Jeanne's presence. Although Jeanne's demands were not great because she was self-effacing, Mme de Vionnet might have found her a disturbing, perhaps even a threatening influence. Might she one day usurp the older woman's place?

At Chad's home, Jeanne is described by Strether in the following way:

> She was fairly beautiful to him—a faint pastel in an oval frame: he thought of her already as some lurking image in a long gallery, the portrait of a small old-time princess of whom nothing was known but that she had died young. Little Jeanne wasn't, doubtless, to die young, but one couldn't all the same bear on her lightly enough. . . . She was fluttered, fairly fevered—to the point of a little glitter that came and went in her cheeks—with the great adventure of dining out. (P. 170)

Jeanne's beauty was not extraordinary and certainly not comparable to her mother's; nevertheless, the pastel tones that are used to describe her underscore the fleeting nature of her being, as compared to the relatively strong pigmentations used to depict her mother. The pale faint coloration suggests a lack of permanence because it can so easily disappear; it also suggests an inability to commit oneself to an adult relationship. Indeed, Jeanne may be considered as a kind of pawn moved about here and there by others. Unable to enter into relationships of her own without the permission of the adult, and incapable of differentiating good from evil, beauty from ugliness, her existence takes on transitory characteristics; she is impressionable, like sequences of light, nuances of iridescent tonalities drawn on paper only to be brushed away moments later. Her oval face is reminiscent of an eighteenth- or nineteenth-century miniature—an idealization of the visage rather than a realistic portrayal.

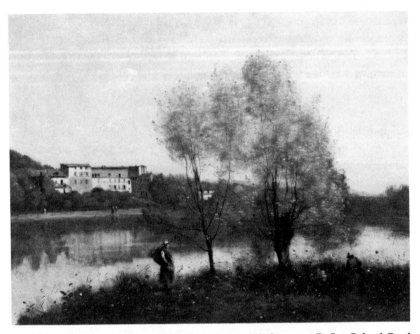

Ville d'Avray by Corot (National Gallery of Art, Washington, D.C., Gift of Cecil Pecci-Blunt, 1955)

Jeanne is a generic figure: the virgin who belongs to the matriarchal principle, the girl prior to her initiation into womanhood. She emerges in Strether's view as a kind of princess whose life will end early. As her name indicates, she may be associated with Joan of Arc (Jeanne d'Arc) who sacrificed herself to help her *mother*land. Jeanne de Vionnet, however, *is* martyred not for the motherland, but for the mother. She is an unwitting sacrificial agent and is to be pitied, therefore, and not admired. The flush of excitement expressed by the pink of her cheeks is reminiscent of many of Renoir's canvases (*Landscape with Bathers, Nude, First Outing*, and so forth), and is a manifestation of the increasing fervor and intensity inherent in her subliminal world. Pink flesh tones emerge but not in happiness; the glitter and flush will serve to terminate her virginal existence—the flame of life and futurity which will shortly be snuffed out. She, as had her mother, will be forced to enter into a conventional and perhaps odious marriage. To reduce Jeanne to a framed oval view, as James does, is to compress her psychologically, to diminish her size and her importance in the story. The distance, therefore, existing between Jeanne and Strether—the central consciousness

in *The Ambassadors*—allows illusion to be maintained, fiction to pursue its course, and impersonality to reign.

Described elsewhere as "the sweetest little thing," as the loveliest "apparition," Jeanne remains just that—a fantasy image, the virgin archetype, purity personified, innocence without insight. An object for the men who surround her, divested of individuality, she is to be married off as were so many princesses of royal blood. The violation of a young girl is symbolically to take place: psychologically the killing of a burgeoning and feeling anima figure so that Mme de Vionnet and her son-lover consort, Chad, would know untroubled happiness.

Mme de Vionnet is an echo of an inner reality, the anima that existed in Henry James's psyche: a sibyl of sorts, a goddess who excites by her charm and attracts through her enigmatic ways. Anima, meaning breath or soul in Latin, is a generative force, a psychic factor that transcends the life experience, endowing man with "consciousness of himself as a personality."[13] Mme de Vionnet and her daughter play out this role in *The Ambassadors*, seeing to the psychological and spiritual evolution of Strether. As anima figures, mother and daughter are archaic as well as ultramodern presences, representing arcane forces that the male psyche summons forth when need arises, to assimilate and make his own, thus expanding man's consciousness of the life experience.

6

Rilke and Rodin:

The *Puer-Senex* Dynamic

The mastery of form and matter made tangible in the sculpture of Auguste Rodin (1840–1917) had a profound effect on the psyche of Rainer Maria Rilke (1875–1926). Rodin's creative genius haunted the young poet's inner world and stirred his imagination: "most events are inexpressible," Rilke wrote, "taking place in a realm which no word has ever entered, and more inexpressible than all else are the works of art, mysterious existences the life of which, while ours passes away, endures."[1]

Rodin's work supplied Rilke with needed direction, activating and nurturing his dormant sensibilities, infusing a needed vital dimension into his verse. Relying hitherto almost exclusively on inspiration, Rilke found his once fresh and vibrant lyrical verse was becoming wan and vapid. The famous French sculptor was to provide him with a new outlook on creative endeavor: the need for disciplined and structured concentration.

Rodin was sixty-two, and Rilke twenty-seven, when they first met in Paris on September 1, 1902. Rilke was relatively unknown at the time, unsure of his talents, hypersensitive, physically weak, and psychologically frail; aesthetically and spiritually the *puer* had yet to find what psychologists term his own "groundbed." Almost immediately he came to regard Rodin as a master in all senses of the word: "A synthesis of greatness and power. . . . a man without contemporaries."[2] Rodin's personality injected an expansionist quality into his creative work, a vitality that, in turn, was conveyed to Rilke, and enriched and deepened his poetic vision. Intense yet aloof, Rodin's godlike being was viewed by Rilke "as a great, quiet, powerful, contradiction"; Rodin represented a *senex* figure to Rilke who healed, at least partially, the *puer*'s wounded psyche.

In keeping with the *senex* archetype, Rodin represented a compensatory force to which Rilke's still unformed or weakly structured ego eagerly

responded. Rodin was a wise, disciplined, master craftsman. His life, which revolved about his art, was highly ordered. He worked regularly and assiduously from eight to twelve hours daily, not merely during heightened periods of intense creativity, but also when he was engaged in what seemed simply routine and monotonous tasks; willpower, self-control, and self-discipline marked his creative existence. Deeply committed to his art, he represented a dominant artistic cultural force to Rilke; on the purely personal level, he acted for a time as a surrogate father by fulfilling the function in which the poet's own father had so dismally failed. As Rilke said of Rodin, he was as "dear as a father."[3]

To Rilke, who was born in Prague, his childhood was chiefly a prolonged torment. His mother was a bigoted, hypocritical woman whose first child—a girl—had died in infancy. Unable to reconcile herself to the fact that her second-born was a boy, she dressed Rilke in girl's clothing until he reached the age of six. Despite this and the fact that the child was very delicate, she had visions of his becoming a distinguished military man. As for herself, she dreamed of social success. Her husband, who had been obliged to retire from the army because of a throat condition and had taken a dull civilian job which left him dissatisfied, was in her eyes a failure. The couple, having never really gotten along, finally separated; and Rilke was successively sent to military school, business school, and law school. Each of these educational forays proved to be a harrowing experience for Rilke and they added to his already damaged psyche. In 1895, Rilke studied philosophy at the University of Prague, in a rather desultory fashion, after which he left for Munich for a year where he studied art. In 1897, Rilke met Lou Andreas-Salomé, fifteen years his senior. A married woman, influential and exciting, this novelist and essayist attracted to her salon some of the most creative men in Europe, including Nietzsche and Freud. For Rilke, she became a positive mother figure, playing the spiritual and emotional role his own mother never fulfilled.

In 1900, the painter Heinrich Vogeler invited Rilke to Worpswede, an artist's colony near Hamburg. There in the homey atmosphere of the old farmhouse which Vogeler had remodeled, Rilke experienced a kind of heavenly serenity. Given to profound periods of depression and resignation, he seemed here to emerge from his state of torpor. It seems unquestionably true, however, that Rilke unconsciously cultivated his torment. His neo-romantic soul sought to be healed in some metaphysical and pastoral clime created by his rich fantasy life.

The following year, against the wise counsel of Lou Andreas-Salomé, Rilke married Clara Westhoff, a former student of Rodin, whom he met at Worpswede; and later that same year—1901—a daughter, Ruth, was born to them. Although Rilke had every intention of being a good husband and father, his suffering became acute when he had to go to work to earn a living as a journalist. His work was consuming all his time and energy, he felt, depriving him of the ability to create his own great passion—poetry. He understood also that writing is both a lonely and solitary process. Life became unbearable. Although deeply devoted to his wife and daughter, he was incapable of assuming the responsibilities that family life required. As his parents had once failed in their obligations to him, so he now failed Clara and Ruth in a similar way.

When the art historian, Richard Muther, asked Rilke to write a monograph on Rodin, he gratefully accepted. He sent a letter to the sculptor in Paris, asking permission to visit him. A change was in order: a different land and people might be what he needed to find renewal—to regain his lost creative élan and some sort of emotional balance.

Even before arriving in Paris, Rilke wrote to Rodin, as if he intuited the role this sculptor was to play in his life: "Your art is such (I have felt it for a long time) that it knows how to give bread and gold to painters, to poets, to sculptors: to all artists who go their way of suffering, desiring nothing but that ray of eternity which is the supreme goal of the creative life." In this same letter, he adds: "All my life has changed since I know that you exist, my Master, and that the day when I shall see you is one (and perhaps the happiest) of my days."[4]

Psychologically, Rilke was very nearly a classic *puer aeternus* type—an eternal adolescent, perpetually wandering in and out of relationships and situations. Later, he would roam through France, Italy, and Germany, and back again in an endless searching round. Moody and frequently subject to an overwhelming sense of despair and helplessness, Rilke at times found himself unable to take any action, to make any decision, and to be quite incapable of artistic creation. Rather than dealing directly with the problems at hand, of facing himself and struggling through the difficulties involved, he sought answers elsewhere—in another land, under different circumstances and skies, or in a world of dream and fantasy.

It is not uncommon for a *puer* to have a numinous experience during periods of extreme despondency. This was what happened to Rilke when he first visited Rodin in Meudon and saw the garden and the various working

areas connected with it. He felt that he was in the presence of a "colossus,"[5] a demiurge, an energizer—one who would point him in the right direction. A titanic force seemed to glow in Rodin—a Promethean being who molded in his sculpture human and animal forms, ideas and sensations, in concrete shape.

Rodin, who functioned as a *senex* figure to Rilke, was creative activity personified; neither frenetic nor unchanneled, he was self-contained, reasoned, measured. His impulses blossomed in what seemed to Rilke to be endless permutations—a "generation of things," constructs of all kinds, but always anchored in both the subjective and objective domains. Rodin had discovered his own inner center of gravity early in life. Whether modeling his subjects in clay, mixing and pouring his plaster, casting his works in bronze, or sketching some future work, he was like a magus transmuting his abstract ideas and energies into palpable form, which he virtually hurled into the collective world with the same assurance as a medieval knight brandishing his sword. Rodin's powerful personality gave Rilke a sense of security and well-being that helped him to overcome the feelings of torment and despair he had experienced.

In a letter to Clara Rilke he wrote, upon meeting Rodin, "And it seemed to me that I had always known him. That I was only seeing him again."[6] As Rodin strode about his atelier, he resembled one of Michelangelo's creations, breathing flame and rippling with energy. Rilke was strengthened, vicariously, by the anthropomorphized creations he saw before him, depicting love, melancholy, thought, sorrow—and the seasons, using the human figure as a metaphor. When in full view of these sculptures, the poet's attention was arrested; he experienced strange vibrations within his own soul.

Nevertheless, Rilke felt deeply perplexed by the great quantity of casts of dismembered parts of the human body lying about Rodin's studio—casts of heads, torsos, arms, hands, figures, legs—such that serious feelings of malaise swept over him. He compared the area to a storm-ravaged center swept by high winds: the work of a dismantling god returning and transmuting an assemblage of once complex entities into their component parts.

Rilke's powerful reaction to the unattached human parts that he saw in Rodin's studio was a psychological projection of his own inner turbulence. "I am scattered like some dead man in an old grave," he wrote to Lou Andreas-Salomé on August 10, 1902. He knew that he had reached an impasse in his work; he sensed his inability to focus any longer, to discipline his writing, or to create out of his own depths. Now, however, things seemed

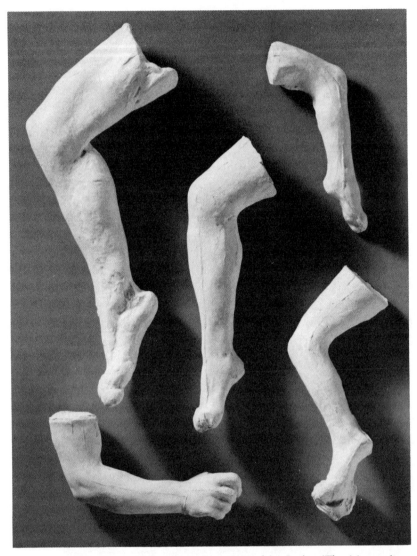

Four Legs and One Arm: Plaster Casts from Original by Rodin (The Metropolitan Museum of Art, New York, Gift of the Sculptor, 1912)

to be beginning to change. He intuited that some compensatory force was coming into being. His libido stirred. He felt a compulsion to surge forward and expel what stirred within him, particularly those corrosive forces gnaw-

ing at his spirit and flesh. He realized that he would have to discover what Hebrew mystics referred to as the "Creative Center" and what Aristotle termed the "Unmoved Mover." To accomplish this, he would have to probe to "discover the smallest basic element, the *cell* of my art," as he wrote.

Philosophically, Rilke realized that the unattached sculptured shapes in Rodin's studio were segments of a whole; luminosities, oscillations, reverberations, that carried their own energy charges, but which, if they were to be effective as a work of art, must be linked together, bound and united into a cohesive whole. These strange haunting casts of disconnected human parts strewn about echoed a former unity, and were somehow a prelude to the mysterious oneness yet to come—the artist's *magnum opus*. "All this would be less of a whole if the individual bodies were whole," Rilke reasoned. "Each of these bits is of such an eminent, striking unity, so possible by itself, so not at all needing completion, that one forgets that they are only *parts*, and often *parts* of *different* bodies that cling to each other so passionately there."[7]

Static yet alive, these fragmented parts of a whole enacted their own strange and haunting drama on the poet's inner being: they attested his feelings as each took on a life of its own, flooding Rilke's subjective world with a secret love and warmth—and yet at the same time with urgency, a strange fear. Rilke stared at the casts of the disparate limbs as if he could penetrate the message of their individual yet collective existence, reacting to this raw material as Marcel Proust did and described when writing *Remembrance of Things Past*—external forces intuitively experienced.

Whether Rodin formed a piece of sculpture or drew from a model, he utilized the detached and disconnected forms to bring the whole into existence, to order detail as required to accomplish and complete the creative act. Psychologically Rodin's ego was strong; every factor in his subliminal world seems to have worked in harmony with the rest. His sensory responses were also well developed. Rodin related to the natural world, experiencing it as a nutritive and fructifying force. His intuitive sense, focused always on the work of art—on the creative principle—he used to its full extent.

Rilke, on the other hand, was physically frail in body and psyche: the fragments, the bits and pieces he saw lying about the studio, scattered here and there, aroused feelings of dread: he himself felt cut off and disoriented. Intuitively, the *puer* feels at home only in sunny climes, in evanescent and transluscent spheres. In that unrestrictive world, he can pursue his infantile visions and dreams, forever escaping the tensions exacted by the outside adult world. The shock that Rilke incurred when facing the unconnected limbs

lying scattered about in Rodin's atelier suggested a mirror image of his own subliminal condition. His libido was triggered by the fragments leading to what might be called Rilke's "inner transformation."

For Rodin there was no conflict between art and life. Each facet of being lived harmoniously with the other: disparate parts, moving, growing, renewing as if part of the eternal cosmic wheel. Rilke, in time, sought to emulate his "master"; he wanted to stop tearing "art and life apart."[8] Yet he found himself forever doing the opposite. Intellectually he knew that art must transcend life, it must emerge as an eternal and independent force. It inhabits an immortal domain. Intellectual concepts before becoming valid and ingrained within the personality must be experienced emotionally. The transmutation process would begin with the hand.

The casts of hands, perhaps more than any other fragment, became the catalytic agent for Rilke: the hand could be considered a virtual hierophany. In his essay *Rodin* and his *Letters*, the hand is consistently and constantly emphasized: "when he [Rodin] fashions a hand, it is alone in space and there is nothing besides a hand; and in six days God made only a hand and poured out the waters around it and bent the heavens above it; and rested over it when all was finished, and it was a glory and a hand."[9]

Symbolically, the hand may be construed as a *senex* image: it stays its memories and imprints feelings and thoughts by its lines, mounds, and curves. Identified with the *pater familias*, the head of the family whose wisdom and cohesive personality create a climate of stability, the hand brings not chaos but repose. Rilke associated the hand with Rodin—the *senex* figure—because the latter molded clay with his hands, using it aggressively, courageously, and forcefully, to shape and bring life into the inert, unformed, amorphous mass by bestowing on it concrete being. "There are among the works of Rodin hands, single, small hands which, without belonging to a body, are alive. Hands that rise, irritated and in wrath; hands whose five bristling fingers seem to bark like the jaws of a dog of Hell. Hands that walk, sleeping hands, and hands that are awakening; criminal hands, stained with hereditary disease; and hands that are tired and will do no more, and have lain down in some corner like sick animals that know no one can help them."[10]

The hand also may be considered an archetypal image of transformation in that it brings about change; grasping and shaping objects, it in itself represents perpetual flux—its contours and lines forever shifting. Rilke responded to the feelings and impulses conveyed by the difference in a

smooth or gnarled hand, as well as to the hand's outer contours. The casts of hands in Rodin's studio provided the poet with a whole inner topography, offering the *puer* subjective but positive attributes. They helped to underscore emerging states of being, open up fresh emotional vistas, thus answering Rilke's present need for change and presenting him with the idea of future

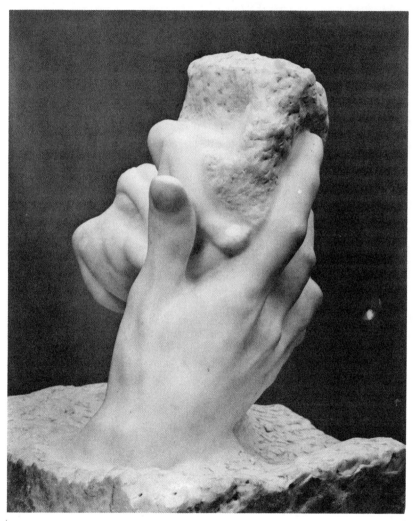

The Hand of God by Rodin (The Metropolitan Museum of Art, New York, Gift of Edward D. Adams, 1908)

possibilities. Hands were also important to him because they revealed certain aspects of his dependency upon others; the hand with fingers outstretched, for example, personified anguish and Rilke's need for others, their approval and their love, as well as their sustaining presences. The hand invoking God's presence in prayer was the hand begging for comfort and serenity. Rodin's casts of hands also spelled power to the poet; they seemed to fill space organically and kinetically, revealing a whole universe of objects to be seized upon and realized by the creative artist, thus ushering in feelings of comple-tion and fulfillment.

As Rilke observed Rodin—"this man rich in years"—at work, he looked upon him as a kind of primeval god molding the *prima materia*, concentrating energy into singularly motionless but active forms. Rilke saw Rodin as an *anthropos* figure who personified life: *vitalism*, to use Bergsonian terminology. The French sculptor possessed the power to transmit his own organic force into an inorganic object. Compared to his own weakness, Rodin's strength reminded Rilke of a tree—a symbol frequently identified by Jung with the *senex*.

Like the roots of a tree, the source of the sculptor's inspiration and strength lay buried deep beneath the ground, whereas the results of that nourishment, reminiscent of the branches of a tree, reached toward heaven. Like a tree, too, Rodin stood erect and solitary in his loneliness. "Deep in himself he bore the darkness, shelter, and peace of a house," Rilke wrote—depending upon his art for fulfillment. Because Rodin converted the unformed into the formed, he thus represented to the poet both spirit and matter, solid and liquid, light and dark. His works stood like trees in a forest, each piece seeming to emerge from—and yet never become fully separated from—the domain of the Great Earth Mother. Rodin was in contact with his primeval world (instinct), which was the seat of his burgeoning force. He experienced the intoxication and frenzy of that terrible moment prior to the outflow of the creative élan.[11]

Watching Rodin at work, Rilke saw how the sculptor first concentrated his energies on specific detail and then encompassed the entire object, and he realized that he had much to master in terms of his own art and life. To observe the outer world, not as a prolongation of his own soul state but as an entity in itself, became of vital importance. He must learn how to select what he wanted to express in an opus; he must not merely wait to be moved and then articulate the fruit of that emotion on paper—to allow merely mood and

emotionality to prevail. Such attitudes would be self-destructive: Rilke's uncontained unconscious would continue to spill over. He needed the example of Rodin, the *senex*, in order "to gather" himself, to learn how to reflect, to order, to increase consciousness, and to develop his undeveloped thinking function.[12] Passivity must yield to activity; the unconscious to conscious factors if he were to evolve as a poet and establish himself in the world. Awareness is virtually nonexistent in one who cannot differentiate and objectify, and the great future of a work of art is all too often stillborn.

There was yet another lesson Rilke was to learn from Rodin: as the sculptor molded his *prima materia,* so the poet shapes and orders his words. Energy must be concentrated first on one specific detail, then encompass the entire object. Rodin amplified his idea when he used the word *modelé* in a conversation with Rilke. *Le modelé* may be likened to an archetype: a pattern of behavior of unknown origin; it is to the psyche what instinct is to the body. It is this *modelé* which the artist must transmute, Rodin suggested, into palpable form. *Le modelé* is the germ of the created work reduced to its most elemental form. On one occasion, Rodin took up a small snail shell in his hand and exclaimed: "Voilà le modelé!" meaning that the pattern or form of this object lives eternally within the collective unconscious. It is the artist's task to reveal this hidden content to the viewer.

In a letter to Clara Rilke, the poet discussed Rodin's concept: "For him there is *only* le modelé . . . in all things, in all bodies; he detaches it from them, makes it, after he has learned it from them, into an independent thing, that is, into sculpture, into a plastic work of art. For this reason, a piece of arm and leg and body is for him a whole, an entity, because he no longer thinks of arm, leg, body (that would seem to him too like subject matter, do you see, too—novelistic, so to speak) but only of a modelé which completes itself, which is, in a certain sense, finished, rounded off."[13]

When shown another snail shell, this time broken and crushed, Rodin remarked: "C'est le modelé gothique-renaissance," indicating by this statement that wholeness had come into being, that perfection had given way to disparity. Archetypal serenity had broken up. The simple harmony, for example, of the "unruffled" Greek shell was no longer: this prototypal form that contained everything and anything in its contours had yielded to the flawed. No longer "infallible," it had been transformed as everything else in the manifest world. "The little snail recalls the greatest works of Greek art: it has the same simplicity, the same smoothness, the same inner radiance, the

same cheerful and festive sort of surface . . . things are infallible! They
contain laws in their purest form. Even the *breaks* in such a shell will again be
of the same kind, will again be le modelé grec."[14]

The notion of *le modelé*, as a kind of archetype, was important for Rilke.
The object, the thing, the vision existed in his collective unconscious—complete and finished. He would probe within himself in order to extract it and
integrate it in the created work—his poem. Rodin had taught Rilke to look at
nature for patterns—a snail shell, a mushroom, a seed, a leaf, an animal—
each in its own way bore its *modelé*. Each was worthy of examination for the
miracle of its beauty, complexity, and originality. To peer into an empty shell
or another seemingly unimportant object was to experience another world, a
different series of patterned configurations from the known one: endless
spirals, circles, ovoids, confluences of line, diagonals. Each encapsulated its
own cosmos. Unlike Rilke's formerly neoromantic attitude, nature henceforth was to be experienced aggressively. The poet would seek out a tone, a
line, an image, a feeling, an inner dimension, as the sculptor models muscles,
articulates gesture, concretizes the arch of an eyebrow or a glance in the
material he shapes.

Rilke also realized at this juncture that loneliness, which he had always
described in his poems and letters as unbearable and from which he had
desperately sought to escape, was a necessity. Solitude allowed for both
indwelling and work: "One must work, nothing but work. And one must
have patience," Rodin told Rilke. To allow one's emotions, sensations, and
thoughts to be dispersed—to dream vaguely about bringing forth a great
creation—was to abandon oneself to outside forces and invite an unresolved
and therefore unproductive inner climate. Work was the answer.[15]

The *puer*, however, shuns work, and prefers to while away his time in
daydreams and undisciplined speculations. In *Symbols of Transformation*, Jung
suggested that there is one great cure for the *puer*: he must give himself to
concentrated work, in order to extract himself from his youthful neuroses.
Jung was not referring to the kind of work accomplished during a highly
inspired period, which the artist who is a *puer* indulges in anyway, but
disciplined, daily labor, whether imposed by an outer or inner authority.
Such a schedule forces the *puer* to adhere to a routine and to face the dull and
boring side of creativity. Only by confronting this fact and by constantly
avoiding it through rationalization, can a sounder life attitude be developed,
and a concomitant deepening of the innovative factor in the domain of art be
realized.[16]

An artist must learn to face the depths within him, to experience the collective unconscious—to realize the loneliness of the rejected and the alienated. That terrifying inner space—that devouring maw or that endless womb that ushers its victims into an *illud tempus*—is also to be looked upon as a nourishing and sustaining element—as it was for Osiris, Christ, Faust, Saint John of the Cross. Rilke now seems to have realized that he must no longer seek to escape his terrors, but must learn to face them and allow them to disorient him now so that a new orientation might finally occur. In effect, he must undergo the ordeal of the dark night of the soul; permit the *dismemberment* to which Rodin's statues had pointed the way.

Rilke took up the challenge. In his novel *The Notebooks of Malte Laurids Brigge*, he described how the protagonist exposes himself to the terror of nothingness and depicts his reactions in various incidents, such as the time that he gazed at himself in a mirror and became so deeply absorbed and overwhelmed by what he saw that he lost consciousness.

> I rushed to the mirror and with difficulty watched through the mask the working of my hands. But for this the mirror had just been waiting. Its moment of retaliation had come. While I strove in boundlessly increasing anguish to squeeze somehow out of my disguise, it forced me, by what means I do not know, to lift my eyes and imposed on me an image, no, a reality, a strange, unbelievable and monstrous reality, with which against my will, I became permeated: for now the mirror was the stronger, and I was the mirror. I stared at this great, terrifying unknown before me, and it seemed to me appalling to be alone with him. But at the very moment I thought this, the worst befell: I lost all sense, I simply ceased to exist.[17]

The fulgurating force that seized hold of him and disrupted his ego consciousness jarred and shook him. He knew that his exploration of his inner being had to be furthered or his fragmented psychological condition would remain and his achievement as a poet would always be peripheral. "I will collect myself out of all distractions," Rilke wrote. He would seal all doors and windows, and hermetically block whatever light infiltrated into his private world. Then he would stumble through the contents of his unconscious, go around and around, fall, wound himself, allowing inward maelstroms to blind him. "Go into yourself. Searching for the reason that bids you to write," he stated in *Letters to a Young Poet*. "Delve into yourself for a deep answer."[18] Only within will the treasure be found; the collective unconscious that holds and contains past, present, and future.

Rodin became Rilke's mentor. "I must follow him . . . in the inner

disposition of the artistic process," he wrote. "I must learn from him not how to fashion but deep composure for the sake of fashioning. I must learn to work, to work. . . ."[19] Still prone to feelings of boredom, of hopelessness, and failure that so often plague the *puer* and lead to weeks of inaction, Rilke looked toward Rodin as a paradigm of well-being, strength, and discipline—a patriarch, a solid tree from whom he could draw sustenance. He decided to abstain from wine and other distractions. In a confessional tone, he wrote to Rodin: "And it is the great rebirth of my life and of my hope that you have given me." Each time he left the sculptor's home outside of Paris, he felt elated, hopeful, suffused with energy, but upon his arrival in the city, particularly during the summer months, the heat and grime and the "weight" of the "heavy" atmosphere descended upon him, paralyzing him, inflicting a sense of uneasiness. Dread and panic sometimes ensued—a sense of alienation.[20]

Gradually under Rodin's steadying influence, Rilke learned to observe, to objectify, to dissect, to relate more accurately to the life around him: in Jungian terms his sensation and thinking functions began to develop. Rilke sought to transform his soft, malleable, inner *puer* nature into a virile force. Gone was his empathy for the *Jugendstil;* and for the Pre-Raphaelites with their fetid and deeply morbid view of life, their perverted sensuality, their visions of entombments, burials, and beauty in death. Dante Gabriel Rossetti, John Everett Millais, among others who had ostensibly rejected academism and sought to reactivate the High Renaissance of Raphael, had failed in their endeavor so far as Rilke was now concerned. He refused to yield to despair, to a sickly and emotionally drained art form. He would follow Rodin's suggestions: discipline, direction, attention, and energy in seeking out *le modelé.*

Rilke went to the zoo in the Jardin des Plantes to study life in its essentials. One animal in particular attracted his attention, a panther. The caged animal seemed to stretch, to grow, then pause for a second and finally cease all activity. It reminded him in certain ways of a small plaster cast of a tiger he had seen in Rodin's studio during the early days of their friendship. He was intuitively drawn to Rodin's little tiger; barely four inches in height and length, it seemed to him a marvel of animation and excitement—an entity unto itself, living apart from the workaday world. Activity exuded from the flow of its lines; feline pride, from its expression.

The animal in Rilke's poem, "The Panther," is a concrete verbal equivalent of a visual emotional experience. The caged animal, described in all of

its intrinsic strength and beauty, suggests the instinctual realm that when overly restrained becomes increasingly poised and determined in its desperate need to escape the barriers constricting it. Rilke's panther lives in a dimension forever barred to humankind. Its feelings as it strides back and forth fill the panther with a force that stretches far beyond its cage, into an unlimited world of sadness. A life being lived inwardly, its circular gestures and feelings reaching a magnitude aptly expressed by Rilke in sweeping sound and rhythmic effects.

> Sein Blick ist vom Vorübergehn der Stäbe
> so mud geworden, dass er nichts meh hält.
> Ihm ist, als ob es tausend Stäbe gäbe
> und hinter tausend Stäben keine Welt.
>
> Der weiche Gang geschmeidig starker Schritte,
> der such im allerkleinsten Kreise dreht,
> ist wie ein Tanz von Kraft um eine Mitte,
> In der betäubt ein grosser Wille steht.
>
> Nur manchmal schiebt der Vorhang der Pupille
> sich lautlos auf—. Dann geht ein Bild hinein,
> geht durch der Glieder angespannte Stille—
> und hört im Herzen auf zu sein.

> So wearied by the passing of the bars,
> his gaze no longer steady holds.
> To him they seem like thousand bars—
> behind the thousand bars no world.
>
> The lissom stride of supple-strong steps,
> which turns within the every-smallest circle,
> is like a dance of strength around a center
> in which a mighty will stands numb.
>
> Only sometimes the curtain of the pupil
> silently shutters open. An image enters,
> then glides through the tense silence of limbs,
> and ceases to exist in the heart.[21]

Rilke studied movement in the tiger: each muscle as it rippled, surged forth, heaved, and swelled had been observed, visually dissected; each breath in all of its measured and spasmodic rhythms had been considered and

contemplated by the poet. Rilke had succeeded in activating *le modelé* in his poem; in forcing it out into the open in the poem. Force, power, and energy were vital in the extracting process: in permitting the artist to draw from within. "Nothing possessed rest, not even death," Rilke had learned from Rodin. Even "decay, too, meant movement, dead matter still subject to life."[22]

Rilke seems to have undergone an emotional transformation during this period. His former weaknesses were turned into strengths. He completed his essay on Rodin, and then went to Italy where he put the final touches on *The Book of Hours*. A crisp, crystalline quality is evident in this collection. The subjects he focused upon are animate concretions—sometimes attenuated and fragile lyrics, at other times subtle yet forceful ones, written in gently or heavily accented rhythms. By dint of disciplined study, patience, and work, Rilke created a new sort of poetry, which he called Thing Poems (*Ding-Gedichte*). Written for the most part between 1902 and 1908 and published in *New Poems*, he introduced the reader to a fresh world of meticulously observed animate and inanimate objects envisioned as sculptured impersonal forms. This impeccable work was not based upon intuitive flashes of inspiration, but written with clarity and objectivity as if the poet had actually built blocks and forms out of some deep mysterious elements. Separating features, ideas, themes, colorations, tonalities, Rilke molded, pounded, cut or abraded these word elements—as Rodin had done with stone, clay, and pencil.

Thing Poems, such as "The Panther," could be called articulated emotion or decanted feeling. The fruit of inspiration, surely, they were the result of severe discipline and extreme concentration. They were pure existence, each inhabited with a metric scheme of its own, images and details which were incised into the very fabric of the poem. Things, for Rilke, lived, breathed, and awakened to their own psychological and physical being. Because motility is one of the salient factors in Rilke's Thing Poems ("The Panther" being an example of this need for flux), action may also be used deceptively. When, for example, the animal looks out from the cage, he sees a world moving about and his inner world longs to participate in it. The reader—or viewer—on the other hand, sees the encaged animal as his muscles pulsate, as his sinews and tendons, revealing their potency and force, stir, change their position, and slowly shift, depending upon his mood.

In "The Flamingos," a poem of extreme delicacy, Rilke divests himself of the kind of German lyricism practiced at the time of Lessing and Goethe; he refuses to decant feeling and speculate about the object; nor is he willing to

depict the moods aroused by the visual entity. More like the plastic poems of Leconte de Lisle (his *Barbaric Poems*), Rilke attempted to distill form, to draw and color the plastic object itself but in verbal properties. In "The Flamingos" we are introduced to the most fragile, refined, and elegant of aquatic birds; the long neck and legs, webbed feet, broad lamellate bill, and rosy-white plumage with scarlet wing coverts and black wing quills are unforgettable.

In Spiegelbildern wie von Fragonard
ist doch von ihrem Weiss und ihrer Röte
nicht mehr gegeben, als dir einer böte,
wenn er von seiner Freundin sagt: sie war

noch sanft von Schlaf. Dann steigen sie ins Grüne
und stehn, auf rosa Stielen leicht gedreht,
beisammen, blühend, wie in einem Beet,
verführen sie verführender als Phryne

sich selber; bis sie ihres Auges Bleiche
hinhalsend bergen in der eignen Weiche,
in welcher Schwarz und Fruchtrot sich versteckt.

Aug einmal kreischt ein Neid durch die Volière;
sie aber haben sich estaunt gestreckt
und schreiten einzeln ins Imaginäre.

Like mirrored images by Fragonard,
so little of their red and white is shown,
and delicately, as if one came alone
and whispered of his mistress in your ear:

She lay there, flushed with sleep. . . . Above the green
reeds they rise and on their rose-stilts turn,
blooming together, as if on a parterre,
seducing (more seductive than Phryne)

themselves; and in the softness where the black
and apple-red are veiled they sink their necks,
hiding the pallid circles of their eyes,

till through their wire cage swift envy shrieks;
they waken in astonishment and stretch
themselves and soar imaginary skies.[23]

The poem vibrates with sound: the tonalities emerging from the words themselves; the metaphors embedded in the sequence of images. As in "The Panther," so here, too, we are drawn into an inner world—the very heart of the object—*le modelé*.

In "The Aschanti," the poet's eyes are focused on a steady, fixed, secret inner realm of archetypal dominion. It is here that the encaged creatures pace up and down; their faces partially hidden from view by the bars that cast their shadows in rigid, parallel formation. They peer from behind these iron poles; looking from within, outward—into the distance.

> Und sie brennen wie ein stilles feuer
> leise aus, und sinken in sich ein,
> teilnahmslos dem neuen Abenteur
> und mit ihrem grossen Blut allein.

> In their great golden eyes a steady fire
> Now glancing out, now sinking like a stone;
> No urge to new adventure, no desire,
> They bide with their great beating blood alone. [24]

In "The Unicorn," the plastic image is again palpable, seizable, but this time the essence of grace as it stirs, shifts, and moves about. Antithetical to this living and advancing animal is the immobility, inflexibility, and rigidity of its stiff horn. Stasis and flux are visual replicas of an inner tension within the animal itself: a world of conflict hidden from the casual viewer, secreted by the animal in its private and intimate domain, but revealed by the poet who peers into the animal's depths—and his own.

> . . . Der Beine elfenbeinernes Gestell
> bewegte sich in leichten Gleichgewichten,
> ein weisser Glanz glitt selig durch das Fell,
> und auf der Tierstirn, auf der stillen, lichten,
> stand, wie ein Turm im Mond, das Horn so hell,
> und jeder Schritt geschah, es aufzurichten . . .

> The ivory framework of the limbs so light
> Swayed like a balance delicately deflected,
> There glided through the coat a gleam of white,
> and on the forehead where the beams collected

Like a tower in moonlight stood the horn so bright,
With every footstep proudly re-erected . . .[25]

Rilke wrote not only about animals, but focused his attention on flowers: "Blue Hydrangea," "Persian Heliotrope," "Rose Bowl," and "Opium Poppy" to mention but a few. These color poems delineate line, form, and contour, attempting to reveal the beauty of the visual image in detail, but also its ephemerality. The pastel colorations are underscored as they stand erect or curved on the earth's surface. These poems, however, do not have the living quality of the animal verses: they are too highly studied, arranged, graded, as if Rilke had set these objects about him and had made up his mind to study them as does a painter; dissecting them with his eye, transmuting the visual image in a most diligent manner into the word.

The cult of the line is most apparent in "Archaic Torso of Apollo" which Rilke so masterfully transmuted into poetry. The body of stone seems to paradoxically leap into existence; the light emanating from a street-lamp adding to the divinity's inner and exterior golden glow.

Wir kannten nicht sein unerhörtes Haupt,
darin die Augenäpfel reiften. Aber
sein Torso glüht noch wie ein Kandelaber,
in dem sein Schauen, nur zurückgeschraubt,

sich hält und glänzt. Sonst könnte nicht der Bug
der Brust dich blenden, und im leisen Drehen
der Lenden könnte nicht ein Lächeln gehen
zu jener Mitte, die Zeugung trug.

Sonst stünde dieser Stein enstellt und kurz
unter der Schultern durchsichtigem Sturz
und flimmerte nicht so wie Raubtierfelle;

und bräche nicht aus allen seinen Rändern
aus wie ein Stern: denn da ist keine Stelle,
die dich nicht sieht. Du musst dein Leben ändern.

Though we've not known his unimagined head
and what divinity his eyes were showing,
his torso like a branching street-lamp's glowing,
wherein his gaze, only turned down, can shed

light still. Or else the breast's insurgency
could not be dazzling you, or you discerning
in that slight twist of loins a smile returning
to where was centered his virility.

Or else this stone would not stand so intact
beneath the shoulders' through-seen cataract
and would not glisten like a wild beast's skin;

and would not keep from all its contours giving
light like a star; for there's no place therein
that does not see you. You must change your living. [26]

Rilke had come a long way since he first set eyes on Rodin. Certainly this
French sculptor was instrumental in causing the change in Rilke's creative
process. Still, there were others also who played their part in altering the
German poet's concepts: the postimpressionist painters, particularly Cé-
zanne, and the fauves and cubists, who stressed the object's importance in
contemporary society, and, therefore, in art. Rilke had learned to relate to
the world of *things* in a new way. No longer did he see the concrete entity as a
projection of his own soul state or as a prolongation of his nebulous
evanescent moods. He observed it with lucidity as a segment participating in
prismatic beauty or ugliness—as part of a whole. His growing self-definition
helped to integrate his divided personality: the *I* and the *Thou* were better
able to relate to one another, and the tension caused by this duality generated
energy that subsequently became the source for the new creative vision he
gave to the world.

Rilke's poetry thus acquired its own new "inner disposition," presenting
fresh observations in highly wrought chiseled forms. Whether poetry or
prose, his work in *New Poems* and in *The Notebooks of Malte Laurids Brigge*, as
well as in other writings of this period, has a consistency all its own; the
vision alters in texture and form as if it had found its own inner life and
burrowed deep into a timeless dimension—*le modelé*—where thought became
incarnated in tightly knit concretions. The disparate had taken on meaning
for Rilke. The disjointed and fragmentary were no longer a threat to
wholeness as they had been when he first saw the casts lying about in Rodin's
studio. Each part had now become an element of a whole, spelling out the
artist's triumph over his material and thus taking on a perfection of its own,
having been explored in depth as if propelled by some inner necessity.

In the fall of 1905, Rodin suggested that Rilke become his secretary,

answer his mail, and devote the rest of his time to his own creative ventures. Rilke, who still looked upon Rodin as "an eastern god enthroned," and who always when he returned to Rodin's studio found himself welcomed "in the way a beloved place receives one," accepted. "He is everything, everything far and wide," the poet wrote to Clara Rilke on September 20, 1905, buoyed up as always when in the sculptor's presence.

The following May, Rilke answered certain letters addressed to Rodin without consulting him, not wanting to bother "the master." For this action, he was summarily "dismissed," like "a thieving servant." Deeply troubled, he moved back to Paris, then wrote to Rodin: "I shall not see you any more—but, as once for the apostles who were left behind saddened and alone, life is beginning for me, the life that will celebrate your high example and that will find in you its consolation, its justification, and its strength."[27]

Time passed. The scars healed somewhat, though never completely. Rilke again saw Rodin, although at infrequent intervals. Nevertheless, the *senex* remained for the *puer* a true *auctor*—one who increases and augments. Rodin's studio had been a sacred area, where the transfiguration ritual began—the poet's consciousness expanded and sustained his vision.

7

Kokoschka:

Murderer Hope of Womankind, An Apocalyptic Experience

The poster and drawings that Oskar Kokoschka (1886–1980) made for his one-act play, *Murderer Hope of Womankind,* reflect an inner being throbbing with a sense of urgency, a need to shatter and destroy the decadent nineteenth-century Austro-Hungarian Hapsburg culture. The harsh and turbulent lines of the play itself pound out the grimaces, gasps, and anger of barbaric human beings, who seem to be volcanic emanations from the shadowy psychic realm of the artist. These men and women are ready to split, tear, and dismember everything that once was whole and unified; gone are the conventional religious, political, and social values. *Murderer Hope of Womankind* is an apocalyptic, overwhelming experience, a massive premonitory event, that speaks directly to all those who encounter it, whether in pictorial form or as drama.

 Kokoschka's play rejects the status quo, holds up to scorn the relationship existing between the sexes, and pours out its author's rage and resentment in gruesome images. In violent, passionate scenes, a full-fledged battle takes place on stage, an earthly replica of a cosmic struggle, depicted in mythical dimensions. It is therefore not surprising that the play's opening night—July 4, 1909—provoked an intense reaction from its audience. Historians of the theatre know about the fighting and tomato throwing that occurred when Victor Hugo's *Hernani* was first produced in Paris, about the catcalls and stamping feet at the opening of Alfred Jarry's *King Ubu,* and of the storm of protests that greeted Strindberg's and Ibsen's dramas. No opening night however, met with the outrage that *Murderer Hope of Womankind* elicited at its first public performance in an open-air theatre in Vienna. No sooner had the play begun than the audience erupted, booing and hooting, stamping their feet, throwing chairs, and slashing supporters of Kokoschka with their

umbrellas. Some Bosnian soldiers, whose barracks overlooked the open-air theatre, were likewise so aroused by the brutality and seminudity of the players, that, drawing their swords, they vaulted over the fence surrounding the area, ready to join the infuriated audience and wreak further havoc when, fortunately, the police arrived and restored order.[1]

Kokoschka, who was born in Pörchlarn on the Danube, near the baroque monastery of Melk, was the son of a goldsmith, the descendant of a long line of excellent Czech craftsmen. Trained in the Prague tradition, Kokoschka's father moved to Austria after his marriage, but because art nouveau, or Jugendstil, was then alone in fashion, his snuffboxes and jewelry did not bring in much money. Poverty, however, did not deter him from reading the writers of the Enlightenment, nor did it prevent him from instilling in his children a love for the literature. The works of the Moravian bishop John Comenius (1592–1670) particularly influenced Kokoschka. Comenius believed that education should be connected with daily life and that through education men and women could be saved and the future redeemed.

Kokoschka manifested his talent for drawing and painting at an early age. In school he designed stage sets and painted scenery for plays. He also loved chemistry and later used to say that he aspired to become a chemist but that his father was so poor that he could not afford to give him advanced training in this field. In 1904, therefore, Kokoschka accepted the scholarship he had won at the School for Arts and Crafts in Vienna. Once enrolled, he became fascinated with ethnological art, spending many long hours in museums, not examining classical works but focusing on exhibits of religious and cult objects from the South Sea islands, Africa, and Japan. He also started to work at the Vienna Workshops, which had been founded in 1903 by a group of progressive artists influenced by the philosophy and works of the English Pre-Raphaelite poet and designer, William Morris. There Kokoschka painted fans, postcards, and other decorative objects. However, in time he grew to dislike the mannered style and excessive elegance of art nouveau.

By 1907, Kokoschka had become an assistant teacher at the School for Arts and Crafts. Although art nouveau remained the predominant style, he more and more broke away from it, allowing his own personal vision to speak out in all its power and strength. Soon, in his pictorial art, he began using distortion and violent, undiluted primary colors. He ceased working from a posed model and was determined to paint his subjects in action, moving about expressively on the picture plane. By 1908, Kokoschka seemed well on

the way to freeing himself from sinuous lines, flowing curves, and ornamental surfaces, and was depicting the human head and body from multiple angles.[2]

It was in 1907 that he composed *Murderer Hope of Womankind*, thereby earning the enmity of those in power. As a result of the scandal it caused, Kokoschka was dismissed from his teaching post and was forced to leave Vienna. Nevertheless, he pursued his own personal vision. The drawings and posters he created for his drama, like the play itself, have been associated with expressionism, the artistic movement that began in Europe in the first year of the twentieth century. In expressionism—the term itself was first coined in 1901 by the French painter Auguste Hervé—external reality is distorted in order to convey the artist's own subjective visionary experience. Influencing, and in turn being influenced by, such other advanced groups as the fauves (wild beasts), the *Brücke* (bridge), and the *Blaue Reiter* (blue rider), the expressionists used violent color and banished traditional techniques. Objects were placed in pictorial space not necessarily for their intellectual meaning or symbolic value, but rather to evoke sensation in the eye of the beholder. Expressionism was intended to represent the artist's inner vision, something that had been extracted from the depths of the psyche, whether it be a harsh distortion, a falsification of realistic objects and figures with all their defects and ugliness—the result of an optical system of the artist's own manufacture. Unlike impressionism, in which the artist seeks to convey the external world in pictorial terms, expressionism works from within outward and often focuses its anger on the bigotry and narrow-mindedness of bourgeois society. It differs markedly from naturalism, however, which aims to present a truthfully objective picture both of the actual lives of men and women and the social environment in which they live in order to pave the way for reform. Kokoschka, like the other expressionists, was himself concerned in only a general way with the society of his day and its betterment. He evoked sensation by the use of form and color and thus revealed his own inner universe no matter how violent or brutal the result might be. In the literary sphere, to convey the central idea through language was of greater consequence than either story line or the psychological development of the characters. The language the expressionists used was violent, abrupt, elliptical, and strident; they compressed their themes into what had been termed "telegram style," which pounds out its message in powerful cacophonies, in images that are often grotesque, grating, and jarring.

Murderer Hope of Womankind—The Play

Kokoschka is said to have completed *Murderer Hope of Womankind* during an evening's rehearsal with drama students. Having earlier written out each player's speeches on separate small pieces of paper, he distributed these to future members of the cast along with an outline of the play's action. The phrasing and vocal rhythms, the shouts and screams, accompanying the fragmentary scenes were inserted as the players proceeded. Kokoschka's archetypal characters, like those in Jarry's *King Ubu,* display in their sponta-neous animality their satirically murderous and vengeful qualities. In expres-sionist drama, all conventional sentiment is banished and logical continuity is willfully disregarded; the aim is, as we have already mentioned, to arouse viewer and reader alike by the use of odd verbal associations, repetitions, images, unusual rhythmic patterns, bizarre analogies, and seemingly unre-lated happenings. Like Jarry, Kokoschka indicates his disdain for the world of appearances by dissociating all semblance of normality in which the characters and events. The acting in *Murderer Hope of Womankind,* which is also similar in some ways to Jarry's, is highly stylized; the speeches and pitch of vocalization follow a specific rhythmic pattern; some words are stammered, others shrieked, thus underscoring the stychomythic dialogue—its disputa-tious stridency and friction.

The theme of *Murderer Hope of Womankind* is conflict. In the immediate sense, the play portrays a battle between the sexes; but some critics have suggested that, symbolically, it parallels a protracted orgasm, and others, a reenactment of the stations of the Cross. Influenced by Strindberg, whose *The Father* and *The Dance of Death* are centered on the hatred and warfare existing between men and women, and whose *A Dream Play* presents a more mystical enactment of the same theme, so Kokoschka expresses his hatred for humanity's existential and spiritual plight in unforgettably savage terms.

To underscore the mythical dimension of his work, his hatred for religious orthodoxy, for the economic and political system, for regimentation, and the whole new increasingly mechanized and industrialized world, Kokoschka in his stage directions places his play in antiquity. *Murderer Hope of Womankind* thus occurs outside any specific setting of time and place, and the drama is presented as if it were part of a timeless and eternal sphere. As the word "mythology" itself implies—stemming from *mythos* (fable) and *logos* (dis-course or reason)—it depicts a fabulous situation, an almost supernatural

happening. The plot may recall the Celtic *Tain*, the Greek *Bacchants*, and the Nordic *Nibelungenlied* in its earthiness and the archaic nature of its violence.

The stage directions also call for a night sky; the daylight hours, perhaps signifying the conscious, rational sphere, are over, leaving room for darkness and for emanations from the hidden subliminal realm to emerge, for phantasms to intrude. It is interesting to note in this connection that by 1907 Freud's *Interpretation of Dreams*, which had been published seven years previously, had made enormous inroads in the lives and psyches of many creative people who were aware of the struggle between *Eros* and *Thanatos*. More and more, it was being realized that every expression of art or belief, if it is to be fully experienced and accepted, must be grasped not merely on the intellectual level, but that the whole instinctual realm must be aroused. Kokoschka fulfills this requirement; the inner being, like the eye and ear, is galvanized by the drama's action, its words, sounds, sights, and imagery. The proceedings stir and intensify the emotions and attitudes of the audience who, like the characters in the play, are outraged, provoked, shocked, responding to Kokoschka's thesis in terms of their own needs, both personal and collective.

The play's directional statements call for a cage resembling a "tower with a great gridiron door," a "torchlight," and "ground rising to the tower," which are visible as the play starts. The action takes place in an ageless atmosphere that allows the imagination to come into play. The towering ascensional shape etched against a vacant sky implies a severing from the earth world, from society, and a withdrawal into another sphere—a cutting of connection in terms of both historical and chronological time. The cage-tower also may stand for a prison, for a restricted world into which one is plunged against one's will, for a stifling, crushing force that injects into the play both sacred and infernal qualities.

Because they are undifferentiated abstractions, the characters are listed according to sex and are not personalized as in conventional theatre: Man, Woman, Warriors, Maidens. The Man and the Woman are archetypal figures; their story has been enacted and reenacted throughout history. Both the characters and the events reflect the personal individual needs, obsessions, and longings of their creator, as well as those of the period from which they emanated—one that Kokoschka described years later as anxiety ridden and pain dealing, and offering to individuals only a false sense of security beneath which lurked gangrenous fears.[3]

The Man, leader and savior of the Warriors, is dressed in blue armor; he wears a white facial mask and has a reddened bandage over his blue headband, concealing a wound that represents the pain of being.[4] The mask, painted by Kokoschka himself, stands for an outer disguise or covering; it is the persona that all of us adopt in public so as to hide our repressed desires and instincts. Kokoschka used the mask not to decorate or ornament but rather, like the classical Greek dramatists, to reveal the moods and passions of the characters, to underline the play's emotional expressiveness; to replicate visually its inner structure. Kokoschka similarly used color to intensify and give added dimension and dynamism to the play's thrust. The chalk white of the Man's mask suggests the ghastly, ghostly color of the dead, but it also connotes the powder-white face of the clown who frolics about, entertaining onlookers, and whose inner being, like the blood-red gash of his mouth and like the Man's wound concealed by the bandage, is bleeding. It implies that the repressed instincts and emotions—hidden behind the mask—are so potent that their release must surely come in one huge detonation. The blue color of the Man's armor and headband, paralleling the celestial or intellectual sphere, indicates that his rational mind is still somewhat in control, but the hot red blood of sexual desire and his will drive him on and on in his quest for domination and possession.

The Warriors surrounding the Man have bare legs and are like wild animals. The play's directions state that they wear "grey and red headcloths, white and black and brown clothes." They carry flaring torches and hand-bells. Creeping about the Man, they try to restrain him, to hold him back, and while so doing, they shout out their own needs and desires in ever-increasing decibels. Their antagonism breaks through in all its primitive passion. These elemental beings elicit empathy from the audience, not necessarily because of the words they speak or howl, but because of their actions and the primal colors they display with their symbolic equivalents; white and black seem again the colors of death; brown, the color of the earth and of their primitive needs. The blazing torches they carry punctuate the dark world, emphasize the elemental passion at play, and energize the action as they tear the night air with all sorts of pulsations and vibrations, injecting into the atmosphere a fiery, flaming quality.[5]

We were the wheel of flame around him,
We were the wheel of flame around you, stormer
　　of sealed fortresses!　　　　　　　　　　　　　　(P. 25)

This metaphoric imagery, metaphysical as well as literary, exposes the potent forces at work, the power of the transpersonal emotions pouring out onstage. The wheel, being circular in its movement, represents continuity, eternality, cyclicality; it also hastens transportation from one place to another, thereby identifying it with the world of movement and action, the diurnal world. In that this is a wheel of flame, composed of the element that purifies as well as destroys, it may be associated with the Hindu god Siva who dances encircled by a wheel of fire, symbolizing that union of space and time which allowed the creation of the world. In Kokoschka's play, the entrance of the Warriors bearing their lighted torches, spreading their flaming wheel of fire, is a transferal of energy from the abstract (verbal) sphere to the semiotic (sign) realm: intellect, color, action, sound, become one. The Man is at the head of this fiery vision; fire represents wisdom and regeneration, but it also stands for heat and passion—the friction encountered in the sexual act.

The Woman now enters, surrounded by the Maidens. They shriek their utterances in a variety of pitches and rhythmical patterns as they surge forward melodramatically. Red-robed and golden-haired, these primal feminine figures, have power, life, excitement, fire, like the Nordic Valkyries. As in the case with all feminine warriors, their strength appears to the male as a castrating force; in this respect they are not unlike Mave, the Celtic queen, and Cybele, the Near Eastern goddess.

> When I breathe the blond disc of the sun flickers.
> My eye gathers up the rejoicing of men.
> Their stammering desire creeps like a beast around me. (P. 26)

The Woman is the dominant force that compels the world around her to do her bidding. Her breathing recalls the Judeo-Christian tradition when God breathing a "living soul" into Adam—causes the sun to flicker. The sun, which is often identified with the male principle, just as the moon is with the female, is disturbed by her lunar force and power. The ancient Egyptians used the eye as a symbol of the cosmic principle; for them its pupil represented the creative Word (an inner mouth). Similarly, the Woman's eye in its orbit sees through matter, plunges through debris, and perceives reality. In so doing, she exerts her dominion over men. Like Siva's third eye or the single eye of the Cyclops, her sight is endowed with extrahuman power. The Woman also knows that the Man needs her because of his male desire. It is the male's sexual need on which her power rests. Still, the Woman dreams of love; woman, too, needs man.

The Woman is addressed as Our Lady; thus Kokoschka endows her not only with mythological import and Valkyrie power, but also identifies her with the Virgin Mary, the Great Earth Mother, the divine theological principle—Matronna, Madonna. Throughout the drama there are frequent allusions to the Christian religion, as well as to Celtic, Nordic, and Greek mythology. We also see her as the moon, fickle, passive, and mysterious as she emerges from darkness and comes to life only as a reflection of the sun, the active male principle.

The Warriors look upon their master as "the new day rising in the East." For them, too, he represents the sun, his godlike power infusing them with fire, masculinity, virility. They confront the Maidens—both groups being reminiscent of the Greek chorus in that they narrate the happenings, take sides, and sometimes intervene in the events. When the two archetypal forces of male and female meet onstage, they look at each other fixedly, shrieking out their speeches with staccato repetition, lustfully, unabashedly, instinctually, hypnotically drawn to one another.

The First Maiden screams shrilly in exaggerated declamatory fashion, "The fortress gate gapes wide!" (p. 27). She understands what is happening and warns the Woman of the dangers ahead if she yields to her instincts. The fortress, a bastion of strength, like those of medieval times designed to keep out the invader, is also a place of refuge, a cavern, a kind of heart, where the inner being may be experienced and where the soul resides. In the Bhagavad Gita, the fortress with its nine portals stands for the yogi's physical body which is closed to outside attachments, detached from worldly needs. Here, however, the gate, the portal is open wide, indicating a weakness and unresolve in the inner being: to leave it ajar signifies that its interior is unprotected and vulnerable. Without defense, or the application of the rational mind, destruction could easily follow.

The First Warrior, more godlike than the feminine forces, declaims in metaphysical terms:

Whatsoever parts air and water,
Bear skin or feather or scale,
Hairy and naked ghost,
Him they all must serve. (P. 27)

Air and water make animal and human life possible: the bear's skin (earthly instinct); the feather (bird, air, spirit); the scale (fish, water, the unconscious); they all indicate that cosmic factors are also at stake—body, mind,

and spirit. Action is henceforth to be understood not solely on the human or animal level, but as an infiltration of the entire universe, endowing it with spiritual and religious significance.

Emotions now vary; tears, laughter, general hysteria, building toward the climactic, orgiastic event. The First Maiden starts to run, tempting, taunting, luring one of the male warriors to follow her, to catch her in his embrace. The sound of laughter is injected into the merry round as in a *Walpurgisnacht* event. The First Warrior encourages the Man to "embrace" the Woman.

> The neighing drives the mare mad.
> Put the thighs to the beast! (P. 27)

The mare, representative of female instinctual sexuality, introduces a dark chthonic element; this is a night mare (nightmare), that shadowy intuitive feminine nature which imparts the knowledge it has gleaned from the subliminal sphere as blood courses through the veins. The Daughter of Night and of Mystery, the mare is the bearer of life and death, fire and ice, of victory and destruction. Identified with the Woman, she is filled with impetuosity, desire; she is a lunar animal following the sexual patterns of feminine primitive life.

Sexual consummation with the Woman remains, however, for the moment difficult for the Man to achieve. The Woman is now withdrawn; tantalizingly she "rises and falls" yet "never is brought low" (p. 27). She can maintain her pride, power, and strength only as long as she remains unconquered.

> Our Lady is naked and smooth,
> but ever of open eye. (P. 27)

She flaunts her sexuality. The Man and the band of Warriors draw ever closer. The Third Warrior compares her and womankind in general to a fish caught on a hook. Like a fish, those aqueous subterranean creatures, and like the unconscious, feminine nature gradually yielding to sexual desire, the Woman is unaware of her actions and feelings until she is caught by The Man—hooked by him—and then it will be too late for her to disengage. The fish is a religious symbol and refers to Jesus (from the Greek word for fish *icthys* which represents an acrostic formed from the five initial letters *Iesous Christos Theou Hyios Soter*, Jesus Christ, Son of God, Saviour), who was also the

fisher of men, the implication here being that the conflict exists on both a human and divine scale—the result of the dichotomies arising after the Creation, when primordial Unity, Oneness, Wholeness with God, broke up into diversity.

The Second Warrior encourages the Man to catch his prey: "The spider had climbed out of the web" (p. 27); thus indicating that this spinner of webs or yarns, this force that extends throughout the universe, like some central intelligence or psychic emanation, weaves its own circular web, to catch its prey and then strangle it. Just as Athena was enraged by the Lydian girl who dared rival her in the art of spinning, punishing her for her pride in trying to equal a goddess, so the Second Warrior implies that the Woman should not challenge the Man, or she, too, will be punished, tortured, trampled upon. The male here is using his primitive psychology to instill awe at his strength in the female, to weaken her; then he will pounce upon her.

The First Maiden again warns the Woman; she urges her to flee. The Second Maiden, however, restrains her. The Third Maiden pleads with the Woman to rid herself of the Man: he can only hurt us all, she predicts. The Woman, confused and perplexed, shrieks out in repeated lamentations her own fear of being caught and bound and consumed. Weak and wan, the result of centuries of repression, the Woman at last determines to yield to her desire, captivated by the Man's power. Like Pandora in Greek mythology who, despite warnings, unleashed all evil upon the human race, the Woman envisions her future unraveling before her. She rejects the illusion of safety as a false and destructive element that serves only to drain away a sense of reality, thus making her unable to face her actions, to understand the consequences of her thoughts, her weakness and the angst every thinking person must experience if (he or she) is to play a vital part in life. The Woman can see her fate sealed before her; yet, as in Greek tragedy, she acts and reacts like a kind of pawn. She is not the master of her fate nor the captain of her soul; a force more powerful than hers—destiny—compels her to reach out to the Man and bind herself to him.

A fiery conflagration now starts. The Man, angered by her initial reticence, orders his men to "take hot iron and burn my brand into her red flesh" (p. 28), searing the physical body of his victim and thereby wholly possessing her. While the act is being perpetrated, the Woman screams out her pain, leaps into the air, and brandishing a knife, stabs the Man, who falls to the ground. Revenge, hatred, the maiming of the enemy, characterize this primal

war. In agony as his blood pours forth, the Man shouts out his passionate
rage.

> Senseless lust from horror to horror,
> Quenchless gyration in the void.
> Gestation without genesis, sun's collapse, reeling space.
> End of those who brought me praise. (P. 29)

Lust and sexuality are the dominant forces that provoked and incited this
furious and deafening diatribe. The bloodshed is described as "quenchless."
The "gyration"—reminiscent of the gyre in the poems of William Butler
Yeats—will continue to pursue its circular course, as it was stated in the
beginning of the play, spiraling in space, wheeling about in cyclical configu-
rations through the void of the *prima materia* from which the manifest world
was shaped. It is through "gestation," as the text states, that the fruit that
will become young, is nurtured; it is in the uterus that what has been
conceived develops—or else it aborts its treasure. The world, the cosmos, life
itself, collapses under the Man's indictment; the sun, straying from its path,
reels in space—out of orbit, out of focus. The Revelation of John predicts
cosmic destruction; the *Götterdämmerung* of Wagner, based on Nordic my-
thology, also presents the apocalyptic burning of Valhalla—World and Word
coming to an end.

A storm of terror breaks loose on the stage as the live flesh of the Woman
still burns. The action grows increasingly violent, ejaculating its poison into
the atmosphere. A cock crows; the first sequence comes to an end. As in the
Gospel of Mark (13:35) at cockcrow humanity should not be taken by
surprise; it must watch and be on guard. Using the crowing of the cock as a
premonitory warning, Kokoschka thus is exhorting those who read or see the
play to think about the future of their world: not merely in terms of the
deadly battles between the sexes, but as a cataclysmic struggle leading finally
to extinction.

Some of the Warriors now ask the "Grecian maidens" to celebrate their
wedding nuptials close to what seems to be an open bier, thus further
associating sexual union with death. Most of the Maidens draw back in fear,
their love turned to terror, but some of them lie down beside the men,
caressing them in an orgy of sexual abandon. Three Warriors now place the
body of the Man on the bier made of rope and branches, then lift it up,
bearing him to the cage where they lock him up. The cock crows again,
announcing the completion of the second phase of the action.

In the next sequence, the Woman creeps ever closer and closer to the towering blood-red cage. "You, you're not dying," she questions, still drawn to the Man, fearful that his life has already ebbed away. She gazes into the cage where the "tamed wild beast" is incarcerated, his force restrained behind civilization's bars (p. 30). The more repressed the sexual instinct is, the greater are its urges. Hungry for release and life, the Man sings of his need as does the Woman in a kind of twentieth-century Tristan and Isolde *Liebestod.* In a moving apostrophe, the Man rhapsodizes his feelings:

Stars and moon! Woman!
A singing being, bright shining
In dream or waking state I saw.
My breathing unravels dark things.
Mother . . . You lost me here. (P. 30)

The Man holds the entire cosmos in his embrace, crying out to the Woman, the Earth, the Great Mother, for needed warmth, expressing his yearnings for her, begging also for freedom of being. Moved, the Woman responds in rhythmic modulations, containing all possible overtones of sexual longing. She unlocks and opens the door of the cage ever so slowly, tenderly announcing herself as the Man's consort, and like her lunar counterpart, showing herself to be shy, subtle, mysterious. In contrapuntal vocalization, the Man addresses her as Mother, speaks of her reticence, refers to her moonlike qualities: "A sliver of shy light!" (p. 31). Then louder, in almost rapturous frenzy, he cries out "Peace, peace" (p. 31). She is wholly captivated, although still fearful of future violence and domination.

I don't want to let you live. You!
You weaken me—
I kill you—you bind me! (P. 31)

Her reason tells her one thing, provides her with the wisdom necessary to forestall her own demise; it discloses her future in vivid terms; her instincts and emotions, however, speak to her in a different tongue. Unable either to forget or leave him, she thrusts the gate wide open now, and the Man emerges. "A shower of sparks" inundates the stage; the Maidens and the Warriors, seeing fire, flee. The Man runs after them, killing them "like flies." He steps between the paths of flame toward a future life of conquest. The cock crows for the third and last time.

Kokoschka's Pictorial Vision

The poster and drawings that Kokoschka made for *Murderer Hope of Womankind* are graphic distillations of the violence and outrage the artist harbored within him.[6] Like a caricaturist, Kokoschka exaggerated the archetypal characters, which he had originally propounded in the play; he drew them with precision and the deftness of a surgeon using his scalpel. These figures are delineated with a sort of robotlike stiffness; unfeeling, detached, they are shown to be cut off from themselves as well as from the world around them. Their distorted heads and bodies are drawn in nervous forceful lines; their elongated chins and cavernous eyes are covered with strange tattoo marks, bleeding gashes. Unlike Giacometti's wistful, threadlike elongated shapes that seem to reach up to Heaven like church spires divested of their earthly flesh, Kokoschka's architectonic frames resemble disemboweled beings, offering their carcasses to a world that looks on with horror.

THE POSTER

The poster with its stark coloration of blood-red, black, blue, yellow, and white was only in part intended to shock, disrupt, and destroy conventional bourgeois responses and complacency. As Kokoschka suggested in his essay, "On the Nature of Visions," written in 1912: "The state of awareness of visions is not one in which we are either remembering or perceiving. It is rather a level of consciousness at which we experience visions within ourselves."[7]

That inner world of being takes form in the poster. Never fixed or clearly defined, it is perceived in glaring primary colors, in the violence rooted in the Teutonic mythical world. On either side of the poster, the sun and moon are drawn without perspective, as they are in medieval illuminations and in various works by naive artists. These forces, representing the male and female principle, do not eclipse each other; but they struggle, for predominance, encounter each other in the full regalia of their golden hues; they attempt to permeate the universe with their light only, but are unable to do so.

The Skeleton featured on the poster, with its white powdered face and black dress, its skull drooped to one side, is like the head of Christ in medieval representations of the Crucifixion. Its blackened eyes, its long black hair, its gaping gash for a mouth, within which are visible two rows of blackened teeth, are horrifying. The Skeleton's elongated fingers, which clutch a blood-red figure, appear in all their contorted ghastliness. Hands,

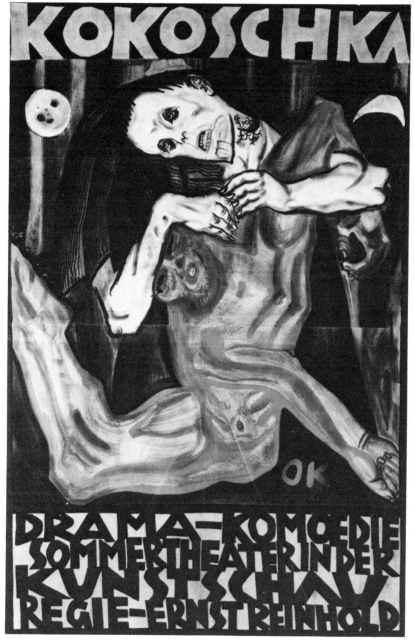

Poster for *Murderer Hope of Womankind* by Kokoschka (Collection, The Museum of Modern Art, New York, Purchase Fund)

those aggressive instruments that reach out into the world, intending and hoping to grasp the object of their desire, have since become a trademark of the artist. Here, too, the hands and arms seem ready to seize and crush. The musculature of the two figures, defined in sharp, rapid brushstrokes on the flat picture plane, vie for dominance. The color is turbulent and speaks out its frenzy and excitement. These grotesque apparitions, these unfeeling and angular entities, reveal the depth of the latent anger inhabiting the artist's psyche.

To accentuate the irrational nature of the delineations, the sex of neither figure is clearly differentiated; the long hair identifies the black figure with the Woman; but the red creature, simianlike in appearance, might well be either male or female. The rigid cultural dichotomies erected by society in terms of male and female, in both customs and religious concepts, are demolished by Kokoschka. Under his brush, once-rigid barriers become fluid. The poster in all of its shattering vision takes on the harrowing quality of Mathias Grünewald's *Crucifixion*, from the *Isenheim Altarpiece*. Human nature, as displayed in Kokoschka's poster—in its violent use of red and black and white—exposes all the anguish and heartlessness of life.

THE DRAWINGS

The drawings also reveal Kokoschka's inner universe, the archetypal images emanating from his collective unconscious—the terror of life as it is now and the dread of that to come. Like Van Gogh and Goya, Kokoschka used his *will* to dredge up his unique vision from the shadowy depths of his psyche. He then eliminated everything from the drawings that did not explicitly relate to the theme and was not absolutely needed to convey the meaning.

The four lined drawings under discussion here are, like the poster, hallucinatory emanations. The distorted forms, the spectral quality, the violence and gore, are somewhat suggestive of Japanese woodblocks of the Nara period with their stark depictions of Samurai warriors. Kokoschka's figures express their outrage and their inherent sadness through the brutality of their gestures; their actions have become stiff and mechanical in keeping with their unfeeling natures. Sensitivity has been destroyed: to hurt or be hurt is their sole means of survival. They have cut their ties with the personal and human level, living out their existences as collective forces, dimensionless entities. Karl Kraus describes Kokoschka's work as follows: "Nobody can

stand before his pictures without seeing at once that the people he represents look as though they had experienced serious illness, or several years in jail, as though they were suffering from repulsive physical and, of course, mental disease. . . . It need not be denied that the way in which Kokoschka attains the effect of his pictures is not one that also leads to the beautification of his subjects; another goal is aimed at by other means."[8]

The characters in the play, as we have seen, exist in a world devoid of continuity, understanding, and feeling. The figures in the drawings also have this same detached, nervous, primordial quality, as though each body had been placed in space and like a mechanical doll had been wound up to hit, strike, force, or cajole all those around him or her without regard for anything else. The figures, like the gestures they make in the drawings, are reminiscent in their flatness of the unidimensionality of many medieval works; they are conveyed by vehement tension-ridden lines, emphasizing their exaggerated facial features and elongated hands and feet.

In Kokoschka's drawings, the Man and the Woman never look at each other; their huge empty eyes never gaze at the opposite person, the implication being that communication between the sexes is not really possible; though sometimes a pretense is made, it is only an illusion. One feature that is highly innovative in Kokoschka's drawings is the way in which he combined both profile and full face in a single image. Each face, being double, is a composite of side and frontal views; this is a technique later used effectively by Picasso in *Guernica* and other works. This device gives his work a primal, archaic dimension. It also serves to underscore the dichotomy that exists, whether consciously accepted or not; for Kokoschka, the values and feelings of men and women were never experienced harmoniously but always antagonistically. A society based on the illusion of happiness, security, and beauty has through the drawings of *Murderer Hope of Womankind* been exposed to the light.

Kokoschka's emanations seem to surge from some strange void. Emerging into being in ghostlike flat shapes, they enact their grimacing sequences in gargoylelike acts; each representing a progressive stripping away of the veneer or facade of cultural pretense, allowing the raw material beneath to be exposed, the elemental turbulence of the instinctual world to be encountered. Interestingly enough, the very hideousness of the distorted forms attracts the viewer; it is as though one were mesmerized by the harsh strength and bluntness of the forces depicted, causing the beholder to give a *Shrei*—a scream, a gasp—which is just what the artist hoped to arouse.

These drawings show a Kokoschka endowed with second sight: an artist who plowed through layers of civilization tore off the mask, isolated the emotions, and forced out into public view all the anguish he experienced so deeply on a personal and collective level. In each of the drawings, he was to capture gestures, expressions, glances, as though he had torn them from his very flesh. The primordial instincts are exposed for all to see. Searching the depths of his being, Kokoschka found and depicted those elements he had believed stultified society. The shaven skull of the Man in the drawings, for example, is reminiscent of penitents and priests of old and of Christian and Buddhist monks today ready to sacrifice themselves, their worldly goods, and their outward appearance for everlasting life—whatever its form. But Kokoschka's shaven-headed protagonist is unwilling to give himself up to the so-called grander force—an illusion of the mind, the artist himself doubtless considered it. He rebels against becoming a sacrificial agent. Fighting against a repressive and repressing world, he seeks to destroy it. Illusion is to be annihilated; reality, allowed to gestate.

The figures in the drawings, as mentioned earlier, are also covered with strange calligraphic marks and signs which represent, perhaps, veins, arteries, muscles, ligaments, and nerve endings; each seems swollen to some extent with bulbous protrusions, as though the blood had clotted. A lifeless world has been born. All beauty and sensual pleasure have been removed from the scene; stark nakedness and flatness of the inner being stand revealed.

The two hybrid beings in Drawing A at first seem to long to come together; they hold hands, each seeks to relate to the other, each is in need of the other, each dreams of the other. However, this yearning for union is shown by the artist to be a trap. An animal, a dog or a wolf, is placed between the Man and the Woman, making true unity impossible. Not a symbol of love or friendship or warm feeling, the animal is reminiscent of the ancient Egyptian god Anubis who escorts the dead to the Underworld; in Kokoschka's drawing, the animal is a divisive entity and a premonitory image—it will escort either the Man or the Woman; like some strange language that only the elect can decipher, it indicates the powerful and ominous forces within the psyche. The Man's protruding forehead indicates perhaps the void that exists in his conscious, rational mind. His elongated chin—an instrument of aggression—his socketlike eyes, his chiseled teeth, are set against the toothless Lorelei with her tear-stained eyes, long hair, half-naked form, expressing a love-hate relationship. An orifice is exposed—perhaps the umbilical cord that binds the Woman to her offspring (the Man). She may be considered as

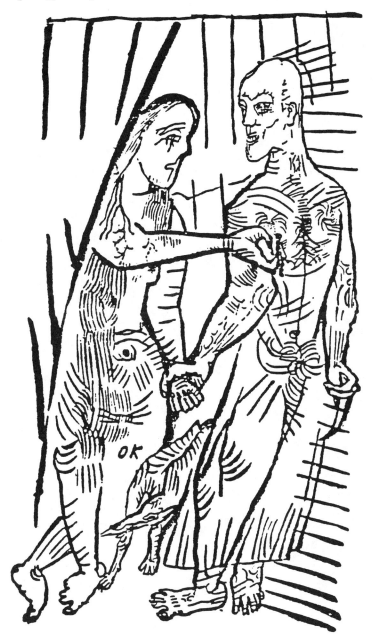

A. Drawing for *Murderer Hope of Womankind* by Kokoschka (Cosmopress, Geneva, and ADAGP, Paris)

a kind of Great Earth Mother who dominates the world around her—or is the hole that Kokoschka drew a symbol of the vaginal void that lures and allures, tames and destroys, man?

Both figures seem to be imprisoned in a network of angular and circular lines. Perhaps these hatchings symbolize society's values that restrict and

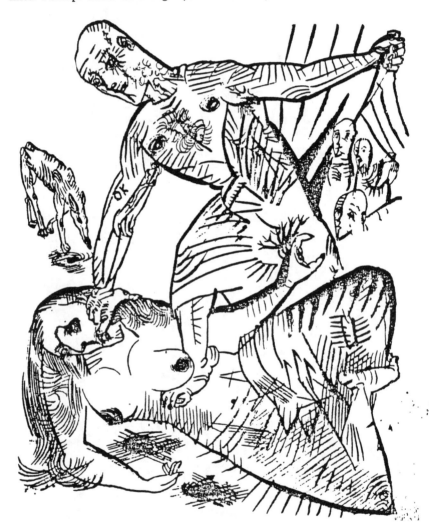

B. Drawing for *Murderer Hope of Womankind* by Kokoschka (Cosmopress, Geneva, and ADAGP, Paris)

wreak havoc upon the psyche, but certainly they represent the bars of the cage in which the Man is later placed. The tense, abrupt, jagged lines articulate feelings of outrage as each, whether moving from right to left or vice versa, seeks to destroy the limitations imposed by time and space.

The savage visceral quality is even more evident in Drawing B in which the Man is shown stabbing the Woman. The Woman is held pinned to the ground; her large breasts are no longer seen as nutritive forces but as sexual symbols—like large balloons ready to be played with and enjoyed, then punctured with a knife. Only one of the Woman's feet is visible; the other remains imprisoned within her skirt. Like Undine, the water spirit, she lures but never satisfies the Man, not because she does not want to, but because she is incapable of doing so. Man's anger rages as his dissatisfaction mounts; he looks at her as his salvation, not realizing that no one but the individual person may make peace with himself.

The Man's foot is placed heavily on the Woman's stomach, as if to crush and destroy the womb, the gestating area where new life comes into being. The yet-to-be must be destroyed; the Woman must be desexualized, sterilized, so that the sequence of life and death can cease its cyclical course. The "mother of sorrows," as she is alluded to, indicating Kokoschka's view of the *Pietà*, must never again procreate. The knife that the Man thrusts down upon the Woman serves to end her existence. In Freudian terms, the knife is to be looked upon as a phallic symbol, ready to penetrate. It may also be symbolically considered a magical instrument, dividing, separating problems into their component parts, attempting in this way to examine each of the segments, to analyze, scrutinize, x-ray them all, before piecing them together again. Thus, the Man unconsciously attempts to liberate himself from the Woman, believing that by cutting himself loose he will no longer be enslaved by his ambivalent feelings. A dog or wolf—representative of nature—reminiscent of the animal in Drawing A, watches these destructive and death-dealing antics. He seems to sniff, to listen, to grasp the essence of things, slinking toward the fighting struggling beings, awaiting with patience his hoped-for meal of meat. As carnivorous as man is, so too is this animal; each in his own way symbolizes a universe that feeds upon itself, thereby allowing life to pursue its course.

The sharp contours used by Kokoschka to delineate his Man and Woman are further hardened in Drawing C, which is even more chaotic in theme. The sun and the crescent moon are in evidence, as they are in the poster. The Woman, as if hovering in space, is attempting to grasp the Man by the

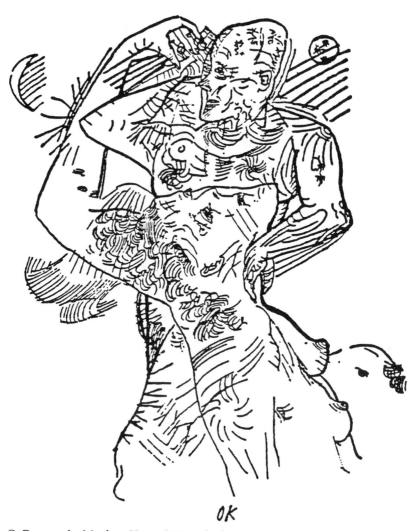

C. Drawing for *Murderer Hope of Womankind* by Kokoschka (Cosmopress, Geneva, and ADAGP, Paris)

shoulder before she breathes her last. Her face is contorted, like those in South Sea masks or Chinese visualizations of the T'ang period. She wants to express the anger and pain she feels as she is about to die, to assert herself one last time, and to declare herself man's equal. Aggressive, driven, she battles

to the last and loses the struggle, beaten down in her attempt to fuse into one what is essentially two (man and woman).

Kokoschka's beings shiver with distress, with impetuosity; their drives are expressed in gyrating vibrations, like repeated gunfire, in rapid, vital pulsations. In the end, however, the Woman, finally subdued, is portrayed nude, her breasts, no longer full and round, have lost their nurturing, vital quality, indicative of despair, hopelessness, the deadening of her spirit. Her gaping, triangular slitted eyes gaze out unseeingly, as if emerging from diverse sequential planes, onto a network of interlocking lines; her hair, defined in circular and semicircular configurations, suggests a being at odds with herself, beset by attraction and repulsion in their most elementary forms.

D. Drawing for *Murderer Hope of Womankind* by Kokoschka (Cosmopress, Geneva, and ADAGP, Paris)

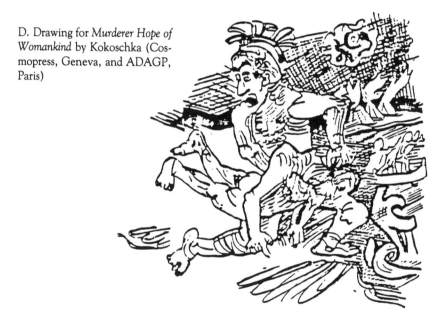

In Drawing D, both figures are asymmetrical. Their imbalance represents insecurity in the outside world and in the elusive domain of the spirit. Struggle, schism, are wrenching apart not only the Woman and the Man, but also the humans and God. Shown here in profile and in full face is the rest of the group of Maidens, fleeing in disarray, the lines growing increasingly chaotic and wavering. The Man's mouth is open as if shouting out in a victorious song his pleasure in his power over weaker beings. As God is depicted by so many painters, so, too, he wears a crown of gold, chanting his

battle hymn of conquest, his huge dark eyes bearing a look of hysterical elation. The crisscrossing linear signs accentuate the activity, the energetic effect. There is no channeling of power, no fusing of focus, only dispersion, a severing and shattering of what once had been bound; fragmentation fills the spatial area as flares blaze forth in a space-time continuum.

Kokoschka once suggested that one must be "aware of such imagery," implying that repugnant and sordid visualizations are a part of life; life selects from infinite forms what best suits its purpose.[9] Each of the drawings illustrating *Murderer Hope of Womankind* emphasizes the relationship as well as the isolation of the figures, thus underscoring the disparity between the part and the whole, and the one and the two, the ambivalence existing within the psyche as well as its counterpart in the cosmic sphere. Although the lines are striated in each of the drawings, light shines from the empty spaces, like sparks of brilliance set against empty blackness. Kokoschka's macrocosm is full, active, electrically charged; it communicates in blunt, searing images what has come into being from the subliminal sphere of this artist and visionary.

Kokoschka knew that hate and violence, love and peace, considered in their general sense, imply a basic duality or opposition within the forces inherent in the universe. This duality or opposition in nature causes activity, just as friction generates a form of energy—electricity. If opposition were nonexistent, then there could be no action, no change. Even looked upon as a perpetual cycle of warfare and destruction, life is a process that is implicit in the cosmic flow. There arises, on the other hand, an equally strong drive for unity or synthesis to gain relief from such antagonism. In the phase of preexistence, before Creation and differentiation occurred, there was unity but because life, as we daily live it, requires a state of change and activity, Oneness is incompatible with it. Conflict, therefore, is essential as a natural life force. It is the ferocious nature and intensity of the struggle that is of import in *Murderer Hope of Womankind;* the artist's goal is to reveal the viscerality inherent in the inner happening. To quote Kokoschka himself: "everything we can communicate, every constant in the flux of living; each one has its own principle which shapes it, keeps life in it, and maintains it in our consciousness. . . . All that is required of us is to RELEASE CON-TROL. . . . All laws are left behind. One's soul is a reverberation of the universe."[10]

8

Virginia Woolf:

Impressionism and Cézannism in *To the Lighthouse*

Virginia Woolf (1882–1941) transmutes the techniques of the French impressionists and the concepts of Cézanne in her novel *To the Lighthouse*. Her heightened awareness of the painter's technique, blended with the stream-of-consciousness method, endowed her novel with drama, sensuality, and spirituality. The growth of her characters, which results from the unfolding of Woolf's intricate visual and psychological patterns, is presented to the reader by means of form, composition, mass, line, pigmentation, and shading of light and dark. Aesthetic reasons were, however, not solely responsible for her adoption of these techniques; psychological considerations also influenced her. In that Virginia Woolf was what in Jungian terms is known as "a feeling and intuitive type," that is, her thinking function was underdeveloped, she projected the contents of her unconscious on what she saw and experienced. For Woolf both the impressionists and Cézanne fulfilled a psychic need: the impressionists answered the requirements of her feeling function, and her study of Cézanne helped develop the primitive thinking sphere within her psyche.

To the Lighthouse (1927) is, in great part, an autobiographical novel. The setting and characters are drawn from Virginia Woolf's own childhood, when she with her parents and their seven other children—three of them from her mother's and one from her father's previous marriages—spent long happy summers at St. Ives in Cornwall, in a house overlooking the bay and the Forevy Lighthouse.[1] These idyllic times came to an end in 1895 when her mother died at the age of forty-nine, after which Virginia had her first mental breakdown. Thereafter, her father lived in gloom, going through painful moments of deep grief and insecurity that demanded constant attention and sympathy from those around him. Although Virginia and her older sister, Vanessa, and her brothers, Thoby and Adrian, agreed that he was self-indul-

gent, self-pitying, and egotistical, they nevertheless cared for him with solicitude until his death in 1904, after which Virginia had her second breakdown.

It is not surprising that Virginia Woolf incorporated the painter's eye into her own prose. She came from a highly cultured environment. Her father, Sir Leslie Stephen, was a distinguished editor and man of letters, who had begun his career as a fellow at Cambridge University. Psychologically, an introverted thinking type, he was rational in all his statements and very much at home with abstractions and logical argumentation. Julia Jackson Duckworth, Virginia's mother, who also came from a distinguished family, was a beauty, and, psychologically, quite the opposite of her husband. A feeling and intuitive type, she was deeply concerned with the well-being of her family and friends. Painters, such as Burne-Jones and Holman Hunt, and writers, notably James Russell Lowell, Thackeray, Tennyson, George Meredith, Henry James, and Thomas Hardy were frequent visitors at the Stephens' home.

After her father's death, Virginia and Vanessa moved to 46 Gordon Square in the Bloomsbury section of London, where they surrounded themselves with their brother Thoby's Cambridge friends. Their circle, which came to be known as the Bloomsbury group, included Lytton Strachery, Clive Bell, Roger Fry, David Garnett, Duncan Grant, Leonard Woolf, and E. M. Forster. Vanessa, who became a painter, married Clive Bell, an art and literary critic; his volume *Art*, published in 1914, contributed much to contemporary theories about style and aesthetics. Roger Fry, who was a painter and an even more distinguished art critic, became a habitué of the Bells' Bloomsbury home and eventually Vanessa's lover. Virginia's friendship with Roger Fry continued, however, and his influence on Virginia's literary and aesthetic development was significant. Her own marriage in 1912 to the writer, critic, and economist, Leonard Woolf, did not alter the warmth of their relationship.

It was Roger Fry who was responsible for introducing the work of Cézanne and other postimpressionist painters into England.[2] Impressionism, as Monet, Sisley, Pissarro, and Renoir practiced it, sought to capture the rapid visual impressions of the artist by painting directly from nature. The impressionists broke up masses or surfaces by using small patches of color, which allowed them then to reproduce very special luminosities. Fully developed impressionism centered around the *plein-air* doctrine, or *divisionism*, that is, the use of spectrum palette and optical mixing to retain the impression of light at one

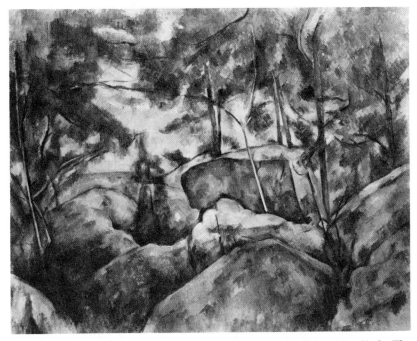

Rocks in the Forest by Cézanne (The Metropolitan Museum of Art, New York, The H. O. Havemeyer Collection, Bequest of Mrs. H. O. Havemeyer, 1929)

specific moment.[3] Psychologically, one may say that the feeling function dominated the impressionists' attitudes and relationships with the outside world as well as their subjective views toward brilliantly or pastel-colored visualizations of mountains, rivers, fields, haystacks, and still lifes. Monet, for example, who wished to paint things as he saw them had no desire to organize what he saw into formal compositions. He valued above all else what pleased his eye and what gave him pleasure or pain.

Unlike the impressionists and their continuous interest in the optics of color and feeling tones, Cézanne's goal was to organize and articulate forces he believed existed beyond the visible world. Vivid color alone was not sufficient for Cézanne, an introverted thinking type. He wanted to create depth in shadows and outlines, to delineate an arcane world that existed beyond or beneath the surface outer form, for example, that of poplars, mountains, or the fruit in a still life. It was his intention to paint nature concretely in both its interior and exterior aspects. In a letter to Emile Bernard, he wrote:

treat nature by the cylinder, the sphere, the cone, everything in proper
perspective so that each side of an object or a plane is directed towards a central
point. Lines parallel to the horizon give breadth, that is a section of nature or,
if you prefer, of the spectacle that the *Pater Omnipotens Aeterne Deus* spreads
out before our eyes. Lines perpendicular to this horizon give depth. But nature
for us men is more depth than surface, whence the need of introducing into our
light vibrations, represented by reds and yellows, a sufficient amount of blue to
give the impression of air.[4]

The structured elements in Cézanne's approach to painting, Fry suggested,
stemmed in part from Cézanne's love of the old masters. For him a painting
was constructed of planes, solids, modifications in color and light. It should
possess a basic unity and solidity, not merely verisimilitude. When depicting
nature, Cézanne, of course, often used the rich subtle variations in color of
the impressionists; but to such visible pictorial elements he added his own
structure and organized space into form and depth, penetrating deeply
beneath the surface of the picture plane.

Impressionism, one might say, reflects the feeling type as defined by Jung,
whereas in the case of Cézanne, it is to be identified with the thinking
function. Both are intuitive modes, but the thinking person uses intellectual
formulas to direct his thought processes for his ideas are linked together by
concepts. The use of ideations in the creation of a canvas or a literary work
relies heavily on structure and patterns of thought activity determined by the
will. Thus, sequences of images are built up through observation, data,
factual information, and frequently through abstraction.

As Virginia Woolf was a feeling type, she reacted similarly to the way in
which the impressionists depicted the sensate outer world. The feeling type,
according to Jung, is not necessarily a hyperaffective or emotional person—
although he may possess these characteristics. Feeling is a *rational* function
that calculates and reasons in terms of what is good or bad, pleasing or
unpleasing to a particular individual. Such a person determines values
according to the above criteria, not according to abstractions; for him
decisions are not necessarily regulated by external events, but rather by
internal feeling tones or sensations. The thinking type of person orders his
(or her) world through concepts; the feeling type, through subjective values.[5]

In *To the Lighthouse*, Woolf used what she had learned from Cézanne and
the impressionists to describe her perceptions in an almost continuous flow of
superb prose visions. Because she was a feeling type, she saw into relation-
ships and had a profound understanding of connections between people and

things. Her mind worked through association by leaping from one image to another, from one sense impression to the next, and was agitated sometimes to the point of disrupting a smooth-flowing passage with highly intuitive insights. Feeling was a cognitive agent for Woolf that allowed her sense perceptions to function powerfully and deeply. The solid, bonelike quality of the framework that supports the entire structure of her novel was influenced by and even modeled on Cézanne's well-thought-out semiotic universe. In *To the Lighthouse*, Woolf fused feeling and thinking with intuition; these characteristics endowed her novel with the timeless character of true art.

To weld abstractions into amorphous images and to transform them into words require work, patience, and skill. The images that flashed into Woolf's mind had to be actualized in a language that would express meaning and sensation in terms of form, shape, and color. Cézanne himself described the leap that must be taken from the initial perception to its reproduction as flesh, blood, and psyche in literary form.

Literature expresses itself by abstraction, whereas painting by means of drawing and color gives concrete shape to sensations and perceptions. One is neither too scrupulous nor too sincere nor too submissive to nature; but one is more or less master of one's model and, above all, of the means of expression. Get to the heart of what is before you and continue to express yourself as logically as possible.[6]

To achieve her goal might have been less arduous had Woolf not rejected the conventions of the traditional novel with its plot and subplots, naturalistic characters and setting. For these she substituted her own adaptation of the stream-of-consciousness technique in which she compressed all outer and inner forces into a new space-time continuum that reflected and psychologically determined a given character's interior at a specific moment. Her depiction of objective and subjective reality through association, symbol, repetition, and a very personal use of syntax enabled her to translate into visual terms aspects of meanings and sensation. Because she presented her images in infinite gradations of color, mass, form, and rhythm, they became analogues of a whole psychological climate.

Woolf's visual approach to writing—influenced by the impressionists and Cézanne—allowed her to connect the disparate, give shape to the chaotic, and depict past, present, and future in unwinding patterns. It also made it possible for her to atomize her characters' sensations, yet portray them in sweeping motion. She underscored feelings of dread, isolation, and power-

lessness by verbal visual determinants, that is, fragmented sequences etched into a cohesive whole. What had been undervalued or overvalued in the psychological sphere (either feeling or thinking), Woolf balanced with her own brand of literary impressionism and Cézannism. Fry's statement concerning Cézanne is applicable to Woolf's literary optic in To the Lighthouse:

> the ultimate synthesis of a design was never revealed in a flash; rather he approached it with infinite precautions, stalking it, as it were, now from one point of view, now from another, and always in fear lest a premature definition might deprive it of something of its total complexity. For him the synthesis was an asymptote towards which he was forever approaching without ever quite reaching it; it was a reality incapable of complete realization.[7]

Only when one has mastered one's technique, Cézanne declared, can the artist possess himself of his vision. To achieve this goal requires the completion of a rite of passage, that arduous journey connected with the transmutation process, of moving from the initial conception to its visible existence. Woolf's trajectory, her unconscious quest, which was to connect the psychological disparities within her and to blend them into a harmonious whole, was accomplished in this superbly structured novel. She later wrote that she hoped that readers "would make it [To the Lighthouse] the deposit for their own emotions" as it had been for hers, that they would "relate and experience the images, characters, colors, and rhythmic patterns in accordance with their understanding and psychological makeup."[8]

To the Lighthouse is divided into three sections; "The Window," "Time Passes," and "The Lighthouse"; each step reflects the completion of its author's literary, artistic, and psychological quest. Each is discussed below in terms of its specific images.

"The Window"

The very title of this first section, "The Window," suggests dichotomy; the distance and difference existing between a framed interior and an unframed exterior space. There is the interior world contained within the house or psyche and the exterior world without, incorporating uninternalized space and reality. Each is dramatic in its own way. The picture space as it exists in "The Window" represents a circumscribed world, a unified family unit, a paradigm of the feminine universe. The house is then a repository for a certain kind of wisdom, that of the mother in both her positive and negative

attributes. Depending upon which spatial level within the house is empha-
sized, the interior may also be viewed symbolically as representing various
layers of the psyche. The window is designed to provide light within and sight
without, thereby paving the way for interrelationships between external
(extroverted) dimensions and internal (introverted) ways. A window is to a
house what eyes are to the body: a means of looking out upon the world.

The real world, the objective daily world, exists beyond the window frame.
During the course of this first section of the book, the eyes of both the reader
and the characters shift from inside or outside the window to the walk leading
to the house, and then to the village, and the lighthouse across the bay.
Moving from the garden to the lighthouse, out of or into the window, the
observer grasps the happenings as a cohesive whole. These movements
catalyze the reader's cerebral and emotional reactions by opening up to him
or her new spatial areas, and his or her eyes are led up and down, back and
forth, diagonally, vertically, and horizontally by the scope of Woolf's
configurations. This constant unrest not only transforms the sensations
evoked by the altering pace of rhythm, form, mass, color, and line in these
verbal pictures; it also draws the reader into a complex world composed of
unfamiliar tonal values.

THE WINDOW

The opening pages of *To the Lighthouse* show Mrs. Ramsay, the protagonist,
sitting framed in the window of the drawing room talking to her small son
James while she knits a pair of socks for the lighthouse keeper's little boy.
James, seated on the drawing-room floor, is cutting out pictures from an
army-navy catalogue; and in the course of their conversation, Mrs. Ramsay
assures him that if the weather tomorrow is pleasant the family will sail over
to the lighthouse. To go on this journey is James's most cherished ambition.

Mrs. Ramsay, fifty years old, is still beautiful. The mother of eight
children, she stands out as a protective, sympathetic, and compassionate
person, forever looking for ways in which to cushion life's abrasions for
others. A feeling type and intuitive as well, she sees into people and
experiences them for what they are. She thinks and senses in terms of the
natural world of which she is a part. Neither hyperemotional nor overly
affective, her judgments depend upon her feelings. *She feels what she is,* is
aware of her characteristics and attributes, and is thus in harmony with
herself and the part she plays in life. It is important for her to love and to

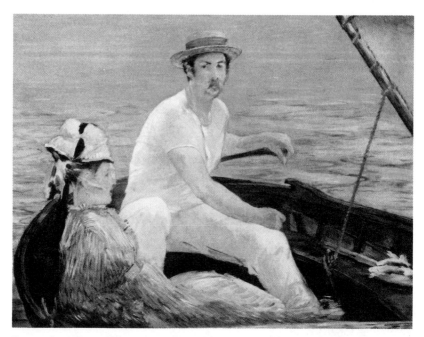

Boating by Manet (The Metropolitan Museum of Art, New York, The H. O. Havemeyer Collection, Bequest of Mrs. H. O. Havemeyer, 1929)

know that she is loved in return. Her presentiments about relationships among both her family and friends allow her to understand emotionally complex situations, which, rather than analyze in abstract terms, she evaluates in terms of her own personal sentiments. To her family and friends, Mrs. Ramsay seems to be goodness incarnate. The colors in which she is portrayed are usually white, gray, and blue; the designs drawn by Woolf to reflect her mood are circles and curves.

Strong emotions are, nevertheless, contained within the framed interior. In their enclosed private universe, mother and son share a feeling of well-being. They privately indulge in their own fantasies. Mrs. Ramsay envisages six-year-old James as a future barrister and judge, robed in ermine and red. He harbors happy thoughts of sailing to the lighthouse, and his mother encourages him when he voices his dream to her, saying that if tomorrow is fine he may indeed go. It is at this juncture that the world outside the window intrudes as Mr. Ramsay appears, and stepping up to the level of the drawing room, announces, "But . . . it won't be fine" (p. 10). The wind,

he continues, is rising; a storm is beginning to brew. An interior storm is now stirring within James. His anger causes him to visualize an ax, a poker, and a knife, instruments of dismemberment and death. The son's hatred for his father, who is associated with the objective, outside world, is instantly aroused. Mr. Ramsay has intruded into the serenely gentle oedipal realm of mother and son, and his harshly rational, logical, factual outlook is the antithesis of his son's mysterious dream world. Mr. Ramsay's patriarchal or judgmental sphere is identified with an "uncompromising" view, focusing on the need for "courage, truth, and the power to endure" (p. 11) as opposed to the gentle matriarchal rule of Mrs. Ramsay.

Mr. Ramsay, the reader gradually discovers, is a professor of philosophy with a speculative, cold, aloof personality. He is remote from the larger family unit and relates only to Mrs. Ramsay—and then only on his own terms. Forever observing life intellectually and from a distance, as if evaluating an important principle, he is described as having "never tampered with a fact" (p. 11). His interests lie in the depiction of intellectual formulas. An example of the objective thinking type, he is more than willing to sacrifice human relationships to abstract principles.[9] Because for him feeling is an inferior function, he is quite unable either to understand or really to relate to others. Hence his aloofness keeps him from understanding the impact of his remarks upon his youngest son. He disrupts the inner harmony of mother and son; he brings sharp, angular planes and structured elements into the magical world of circles and cones. The split in the family structure is now clear, the contrast of the maternal tenderness and understanding of Mrs. Ramsay, and her youngest son's dependency on it, with Mr. Ramsay's dry and arid cerebrality that alienates him from his children's secret domain.

In To the Lighthouse, words are daubed and splashed in impressionistic dots of color, nuances, and overtones, which accentuate subtle gradations of emotion; heightened lights or shadow sometimes fill the atmosphere as the reader is drawn out of the circumscribed happy, domestic, feminine realm into the foreign, uncertain, outside world of imponderable space—"leaves whitening before rain, rooks cawing, brooms knocking, dresses rustling" (p. 9). Each descriptive word takes on continuity and consistency by the pictorial image it creates.

In keeping with Cézanne's dictum of bringing everything one wanted to include in proper perspective, "so that each side of an object or a plane is directed towards a central point,"[10] Woolf shifted relationships by introducing the divergent personalities of Mr. and Mrs. Ramsay and by psychologically

casting certain objects within their orbit. Like a painter who intends to establish connections between people and things on canvas, Woolf patterns her protagonists, whose awareness of themselves and others may, or may not, develop during the narrative. They are presented not only in terms of form and coloration, but also, and far more significantly, in terms of their placement within or without the pictured window frame. By means of this visual device, Woolf was able to establish either an affinity or lack of it between her characters, moving the creatures of her fantasy around as a chess player moves chessmen around a board. The fact that Mr. Ramsay is outside the window frame indicates that, at least by his son, he is felt to be an intruder, an icy force that congeals the warmth within. There is a physical and emotional separation between the framed interior space and the world exterior to the frame where the maternal feminine does not necessarily reign.

Mr. Ramsay's statement causes fear and resentment in his small son. Mrs. Ramsay, realizing this, however, counters her husband's self-important remark, tells James, "But it may be fine—I expect it will be fine" (p. 11), and James's mercurial emotions, which flared only moments earlier, diminish in intensity as serene matriarchy again takes over.

Carefully and methodically, Woolf gives depth and reality to Mrs. Ramsay's feeling world. Like a draftsman figuring out spatial considerations and dimensions, she puts down the contours and colors within the confines of the visualized scene. Mrs. Ramsay connects events and people as well as ideas by means of valuations, which are actually attributions of her own consciousness;[11] she weighs and values, but it is always her heart that is the barometer. The particular person and the situation itself are only the point of departure. From this standpoint she is a paradigm of Pascal's dictum: "The heart has its reasons that reason cannot understand." Perhaps unintentionally but effectively, nevertheless, in her own way, she dominates the home and all connected with it and determines the destinies of everyone with whom she comes in contact.

THE WALK

Mrs. Ramsay is next seen having stepped out of her framed domestic existence. She is strolling to the village with a friend of her husband's, "the atheist Tansley"—a young man who is highly unsure of himself. Like Mr. Ramsay, Charles Tansley is a cerebral type, and also like Mr. Ramsay, he has earlier in the book predicted inclement weather for the following day, making James's longed-for journey to the lighthouse impossible.

Woolf portrayed Charles Tansley by inserting into the mass of her prose daubs of pure color, thus impressing form and texture into the substructure of his being. In other words, the character of Tansley is conveyed through metaphor, synecdoche, and visual detail, all endowed by these means with emotional value; for example, Tansley is "all humps and hollows" (p. 15), and his "bony fingers" feel the wind blowing through them. As a character he is stripped of all extraneous accoutrements, pared down to essentials; he is a leaden, rigid skeletonlike structure devoid of feeling and warmth.

Removed from her initial framed setting, Mrs. Ramsay joins Tansley to go on a number of errands to the village and afterward they walk down to the quay, "she holding her parasol erect" (p. 25), where there is "the whole bay spread before them" (p. 23). In a description reminiscent of the painting *A Sunday Afternoon on the Island of the Grande Jatte* by Seurat, the reader sees Mrs. Ramsay stepping into the outside world of space and distance on her own terms; her composure brings calm to the environment. She blends into the delights of the landscape, but nonetheless she can be impassioned as when she exclaims, "Oh, how beautiful!" (p. 23). The bay and the lighthouse are both encompassed in her gaze; objects, quite disparate in essence, are blended and integrated in the expansive nature of her embracing sight. Alternating patterns of sensations are interwoven in Woolf's verbal canvas, depicting a veritable *hieros gamos*: integration of inner and outer worlds, of matriarchal spheres with a stable lighthouse looming like a steeple amid fluid and formless waters. "For the great plateful of blue water was before her; the hoary Lighthouse, distant, austere, in the midst; and on the right, as far as the eye could see, fading and falling, in soft low pleats, the green sand dunes with the wild flowing grasses on them, which always seemed to be running away into some moon country, uninhabited by men" (p. 23). Words such as "plateful" and "pleats" (identified with the watery expanses, the unconscious, the uterine sphere), the alternating currents, and the changing moon are juxtaposed with the unchanging, erect shape of the lighthouse.

Woolf's verbal pyrotechnics focus on Mrs. Ramsay. She alone matters as she walks on the quay, and Tansley feels an "extraordinary pride" as he walks beside Mrs. Ramsay. A new dimension has entered his world—the pleasure principle. He feels "the wind and the cyclamen and the violets" in the air because he is accompanied by a "beautiful woman" (p. 25). Splashes of impressionistic color—purples, grays, whites, greens, glimmerings of opalescent hues, azure blues, deep mauves—appear throughout this scene. Although disparate, they create order and synthesis by means of Woolf's

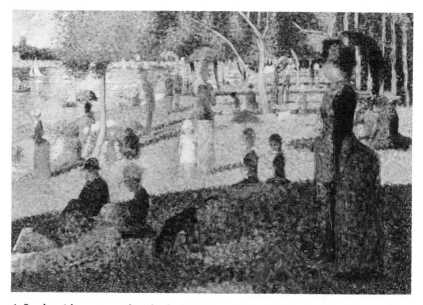

A *Sunday Afternoon on the Island of the Grande Jatte* by Seurat (The Metropolitan Museum of Art, New York, Bequest of Samuel A. Lewisohn, 1951)

brushstrokes. The heretofore empty sky and bay—churning waves and dense masses—acquire spiritual depth and definition, simply through Mrs. Ramsay's witness and presence, and by Tansley's reaction to it. Womanly caring and feeling have penetrated the world of arid abstractions and of empty prognostications. Tansley's masculine nature, so long barren and empty, has been stirred, his blood warmed. Now he knows enrichment.

THE PAINTING

The problem of the artist is explored in this first section of *To the Lighthouse* through the character of Lily Briscoe, an unmarried thirty-three-year-old painter who spends much of her life looking after her widowed father. She is in the process of painting Mrs. Ramsay, seated in the window frame with James, and her goal is to create a fresh personal vision with spatial colorations, form, texture, balance, and depth. To succeed in such an undertaking requires, as Cézanne suggested, mastery of technique as well as *possession of oneself*.[12] Lily, however, has yet to realize her own capabilities and identity. She knows that if she is to continue to paint she must develop a certain consistency and autonomy, and that only then will she grow in confidence in

herself and in the mission she has set for herself. Lily's painting—its progress or lack of it—parallels her inner evolution; it is a reflection of her life.

In Lily, the separation between the aspects of the woman and artist is not clearly defined; each exists in the subliminal realm *in potentia*. Lily is haunted by her inability to reproduce on canvas the beauty of her inner sensuous vision.

> The jacmanna was bright violet; the wall staring white. She could not have considered it honest to tamper with the bright violet and the staring white, since she saw them like that, fashionable though it was. . . . Then beneath the colour there was the shape. She could see it all so clearly, so commandingly, when she looked: it was when she took her brush in hand that the whole thing changed. It was in that moment's flight between the picture and her canvas that the demons set on her who often brought her to the verge of tears and made this passage from conception to work as dreadful as any down a dark passage for a child. (P. 31)

The reader first sees Lily standing in front of her easel on the lawn. She is described as having "little Chinese eyes" and a "puckered-up face" (p. 29). Lily is trying to concentrate on her painting but she senses an intruder and is distracted. It is not, however, Mr. Ramsay but a house guest, the widower and botanist, Mr. Bankes. "Scrupulous and clean," cerebral also in his own way, but imbued with compassion and understanding, he is psychologically a "bridging" figure, one who stands midway between the overly cerebral Mr. Ramsay and the emotionally responsive Mrs. Ramsay. He can, therefore, relate to Lily, and in his own way understand her aims as an artist. Later, Mrs. Ramsay is suddenly to hope that Mr. Bankes and Lily will one day marry.

Like Mrs. Ramsay, Lily is a feeling type, but is capable of developing her thinking function. Unlike Mrs. Ramsay, who is fulfilled, Lily is incomplete; she is unloved, and until recently has herself been incapable of giving affection. Her inner world is as vacant as the canvas she is trying to fill. Her inferior thinking function works slowly, impedes her creative process, and diminishes her capacity to relate to others. She adapts only with difficulty, sees things symbolically, and frequently feels alienated from her environment. She cannot bear it when Mr. Bankes or, particularly, Mr. Tansley criticizes her work and questions the artistic abilities of women in general. Self-conscious, she must be approached only at the right moment when she is in the right mood.

Lily is unsure of herself because she has yet to develop her own capabilities and talent. She is insufficiently objective about herself, too little distance exists between the *I* and the *Thou*, subject and object, ego and self. Her vision is blurred, her world buried in intangibles or fixed in dichotomies. Nothing seems to be truly hers; she has neither order nor visible structure. Therefore, when someone whose outlook is alien to her own approaches her, Lily is inhibited—even disabled—by fear. Lily has thus not yet been able to complete a creative work. She has yet to find her own groundbed and gain a sense of her own uniqueness and talent. Should she not do so, vision and talent may come to nothing for it is essential for her as an artist to explore the depth of her inner being, to discover the extent of her own inner wealth.

The struggle to create and the torment Lily feels as she mixes her paints and tries to transfer her subject onto canvas are excruciating; she forces herself, however, to hold onto the remains of ineffable feelings "which a thousand forces did their best to pluck from her" (p. 32). Her senses help her cognitively and encourage her to question the validity of her vision: "But this is what I see; this is what I see" (p. 32).

Lily idolizes Mrs. Ramsay and the maternal, domestic life surrounding her; therefore, she is not in a position to evaluate Mrs. Ramsay's positive and negative qualities. In Lily's eyes, Mrs. Ramsay is a *complexio oppositorum*, a perfect being, not a flesh-and-blood woman. Lily senses what she wants to create in paint but lacks the focus and technique to bring it to fruition. There are moments when she grows desperate and would like "to fling herself . . . at Mrs. Ramsay's knee" and tell her "I'm in love with this all" (p. 32)—that is, with Mrs. Ramsay's fulfilled feminine existence.

As a "medium" figure, Lily, who reflects Mrs. Ramsay's moods and the household climate in general, does not generate life. To underscore her passive world, her subjective relationship with Mrs. Ramsay, Lily gazes out over the bay and tries to telescope her vision, to squeeze nature's infinity into her own frame of reference. But she is unable to grasp the meaning of the vast expanse of open water mirrored in the bay and the unending ocean beyond, or the ardor and tensions implicit in the push and shove of the waves as they break against "a sailing boat, which, having sliced a curve in the bay, stopped; shivered; let its sails drop down" (p. 34). The wall and cylindrical hedge that enclose the garden, the nearby angular rocks, the perpendicular trees and their spreading rounded foliage, and the other horizontal and vertical lines delineated in the author's panoramic description of the view are

beyond Lily's comprehension. Her spatial geometry is elementary; her inner world is merely sprinkled with sense impressions.

In describing Lily's painting, the bay, the sea, the sailboat, the house, Woolf was concerned with the placement of objects in terms of receding or increasingly magnified space and planes, each graduated in terms of the situation of the moment, each reflecting a psychological mood and tonality. In so doing, she gave concrete substance to her vision; she followed Cézanne's suggestion, to concentrate on form and depth—whether rendered by means of cylinders, cones, or spheres—to bring into being a powerful emotional dimension. In describing the lighthouse surrounded by waves, or the lawn and the house enclosed by the hedge, and by setting the principal characters in the foreground, Woolf varied her distant and closeup spatial elements, thus creating a truer relationship between background and foreground, objects and people.

Mr. Paunceforte, an artist and an earlier visitor at the Ramsay home, had once suggested to Lily that she should paint conventionally, perhaps in the style of a Puvis de Chavannes. But such a suggestion was anathema to Lily. She wants to fill her canvas with vivid colors and exciting rhythms, hoping thus to give shape to her inner, and as yet unlived, existence. At this point, however, it is beyond Lily's capacity to construct a structured, brilliantly hued composition. She needs time to assess her worth and to understand how she must "modify" her vision if she is to present a complex pattern of relationships. She has to train her eye to draw and paint what she sees and feels, not only subjectively but objectively as well, and thus develop assurance and distance. If art is the transmutation of what has been experienced in the natural world by cognitive means, Lily must learn to fuse the dichotomy that exists between her feeling and thinking functions in order to depict people and objects in all their fullness, rather than in terms of herself and her own personal feelings. Once she can achieve her own stance and reject the banal and the peripheral in her life, she will be able to come to grips with the vital compositional elements she longs to put on canvas, which stem from her own psyche. Only then will it be possible for her to integrate form and color, light and dark, rhythm, mass, and composition.

Suddenly Lily is "transfixed" by a pear tree in the garden, and impressions begin to pour in. At this point she seems to understand the meaning of growth and proliferation, the generative factors in the creative process. The tree, with its branches reaching toward the heavens, its roots burrowing deep

in the earth, becomes for her the focal center of the world. In her mind, it takes on the power of the Tree of Life or the Tree of Knowledge of Good and Evil—a symbol that encompasses humanity's eternal quest for truth and reality. The tree, a composite of "little separate incidents which one lived one by one" (p. 73), also represents continuity and cohesive unity in design and purpose.

The tree becomes the focal point of Lily's canvas: form, volume, density, mass, and perspective are to be apprehended through it; the tree, therefore, must be placed in just the right space to give the whole composition structure and balance—a replica of the psychic harmony Lily seeks to achieve. Reminiscent of Cézanne's painting A *House on the Banks of the River Marne,* the tree also serves to center and divide the window space in which Mrs. Ramsay is sitting framed from the world outside. But when Lily looks at the canvas, she wants to cry.

> It was bad, it was bad, it was infinitely bad; she could have done it differently of course; the colour could have been thinned and faded; the shapes etherealised;

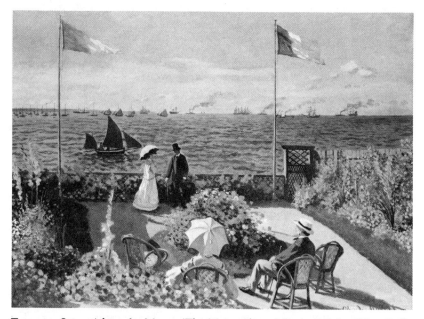

Terrace at Sainte-Adresse by Monet (The Metropolitan Museum of Art, New York, Purchased with special contributions and purchase funds given or bequeathed by friends of the Museum, 1967)

that was how Paunceforte would have seen it. But then she did not see it like
that. She saw colour burning on a framework of steel; the light of a butterfly's
wing lying upon the arches of a cathedral. Of all that only a few random marks
scrawled upon the canvas remained. And it would never be seen; never be hung
even. (P. 75)

To fight her feelings of helplessness and incompetence, Lily scrapes
"mounds of blue and green" as well as clear pigments off the canvas, with her
palette knife, virtually attacking her painting. She is annoyed because she
realizes that she does not know how to inject rhythmic movement and a
flowing quality into the static elements that permeate her work. She must
have unconsciously sought to emulate Cézanne with his "great sweeps of the
palette knife" and his "rich paste" that evoked such daring tonalities.[13] While
she pauses, Lily wonders what secrets Mrs. Ramsay possesses that she can
hold such tranquil dominion over those around her and can preside "with
immutable calm over destinies which she [Lily] failed to understand" (p. 78).
She would like to get inside Mrs. Ramsay, to find this unity, this harmony.
By projecting her own needs and desires upon Mrs. Ramsay, however, Lily
only dilutes her own psychic forces, encouraging those that prevent her from
having a structured existence. To Lily "the deposit of each day's living . . .
was an agony" (p. 81). She aches when she looks at her painting. The daubs
of paint with the palette knife and the thick brushstrokes represent boldness
of feeling but inadequacy of technique; the colors do not correspond to the
mood she sought; the forms do not parallel the movement; wholeness of
vision does not encompass the disparate nature of what she hoped to depict.

When Mr. Bankes asks Lily what she intended to indicate by the "triangu-
lar purple shape" on her canvas, she replies it is Mrs. Ramsay reading to
James (p. 81). Because "no one could tell it for a human shape" (p. 81), she
senses Mr. Bankes's dissatisfaction, but he does not mock her because he
understands the artist's need for self-expression. Verisimilitude is not Lily's
goal. What she seeks is contrast—light and shade, opaqueness and density.
Mr. Bankes ponders: "Mother and child then—objects of universal venera-
tion, and in this case the mother was famous for her beauty—might be
reduced . . . to a purple shadow without irreverence" (p. 81).

For Lily the triangle is the right shape. It incorporates the trinity of
mother, son, and a third force, which might have been Mr. Ramsay, the
child's father, but is, unconsciously, Lily herself. Moreover, purple, the color
with the highest charge of intensity, the most powerful concentration of
emotion, is also a regal tone. It stands for passion—that secret unprobed

world of hers—which she has projected as an unindividuated mass onto Mrs. Ramsay and James. To reduce the two figures to a triangle is to dehumanize mother and son, to imbue them with solidity; but also to have discovered their essence and replicated it in visible form is to give substance to life.

As Cézanne suggested, the triangle, the sphere, and the cone help the artist to portray nature concretely—to give it depth and a three-dimensional quality. These shapes make for focus, that is, direct vision toward a central point—that "Creative Center" alluded to by the mystics as the universal generative force. As precursor of the cubists and futurists, who broke forms up into geometric forces and shapes, Cézanne examined nature microscopically and also as a compositional whole, thus giving balance and harmony to each segment of his work.

Although she has experienced Mrs. Ramsay and James as a purple triangle, Lily still does not know how to position the other objects in her painting in relationship to them. Her vision is incomplete; because her personality is not yet developed, she is unable to achieve a cohesive, unified composition.

Mr. Bankes must sense Lily's lack of harmony when he questions her as to "the relations of masses of light and shadows" in her canvas (p. 82). Because Lily is a feeling type, she paints out of an inner compulsion to use color, form, and shape without quite knowing why or how she goes about it. "She took up once more her old painting position with the dim eyes and the absent-minded manner, subduing all her impressions as a woman to something much more general; becoming once more under the power of that vision which she had seen clearly once and must now grope for among hedges and houses and mothers and children—her picture" (p. 82). Because Lily has yet to discover her own inner harmony, she cannot respond to the congruity of which she is aware outside herself. The hedge and the house, and the mother and the child, remain for her unintegrated entities. Lily is tempted to believe that her inability to consolidate her vision can be explained by the fact that she has been to so few art museums—only to those in Brussels, Paris, and Dresden. But then she realizes that it is probably better not to have seen "masses of pictures," because "they only made one hopelessly discontented with one's own work" (p. 109). Her reasoning is in keeping with Cézanne's statement: "The Louvre is a good book to consult, but it must only be an intermediary. The real and immense study that must be taken up is the manifold picture of nature."[14] Lily has much to learn. She has to study life to discover the roots of her artistic and psychological problems; only then will she be able to endow her work with the timelessness of true art.

THE DINNER

The scene shifts within the Ramsay home. It is evening, and perhaps here, especially, Woolf proves her mastery of the techniques of the impressionists and Cézanne in cutting through mass, dividing solids, stilling flux, and integrating fragmentary glances, thoughts, phrases, and objects into a cohesive whole by means of her skillful verbal brushstrokes.

The dinner scene takes on the power and dimension of a religious ritual. It begins with a preparation (prelude), continues with family and friends (congregation) assembling to partake in the meal (communion) that leads to celestial configurations, and ends with the return into the earthly sphere. In each of the sequences, Woolf manipulates her visual images by interconnecting ideas and feelings on dramatic emotional planes as well as in cool or hot tones, accenting or diminishing them in accordance with the mood of the moment.

The prelude: Mrs. Ramsay with two of her children are in her bedroom. She is getting dressed for dinner, and she encourages them to select the right jewelry for her to wear. The children open her jewelry box, remove much of its contents, and strew the jewelry about in the excitement of making a choice. The disorder within is suddenly paralleled by that of the rooks outside. Attempting to find a tree upon which to settle, the birds fly here and there, chirping, rising "up into the air" and down again, dissatisfied, trying to decide on the best branch on which to alight.

When Mrs. Ramsay presently goes down to dinner, her attitude is regal as she accepts the silent plaudits of those gathered below as a "tribute to her beauty . . . like some queen who, finding her people gathered in the hall, looks down upon them, and descends among them, and acknowledges their tributes silently, and accepts their devotion and their prostration before her" (p. 124).

The congregation: Mrs. Ramsay is now installed at the head of the table like those ancient masters of ceremonies, the priests, handing out the Host and the wine. The archetypal mother, she exists on both a personal and a transpersonal plane, in the moment as well as in eternity: "She had a sense of being past everything, through everything" (p. 125). The table may be looked upon as an altar and the plates on it, like "white circles" (p. 125), as mandalas or Hosts; each plate—standing individually and in group formation—represents life's continuity, a harmony of contraries. As paradigms for the Host, the plates may be considered mysterious forces, essences that flow

into an individual at the height of Communion and provoke feelings of ecstasy during the Mass when all present are engulfed in a single and unique experience.

The evening meal is "the culmination of a life" for Mrs. Ramsay; it is an agape during which each person present will enter a blessed area and there experience a sense of sharing and belonging. Yet, as Mrs. Ramsay looks down the table, she wonders whether her life has amounted merely to "ladling out soup." She sees her husband, seated at the opposite end of the table, and feels his moodiness; emotional vibrations of other sorts momentarily encircle her, weigh her down. She looks at the old Augustus Carmichael, the lyric poet, at Charles Tansley, at Mr. Bankes, and at Lily. "They all sat separate. And the whole of the effort of merging and flowing and creating rested on her" (p. 126). Mrs. Ramsay realizes that she is the nurturing maternal force, the unifying power that bestows collective existence on those within her orbit, allowing each to relate to others and to his or her self. She is mother, wife, friend; she is provider of understanding, sympathy, and compassion. Nevertheless, as archetypal mother, she is alone.

Lily's thoughts are meanwhile focused not only on the ceremony of the family dinner that will shortly begin but also on her painting. Withdrawing into her interior world, she questions herself about the perspective and unity—or lack of these—that she hopes to instill into her painting. "Yes, I shall put the tree further in the middle; then I shall avoid that awkward space" (p. 128). To remind herself to move the tree, she takes up the saltcellar and puts it down on a budding flower in the pattern of the tablecloth. Her choice of saltcellar as a mnemonic device is not surprising. It stands out from its surroundings, not unlike the lighthouse, in its vertical spatiality and concrete upright shape. It also represents an abstract and philosophical notion: that of a tree as axis and that of salt as wisdom. Salt preserves and destroys through corrosion—hence, if the upright tree were misplaced, its effect would be negative. For Christ, salt was a purifying force (Matt. 5:13); it was used in the ritual of baptism and spells spiritual nourishment. If one partakes of bread and salt, fraternity and consociation result.

Lily's eyes shift back to the others at the table. She observes the silences and the idle chatter, and Mrs. Ramsay who "pitied men always as if they lacked something—women never, as if they had something" (p. 129). Her thoughts drift off again to her canvas: "There's the sprig on the tablecloth;

there's my painting; I must move the tree to the middle; that matters—nothing else" (p. 130). Lily suddenly feels as if she is sitting among opposing energy patterns, each personality conflicting with the others. She probes the essence of being "as in an x-ray photograph" (p. 137). Her eye catches a fixed point on the tablecloth, the saltcellar, a paradigm of the tree in her painting as well as of the lighthouse—imponderables. Both objects come to life in her mind, giving her the impression of form, density, and mass. The interstices of white amid the floral designs fill Lily with accentuated rhythmic sensations as if she were floating on water to the lighthouse. The floral design recedes briefly as she looks at it; then grows in dimension as if the tablecloth itself were apprehending space, taking on volume, modifying complex visual sensations.

Meanwhile, because he wants to proceed to the main course, Mr. Ramsay is annoyed when Augustus Carmichael asks for a second helping of soup. Furthermore, the children notice their father's irritation and are about to burst into open laughter. Mrs. Ramsay, intuitive and sagacious, knows how to commandeer her family's attention: "Light the candles." It is time to prepare for the heart of the ritual—the agape or communal meal—to unite the fragmentary, if only for a moment in eternity (p. 145).

Eight lit candles are placed on the table, where they seem to take on the upright configuration of a church spire: "the flames stood upright and drew with them into visibility the long table entire" (p. 146). Symbolically, the number eight represents eternity, enlightenment, circularity, fluidity. What is almost an epiphany seems to take place: "and the faces on both sides of the table were brought nearer by the candlelight, and composed, as they had not been in the twilight, into a party round a table, for the night was now shut off by panes of glass, which, far from giving any accurate view of the outside world, rippled it so strangely that here, inside the room, seemed to be order and dry land; there, outside, a reflection in which things wavered and vanished, waterily" (p. 146). The focus here is on domestic detail: candles, plates, saltcellar, each of which occupies its own particular space and has its own density and mass. The most arresting object, "a yellow and purple dish of fruit," is in the middle of the table, the whole scene presenting symphonic modulations in color that range from the ineffable gold brilliance of candle flame to blackness. The glimmering, almost unearthly flickerings from the candles illuminate Mrs. Ramsay's face, thereby enhancing for the reader her archetypal nature.

The communion: The offering begins as the "Boeuf en Daube" is now brought in and placed before Mrs. Ramsay, who proceeds to put some of the delicious stew, cooked to perfection, on each "staring white" plate (Host).

> And she peered into the dish, with its shiny walls and its confusion of savoury brown and yellow meats and its bay leaves and its wine, and thought. This will celebrate the occasion—a curious sense rising in her, at once freakish and tender, of celebrating a festival, as if two emotions were called up in her, one profound—for what could be more serious than the love of man for woman, what more commanding, more impressive, bearing in its bosom the seeds of death. (P. 151)

Symbolically, the meat here represents the blood of deity; it is energy—the food of life. Mr. Bankes, bored moments earlier, pronounces it "a triumph" (p. 151). Before the meat ceremony nothing seems to have truly taken on life or texture; their world was barren, the participants alienated. The succulent meat dish arouses feeling and passion; it is a hierophany possessed of its own power and magnetism, its own spiritual fermentation. Consequently, Lily finds it absurd when the sublime Mrs. Ramsay begins to talk about vegetable skins. The conversation does not fit in with Lily's view of Mrs. Ramsay. Yet she soon reverts to her veneration of her "irresistible" older friend, who spells "abundance" in contrast to Lily's "poverty of spirit" (p. 152). Whenever Lily feels herself uncomfortable or overwhelmed, as if Mrs. Ramsay were leading her "victims . . . to the altar" (p. 153), she returns to her painting, considering the saltcellar, the pattern on the tablecloth, the tree. In much the same way that Cézanne searched to discover the proper place for volume and mass in an empty picture space, so Lily pursues her quest. She also resolves not to marry; why dilute her aim?

Mrs. Ramsay feels inadequate when she tries to enter the men's discussion about mathematics and other subjects—"this admirable fabric of the masculine intelligence" (p. 159). Borrowing thoughts that are not her own confuses her; she gets lost in detail and "fire encircled" her. She is "forced to veil her crest, dismount her batteries" (p. 156). This happens to those whose thinking function is underdeveloped. But Mrs. Ramsay, endowed with magical understanding, offsets what might have proved her undoing by concentrating attention on the dish of fruit in the middle of the table, her eyes going in and out among "the curves and shadows of the fruit, among the rich purples of the lowland grapes, then over the horny ridge of the shell, putting a yellow against a purple, curved shape against a round shape,

without knowing why she did it, or why, every time she did it, she felt more and more serene; until, oh, what a pity that they should do it—a hand reached out, took a pear, and spoilt the whole thing" (p. 163).

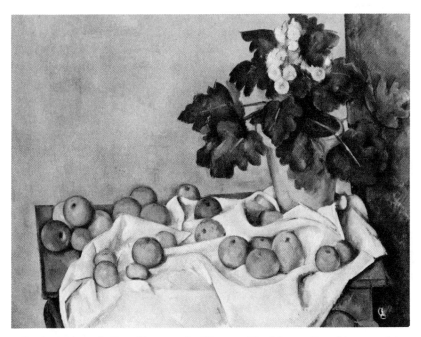

Still Life: Apples and a Pot of Primroses by Cézanne (The Metropolitan Museum of Art, New York, Bequest of Samuel A. Lewisohn, 1951)

The description of the fruit dish, a verbal Cézanne still life, is the finale of the agape. Unconsciously, Mrs. Ramsay keeps a jealous guard over it, for with the disappearance of the fruit comes her dethronement and fall to earth.

The beautiful centerpiece of fruit may be looked upon as a microcosm—a painting. The exquisite nature of these inanimate offerings, which Mrs. Ramsay's daughter Rose has arranged with such care, taking into account gradations in their color and form, represent to her mother a fusion of mind and senses, a journey into the depths of her aesthetic, spiritual, and psychological being. Harmony and balance emerge from this: hence, the centerpiece of fruit is in a sense symbolic of Mrs. Ramsay's life experience.

This description of the fruit dish may well be the apogee of Woolf's art. Roger Fry pointed out that Cézanne's still lifes "frequently catch the purest self-revelation of the artist,"[15] and this is also true of Woolf's pictorial

imagery. Although the deep pure yellows and rich purple tones of the pears, bananas, and grapes in the fruit bowl provide a synthetic summing up of Mrs. Ramsay's own needs, desires, and loving nature, it is in the contemplation of the shapes of the fruit itself that a concentration of emotion takes place; a silent drama is lived out in what appears to have been a fairly eventless existence. With minute but deft touches of verbal brushstrokes, Woolf was able to re-create the psychic tension and the successive layers of a searching soul. The spirit of unity that Mrs. Ramsay achieved by this lighting of the candles, the Boeuf en Daube, and her contemplation of the dish of fruit is the goal Lily seeks to replicate—"the harmonic principle" that Lily longs to integrate in her painting.

The return: Once the meal has ended, however, the unity achieved in the Communion meal breaks up. Each person returns to his own dimension and energy pattern; the mysterious earlier agitations at the dinner table no longer crisscross in complex relational systems. Family and friends leave for other parts of the house, and the dining room becomes empty; its shape, luster, and patina change. Mrs. Ramsay alone realizes that she has undergone a numinous experience and that "nothing on earth can equal this happiness" (p. 186)—that is, to have a love-filled and love-bestowing existence.

"Time Passes"

Ten years have elapsed since the first section of the book, and Mrs. Ramsay has been dead for almost an equally long time. The house has been uninhabited; "nothing stirred" (p. 190). The colors that permeate this section are mostly blacks and grays, alternating with silver and white light of moonbeams, the latter indicating symbolically a return to the *prima materia*. Unrefined and undifferentiated subliminal spheres seem to have, in effect, taken over. The moon imagery interspersed throughout this section indicates the domination of the woman's reflective world. Dull and dim colors nevertheless prevail rather than the powerful, luminous colors of the outer world—the conscious domain.

THE HOUSE

In the Ramsay's house in Cornwall, damp, mold, and falling plaster are everywhere; swallows nest in the drawing room. Memories of past times intrude on Mrs. McNab, the seventy-year-old housekeeper, as she shuffles

about wondering how she will find the strength to make the house livable now that the family had decided to return. She examines the worn, faded fabric on the once vivid tapestries. Bitterness and loss have followed Mrs. Ramsay's death, and the death of her daughter Pru, after childbirth, and the death of her son Andrew killed on the front in the war by an exploding shell. The intervening windswept years have left their debris of doom.

 Virginia Woolf's thinking eye endows the objects in the house with life as she silhouettes chairs, mirrors, beds, and walls; then directs the reader's view to the outside world, to the lighthouse. Her observing eye darts in and out of corners as well as open spaces; like an arcane sign it floats about in a suspended dimension, laying the groundwork for a new frame of reference and mode of being.

 The house and its furnishings are drawn into life—as past, present, and future fuse under Mrs. Ramsay's spirit—which is still felt hovering, alive and tender, over even this decaying world. Doors and windows that have been shut for so long, cutting out the light of life, are soon to be opened. Under Mrs. McNab's aegis, transformation and renewal will occur, giving the house a fresh purpose, with different cadences, perhaps, but with new geometrical schemes. Rather than linear time, it is a free-flowing cyclical or mythical time that arises and allows the sound of laughter and joy to reverberate throughout the still vacant house. We see synchronistic images as an "ashen-coloured ship" and "a purplish stain upon the bland surface of the sea" (p. 201) merge in Woolf's palette, circulate about amid transparent waves—leading to the lighthouse.

THE RITE OF PASSAGE

 Moon imagery alternates with visions of glass and mirrors, each reflecting a "hollowed out" world (p. 194)—that is, a world no longer lived in. The mirror, identified frequently with lunar elements, represents fragmentation, immobility, one-dimensionality; but when associated with imagination, the mirror also suggests self-contemplation.

 Lily Briscoe's return to the Ramsay house implies that she is ready to face her lunar or feminine world; she is prepared to gaze into her own inner mirror. Wandering in the abandoned cottage, she enters into "immense darkness" (p. 189). She feels the moon weaving its web about her and the stilled, sorrowful world embedded in the furniture, now enclosing "the sunset on the sea, the pallor of dawn" (p. 201). Each object seems to reflect

something that is buried in darkness, not yet fulfilled. A woman's domain is subsumed here; the matriarchal consciousness that is mysteriously empowered to revive what has been momentarily stilled; hence, that can transform immobile or dormant elements into active entities. Lily has experienced her passive, receptive phase for the past ten years; now colorations and flashing light emanating from the lighthouse strike "the carpet in the darkness, tracing its pattern," and enter the home "in the softer light of spring mixed with moonlight gliding gently as if it laid its caress and lingered stealthily and looked and came lovingly again" (p. 200).

Lily sees herself as a vacant house that absorbs the light from the moon and the lighthouse, which invokes within her a variety of emotions that annihilate both time and space. The light that inhabits her inner world has now come to generate its own energy. To the mystic, mirrors represent doors; and moon glow with its accompanying moisture becomes a fructifying force that enables the hierophant to pass from one side of life to another. Lily, therefore, passes her initiation ritual; she travels from a world of indwelling to one of exteriorization, from amorphous mental visions to the creation of stimulating visual patterns. Mnemonic images and perceptions have stirred previously unknown elements within her and vitalized dormant parts of her psyche, which she now seeks to express in her painting.

Lily does not know why she has come back to the cottage, but she sleeps soundly the first night of her return. "Through the open window the voice of the beauty of the world came murmuring" (p. 213). She had at first, after Mrs. Ramsay's death, been virtually paralyzed, detached even from herself, so great was her feeling of profound loss. Her very loneliness, however, proved instrumental in her discovery of her true identity. She had learned to differentiate, select, and objectify the elements within her that helped to reenforce her creativity, and to give consistency and wholeness to the colors and shapes she brushes onto her canvases. Lily now feels a bond with the house as she did with Mrs. Ramsay, but she is no longer enslaved by such a relationship.

It is morning. Lily opens her eyes. "Here she was again, she thought, sitting bolt upright in bed. Awake" (p. 214). The word "awake" is the key to "Time Passes." A new day, a new world, has begun for her. Glorification and idealization are things of the past; reality and consciousness are born. She can begin her painting of Mrs. Ramsay afresh. As Cézanne wrote: "We must not, however, be satisfied with retaining the beautiful formulas of our illustrious predecessors. Let us go forth to study beautiful nature, let us try to free our

minds from them, let us strive to express ourselves according to our personal temperaments. Time and reflection, moreover, modify little by little our vision, and at last comprehension comes to us."[16]

"The Lighthouse"

Mr. Ramsay, his daughter Cam, and his son James also returned to the house. They will go to the lighthouse, thus fulfilling the hope and dream that James ten years before had at the outset of the novel—a dream, however, that is perhaps no longer meaningful to anyone except Mr. Ramsay. For him it has become the sine qua non of his existence. Lily's creative vision also falls into place in this integrative phase of Woolf's novel. The exterior objective world that heretofore emphasized discontinuity and prevented interrelations has been banished. The sensate world now functions on a series of corresponding planes; what was formerly detached presently mirrors a harmony of form and feeling; color and fugal relationships develop. The desolation that

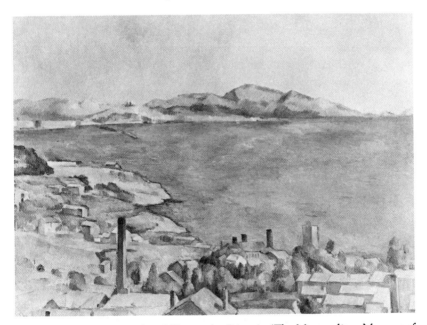

The Gulf of Marseilles Seen from L'Estaque by Cézanne (The Metropolitan Museum of Art, New York, The H. O. Havemeyer Collection, Bequest of Mrs. H. O. Havemeyer, 1929)

the family experienced after Mrs. Ramsay's death is subsiding. Forced to rely on themselves, they begin delving into untouched and until now sterile realms, and such probings have fostered in each one new patterns of existence.

THE PAINTING

Lily places an empty canvas on the easel. She is ready for the struggle to fill the empty space with sonorous and rhythmical forms and volume—with coloration. No outside force is there to help her develop perspective. She has grown self-reliant and is exploding with vitality and creativity—there is nothing that can dampen it. Mrs. Ramsay's image floats into Lily's mind, and brings her a renewed understanding of intermingling relationships, but she no longer seeks to merge her being with Mrs. Ramsay's world; instead, she wants to "hollow" out her own domain, to listen to those symphonic rhythmic patterns stirring within her. She knows now that form and shape are embedded within chaos.

Still, "there was the wall; the hedge; the tree" (p. 221). How was Lily to place these on her canvas? How much space should they fill? How can she interweave them? Lily remembers the floral pattern on the tablecloth, which had, ten years earlier, prompted her to move the tree to the middle of the canvas. At that time she had been unable to work out her problem either technically or psychologically.

The hedge, the steps to the drawing room window in which Mrs. Ramsay used to sit, and the wall Lily had wanted to use in her painting surface again and come to mind: three segments of her life process. In Cézanne's view such entities could be looked upon as phases of an "analytical and searching gaze," elements of "unspeakable richness."[17] The same may be said for Lily. The hedge represents the boundaries around her inner world that prevented the free-flowing forces from fructifying her creative instinct and psyche. The steps represent the effort she must make to assure her ascensional journey into more spiritual climes. The wall stands for Lily's separation from the world at large that had incarcerated her in her own shadowy realm. Now, ten years later, she has finally understood that inner strength emerges with increased knowledge of self, which, in turn, paves the way for growing confidence in one's qualities and capabilities. When Mr. Ramsay approaches her, longing for sympathy and demanding she play the role his wife had played for so long, Lily refuses to "surrender herself"; she stands firm against "this enormous

weight of sorrow," these "heavy draperies of grief" (p. 227). Rather than sympathize with him, she comments on the "remarkable boots" he is wearing "sculptured" and "colossal." This impersonal comment indicates her determination to enter only into a general—not a personal—relationship with Mr. Ramsay. But she feels almost guilty that she should "praise his boots when he asked her to solace his soul" (p. 229). Lily has no choice. To save herself and grow in the life process demands that she reject her emotionally enslaved condition. She has to act in what many might call an egotistical self-centered way.

Lily's canvas at first seems to "rebuke her with its cold stare" (p. 234). Then, compelling her to draw close to it, the empty and uncompromising picture space becomes renewed with life. She squints with half-closed eyes to better focus on the hedge's "green cave of blue and browns," and grasps her brush. The first step in the creation of a painting is always the most difficult because it eliminates all other possibilities; but each step paves the way for the next. Lily makes her "first quick decisive stroke. The brush descended. It flickered brown over the white canvas, it left a running mark" (p. 235). Twice, three times, she attacks the picture space; rhythms, relationships, interconnections, colors, contours, come before her. She becomes an active force, working her way toward enlightenment and, in so doing, involving herself in the giant awakening of life.

The imagery proceeds synchronistically. At the same time that morning that Mr. Ramsay, Cam, and James set out for the lighthouse, Lily's painting starts to jell. Like cubist delineations, where visual impressions of volume are experienced simultaneously by breaking them up into their component planes, the progress of the boat on the water parallels Lily's progress with her canvas. Human life expressed impressionistically through vivid clusters of glowing light interspersed by insertions of pure color allows Lily to frame her vision. It permits her to look beyond the visible world and divide it into cylinders, spheres, cubes, and cones. As she paints, each side of the objects—the all-over view—is directed toward a central point: that forceful mystical center that lies buried within the artist.

Lily is on the way to mastering herself, or as Cézanne phrased it, to "possessing" herself.[18] The hedge, the steps, and the wall have played their role in the developmental process; without Mrs. Ramsay's death, however, without the empty house, the period of solitary indwelling and the play of harrowing emotions, Lily would not have discovered the vision within her, or the inner force "dictated to her" (p. 237). Lily has followed Cézanne's

principle: "The artist must scorn all judgment that is not based on an intelligent observation of character."[19]

A superb passage, reminiscent of a Monet painting, describes the Ramsays' journey to the lighthouse: "The sails flapped over their heads. The water chuckled and slapped the sides of the boat, which drowsed motionless in the sun" (p. 242). Looking out to sea, at a "cork" in the distance that can only be the boat, Lily comprehends the difficulties involved with regard to personalities as well as spatial elements involved in the process of artistic creation. Whichever the way—whether that of the impressionists and the breaking-up of mass through the use of pure color, or of Cézanne's technique with its structured elements and three-dimensional form and geometric patterns—the painter must endow the canvas with a sense of cohesion and strengthen every element in it as if it were "clamped together with bolts of iron" (p. 255). To give a work meaning requires form and depth; structures must be solidified, feelings conceived and built with method, but so firmly that it is impossible to "dislodge [them] with a team of horses" (p. 255). As Lily watches the boat in the distance and sees Mr. Ramsay and his daughter and son approach their destination, it becomes clear to her that she is about to reach hers. "Distance had an extraordinary power; they had been swallowed up in it, she felt, they were gone forever, they had become part of the nature of things. It was so calm; it was so quiet" (p. 279).

Simultaneously, the Ramsays complete their journey to the lighthouse and Lily puts the last brushstroke on her painting. What had been antagonistic (water and earth, matriarchy and patriarchy) is now separate yet coordinated. Once rigid and distant, Mr. Ramsay embarked on a journey of understanding with his children. Rather than rage against him, they give him their affection and admire his heroic act of atonement—his venture into his own ocean world. The remaining members of the Ramsay family are thus again tied by the bond of love. Amid the swell of rhythmic undulations, Lily reaches into her matrix and feels regenerated. "Within a sudden intensity, as if she saw it clear for a second, she drew a line there, in the centre. It was done; it was finished. Yes, she thought, laying down her brush in extreme fatigue, I have had my vision" (p. 310).

The death of Mrs. Ramsay, who had been so much the focus of Lily's life in the opening section, "The Window," usurping many of her emotions, feelings, and even reasoning capacities, left Lily—as well as Mrs. Ramsay's family and friends—bereft and off balance. She had been unable to complete the painting on which she had been working. Her own lack of perspective,

her inability to comprehend the structure and composition of her work stymied her. The indwelling period that followed Mrs. Ramsay's death forced Lily to come to terms with many things, including her own interior loneliness and silence—that empty hollow within her and the other characters in the novel. In Cézanne's words, "the knowledge of the means of expressing our emotion"[20] can only be acquired through deep and lengthy experience. Lily underwent the required trauma in the section "Time Passes," when she entered the empty house and recognized the positive elements still remaining in what had been Mrs. Ramsay's domain. What she unearthed activated her libido and gave her faith in her own creative instinct. Thus, upon returning to the house, she was able to meet on her own terms Mr. Ramsay's importunate need for sympathy; she had gained the strength to concentrate on her own development, her own awakening into life. Integration and synthesis thus take place in the final section, "The Lighthouse." During this same period, Mr. Ramsay, the small boat, and his two children safely complete their journey to the lighthouse. His son and daughter had been estranged from him, but he has found the means to reach them.

Long after her parents had died, Virginia Woolf succeeded brilliantly in harmonizing her tangled emotions. In To the Lighthouse, she released melodious and strident verbal tonalities of mass, color, and form, blending the feeling tones of the impressionists with the thinking sphere of Cézanne. She confronted the mysterious dimensions of her own psyche—giving the chaos within her structure and shape. Thus in her novel she was able by her literary art to create—to use Cézanne's phrase—"a union of the universe and the individual."[21]

9

Malraux and Goya:

The Archetypal
Saturn/Kronos Interplay

What are the implications of the Saturn-Kronos archetype that it should have caused Francisco de Goya (1746–1828) to paint one of his most spectacular canvases and inspired André Malraux (1901–1976) to write one of his most deeply moving essays? Did this ancient mythical deity correspond to some inner psychic experience within both men, some transcendental or primal visitation from another dimension that sprang full-blown into consciousness?

Goya's later works in general, and in particular his *Saturn Devouring One of His Children*, drew Malraux into a subliminal region which few have the courage to penetrate and fewer still the ability to understand. When Malraux looked into Goya's shadowy inner world, the world which he captured in his *Saturn, An Essay on Goya*, what he saw allowed him to respond to the Spanish master's strange rhythms and shapes, erotic pulsations, abrasive colors, and the haunting cry of one who desperately seeks wholeness.[1]

The *Saturn* essay, in particular, seems to have enabled Malraux to penetrate mystery, to become both *mystai* and psychopomp, initiate and guide. Malraux thus entered that inner world where the inchoate and uncreated lay fallow until it was stirred by the quest of the great Spanish artist. With his responsive eye Malraux was also roused by the sight of those limitless areas filled with multitudes of deformed and hideously contorted beings found in Goya's etchings. He translated his own emotional response into elliptical language: verbal equivalents of instincts found their way to the printed page. Malraux thus bore witness to a whole society of macabre forms and shapes, of skeletons, hobgoblins, buffoons, grotesque animals of every kind—a dog staring longingly into empty skies, bats, vultures clawing their victims. Each animate and inanimate entity took root in his being as it had in Goya's paintings and etchings more than a century before. It was far from easy for the

French writer to enter into the Spanish artist's beclouded domain; for it was as if the acid Goya used on his plates to incise his etchings had spilled over on Malraux, abrading his flesh, flaying his psyche.

Malraux focused on *Saturn*, on that stupendous canvas of the gigantic Titan—a crazed old man, emerging from the thickly pigmented dark of the black background, clutching his victim portrayed in blood reds, livid whites, with somber tones in the foreground, a god dismembering and devouring his son, erroneously believing that by consuming what he most feared he would assuage his terror and anguish. Goya's *Saturn* served as Malraux's *obulus*, that ancient Greek coin given by the shades to Charon, the ferryman in the Underworld, to carry them across the river Styx. It forced open the doors of Malraux's inner world, allowing pessimism, melancholia, and fear—a whole new dimension teeming with disrupted and tangled feelings, and metaphysical unrest—to ejaculate into being, then to be articulated later in his essay. It spoke to Malraux viscerally, erotically, and dramatically.

To understand the psychological depth of Malraux's involvement with *Saturn* as well as with Goya's etchings and the eighteenth-century artist's own identification with this mythical Graeco-Roman deity, requires a brief digression to investigate the complex attributes associated with this figure.

The Saturn-Kronos Myth

The Roman god Saturn was a *senex* figure whose function was to sow and to harvest. He was, therefore, looked upon as the regulator of time.[2] That he carried a scythe—or sickle—and frequently an hourglass, confirms his association with a linear (chronological) view of life, and thus with change and mortality. The black mantle that Saturn usually wore drawn over his head indicates introversion, a desire for secrecy, concealment of elements within himself that he sought to hide.

Saturn has always been identified with the Greek god Kronos, whose life was one long agony, and whose personality—fearful, tormented, and possessive—was to a large extent an outgrowth of the needs that shaped his destiny. Hesiod tells us that Kronos, the youngest of the Titans, was the son of Gaea and Uranus (earth and heaven).[3] With the help of his mother and other Titans, he rebelled against Uranus, castrated him and took over his reign. Uranus cursed his son and prophesied that one day Kronos in turn would be supplanted by one of his children. Thereafter, Kronos, who had

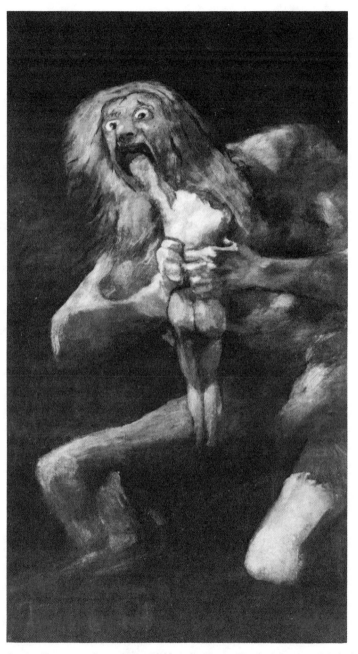

Saturn Devouring One of His Children by Goya (Prado Museum, Madrid)

married his sister Rhea, lived for many years in constant dread of such an eventuality. To ward off this fate, he devoured at birth each of his children— the Olympians—Hestia, Demeter, Hera, Hades, Poseidon—except for Zeus, his last child, whom Rhea saved by presenting her husband with a stone wrapped in swaddling clothes in place of the actual baby. For years Kronos seemed content, pleased at least outwardly that his father's curse had come to nothing. Unconsciously, of course, he was consumed by guilt and fear, though consciously he remained undiscerning and unquestioning, blinded to reality.

Once Zeus grew up and became a man, however, he, with his mother's help, attacked his father, defeated him, and forced Kronos to drink a noxious potion that caused him to disgorge all the other Olympians. According to the ancient Romans, Saturn-Kronos (Kronos was identified with the Roman god Saturnus) was then exiled from the heavens and came to earth, to Latium, where he was received by Janus, who crowned him king on the Capitoline Hill. It was at this juncture that he bestowed the gift of agriculture on the people of Italy, before he finally disappeared. Saturn's rule on earth has always been identified with the Golden Age. In Italy annually, from December 17 to 23, the Romans honored and remembered him in those festivities known as the Saturnalia. Feasting and celebrations of all kinds took place; work stopped; criminals went unpunished; and slaves were served by their masters, recalling the days when Saturn reigned and differences in social rank were nonexistent. A reversal of values, then, was the rule of the day. (Such reversal, psychologically, may indeed have been beneficial. It allowed the irrational to be expressed; the mad, the frenetic, the unconscious, could cast logic and control to the winds. To encourage such a period, when pent-up emotions could be unleashed, is a way, perhaps, of averting a build-up of resentment, hatred, and anger that might otherwise have burst forth in dangerous forms of rebellion.)

Saturn-Kronos is a complex and ambiguous figure. In that he was a Titan, a primordial and pre-Olympian being, he was endowed by the Titans with a distinctive generic personality. As a Titan he was guided largely by instincts and emotions, what might be termed his "Titanic impulses," or inner fire. When under the sway of his powerful instinctual emotions, he lost all perspective. This sort of direct emotional response also had its positive attributes. It was responsible for the Titans' élan vital, enabling those who possessed it to give form and shape to what would otherwise have remained amorphous. If a Titan, therefore, were able to channel his chaotic impulses

into constructive paths, he could move mountains; if he followed his
impulses blindly, he could cause destruction. Saturn-Kronos took the latter
course.[4]

Other dichotomies are also present in the Saturn-Kronos archetype. In
that the god was identified with agriculture, with seedtime, planting, and
harvest, he entered the existential mortal sphere, subject to the ever-chang-
ing seasonal cycle of birth, growth, and decay. His symbol, the scythe or
sickle, is an instrument that cuts, severs, and detaches, and like his other
symbol, the hourglass, emphasizes his and our mortality. Saturn-Kronos's role
as deity, however, permitted him to continue to live and to enjoy and
participate in the annual cyclical aspects of nature's perpetual round of life,
death, and rebirth, thus underscoring the immortal and transpersonal sphere.

The dual aspects of mortal and immortal invested in Saturn-Kronos
created a schism within his personality. In that he planted and harvested, he
worked in consort with the Great Earth Mother, seeing to her eternal
renewal. In that he devoured his offspring,[5] he was in effect rejecting all
growth and change, fruition and a new harvest, and was symbolically acting
against nature. His temporal needs were antithetical to his atemporal desires,
as he sought to maintain the status quo, to force the world to stand still. The
rejection of change—of birth, growth, death, and renewal is also, however, a
rejection of life. What he actually struggled to prolong, then, was what he
considered to be his present safe existence; in so doing, he sought a condition
of stasis, hoping in this way to do away with the loneliness imposed upon
those who must deal with change in order to trudge down the lonely road of
the innovator. Psychologically speaking, Saturn-Kronos refused to let his
conscious self grow and develop. Concomitantly he divested himself of the
joy of self-discovery, the feeling of pleasure one knows when he has won
independence and reached maturity. Identified by his archaic traits, the
archetypal Saturn-Kronos augurs neither growth nor evolution, but rather,
infantile regression.

When Saturn-Kronos refused to allow his children to develop and take
over his kingship, he was refusing to accede to any diminution of his powers
and to the inadequacies that accompany senescence, with its lessening
physical and mental faculties. In addition to this powerful conflict, there
were his own feelings of guilt with which he had to contend for his father's
overthrow and castration and the devouring of his own children. The more
agonized he became, the more possessively cruel were his actions, as he
attempted to stay the fleeting present moment. The virulent emotions thus

aroused within him erupted into negative qualities: cupidity, jealousy, avariciousness, anger, gluttony. His primitive and instinctual rage reached demoniac proportions. With such a makeup, how could Saturn-Kronos possibly learn to relate to others or earn their affection or love? Yet this was the condition he desperately needed to experience and which might have partially assuaged his corrosive feelings of loneliness and his terror at the thought of his own extinction.

When associated with the cold and distant planet, Saturn is considered a "transconscious factor," as are all the planets. It exists "beyond the will" yet is perceivable by earthly mortals.[6] So here, too, as C. G. Jung suggested, we are faced with a dual point of view—terrestrial and mortal factors, celestial and eternal aspects. To relate to both these attitudes is vital, if one is to achieve a harmony of being, and if the ego-self dynamic is to be balanced. Alchemists, like the thirteenth-century Raymundus Lullus, understood the problem. He equated Saturn with lead, the basest of metals, with the *prima materia*, with *sol niger*, or counter-sun, and with the earth. Because lead can be purified, because this earthbound being can be translated into spirit, this same element must possess godly characteristics, which when transmuted by the alchemist could help man attain supreme enlightenment—through the creation of the philosophers' stone.

The Saturn-Kronos archetype spoke to both Goya and Malraux. Separated by more than a century, each man had seen bloodshed, death, and destruction; the havoc of war, the agonizing, aching pain caused by man's inhumanity to man. Each understood the conflict that raged in the mortal-immortal syndrome; and the need to accept both aspects of life's round. Still, they shuddered when they witnessed monstrous war and death consuming the young, and time devouring the future. Unable at first to assimilate these dichotomies which they saw in the outside world and sensed in their own psyches, after their forty-sixth year, they chose the path of introversion. Henceforth, Goya and Malraux may be said to have worn Saturn-Kronos's black mantle, which they lifted only partially during their creative moments and then only to reveal a somber, melancholy mood and an anxiety-filled realm of darkness.

Francisco José de Goya y Lucientes

Goya, who was born in the village of Fuendetodos in the province of Aragon, began his serious study of art in Saragossa, where at the age of

fourteen he was apprenticed to the painter José Luzán. Before embarking on
his brilliant career, he traveled across Spain with a group of bullfighters, then
pursued his studies in Rome. Afterward, he returned to Spain and married
Josefa Bayeu, the sister of the well-known painter, Francisco Bayeu. In 1776,
thanks to his brother-in-law, Goya was hired to paint cartoons for the royal
tapestries that were to be hung in the king's palace. It was not long before
those in positions of power noted the freshness of his striking forms, which
depicted village life and the farming world; his paintings were far more
original in design and coloration than those offered by such established artists
as Bayeu and Anton Raphael Mengs.

While working on the cartoons which were full of joyous freedom, levity,
and charm, Goya discovered the works of Velásquez. He was so fascinated
that he copied them in pencil and pen, etched them, and immersed himself
in this Spanish master's idiom. He worked untiringly at his art and was
rewarded in 1785 by being appointed director of the Academy of Arts. His
paintings of the Spanish royal families of Charles III and Charles IV,
although derisive—they expressed his contempt for the Bourbons' stupidity,
bigotry, and decadence—were received at the court with admiration.

It was in 1786 that Goya first met the Duchess of Alba, with whom he was
to have his celebrated liaison. A strange creature brought up by her father
according to the precepts of Jean Jacques Rousseau, as enunciated in *Emile*,
and in keeping with the broad and spirited views of the French Encyclope-
dists, this charming, beautiful, and well-educated woman rarely took into
consideration the effect of her actions. Interested primarily in gratifying her
own desires, she was politically, religiously, and socially liberal. In her small
court, she made evident her propensity for the grotesque, for the freaks of
nature, for dwarfs and other deformed beings. Yet she was certainly not
unique in this regard; the king of Spain himself had his dwarfs and fools—na-
ture's aberrations—in his palace. Perhaps, in both cases, they reinforced
through unconscious comparison a sense of superiority, majesty, and power.

In 1792 Goya fell seriously ill. The symptoms started by his hearing noise
and culminated in dizziness and deafness. His condition became so acute that
he could not even walk up or down stairs without the greatest difficulty. He
thought that not only his hearing was affected but also that he was going
blind. Some authorities have diagnosed this illness, about which little more is
known, as syphilis. Today, however, medical men generally believe that
Goya suffered either from neurolabyrinthitis—a neural inflammation of the

inner ear—or perhaps from lead poisoning. In any event, after weeks of incapacity, he recovered except for remaining deaf. It was at this point that he began to understand the real meaning of isolation; he was cut off from the outer world as Saturn-Kronos had been. His way, henceforth, was to be inward. In a letter written in 1794 to a friend, he said: "My health is neither better nor worse; there are moments when I am so furious with everything that I hate myself as well; others when I feel relatively calm."[7] Nevertheless, he experienced saturnine frustration and rage, and in time the *Caprichos* were born.

Goya was also beset by problems of a political nature. When the Napoleonic forces entered Madrid in 1808, he had to choose between the Spanish Bourbons, who represented to him all the forces of reaction, the Inquisition and political corruption, or the French, who stood for a politically liberal point of view. Goya sided, as did many intellectuals and enlightened Spanish aristocrats, with the French invaders. On May 2 and 3, however, violent rioting broke out in the streets of Madrid. There was bloodshed followed by mass executions. Charles IV abdicated, ceding his rights as monarch to Napoleon. Charles's son and heir, Ferdinand VII, accepted a pension; Joseph Bonaparte, Napoleon's brother, was enthroned as king. Spain was given a new, more modern constitution.

The bloody riots that Goya witnessed made deep inroads upon him emotionally. The savagery, slaughter, executions, physical cruelties of every sort tormented his sensibilities, shocked his ideals, and certainly tempered his positive feelings concerning the new regime. They also triggered still further a receptivity to the latent Saturn-Kronos elements within him, which soon grew to titanic proportions. Goya returned to his birthplace, Fuendetodos; he was appointed as court painter to the Napoleonic regime, and he fulfilled his obligations, but he did so reluctantly.

In 1812, when the Duke of Wellington entered Madrid in triumph, Goya painted his portrait. There had previously been more bloodshed, and Goya expressed his reactions to violence and cruelty in his *Disasters of War* (1810–1813), etchings attacking the abusive and hypocritical French regime. In these etchings the gradations of light and dark coloration are intense, the blacks bite into the metal plate, broken, disconnected, taking on terrifying dimensions by riddling the image with dark-shadowed forms set against the patches of light. In these works Goya spoke out powerfully and directly from his interior world. The same thing is true of his painting *The Colossus* (1808),

which portrays a giant bestriding the heavens, his very immensity and strength and ugliness striking terror in the hearts of the multitude who view him from below.

In 1813 Ferdinand VII returned to power. Although he was considered a hero by many of his countrymen, to Goya he represented everything that was reactionary and decadent. The artist was examined by a special trial court and was permitted to continue his official obligations. His *Tauromachia* (1815), his fourth series of great etchings, show his feelings of anger and violence at this particular turn of events, as well as his disgust with autocratic regimes in general. In 1816, Goya purchased a house a short distance from Madrid and there in frescoes he painted further horrific visions: *Witches' Sabbat, Three Fates, Saturn Devouring One of His Children*—that whole company of eerie abnormal creatures that came to be known as "the black paintings."

At the age of seventy-eight, when the Inquisition had returned in full force to Spain, Goya journeyed across the Pyrenees to France. There he settled in Bordeaux, much to the joy of other Spanish emigrés who had already taken this road. He continued to produce his etchings, drawings, lithographs, and paintings—the only valid exercise for this eternal spirit. One hundred and twelve years later, Malraux was to cross those same Pyrenees, traveling in the reverse direction—into Spain—two days after the outbreak of the Spanish Civil War. He also was greeted with warmth and cries of jubilation by the liberals of that period—the Spanish Republicans.

André Malraux

Malraux's youth and early manhood were, for the most part, spent in the pursuit of exciting and dangerous achievements. Obsessed by the question of death and dying, by the absurdity of the human condition, he was forever attempting to find a way of branding his earthly existence with meaning—of transcending his mortality by some heroic act. In 1923, he went to Indochina to explore the Khmer temples on the old Buddhist pilgrimage route that ran through the jungles of Laos and Cambodia; he then traveled to the steppes of Central Asia to study Gothico-Buddhist art. Another archaeological trip took him to the Middle East, where a flight over Yemen in 1934 resulted, so he claimed, in the discovery of the queen of Sheba's capital. Two years later, he became involved in the Spanish Civil War and served in the Republican air force, flying on sixty-five missions as a bombardier. After the defeat of the

Spanish Republican army, Malraux returned to his native land. The European situation was growing ominous, and it was time for him once again to become involved in a military venture. He joined the French army as a private and was captured along with his tank unit in 1940 when France fell. Soon afterward, he escaped and made his way to the so-called Free Zone. He became a member of the French Resistance, was wounded, taken prisoner by the Germans, and then released by the French Liberation army. That same year he earned distinction as commander of the volunteer Alsace-Lorraine Brigade and was instrumental in the liberation of Strasbourg. The war over, Malraux was appointed minister of information in de Gaulle's provisional government; the following year he accepted the post of director of propaganda and became—and remained—active in de Gaulle's Rassemblement du Peuple Français until 1952.

Malraux's protagonists in his early novels—*The Royal Way* (1930), *Man's Fate* (1933), and *Man's Hope* (1938)—were extroverted, active types; they were explorers and political revolutionaries, intellectuals whose energy and courage seemed limitless, whose need to transcend their metaphysical anguish and to overcome their own mortality forced them to act. Danger was to them a means of proving one's strength, a test of one's ability to dominate fears, and therefore to overcome the anguish associated with death. By 1935, in *Days of Contempt*, Malraux added yet another value to his outlook on life: the concept of "virile fraternity," of comradeship, which he felt could assuage humanity's excoriating feelings about solitude and death. During and after World War II, when Malraux witnessed so much cruelty and bloodletting, he came to realize that such an attitude, even a friendship of the most valuable kind, whether on an individual or a collective basis, was an illusion—a placebo. The individual person was alone; his or her path was, of necessity, solitary. In fact, in *The Walnut Trees of the Altenburg* (1943), Malraux concluded that far from being a heroic act, "virile fraternity" was just the opposite; it was an escape. The answer, Malraux now stated, lies within the person, in the individual's creative élan. He believed that the fruit of the immortal self, manifested in a work of art, is the only way in which humankind can transcend its earthly condition of solitude and mortality. It is those who are *deus faber* who bestow dignity on human life, who give it definition and stature.

From 1947 to 1950, Malraux, the anti-Spenglerian and antideterminist, focused all his labor and vision on the realm of art—not as a practicing novelist but as an art critic, art interpreter, art revealer. Like Saturn-Kronos,

he, too, trod in two worlds: the immortal domain of the *spiritus creator*, whose works live on and whose impact is determinèd by the depth of the projection that individuals and nations can produce; and that of the critic, highly mortal, intellectual, a member of France's government, who in this capacity extrapolated from a given work of art those insights that he then articulated in a written message. As transmitter of the artist's apocalyptic images, feelings, and sensations, particularly in such works as *Saturn, An Essay on Goya* (1950); *Psychology of Art*, originally published in 1947 but later revised and reprinted in 1951 as *The Voices of Silence;* and *Metamorphosis of the Gods* (1957), Malraux well earned the title of psychopomp.

Malraux had thus apparently discovered a new vein within himself, a world *in potentia.* His intuitions and his forays into ancient and modern history, Asian, Celtic, and Iberian traditions, encouraged him to extend his scope further and further. Such intense intellectual activity, and the insight resulting from it, became in and of itself a creative process. While he was writing about Gandhara Buddhas or Alexandrine gnomes, his consciousness of mortal and divine aspects of existence expanded. The study of art became an *exercitia spiritualia,* an example of active imagination that had a positive contagious effect not only upon Malraux himself but also upon those who read his works.[8] The created image, the work of art, whether graphic, painted, sculptural, or architectural, which was excised from the depths of personal being, torn from the flesh—"*arracher,*" to use Malraux's own word—acted as a catalyst on Malraux; it unleashed inner springs, then verbally released their feeling in somatic effects. When writing about art, Malraux became in a sense Saturn-Kronos, the Titan. Passion and life filtered onto the pages before him, his piercing sensibility banishing all restraint.

Saturn (1950)

SATURN-KRONOS AND INTROVERSION

After World War II, Malraux's heroic protagonist was no longer the revolutionary, the politically oriented individual whose claim to fame rested solely in the existential and extroverted act or in fraternity. His path led inward, as did Malraux's and Goya's in the second part of their lives. It was then that both men probed and sounded out their inner depths and—during their creative moments—lived in the space-time continuum: "it took forty

years for him [the man] to become Goya [the artist]," Malraux wrote.[9] Only then did the Spanish artist reach his level of bedrock that made him capable of connecting with his inner microcosm—that realm peopled with shadows, spectral illuminations, archaic forces of all kinds—the Saturn-Kronos element within him.

It was Goya's serious illness and his ensuing deafness that led to the discovery of that other interior zone, that region of being as hidden and remote as if it were enshrouded by Saturn-Kronos's mantle. Feelings of alienation pursued him and his insecurity and fear grew. He took "horror for his providence," as Saturn-Kronos, the sower of seeds and reaper of harvests; the god who devoured his spawned progeny, and then, unable to bear the noxious brew, regurgitated these inner contents, transformed into hideously misshapen entities in a kind of frenetic *danse macabre*, as if the participants themselves were celebrating the Saturnalia—their liberation into the manifest world.

The creative individual, perhaps more sensitive than others, often serves as a kind of forerunner of what is to be: a prototype of the prophet, a "retort in which [the] poisons of the collective are distilled." Goya certainly seems to have sensed the rumblings that would occur in both Spain and Europe—Napoleon's usurping huge chunks of land for France—and he transmuted these as yet unborn sensations into the concrete world of art. The contents that sprang from this deepest region of his psyche in the form of archetypal motifs became the substance with which he molded and shaped the forms and color embedded in his works. Goya was "conditioned by the power of inner psychic realities," which appeared first in his fantasies, then in the works of art, and finally in the existential sphere.[10]

The inward feeling of decay that Goya experienced during and after his illness was concomitant with the dissolution of both the political and religious structure of Spain. Rapid change and destruction, the crumbling of what had formerly seemed indissoluble, aroused feelings of panic within him. Like a trapped animal—unconsciously speaking—Goya felt haunted, terrified by the thought of the anarchy that could be brought on by the swiftly shifting zeitgeist. Artists are frequently aware when they have reached a crossroads in the existential and emotional spheres. Hieronymus Bosch, the Flemish painter, experienced spiritual and social uncertainties when the Middle Ages were giving way to the Renaissance. His *Garden of Delights* reveals the pain, the anger, the sensual torment living within him. Goya, too, was heading

into a no-man's-land. He was born in and belonged to the eighteenth century, but he also was a herald of the nineteenth-century romanticism—passionate in its lure for the mythic and the grotesque.

A sense of social and emotional unrest, of dissolution, vibrated from Goya's broken lines in his work at this time. His world of dreams and fanciful colorations expressed in *Saturn*, as well as in his four great groups of etchings—*Caprichos, Disparates, The Disasters of War*, and *Tauromachias*—reveal a new dimension, unheard of, uncreated until this period. Goya, like Saturn-Kronos, struck down barriers with his scythelike instruments, allowing forms that had never before been seen to erupt into existence. Like the archaic deity, Goya wrestled with chaos, churned matter—the leaden *massa confusa* within his collective unconscious—transformed it with brush, or with the special needles and acids that he used to bite into the metal etching plate upon which he was working.

Uncertainty, anguish, and feelings of alienation had forced Goya into a condition of deep introversion and depression, leading beyond the transient life experience. Extracting from these depths visions of his own manufacture, which might not always appeal to conventional standards, this solitary individual expressed the powers within him. In so doing, he recorded the torturous pain of a highly charged nervous system, detaching each figure as if from wounded flesh, allowing him or her to float alone in the vastness of an oceanic, unfeeling collective world. The deeper Goya's soundings, the more painful the rupture, and the less able was he to relate to others in a society that was superficial and pragmatic. One readily understands why Goya fled to his birthplace after the French established themselves in Spain, and why, after the return of the Spanish monarchy, he went to live in Bordeaux. Both exiles led to greater isolation—the Saturn-Kronos introversion.

RELIGIOUS-MYTHIC ROUTE

Each of Goya's descents into his collective unconscious allowed him to pursue his own unique visions; yet, paradoxically, they were those that were shared by all humanity. What Goya was unearthing was a religious-mythic dimension. The word "religious" is not to be understood here as adherence to a strict set of rituals and dogmas, but rather in keeping with the Latin root of the word—*religio*—a tying or linking back, a reconnecting, with our mythological ancestral heritage, with that which belongs to the world as a whole and exists within the space-time continuum. To exist in both religious and

existential spheres can create friction—as it did for Saturn-Kronos. In Goya's case, however, it also led to expanded consciousness.

Goya's view of "Nature," on which Malraux elaborates in his essay on *Saturn*, involves religious and mythic concepts. The natural in Goya's work does not imply merely trees, lakes, grasses, crags, mountains, and flowers; in fact, these are singularly absent. Nature, for Goya, was a state of mind. It was a world he sensed and suggested, a place of misty climes, eerie contours, shadowy or dark tonalities—of black silhouettes set against a stark white sky, a sphere peopled with giants and dwarfs. Goya's world of nature was bathed in haunting colors, as if it were just emerging from the world of dreams. There was a nonvisual dimension in both his etchings and canvases—an echo of a world that reached into the very heart of being, the very core of mystery.

The agnostic Malraux responded to Goya's great series of etchings, the *Caprichos, Disparates,* and *The Disasters of War,* and to his paintings *Saturn* and *The Colossus;* they were like visitations from another world and revealed a shadowy, fearful, and titanic element that Malraux had not yet dared to confront. What Goya had reproduced in these works was what the seventeenth-century Spanish mystic, Saint John of the Cross, called "the dark night of the soul," that area in the being where nature takes root and abides and from which life is carved.

Goya had reached far back into an *illo tempore* of humanity's and his own beginnings; in so doing, he discovered what mystics allude to as the "Creative Center" and what psychologists label the "groundbed." His illness and deafness, in addition to the instability of his time, forced him into an inner exploration of mythological dimensions—with a resulting *renovatio*. Interestingly enough, Malraux took a similar route. Not during his early years, but after World War II—after civilized barriers had been shattered, human lives destroyed, an entire way of life vanished. It was then that Malraux began writing about art at the age of forty-six, which led, after a near-fatal illness in 1973, to his mystical works *Lazarus* (1974) and *Transient Guests* (1975).

Malraux's statement concerning the Spanish artist's world, "made up of men and stones" (p. 10), reflects Goya's religious and mythological dimensions. The very duality between the animate and the inanimate spheres not only heightens tensions but also expands our understanding of Goya's own vision. Like Saturn-Kronos, Goya lived in two domains; unlike that Titanic deity, however, whose introversion led him to a condition of stasis, Goya's "dark night of the soul" was productive in that it enabled him to experience the trauma of solitude, after which he gave birth to his human and inhuman

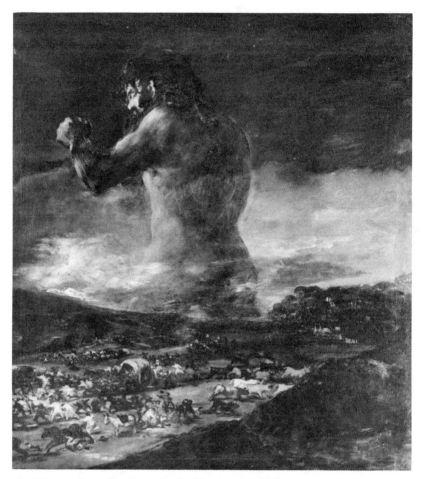

The Colossus (Panic) by Goya (Prado Museum, Madrid)

creatures. He came to *know* the meaning of death, personally and collectively, and he was able to objectify his knowledge in his visionary works. They, one by one, took on an existence of their own and bore within them the very fire of creation, that numinous power which kindles reciprocal feelings within those observing them.

Stone, Malraux contended, is the foundation of Goya's world; it symbolizes unity, solidity of purpose, and permanence. Unlike living matter, stone is not subject to growth and change; but stone represents the continuity within nature itself. Some look upon stones as hierophanies: the Kaaba in Mecca;

the dolmens and menhirs of Brittany and Cornwall; and the stone wrapped in
swaddling clothes that Rhea gave to Kronos, thus protecting the infant Zeus.
Stone has also been used to represent the indestructability of the divine
message: "And this stone which I have set for a pillar shall be God's house"
(Gen. 28:22). For the Christian, Christ "is the chief corner stone" (1 Pet.
2:5–7); for the Free Mason, the Temple of Solomon is believed to be "the
perfect stone." Medieval cathedrals—those monuments to eternity—were
also constructed of stone. Malraux admired them as works of art, but not as
expressions of the Christian faith. He did admire, however, the creative
energy invested in all works of art that were inspired by faith—whether these
were found on the walls of the Lascaux caves, in stone Buddhas of the Dun
Huang caves, or in Japanese and Chinese stone rubbings.

When the artist experiences stone as a hierophany, when his vision takes
on its durability and solidity, it springs into life and man and stone become
one. The seventeenth-century alchemist Gerhard Dorn expressed this notion
in the following way: "Transform yourselves from dead stones into living
philosophical stones!"[11] Goya succeeded in transmuting what he saw in his
mind's eye into a living vision for all to observe. Because of this achievement,
he became a *spiritus creator*.

DEATH: TIME DEVOURS

Goya and Malraux, who had both seen and subliminally experienced death
and destruction, identified easily with Saturn-Kronos whose very destiny was
deeply involved in the *mortificatio* condition. Raw, brutal, abrasive visions
arose in Goya's etchings and paintings, and they were described by Malraux
when he wrote of these works. How could either man pursue his life among
the living when obsessed by the force of so great an emotional impact? Goya
faced his fears in his works and channeled into them his fury and outrage;
Malraux glimpsed his metaphysical agony by sounding the depths of Goya's
world as if it were a mirror image of his own.

Both Goya and Malraux equated death with evil because of the brutal
slaughter they had witnessed. Time had devoured the young and promising,
not the old who had lived their lives. Goya and Malraux were not alone,
however, in their feelings. Interestingly enough, Philip II, one of the most
powerful monarchs of all time, was also haunted by the glacial presence of
death, which at times took for him the shape of the devil or one of his
demons. He forced himself to view those insidious creatures in the paintings

of Bosch and Brueghel which he had hung on the walls of his palace, perhaps believing that by confronting these emissaries of Satan, he might be able to overcome his anguish. Scourging and flagellation were almost his daily penance, to earn him, he prayed, pardon and redemption. Goya depicted this kind of attitude, held by so many of his compatriots, in his paintings: *Procession of Flagellants*, *The Burial of the Sardine*, and *Pilgrimage to San Isidro*.

In Biblical times, death was considered an aspect of the life process; it was inevitable but not to be feared because it represented a return to the Creator. The Egyptians built the pyramids in honor of their dead pharaohs, attempting to assure their rulers' safe journey to that other world. The Gnostics, however, associated death with the "demiurge and the highest archon"; the Sabbeans associated it with the "black star," the "*maleficus*," one that inhabits those regions in which "Dragons, serpents, scorpions, vipers, foxes, cats, mice, nocturnal birds and other sly breeds" multiply.[12] The medieval mind influenced, perhaps, by the many deaths which occurred during the Hundred Years War, the plagues, and other disasters, also equated it with evil.

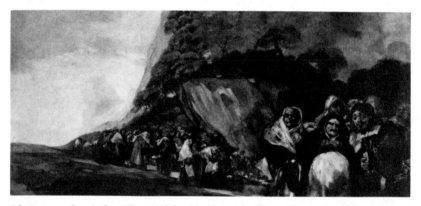

Pilgrimage to San Isidro (House of the Deaf Man) by Goya (Prado Museum, Madrid)

The alchemists understood the dangers implicit in such an extreme point of view. As holists, they realized that death was part of life, just as evil was implicit in good. Saturn-Kronos, therefore, not only had his *nigredo*, or leaden side, but his *albedo* nature as well, which was alluded to at times as a "shining white dove" and as the "salt of metals."[13] These ideas, of course, ran counter to those of the fifth-century Saint Augustine, who denied the

existence of evil, thus lighting the flame of divisiveness which grew like a cancer during the centuries to come.

How could evil exist in a world created by an all-good God, St. Augustine questioned. It could not, he concluded. Evil, then, was a *privatio boni.* In his "Argument against the Manicheans and Marcionites," he wrote, "EVIL THEREFORE IS NOTHING BUT THE PRIVATION OF GOOD. And thus it can have no existence anywhere except in some good thing." Evil is therefore to be considered "a defect in good things" and related to the figure of the Antichrist.[14] Because God-Christ was free of darkness he represented only one aspect of worldly life and, by extension, man's unconscious.[15] The conflict between opposing forces was henceforth inevitable. To resist the devil by flagellating oneself or by denial was one test of the Christian's strength (1 Pet. 5:9). In Christ, humankind experienced only half his nature: the good or godly side. Evil was relegated to infernal regions, or worse still, its existence was denied.

When evil is denied substance, and attempts are made through flagellation and other devices to subjugate it, rather than experience the emotions associated with this force, it merely increases its dominion until it reaches obsessive proportions, resulting in such destructive collective actions as the Spanish Inquisition—which burned "heretics" alive, or the brutalities involved in the conversion techniques used by the Spanish in ruling their colonies.

To consider good and evil as implicit in the workaday world is to accept life's cyclical pattern—the whole process of birth and death. Instead of struggling against the inevitability of change, the temporal can then be faced with equanimity. A similar parallel can be seen in the psychological realm. Once the ego, the conscious ruling principle, is no longer able to be productive, it may be considered to be degenerating; it is at this moment that death, an eclipse of consciousness, intervenes and that a reblending of subliminal contents creates a rebirth. The fixed, the rigid, whether in the psyche or in the existential world, must be destroyed before a new situation can come into being. The mythological ritual of the slaying of the old king belongs to this category. Saturn-Kronos's overthrow and castration of his father, Uranus, and Zeus's battle and victory over Kronos, are all implicit in altering a condition when libido, either personal or collective, can no longer fulfill the life function. In the Greek mysteries, death was referred to as *demetreioi;* so man's acceptance of the death-resurrection cycle is also an aspect of life once he enters the world (as corn emerges into being and then

dies).[16] In the gospel of John (12:24) the same idea is expressed: "Verily, verily, I say unto you, Except a corn of wheat fall into the ground and die, it abideth alone; but if it die, it bringeth forth much fruit." Whatever its form, killings symbolize the stage of death in the evolutionary cycle.

During his illness Goya explored, psychologically speaking, the realm of the dead—that undifferentiated region where raw energy exists at its least visible level. Every now and then he portrayed in archetypal images whatever of this experience he could shape into conscious art. The resultant renewal he knew was an evil from one point of view, in that it entailed both physical and spiritual suffering, in keeping with the mythic Saturn-Kronos prototype. In Goya's hands, this evil turned into its opposite; not only did it account for the intensely productive artistic period that followed, but also it transformed him from merely a distinguished painter to a truly great artist, to a prophet, a seer, a visionary. The world that he now brought forth went beyond good and evil in the Nietzschean sense; he allowed *all* existence to speak forth in its own language, to be experienced either subjectively or objectively by the beholder.

THE IRRATIONAL VERSUS THE RATIONAL: A SATURNALIA

As seer, Goya was able to gain access to his irrational domain; to his own world of dream which in no way resembled that of Lorenzo Lotto, the sixteenth-century Italian artist, who depicted a beautiful realm in his canvas *The Young Girl's Dream*, showing an angel descending into a serene landscape. Goya's vision was more like Bosch's, Dürer's, and Brueghel's experiences of the chaotic, ebullient, and irrational sphere. Malraux tells us that the *Caprichos* (1793–1797), that famous series of Goya's etchings numbering eighty in all, has two sections: Numbers 1 through 43 are entitled "The So-Called Scenes from Social Life"; more than ninety percent of the second group, "The Sleep of Reason Brings Forth Monsters," however, is concerned with demons and hobgoblins, witches, and warlocks. A veritable *corrida* is evident here between the rational and irrational zones.

In "The Sleep of Reason Brings Forth Monsters," a man is seated in front of a table, leaning upon it, hiding his head with his arm, as if in deep meditation or in dream; like the figure of Saturn-Kronos he is covered by a black mantle. Swarms of bats and owls are visible above the figure, and if one concentrates, one can virtually hear them squeak and hoot. The terror in the atmosphere is rendered even more acute by a large lynx seated at the right of the man: one realizes that the animal's eyes are dilated as they stare straight

ahead. Henri Focillon looked upon the image as a "cruelty." The dreamer has been forced by the etcher's sharp instruments to extract himself from a whole cast of characters.[17] Like the flood in Genesis, which destroyed all living creatures—save Noah, his family, and the animal kingdom—so Goya's upsurge of his own inner ocean momentarily drowned his cerebral and logical world. No longer bound by the necessity of deferring to retrograde governmental or religious forces, he was free to listen to his inner voice speaking its own thoughts in universal rhythms that echoed the powerful forces that he found within himself.

Because the irrational fascinated Goya, it is understandable that he should also be drawn to the world of the insane, which so many of his predecessors and contemporaries referred to as a "dunghill."[18] Identified with evil and considered to be possessed by the devil, the insane were looked upon as spreaders of disorder, disrupters of the organized systems of society, and disseminators of chaos. This view was a far cry from Erasmus, the Renaissance sage, who in his *In Praise of Folly*, described those who are mad as the source of joy, hope, and renewed energy. Goya's *Madhouse, Raging Madness, Strange Madness,* and *House of the Deaf Man* depict beings tyrannized over by some demoniacal force, some *idée fixe*. By concretizing them, he was able to discover that those characteristics that he projected upon them evidently existed in his own unconscious. He began, then, to understand the quality that pervaded their lives as well as his own, and to confront them in his own darkened Saturn-Kronos-like world.

Nowadays one might regard Goya's incursions into the irrational sphere as evidence that he was a person under the spell of a powerful complex—a "splintered psyche"—in which unconscious negative contents were not integrated into the rest of the psyche and thus became separate autonomous entities within the unconscious, each split off, each going its own way. Goya was perhaps fearful of going insane at times; he heard strange interior voices within his world, particularly after he became deaf. Malraux also experienced periods when the irrational surged forth in the elliptical statements, insights, *Einfälle*, making up his writings on art, which critics have used to denigrate his work. Because he did not construct his essay on *Saturn* or his *Voices of Silence, Metamorphosis of the Gods, The Unreal,* or other critical works in a logical fashion, but gave rein to his intuitions which seemed disconnected, his philosophical and psychological writings have not always been taken with the seriousness they deserve. The thoughts were considered scattered, cut, severed, like detached particles, as if Saturn-Kronos had taken his scythe and

severed them. What the logically or rationally oriented art critic failed to take into consideration was Malraux the artist, the man whose unconscious functioned as an entity unto itself, allowing him to apprehend and transmute into words a world filled with apocalyptic visions. So, too, did the minds of many alchemists function; they wrote their works not in the discipline of Cartesian thought processes, but, rather, in an acausal manner, in disconnected visualizations that only an intuitive reader could comprehend.

In Goya's case, the split-offs or miniature complexes were actualized in his paintings and etchings. His contact with the irrational expanded his consciousness as an artist and allowed him to depict his ghouls and gnomes which had come to represent a kind of toxin and resisted every attempt on the part of his will to repress them. What could have become poisonous, however, became healthful in that Goya rid himself of the unhealthy material in his unconscious and transmuted it into art. Dürer, earlier, had also done so, concretizing death or dormant contents within his subliminal world in such works as the *Despaired Man*, where, like a nightmare, a face hidden behind haggard hands, a bodiless anguished man, gaping mouths, and a woman sprawled in sensual posture seem to emerge from the picture. The sixteenth-century Agostino dei Musi, known for his engravings, offered the world an equally powerful vision in *The Carcass*, depicting hideous skeletons and prehistoric monsters; nor should the eighteenth-century Johann Füssli be omitted from the list and his achievement in *Nightmare*. William Blake poetized and prophetized his visions in *The Marriage of Heaven and Hell*, in *The Book of Thel*, and in other works.

Insanity and the irrational were being studied at close range in the eighteenth and nineteenth centuries by such doctors and charlatans as Philippe Pinel and Anton Mesmer; and by such scholars and poets as Diderot, Rousseau, Nerval, Balzac, Baudelaire, and many others.[19] Society, however, was a long way from according insanity or the irrational its place in the cosmic ladder. In the same way that Saint Augustine earlier denied that evil had material substance, those who veered from normalcy were now deemed sordid and unworthy of godliness. (The finest paradigm of this point of view is to be found in Plato's myth of the soul in *Phaedrus*.)[20] Goya did not adhere to such a doctrine. His personality would not allow it. His titanesque inner voices spoke out to him as loudly and clearly as did the light of nature, *lumen naturae*. Both, each in its own way, gave him insight into the "natural patterns" existing within himself and in the outside world. What the fashion

in Spain considered unworthy or unacceptable, those aspects of humanity that did not conform to the contemporary ideal of beauty, emerged full-blown in Goya's vision. Like Galileo who had been imprisoned by the Inquisition for having stated that the earth revolved around the sun, and who muttered his famous denial of Church doctrine on the subject, "*Eppur si mouve,*" Goya proved that the irrational not only existed in God's created world, but that it was no more evil than it was good, or ugly, or beautiful. Such moral and aesthetic considerations existed in the eye of the beholder.

Goya faced his irrational forces in many of his works including his famous *Mirror* series in which a person gazing into a looking glass sees a monkey, cat, or frog instead of the expected human shape. In one etching the man vanishes completely, the frog alone remains—humanized. In *Mirrors II*, a man peers into the looking glass and sees the figure before him wearing an iron collar bound tightly about his neck; the constriction and imprisonment thus delineated is a plastic realization of the man's subjective state. Other drawings include hobgoblins, demons, spectral images, and witches shrieking their strident cacophonies as they soar on broomsticks or touch and caress beautiful young maidens—the negative shadow aspects of the archetype of the Great Earth Mother. Until Goya discovered these creatures inhabiting his irrational world, he was unaware of the shadow forces existing within him: "Only when light falls on an object does it throw a shadow."[21]

The irrational was not sufficient, Malraux concluded. "This raw material, however, could not become art except by becoming style" (p. 36). By "style" Malraux meant a perception of what went beyond the personal and became part of the universal. As Montaigne suggested in his essay "Of Repentance," "Each man bears the entire form of man's estate," implying that ontogeny repeats phylogeny, or that the development of the individual contains and recapitulates the development and history of the human race. So within the artist exists the universal; within the mortal, the immortal. Style belongs to the artist who is intuitive, who is able to seize the vision, and who is also a master of technique. Goya was in command of his faculties, not through repressing his instinctual world but by experiencing it fully and potently. In so doing, he dredged up the sum total of his visitations, transfigured them in the light of consciousness, of *his* rational mind, so that they were then there to guide his hand. Goya tamed his madness, Malraux suggests, and made "a language of it" (p. 143), endowing it with its own pictorial grammar, figures of speech, and syntax, as well as its pulsing flame.

THE SATURN-KRONOS MANTLE AS MASK AND PUPPET

Goya used the Saturn-Kronos mantle to hide the flesh-and-blood human being: the fickle nature of the living actor. He preferred the hard changeless entities—the quality of enduring stone that implied eternality. (He was perhaps influenced by Spanish dress in this regard, with its stiff laces, velvets, coiffures, its rigid and unyielding form, preventing real and poignant feelings from ever manifesting themselves.) Unlike the baroque painters of the period who expressed fear, anguish, love, and moods of all sorts through smiles and tears, Goya's feelings took root in his "fantastic shapes," and in bodily distortions. His faces remained immobile, stilled, frozen in their expressions. Whether pursued by monsters, gallants, flies, one-eyed monks, or witches, the faces of Goya's figures betray no emotion. In fact, in many of his works he replaced them with animal heads—monkeys, horses, frogs, asses, dogs—thus giving birth to his own theriomorphic carnival.

The mask and the puppet fascinated Goya, as they had the people of ancient Greece and the Orient. The mask, Malraux suggested, does not hide the face; rather it "determined it" (p. 142). It was an abstraction of the human physiognomy; it divested the person of his individuality, always restricted by physical characteristics, and infused superhuman or extrahuman traits. To don a mask allowed one to inhabit two worlds—the real and the unreal—to be transformed into anything and everything from God to man, saint to sinner, sane to insane. A pure and mysterious life inhabited these forms. Like phantoms, mask and puppets stir and terrify, in a strangely extratemporal manner. Once these entities are endowed with life, as they are in Goya's etchings and paintings, they ambulate like automatons, are energized by projection, and take on a stature and a haunting power of their own. Indeed, they become catalysts for some, forcing emotions to erupt within the observer's psyche, and in this way, they enter the real world.

The Colossus is an example of Goya's godlike power: he not only captures the face of this giant, but also transforms it into a mask, so gruesome and fearful as to make the people flee in terror as they vainly attempt with all their might to avoid the inevitable butchery. In Saturn, the mask is spotted with blood, in keeping with Malraux's belief that Goya was "the greatest poet of blood" (p. 110); this is a statement particularly revelant when used to describe the naked Titan emerging from blackness, giving vent to his biological and organic power by quenching his thirst for blood. This "blood-

red Saturn," to use Malraux's epithet, rises forth with dilated eyes as he bites into his prey and tears apart the flesh with his teeth. Raw instinct alone seems to dominate here; the style, however, is controlled. A great master of art is at work, forever refining his mask and puppet, each orchestrated in color tones and outlines that suit the emotions he seeks to express in the rhythmic sweep of his canvas.

Red blood is that vital, hidden essence contained within the body that spells life when red and abundant and death when drained from the individual; it may also be defined in terms of moral categories: evil, when alluding to the red mantle worn by Mephistopheles, the Prince of Darkness; and good, when viewed in the blood-red capes donned by the cardinals as princes of the Church. So Goya's ambivalence on the subject can be seen in *Saturn* as well as in his *Procession of Flagellants, The Burial of the Sardine,* and so many other paintings depicted with blood-red hues.

The ominous note implicit in Goya's *Saturn* is of prime importance. As *vates,* the artist was staring into the future, into a world filled with jealous, devouring Titans; it was a world that Malraux also knew well and was quick to recognize in Goya's canvas, as well as in the real world with wars in China and Spain, and the most savage of all—World War II. In *Saturn,* Goya constellated an archetypal element that he saw within himself and which was prophetic in depicting the years and centuries to come: an introverted voracious father figure, the Great Destroyer, a brooding god-man, forever looking ahead, in fear and anguish, into the black bleakness of the future. Guilt-ridden because of his own actions, but unwilling to confront and transform them, as Goya succeeded in doing in his art, Saturn-Kronos prolonged his psychological frozen state, thus making growth and maturation impossible, until finally he was lead into the alchemist's *putrefactio.* The archetypal figure featured in Goya's *Saturn* injected terror in Goya's and Malraux's hearts because they knew that this force of nature would again emerge into existence—not in canvas, however, but in the real world—to wreak havoc in another round of bloodletting.

Goya's "never-ending song of darkness" helped Malraux to penetrate his own closed, sealed, and sacred world and to decipher his arcane language (p. 142). Goya was a "medium" figure for Malraux, a force in which the divine and the human met; Saturn-Kronos, reaper and sower, bloodied and bloodless, a *sol niger* and the blazing sun of the sensitive spirit. Goya was "the

greatest interpreter of anguish the West has ever known. Once this genius had hit upon the deep melody of the song of Evil, it mattered little whether in the depth of night his multitude of shades, his throngs of owls and witches, returned to haunt him or not" (p. 128).

Conclusion

"A great work of art is like a dream," Jung wrote, "for all its apparent obviousness it does not explain itself and is always ambiguous."[1] Like interpreters of dreams, Gautier, Baudelaire, the Goncourt brothers, Huysmans, Henry James, Rilke, Kokoschka, Virginia Woolf, and Malraux set down their own reactions to the work of the artists they explored in memorable, vibrant, and forceful intuitions and thoughts. For them, certain works by certain artists acted as catalysts, touching specific personal joys and pains in the depths of their beings and bringing a whole new world into consciousness. These same visual representations also stirred the collective: interrelationships, environments, and the world at large in a space-time continuum. The eminent nineteenth- and twentieth-century writers who reached into the heart of both empirical and subliminal realms were indeed seers. Their perceptions of the primordial manifestations of their psyches gave shape and form both to their writings and also to the significant trends in their own and future times.

Art criticism was for them an active—and for some even an aggressive—spiritual, aesthetic, and psychological experience. Ribera's and Zurbarán's paintings aroused anger in Gautier; he was antagonized by their brand of religiosity, which he considered dehumanizing and ugly. Art for Huysmans, Kokoschka, and Malraux acted as a catharsis, enabling each to position and exteriorize certain troubled areas within his unconscious. Baudelaire soared into mythical and metaphysical regions by means of the pictorial world. The sensate sphere was tapped by the Goncourts and Woolf, for whom it grew more acute as the eye gained dominion over other aspects within the psyche. Rilke acquired discipline and strength from Rodin's sculpture, thereby increasing his own creative and judgmental faculties. The nine writers in *Word/Image/Psyche* thus responded directly to the paintings and sculptures

before them in terms of their own personalities in which rationalization coexisted with feeling tones; cerebrality, with affectivity.

All great artists, whether writers or painters, create worlds of their own—fresh visions of life. In so doing, they seek to share their treasured discoveries with the world at large—the writer through the medium of words, the painter with pigments and brush. "Art postulates communion," Igor Stravinsky wrote, "and the artist has an imperative need to make others share the joy which he experiences himself."[2] Art enabled Gautier, Baudelaire, the Goncourts, Huysmans, James, Rilke, Kokoschka, Woolf, and Malraux to assuage their loneliness and solitude, not openly, but by projecting their thoughts and feelings in works of art. Visual art was a vehicle that helped them to reach out to the outside world—to establish a common sharing with humanity. Art transcends the language barrier in the same way that music does, and like music and like our dreams, it can be experienced and interpreted on many levels. A masterpiece is an accomplice, a friend, an autonomous entity in whose presence one may feel exhilarated, soothed, comforted, distraught, anxious, or serene. As an echo of what lies hidden within the depths of the unconscious, it animates, harmonizes, disperses, distills aspects of the self, the perceived image being a mysterious force that conjures up in infinite ways and forms the creative spirit that observes it.

"The artist is not a person endowed with free will who seeks his own ends, but one who allows art to realize its purpose through him."[3] This certainly holds equally true of the writers discussed in *Word/Image/Psyche*. Each is a complex of opposites: object and subject, observer and observed. Their reactions stem from an innate drive of unknown power that functions in darkness, much like a germinating seed that draws its sustenance from an underground spring—from the richness of the Great Earth Mother. We know only the visible fruit which we experience sensually, spiritually, psychologically, and, finally, interpret according to our understanding. The origin of the creative and critical forces of the genius whose world takes root in an inner source of psychic creativity can never be deciphered or explained. As C. G. Carus wrote:

> Strange are the ways by which genius is announced, for what distinguishes so supremely endowed a being is that, for all the freedom of his life and the clarity of his thought, he is everywhere hemmed round and prevailed upon by the Unconscious, the mysterious god within him; so that ideas flow to him—he knows not whence; he is driven to work and to create—he knows not to what

end; and is mastered by an impulse for constant growth and development—he knows not whither.[4]

We know only that art exists as does the dream; that its meanings are unlimited; that it enriches life, expands consciousness, and activates word/ image/psyche.

Notes

Introduction

1. C. G. Jung, *Collected Works*, 15:138.
2. René Huygue, *Sens et destiné de l'art*, pp. 7–16.
3. Erich Neumann, *Art and the Creative Unconscious*, p. 82.
4. Rudolf Otto, *Le Sacré*, p. 103.
5. Jolande Jacobi, *Complex Archetype Symbol in the Psychology of C. G. Jung*, p. 48.
6. Huygue, *Sens et destiné de l'art*, pp. 7–8.
7. C. G. Jung, "Approaching the Unconscious," *Man and His Symbols*, p. 85.

Chapter 1

1. Adolphe Boschot, *Théophile Gautier*, p. 252.
2. Émile Bergerat, *Théophile Gautier*, p. 242.
3. Théophile Gautier, "La Comédie de la Mort," *Poésies*, 2:3–49.
4. Théophile Gautier, *Mademoiselle de Maupin*, pp. 26–60.
5. Théophile Gautier, "Civilization and the Plastic Arts," *Works of Théophile Gautier*, 5:235.
6. Gautier, *Mademoiselle de Maupin*, pp. 26–60.
7. Théophile Gautier, *Histoire du Romantisme*, p. 160.
8. Théophile Gautier, *Pochades et Paradoxes*, p. vii.
9. Boschot, *Théophile Gautier*, p. 247.
10. Charles Baudelaire, *Oeuvres complètes*, p. 877.
11. Gautier, *Mademoiselle de Maupin*, pp. 26–60.
12. Gautier, *Works*, 2:58; *Travels in Spain*, pp. 471, 497.
13. Gautier, *Works*, 2:58. See also ibid., "The Louvre," 10:87, 155.
14. Edward Edinger, *Ego and Archetype*, pp. 146–55.
15. Gautier, *Travels in Spain*, p. 59.
16. Ibid., p. 60.
17. Gautier, "Civilization and the Plastic Arts," *Works*, 5:229.
18. Ernesto Buonaiutu, "Symbols and Rites in the Religious Life of Certain Monastic Orders," *Eranos Yearbook*, 6:172.
19. Gautier, "Civilization and the Plastic Arts," *Works*, 5:233.
20. Ibid., p. 230.
21. Ibid., p. 231. See also Richard B. Grant, *Théophile Gautier*, and P. E. Tennant, *Théophile Gautier*.

Chapter 2

1. Charles Baudelaire, *Oeuvres complètes*. All quotations have been taken from this edition.

2. Charles Baudelaire, *The Mirror of Art: Critical Studies by Baudelaire*. Most of the translations, some quoted directly and others in slightly altered form, come from this volume.

3. Herbert Read, *The Meaning of Art*, p. 183.

4. Dorothy Bussy, *Eugène Delacroix*, p. 8.

5. Ibid., p. 33.

6. Claude Roger Marx and Sabine Cotte, *Delacroix*, p. 29.

7. Ibid., p. 67.

8. Emerson's essay is entitled "The Conduct of Life."

9. Edward Edinger, "An Outline of Analytical Psychology," p. 12.

10. René Huygue, *Les Puissances de l'image*, pp. 129–30.

11. Marie Louise von Franz, *Puer Aeternus*, p. 25.

12. C. G. Jung, *Collected Works*, 12:321.

13. Edward Edinger, *Ego and Archetype*, p. 49.

14. Ibid., pp. 56–57.

15. Will Durant, *The Story of Civilization*, 4:606.

16. Georges Poulet, *Qui était Baudelaire?*, p. 73.

17. Jung, *Collected Works*, vol. 9, pt. 2, p. 75.

18. C. G. Jung, *The Visions Seminars*, 2:369. Cited in M. R. James, *The Apocryphal New Testament*, Oxford University Press, 1942, p. 11.

19. Charles Baudelaire, "L'Heautontimoroumenos," *Oeuvres complètes*.

Chapter 3

1. Goncourt: *L'Art du dix-huitième siècle*, J. P. Bouillon, ed., pp. 17–18.

2. Ibid., p. 16.

3. Ibid., p. 65.

4. Gerd Muehsam, ed. and comp., *French Painters and Paintings*, p. 185.

5. Ibid.

6. Goncourt: *L'Art du dix-huitième siècle*, Bouillon, ed., p. 82.

7. Muehsam, *French Painters and Paintings*, p. 215.

8. Ibid.

9. Goncourt: *L'Art du dix-huitième siècle*, Bouillon, ed., p. 82.

10. Ibid., pp. 86–87.

11. Muehsam, *French Painters and Paintings*, p. 215.

12. Colta Feller Ives, *The Great Wave*, p. 7.

13. John Rewald, *Post-Impressionism*, p. 207.

14. Goncourt: *L'Art du dix-huitième siècle*, Bouillon, ed., p. 189.

15. *Paris and the Arts, 1851–1896: From the Goncourt Journal*, George J. Becker and Edith Philips, eds. and trans., p. 91.

16. Ibid., pp. 209–11.

17. Goncourt: *L'Art du dix-huitième siècle*, Bouillon, ed., pp. 202–03.

18. Ibid., pp. 198–99.

19. Ibid., pp. 199–204.

20. Ibid., pp. 206–10.
21. Ibid., p. 208.
22. Ibid., p. 208–09.
23. Edmond de Goncourt and Jules de Goncourt, *Manette Salomon*, p. 18.
24. Ibid., p. 158.
25. Ibid., p. 172.
26. Ibid., pp. 182–83.
27. *Goncourt Journal 1851–1870*, p. 68.

Chapter 4

1. Joris-Karl Huysmans, *Trois églises et trois primitifs*, p. 184.
2. Gustave Coquiot, *Le vrai J.-K. Huysmans*, p. 15.
3. Huysmans, *Trois églises*, p. 210.
4. Herbert Read, *Art and Alienation*, p. 60.
5. Huysmans, *Trois églises*, pp. 159–60.
6. Read, *Art and Alienation*, p. 61.
7. Peter Selz, *German Expressionist Painting*, p. 18.
8. Huysmans, *Trois églises*, p. 189.
9. Ibid., pp. 104, 190–91.
10. Ibid., pp. 200, 203.
11. Ibid., p. 210.
12. Ibid., pp. 203–04.
13. Joris-Karl Huysmans, *La-Bas*, p. 12.
14. Huysmans, *Trois églises*, p. 197.
15. Ibid., pp. 207–08.
16. Huysmans, *La-Bas*, p. 157.

Chapter 5

1. Henry James, *The Painter's Eye*, p. 277.
2. Viola Hopkins Winner, *Henry James and Visual Arts*, pp. 1–39.
3. René Huygue, "Color and the Expression of Interior Time in Western Art," *Color Symbolism*, p. 137.
4. F. O. Mathiessen and Kenneth B. Murdock, eds., *The Notebooks of Henry James*, p. 380.
5. Henry James, *The Ambassadors*, p. 137. All references to *The Ambassadors* are from this edition.
6. James, *The Painter's Eye*, p. 219.
7. René Huygue, *Les Puissances de l'image*, p. 87.
8. Mathiessen and Murdock, eds., *Notebooks of Henry James*, p. 229.
9. Ibid., p. 371.

10. Charles R. Anderson, *Person, Place, and Thing in Henry James's Novels*, p. 272.
11. James, *The Painter's Eye*, p. 162.
12. John Rewald, *The History of Impressionism*, p. 180.
13. C. G. Jung, *Collected Works*, 5:388.

Chapter 6

1. Rainer Maria Rilke, *Letters of Rainer Maria Rilke 1892–1910*, p. 17.
2. Ibid., p. 76.
3. Ibid., pp. 190–91.
4. Ibid., pp. 76–77.
5. Ibid., p. 125.
6. Ibid., p. 77.
7. Ibid., p. 79.
8. Ibid., p. 126.
9. Ibid., p. 118.
10. Rainer Maria Rilke, *Auguste Rodin*, p. 24.
11. Rilke, *Letters 1892–1910*, p. 118.
12. James Hillman, "The Great Mother Motif, Her Son, Her Hero, and the Puer," *Fathers and Mothers*, pp. 75–116.
13. Rilke, *Letters 1892–1910*, p. 83.
14. Ibid.
15. Ibid., p. 84.
16. C. G. Jung, *Collected Works*, 5:340.
17. Rainer Maria Rilke, *The Notebooks of Malte Laurids Brigge*, p. 95.
18. Rainer Maria Rilke, *Letters to a Young Poet*, p. 95.
19. Rilke, *Letters 1892–1910*, pp. 122–23.
20. Ibid., p. 86.
21. Siegfried Mandel, *Rainer Maria Rilke: The Poetic Instinct*, p. 65.
22. Rilke, *Auguste Rodin*, p. 18.
23. Mandel, *Rainer Maria Rilke*, p. 23.
24. Frank Wood, *Rainer Maria Rilke*, p. 72.
25. Ibid., p. 73.
26. *Rainer Maria Rilke: Selected Works*, trans. J. B. Leishman, p. 143.
27. Rilke, *Letters 1892–1910*, pp. 211–12.

Chapter 7

1. Edith Hoffman, *Kokoschka: Life and Work*, p. 54. The audience's reaction of outrage did not cease after the play's opening night. In 1911 when Kokoschka's *The Sphinx and the Straw Man* was to be produced in Vienna, authorities demanded to see a private performance prior to the public showing. The heir to the Hapsburg throne was

present, and after seeing the happenings, said "This fellow's bones [Kokoschka's] ought to be broken in his body." Even one of Austria's best-known art critics, Josef Strzygowsky, declared that Kokoschka was a "mangy creature," that his works were "disgusting plague-sores" and "puddles of foul stink," and that he should "apply his talents to the decoration of brothels with warning pictures of syphillis and paralysis." (Ibid., p. 86, cited from *Die Fackel*, April 1, 1911.) *Murderer Hope of Womankind* (*Mörder, Hoffnung der Frauen*) was performed in 1917 in Dresden at the Albert Theatre, along with two other plays by Kokoschka: *The Burning Bush* (*Brennende Dornbusch*) and *The Sphinx and the Straw Man* (*Sphinx und Strohmann*); again in 1919 at Reinhardt's Kammerspiele; in 1920 in Frankfurt; and in 1925, with Hindemith's musical score, in Frankfurt and Stuttgart.

2. Peter Selz, *German Expressionist Painting*, pp. 161–63.

3. Ibid., p. 165.

4. Oskar Kokoschka, *My Life*, p. 29. Referring to the costumes for *Murderer Hope of Womankind*, Kokoschka wrote: "I dressed them in makeshift costumes of rags and scraps of cloth and painted their face and bodies." Inspired by his trips to the ethnological museums, Kokoschka further declared: "I had learned how primitive peoples, presumably as a reaction to their fear of death, had decorated the skulls of the dead with facial features, with the play of expressions, the lines of laughter and anger, restoring to them the appearance of tendons, just as they can be seen in my old drawings" (p. 29).

5. The quotations from *Murderer Hope of Womankind* are by J. M. Richtie from *Seven Expressionist Plays*.

6. Two of the drawings illustrating *Murderer Hope of Womankind* were printed in *Der Sturm*, pp. 14 and 21, 1910, a weekly that published poetry and political and literary articles.

7. Herschel B. Chipp, *Theories of Modern Art*, p. 170.

8. Hoffmann, *Kokoschka*, p. 86.

9. Chipp, *Theories of Modern Art*, p. 171.

10. Ibid., p. 172.

Chapter 8

1. George Spater and Ian Parsons, *A Marriage of True Minds*, p. 19.

2. Roger Fry was offered the directorship of the National Gallery in London but accepted instead the curatorship of painting at the Metropolitan Museum of Art in New York City (1905–1910). In 1933, he was appointed Slade Professor of Fine Arts at Cambridge. His lectures, always extremely well attended, emphasized the importance of analyzing formal and structural characteristics in the work of art.

3. Herschel B. Chipp, *Theories of Modern Art*, p. 19.

4. Roger Fry, *Cézanne: A Study of His Development*, p. 33.

5. C. G. Jung, *Psychological Types*, p. 543.

6. Ibid., p. 20.

7. Fry, *Cézanne*, p. 3.

8. Quentin Bell, *Virginia Woolf: A Biography*, p. 361. Virginia Woolf, *To the Lighthouse*, New York: Harcourt Brace, 1927, is the edition used.

9. Marie Louise von Franz and James Hillman, *Jung's Typology*, p. 83.

10. Chipp, *Theories of Modern Art*, p. 19.

11. Franz and Hillman, *Jung's Typology*, p. 87. See Roger Fry, *Transformations*, p. 189. The essay on Seurat is most illuminating.

12. Chipp, *Theories of Modern Art*, p. 21.

13. Fry, *Cézanne*, p. 19.

14. Chipp, *Theories of Modern Art*, p. 19.

15. Fry, *Cézanne*, p. 4.

16. Chipp, *Theories of Modern Art*, p. 21.

17. Fry, *Cézanne*, p. 36. See Roger Fry, *Characteristics of French Art*.

18. Chipp, *Theories of Modern Art*, p. 21.

19. Ibid., p. 19.

20. Ibid., p. 18.

21. Ibid., p. 13.

Chapter 9

1. Pierre Gassier, *The Drawings of Goya*, p. 54. A need for secrecy, perhaps a certain element of fear as to the reception of some of Goya's works, may have encouraged him to stop the sale of the *Caprichos*; as for *The Disasters of War* and the *Disparates*, few saw these etchings during Goya's lifetime; the same may be said of the canvases included in *House of the Deaf Man*. Not until the end of the nineteenth century were the *Caprichos* catalogued and studied, and Goya's other works disseminated.

2. Jane Harrison, *Epilegomena to the Study of Greek Religion and Themis*, pp. 75–76.

3. Mircea Eliade, *Patterns in Comparative Religion*, pp. 173–78.

4. Marie Louise von Franz, *Creation Myths*, pp. 179–85.

5. In the Kronos situation, we see the reverse of the Oedipus myth.

6. C. G. Jung, *Collected Works*, 14:8.

7. Jacques Lassaigne, *Spanish Painting*, p. 89.

8. Marie Louise von Franz, *Alchemical Active Imagination*, p. 45.

9. André Malraux, *Saturn, An Essay on Goya*, p. 9. All quotations come from this edition.

10. Erich Neumann, *Depth Psychology and a New Ethic*, pp. 30, 107.

11. Alice Raphael, *Goethe and the Philosophers' Stone*, p. 40.

12. Jung, *Collected Works*, vol. 9, pt. 2, p. 75.

13. Ibid., p. 139.

14. Ibid., pp. 50–51.

15. A dualistic formula is expressed in 2 Thessalonians: the earthly or eschatological manifestation of God in Christ and of Satan in the Antichrist. See Victor Maag, "The Antichrist as a Symbol of Evil," p. 61.

16. Marie Louise von Franz, *Shadow and Evil in Fairytales*, p. 162.
17. Henri Focillon, *Maîtres de l'estampe*, p. 142.
18. Jung, *Collected Works*, 13:17.
19. René Huygue, *Les Puissances de l'image*, p. 124.
20. William Barrett, *Irrational Man*, p. 83.
21. Franz, *Shadow and Evil in Fairytales*, p. 32.

Conclusion

1. C. G. Jung, *Collected Works*, 15:104.
2. Igor Stravinsky, *An Autobiography*, p. 10.
3. Jung, *Collected Works*, 15:101.
4. Ibid., p. 102.

Bibliography

Anderson, Charles R. *Person, Place, and Thing in Henry James's Novels*. Durham, N.C.: Duke University Press, 1977.

Arnheim, Rudolf. *Visual Thinking*. Berkeley: University of California Press, 1971.

Baldick, Robert. *La Vie de J. K. Huysmans*. Paris: Denoël, 1958.

Barrett, William. *Irrational Man*. New York: A Doubleday Anchor Book, 1961.

Baudelaire, Charles. *The Mirror of Art: Critical Studies by Baudelaire*. Translated by Jonathan Mayne. New York: Anchor Books, 1956.

_____. *Oeuvres complètes*. Paris: Pléiade, 1961.

Bell, Quentin. *Virginia Woolf: A Biography*. New York: Harcourt Brace Jovanovich, 1972.

Bergerat, Émile. *Théophile Gautier*. Paris: Charpentier, 1879.

Billy, A. *Les Frères Goncourt*. Paris: Flammarion, 1954.

Boschot, Adolphe. *Théophile Gautier*. Paris: Desclée de Brouwer et co., 1933.

Buonaiutu, Ernesto. "Symbols and Rites in the Religious Life of Certain Monastic Orders." *Eranos Yearbook*, 6. Princeton, N.J.: Princeton University Press, 1968.

Bussy, Dorothy. *Eugène Delacroix*. London: Duckworth and Co., 1912.

Chipp, Herschel B. *Theories of Modern Art*. Los Angeles: University of California Press, 1973.

Cogny, Pierre. *J. K. Huysmans à la recherche de l'unité*. Paris: Librairie Nizet, 1953.

Coquiot, Gustave. *Le vrai J.-K. Huysmans*. Paris: Charles Bosse, 1912.

Delzant, A. *Les Goncourt*. Paris: Charpentier, 1889.

Durant, Will. *The Story of Civilization*. Vol. 4. New York: Simon and Schuster, 1950.

Edinger, Edward. *Ego and Archetype*. New York: G. P. Putnam's Sons, 1972.

_____. "An Outline of Analytical Psychology." Unpublished paper.

Eliade, Mircea. *Patterns in Comparative Religion*. New York: New American Library, 1974.

Focillon, Henri. *Maîtres de l'estampe*. Paris: Flammarion, 1969.

Fosca, F. *Edmond et Jules de Goncourt*. Paris: A. Michel, 1941.

Franz, Marie Louise von. *Alchemical Active Imagination*. Irving, Tex.: Spring Publications, 1974.

_____. *Creation Myths*. New York: Spring Publications, 1971.

_____. *Puer Aeternus*. New York: Spring Publications, 1970.

_____. *Shadow and Evil in Fairytales*. Zürich, Switzerland: Spring Publications, 1974.

Franz, Marie Louise von, and James Hillman. *Jung's Typology*. New York: Spring Publications, 1974.

Fry, Roger. *Cézanne: A Study of His Development*. London: Macmillan Co., 1927.

_____. *Transformations*. London: Chatto and Windus, 1926.

_____. *Characteristics of French Art*. London: Chatto and Windus, 1932.

Gassier, Pierre. *The Drawings of Goya*. New York: Harper and Row, 1975.

Gautier, Théophile. *Histoire du Romantisme*. Paris: Charpentier, 1927.

_____. *Mademoiselle de Maupin*. Paris: Garnier-Flammaridu, 1966.

_____. *Pochades et Paradoxes*. Paris: Hachette, 1856.

_____. *Poésies*. Vol. 2. Paris: Charpentier et co., 1885.

———. *España* (Spain). Paris.

———. *Voyage en Espagne suivi de España* (Travels in Spain). Paris: Gallimard, 1981.

———. *Works of Théophile Gautier.* Translated by F. C. de Sumichrast. New York: Bigelow, Brown and Co., n.d.

Goncourt: *L'Art du dix-huitième siècle.* J. P. Bouillon, ed. Paris: Hermann, 1967.

Goncourt *Journal, Paris and the Arts, 1851–1896: From the Goncourt Journal.* Translated and edited by J. Becker and Edith Philips. Ithaca, N.Y.: Cornell University Press, 1971.

Goncourt, Edmond de and Jules de Goncourt. *Manette Salomon.* Paris: Gallimard, 1979.

Grant, Richard B. *Théophile Gautier.* Boston: Twayne Publishers, 1975.

Guillaume-Reicher, Gilberte. *Théophile Gautier et l'Espagne.* Paris: Hachette, 1935.

Guinard, Paul. *Les Peintres espagnols.* Paris: Livre de poche/Art, 1967.

Harrison, Jane. *Epilegomena to the Study of Greek Religion and Themis.* New York: New American Library, 1974.

Hillman, James. "The Great Mother Motif, Her Son, Her Hero, and the Puer," *Fathers and Mothers.* Zürich, Switzerland: Spring Publications, 1973.

Hodin, J. P. *Oskar Kokoschka: The Artist and His Time.* New York: Graphic Society, 1966.

Hoffmann, Edith. *Kokoschka: Life and Work.* London: Faber and Faber, 1947.

Huygue, René. "Color and the Expression of Interior Time in Western Art," *Color Symbolism: Six Excerpts from Eranos Yearbook 1972.* Zürich, Switzerland: Spring Publications, 1977.

———. *Les Puissances de l'image.* Paris: Flammarion, 1965.

———. *Sens et destiné de l'art.* Paris: Flammarion, 1967.

———. "Les thèmes-clefs et l'évolution de l'artiste: Vermeer, Rembrandt, Delacroix," *Eranos Jahrbuch.* Leiden, The Netherlands: E. J. Brill, 1973.

Huysmans, Joris-Karl. *La-Bas.* Paris: Le Livre de Poche, 1966.

———. *Trois églises et trois primitifs.* Paris: Plon, 1908.

Ives, Colta Feller. *The Great Wave.* New York: Metropolitan Museum of Art, 1974.

Jacobi, Jolande. *Complex Archetype Symbol in the Psychology of C. G. Jung.* Princeton, N.J.: Princeton University Press, 1957.

James, Henry. *The Painter's Eye.* Cambridge: Harvard University Press, 1956.

———. *The Ambassadors.* Edited by F. P. Dupee. New York: Holt, Rinehart and Winston, 1967.

Jasinski, René. *Les années romantiques de Théophile Gautier.* Paris: Vuibert, 1929.

Jung, C. G. *Collected Works.* Vol. 8. Translated by R. F. C. Hull. Princeton, N.J.: Princeton University Press, 1969. Vol. 9. Translated by R. F. C. Hull. Princeton: Princeton University Press, 1968. Vol 11. Translated by R. F. C. Hull. New York: Pantheon Books, 1963. Vol. 12. Translated by R. F. C. Hull. London: Routledge and Kegan Paul, 1953. Vol. 13. Translated by R. F. C. Hull. Princeton, N.J.: Princeton University Press, 1967. Vol. 14. Translated by R. F. C. Hull. New York: Pantheon Books, 1963. Vol. 15. Translated by R. F. C. Hull. New York: Pantheon Books, 1966.

———. *Psychological Types.* London: Pantheon, 1964.

_____. *The Visions Seminars*. 2 vols. Zürich, Switzerland: Spring Publications, 1976.

Kokoschka, Oskar. *My Life*. Translated by David Britt. New York: Macmillan Co., 1974.

_____. *Murderer Hope of Womankind. Seven Expressionists Plays*. Translated by J. M. Ritchie. London: Calder and Boyars, 1968.

Lassaigne, Jacques. *Spanish Painting*. Translated by Gilbert Stuart. Geneva, Switzerland: Skira, 1952.

Maag, Victor. "The Antichrist as a Symbol of Evil." *Evil*. Evanston, Ill.: Northwestern University Press, 1967.

Malraux, André. *Saturn, An Essay on Goya*. Translated by C. W. Chilton. New York: Phaidon, 1957.

Mandel, Siegfried. *Rainer Maria Rilke: The Poetic Instinct*. Carbondale and Edwardsville, Ill.: Southern Illinois University Press, 1965.

Marx, Claude Roger. *Les Goncourt et l'Art*. Reprinted in *Maître d'hier et d'aujourd'hui*. Paris: Calmann-Lévy, 1914.

Marx, Claude Roger, and Sabine Cotte. *Delacroix*. New York: George Braziller, 1978.

Mathiessen, F. O., and Kenneth B. Murdock, eds. *The Notebooks of Henry James*. New York: Oxford University Press, 1947.

Muehsam, Gerd, ed. and comp. *French Painters and Paintings*. New York: Ungar Publishers, 1970.

Neumann, Erich. *Art and the Creative Unconscious*. New York: Pantheon, 1959.

_____. *Depth Psychology and a New Ethic*. New York: G. P. Putnam's Sons, 1969.

_____. *The Origins and History of Consciousness*. New York: Pantheon, 1954.

Otto, Rudolf. *Le Sacré*. Paris: Payot, 1969.

Poulet, Georges. *Qui était Baudelaire?* Geneva, Switzerland: Skira, 1969.

Richtie, J. M. *Seven Expressionist Plays*. London: Calder and Boyars, 1968.

Raphael, Alice. *Goethe and the Philosophers' Stone*. New York: Garret Publishers, 1955.

Read, Herbert. *Art and Alienation*. New York: Viking Compass Books, 1970.

_____. *The Art of Sculpture*. Princeton, N.J.: Princeton University Press, 1969.

_____. *The Meaning of Art*. New York: Praeger, 1972.

Rewald, John. *The History of Impressionism*. New York: Museum of Modern Art, 1961.

_____. *Post-Impressionism*. New York: Museum of Modern Art, 1956.

Ricatte, R. *La Création romantique chez les Goncourts*. Paris: A. Colin, 1953.

Richard, J. P. *Littérature et sensation*. Paris: Seuil, 1954.

Rilke, Rainer Maria. *Auguste Rodin*. London: The Gray Walls Press Ltd., 1946.

_____. *Letters of Rainer Maria Rilke 1892–1910*. Vol. 1. Translated by Jane Bannard Greene and M. D. Herter Norton. New York: Norton Library, 1972.

_____. *Letters to a Young Poet*. Translated by M. D. Herter Norton. New York: W. W. Norton and Co., 1962.

_____. *The Notebooks of Malte Laurids Brigge*. Translated by M. D. Herter Norton. New York: Norton Library, 1964.

Rainer Maria Rilke: Selected Works. Translated by J. B. Leishman. New York: New Directions Books, 1957.

Sabatier, P. *L'esthétique des Goncourt*. Paris: Hachette, 1920.

Selz, Peter. *German Expressionist Painting*. Los Angeles: University of California Press, 1957.

Spater, George, and Ian Parsons. *A Marriage of True Minds*. New York: Harcourt Brace Jovanovich, 1977.

Stravinsky, Igor. *An Autobiography*. Stonington, Conn.: October House, 1966.

Tennant, P. E. *Théophile Gautier*. London: The Athlone Press, 1975.

Venturi, Lionello. *Histoire de la critique d'art*. Translated from the Italian by Juliette Bertrand. Paris: Flammarion, 1968.

Winner, Viola Hopkins. *Henry James and the Visual Arts*. Charlottesville, Va.: The University Press of Virginia, 1970.

Wood, Frank. *Rainer Maria Rilke*. New York: Octagon Books, 1970.

Woolf, Virginia. *To the Lighthouse*. New York: Harcourt Brace, 1927.

Index

ABOUT THE AUTHOR

Bettina L. Knapp teaches Romance Languages and Com-
parative Literature at Hunter College and at the Graduate
Center of the City University of New York (CUNY). She
received her bachelor of arts degree from Barnard College
and her master of arts degree and doctorate from Columbia
University. A prolific writer, she is author of more than
twenty-nine books, of which the following were published
by The University of Alabama Press: *Jean Racine: Mythos
and Renewal in Modern Theatre; Céline, Man of Hate;* and
Gérard de Nerval: The Mystic's Dilemma.